ISRAEL THROUGH MY LENS

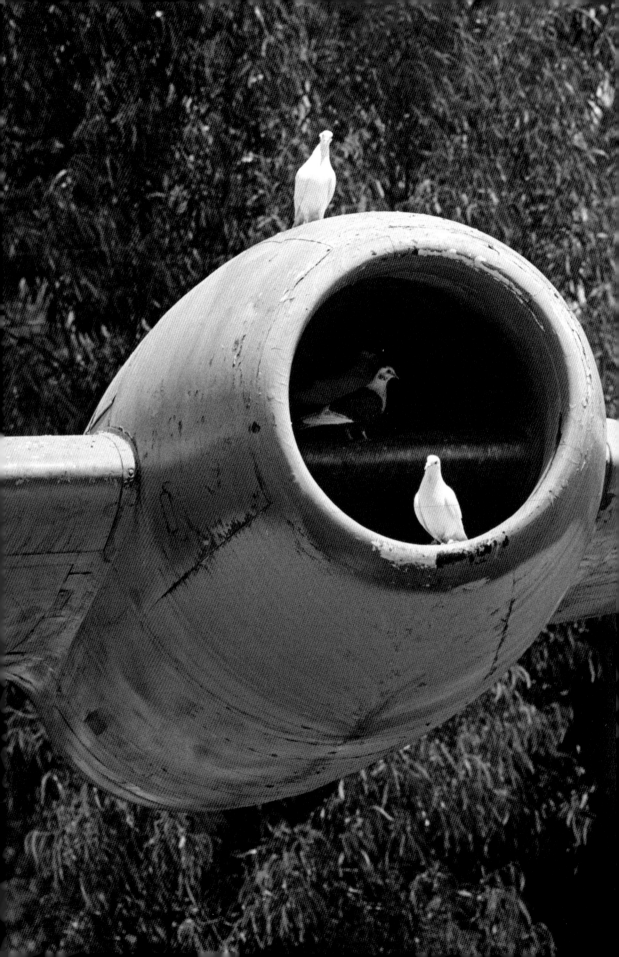

ISRAEL

SIXTY YEARS AS A PHOTOJOURNALIST

THROUGH

MY LENS

DAVID RUBINGER

WITH RUTH CORMAN

FOREWORD BY SHIMON PERES

ABBEVILLE PRESS PUBLISHERS

NEW YORK LONDON

FRONT COVER: Three Israeli paratroopers minutes after taking the Western Wall on June 7, 1967, during the Six Day War (see plate 54).
BACK COVER: A hand on the Western Wall, 1971.
1. (page 2) Doves nest in the engine pod of a disused Meteor fighter jet.

EDITOR: David Fabricant
COPY EDITOR: Ashley Benning
PRODUCTION MANAGER: Louise Kurtz
DESIGNER: Misha Beletsky

The photographs by David Rubinger herein are reproduced by kind permission of *Yedioth Ahronoth*.

First edition
10 9 8 7 6 5 4 3 2 1

ISBN-13: 978-0-7892-0928-3
ISBN-10: 0-7892-0928-4

Library of Congress Cataloging-in-Publication Data
Rubinger, David, 1924–
 Israel through my lens : 60 years as a photojournalist / David Rubinger with Ruth Corman ; foreword by Shimon Peres.
 p. cm.
 Includes bibliographical references and index.
 ISBN-13: 978-0-7892-0928-3 (hardcover : alk. paper)
 ISBN-10: 0-7892-0928-4 (hardcover : alk. paper)
 1. Rubinger, David, 1924– 2. Photojournalists—Israel—Biography. 3. Photographers—Israel—Biography. 4. Israel—History—20th century—Pictorial works.
I. Corman, Ruth. II. Title.

TR140.R83A3 2007
770.95694092—dc22
 [B]
 2007020580

For bulk and premium sales and for text adoption procedures, write to Customer Service Manager, Abbeville Press, 137 Varick Street, New York, NY 10013, or call 1-800-ARTBOOK.

Visit Abbeville Press online at www.abbeville.com.

CONTENTS

ACKNOWLEDGMENTS

It was in 2003 that the idea of an autobiography was first suggested, by Charles Bronfman and his late wife Andy, who felt that my life story should be told. Nothing further happened for a couple of years, until Ruth Corman and I began to work together again on an exhibition and she too suggested that mine was a tale worth telling and offered to write it. I shall always be grateful to Charles Bronfman for his enduring friendship and encouragement. My special thanks to Ruth for spending an inordinate amount of her time trying to make sense of my meanderings and putting my life in order for our readers. Last, but most important, my personal gratitude must go to my late wife Anni, who somehow managed to support me through those turbulent years. I would like to dedicate this book in her memory.

Ruth thanks her husband Charles for his tremendous support and enthusiasm throughout this project and also for his editing of the first draft. His comment "I could not put it down!" made it all worthwhile.

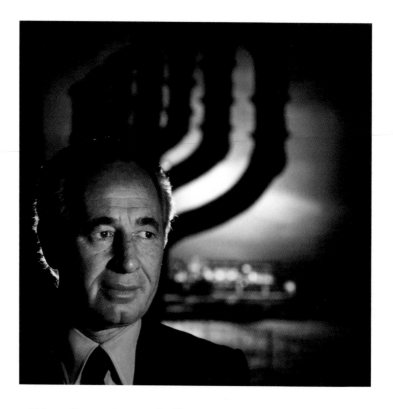

2. Shimon Peres, photographed by
David Rubinger, 1981.

FOREWORD

BY SHIMON PERES

Nothing can stop the past from escaping or the future from coming about. Hence the Hebrew language shows impatience but does not lack in logic, because basically, Hebrew has two tenses and not three: the past and the future. The present exists only as an option, because in life, things have happened or will happen—nothing happens in the present. For as soon as it does, it has already passed. It is only with the future that we meet. And it is hard for us to conserve the moment created by the future, because that moment has already turned into the past. To perpetuate the past (without which it is hard to understand the future), we immortalize history: the history of words or the history of pictures. History related in words relies on the writers of history and, in most cases, is a subjective rendition that is the product of the writer's perspective. History captured in pictures is perceived by a much more objective eye: the camera. The camera is much more trustworthy than the pen. It captures the passing moment unadorned. It is an uncorrupted witness. Yet what can be defined as a picture that is worthy of the events it exposes? This depends on the photographer. The photographer must be reliable technically and an artist intellectually. He must be able to create a picture that reproduces the story and the place in real time, and represents the essence of a period as a whole. The selection of the moment is both an art and also an act of judgment, the depiction of an era that is fast disappearing.

David Rubinger is such an artist. He is the photographer of a nation in the making and the photographer of dramatic events that occur at a dizzy pace. Because Israel is a drama no less than a nation. And we must keep in mind that history that is penned can be rewritten. A picture that is taken cannot be altered.

A painter can create a picture. A photographer must encapsulate a situation. A painter can use colors, draw on his imagination, or base his picture on a myth. As for a photographer, his colors are those of nature. His words are body language. His imagination is anchored to the fast rhythm of life.

When David Rubinger is stalking his "victims," the extraordinary effort he invests to avoid missing the moment and capture it faithfully is apparent. There is no deceit, exaggeration, or minimization, but rather an aspiration to create a genuine picture, an aspiration that is imbued with inspiration.

When David Rubinger looks back, he can be at one with himself—war and construction, nervousness and patience, the new and the sad, a rich tapestry of people, a cornucopia of personalities, a series of events, all follow one another to depict a unique chapter of history. No story can replace the incredible power of the pictures—the authenticity and the uncompromising truth they represent. As the saying goes, one picture is more effective than a thousand words, on condition that the picture be a lasting one, and not a fleeting glance.

And for us, the students of history, we have no option but to submit to the verdict of the picture, and the judgment of the photographer. In it we feel the warmth of the days gone by, their uniqueness, and a reflection of a constant nostalgia that has never been void of drama. We are looking at a world that has vanished, and which is presented to us at its very best. We are witness to the opening notes of tomorrow's day. The setting of the sun and the breaking of the dawn create a miraculous album that depicts a personal biography and the history of a nation.

A good photograph is like an identity card with a date of birth but no ending. David Rubinger took pictures of many births and therefore reminds us anew of the room of our own childhood.

1. HOW IT ALL BEGAN

In 2004, I celebrated my eightieth birthday.

On December 26 of that year, the very day that the tsunami struck in Asia, I was confronted by my own personal tsunami. It seemed impossible that any personal drama could reduce to insignificance the overwhelming tragedy in the Far East. Something did.

That same morning, I had arranged to go swimming with Ziona, my companion of the past two years. For some reason, she changed her mind, and we agreed to meet at her home for lunch.

Lunchtime came. I went around to the house and found the front door locked. There was no response to my ringing the doorbell, nor did she answer her home phone. I was unconcerned at first, but then a niggling anxiety began to creep in that something was not quite right. She was always very reliable, and it was totally out of character for her not to be in touch.

After a short time, I rang her daughter-in-law, who had a key to the house. We went there together and let ourselves in. To our absolute horror, we found Ziona with her throat slit lying dead on the kitchen floor. She had been murdered, so it turned out, by her gardener Muhammad, who had asked her for a lot of money, which she had refused to give him.

Suddenly I, the well-known photographer, found myself on the other side of the lens. The story was on the front page of all the papers and featured on every TV news program. Without warning, I and my life were thrust into the spotlight of media attention. In addition to the horror of what had happened, it was a very unaccustomed situation for me to find myself in.

It was probably this intense media focus on my life that prompted me to start thinking about recording it in some way. If you believe in

fate, then it was no coincidence that in March 2005 I met an old friend with whom I had not been in touch for some time. She told me I had had a fascinating life and was a natural and gifted raconteur, and bullied me into talking to her about my life story. She offered to write it. Here it is.

2. THE EARLY YEARS IN EUROPE

I entered this world on June 29, 1924, in a third-floor apartment on Rampersdorfergasse, Vienna—the home of my maternal grandparents Berish and Yetta Kahane. I was the only child of my parents Kalman and Anna Rubinger.

In those days, the dream of many Jews was to leave their *shtetl* (village) in eastern Europe and somehow get to Vienna—the heart of the Hapsburg Empire and the pinnacle of European culture. My parents were part of this migration away from the countryside. They were born in different towns of Poland, my father in Kosow, my mother in Monastarsko. They eventually met and married in Vienna in 1922. I was born soon afterwards. Their life and that of most of their fellow Jews did not embrace the sophistication of Viennese society. Not for them were trips to the world-famous Opera House, but they did occasionally visit the Yiddish Theater in Leopoldstadt, the Jewish district of the city. When they were not actually working, social life for them involved visiting relatives and regularly attending the synagogue.

My father set himself up in business as a scrap metal dealer. A cavalcade of characters, rag and bone men and others, would turn up at our home with sacks filled with a variety of metal items that they had presumably found, bargained for, or stolen. My father would pay them a small sum for these old pieces of metal, and then carry everything to a little basement that he had rented not far from our home. Here he would laboriously sort them into categories. I remember being allowed to help him sometimes. I recall that his hands were always black and ingrained with dirt from this task, and I also remember the pride with which I assisted him in sorting the tin from the copper or the brass. Once a week, he hired a local man who owned a horse-drawn wagon,

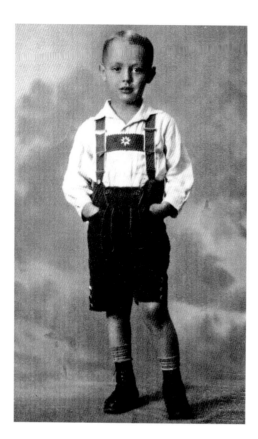

and together they loaded up the sacks and took them to local foundries where the metals were melted down and reused.

4 My mother was a typical Jewish housewife of those times. She reigned over the household and spent much of her day cooking, as Father came home every day for his lunch, except Friday, when he worked through his lunch hour and came home early for Shabbat. Friday evenings were festive, and to this day I can recall the tastes and smells emanating from my mother's kitchen. She made kasha and *mamaliga* (polenta) regularly, food that I still crave today. As a child, I loved to watch her cook this dish, as it would erupt and bubble like a volcano while she was stirring it. Every Saturday, my father walked to his *shtiebl* (small synagogue), which was quite a distance from our home, as we lived in a predominantly non-Jewish area. He continued to attend this particular shtiebl from a sense of loyalty, as my grandfather was the *gabbai* (warden) there. I was very much aware that I was Jewish, even to the extent that I was terrified of the church that I had to pass on my way to school. I would always cross to the other side of the road "just in case." I am not sure what I thought would happen to me if I walked too close to it.

My grandmother was a favorite of the Social Democratic Party mayor, Dr. Seitz, possibly because of our family's political support for him. My aunt Peppi was extremely active in the socialist youth movement. I remember her blue shirt decorated with a pin showing the

4. My mother, Anna Rubinger, 1938.

Three Arrows—the symbol of the Social Democratic Party. Once she gave one of these pins to me, but my parents refused to allow me to wear it, in case it was spotted by the right-wing Fascists who roamed the streets. Presumably because of these political connections, Grandmother was given the concession to run a city-owned laundry, one that exists to this day. This privilege provided her with the means to support her family, allowing my grandfather to spend most of his time in the synagogue in the company of his contemporaries.

I recall little of my grandparents other than my weeping copiously when I watched someone throwing my grandfather's hat into a burning stove, presumably just after he had died. I guess I was aged about three. I also remember visiting my paternal grandparents in Kosow, which was then in Poland and today is in Moldova. We went by train, and I think it took several hours, as to me it seemed endless, but all I recall of the visit is eating a cold chicken leg in the train on the journey. As with most of my mother's cooking, the memory of the taste of it remains pleasurably with me to this day.

I went to the synagogue infrequently with my father—usually only on the High Holy Days. It was also at my father's insistence that the services of a Hebrew teacher were secured so that I could begin to study Hebrew even before I attended proper school—the Talmud Torah—at the age of five. The person I have known the longest in my life and who sat next to me at this school was Erwin Rindner, who also left for Palestine and later became known as Miki Ben Ari. At the height of his career, he served as Israel's ambassador to West Germany—quite an illustrious position for my Talmud Torah mate. I have no idea what his dreams may have been at the time, but mine were much more down to earth—my burning ambition at around the age of seven or eight was to be a tram driver. I wanted to be the kind that we saw in Vienna in those days, who stood on a platform and had a bell near his foot, which he kicked when approaching a stop or to warn pedestrians. From somewhere I had

acquired a bell. I erected a table in the doorway between the kitchen and the living room and placed the bell underneath so that I could hit it with my foot, just like a professional driver.

Being an only child, I was totally indulged by my mother. Each Sunday morning, she woke me up to give me a special triangular chocolate wafer that was called a *Dacherl* (small roof) because of its shape. Again, as with all the food she gave me, I still remember its taste!

My Hebrew teacher taught me my bar mitzvah *sedra* (portion). I read this in the synagogue, and then afterwards a reception was held at home, where I remember standing on a chair and delivering a speech. I recall saying something about how "the more we are pressed, the stronger we become." Usually bar mitzvah and puberty go together, so it must have been about the same age that I would spend a lot of time lying on my bed, looking into the third-floor window of the apartment opposite. There lived Marta, a raven-haired young woman of eighteen, about whom I would dream and long for her to appear. She was probably my first "love," although she was never aware of the existence of the little blond Jewish boy who worshipped her from afar.

My interest in her had possibly been aroused by a book that I had found in my parents' sideboard in the living room and to which I returned regularly whenever the opportunity arose, that is to say whenever my parents were out and I was in no danger of being discovered. The book was *Die vollkommene Ehe*, by T. H. van de Velde, published in the mid-twenties. The English translation was *The Ideal Marriage: Its Physiology and Technique*. It was a very explicit book about sexual intercourse that covered topics such as how to arouse and satisfy a woman, which of course I devoured eagerly. Although I had never put any of this into practice, and was not likely to do so for some time, I felt that at least I was prepared. I realized years later that the world of sex had not been totally unfamiliar to me, as I had slept in the same room as my parents when I was very young and remember waking once and hearing that they were doing something, although I knew not what. I can only have been about four at the time, for when I celebrated my fifth birthday, I attended Talmud Torah and was promoted to having a bed of my own in the living room.

When asked about my early childhood, I found it difficult to recall very much about my playmates until an incident occurred in 1982 that

5. Reunion with my childhood friend Poldi Kammermeyer (left), Vienna, 1982.

brought memories flooding back. I received a phone call from someone in Haifa. "Are you Rubinger?" he asked. "Did they call you Ditti when you were a child?" When I replied in the affirmative, but added that very few people had called me this for years, he told me that he had just returned from Vienna, where a taxi driver had asked him if he knew anyone in Israel called Ditti Rubinger. It was I. As a child in Vienna at that time, I could not be called David, as no one in any German-speaking country could use biblical names such as Solomon or David without attracting unwanted attention, so the name by which I was known became Dietrich, or Ditti for short.

The taxi driver was called Poldi Kammermeyer. Poldi had been practically my closest friend when we were about eight or ten. He was not Jewish, and lived opposite our apartment in an inn that his parents ran and above which they had living quarters. We did not attend the same school, but met frequently in each other's homes. His father the innkeeper was a large man who frequently whipped Poldi with a belt. His mother was an equally well-built woman, but kindly.

I remember that one afternoon when I had gone to his home, his mother offered me some bread spread with pork fat. I recall the terror I felt at having to eat this, sure that the sky would fall in on my head as the *schmaltz* (fat) was not just unkosher, but even worse, it was pork! Nothing happened to me, however, nor did any heaven-sent catastrophe fall upon me when I ate her liver dumpling soup every Friday at lunchtime. My mother, knowing how fond I was of this delicacy, bought this illicit treat for me from the inn. She collected it secretly in a special dish that was kept for this purpose, but stayed diplomatically quiet, not

mentioning it to my father on his return from work midafternoon prior to going to the synagogue.

5 My reunion with Poldi took place some fifty years later, in 1982. We arranged to meet at the Ambassador Café, a well-known coffeehouse on the Kärtner Strasse in the fashionable center of Vienna. Suddenly a huge man wearing a loden-green coat and sporting a Tyrolean hat with a feather rolled in and, on seeing me, burst out crying and gave me a huge bear hug. Little Poldi had grown up . . .

We talked for hours about the past. He told me a lot about his life, among other things how difficult it had been when he had served in the German army on the Russian front. I felt momentarily uncomfortable at the thought of my closest childhood friend having been a fighting member of the "Master Race," but this feeling dissipated when all at once he reached into his inside pocket and took out an object wrapped in paper. "Ditti," he said, "I would be really grateful if you could give me this now as a present." I opened the package and found to my surprise that it was an old rusty file, which apparently had belonged to me in those early days when we had played together as children. On seeing this, it came back to me that we had spent a lot of time together carving shields out of wood to represent the various regions of Austria. Poldi had kept this file safely for more than sixty years in the hope of one day finding me and returning it to its rightful owner.

We both sat there with tears in our eyes. I was so very deeply moved by this sensitive and kindly man who had kept the memory of me alive in his heart for so many years. It made me realize how wrong one can be to generalize about national characteristics. Many Jews, myself included, were presumed to hate the Germans for what they had done to us during the war, yet here I was confronted by my childhood friend whom I could not help visualizing wearing a German army uniform, but found him to be a warm and sympathetic man. It taught me that one should never jump to conclusions about people just because of the stereotypes that one holds, but instead judge each man on his own merits and behavior. I tried to contact him again recently on a trip to Vienna but was unable to trace him. However, I have never been to Vienna even once without ordering liver dumpling soup—perhaps as some kind of subconscious tribute to my old friend.

My later schooldays were uneventful, other than facing the anti-Semitic indignities that the three other Jews in my class and I suffered in one form or another. In particular, I recall the "punishments" handed out by Professor Reichert, our Latin teacher, who picked on us mercilessly. He would sarcastically ask us, "What have you been reading in the *Heint* today, instead of studying your Latin?" (*Heint*, Yiddish for "today," was a Jewish daily newspaper that was published in pre-Nazi Austria.) One of our group, a young boy whose family name was Neuhaus, died some time later when his parents committed suicide together with their children. I can still recall the shock that we fourteen-year-old children felt when this tragedy was announced by our headmaster. We never really found out why the family had taken such tragic action, but could only assume that they found life intolerable. This was just a few weeks after Hitler's march into Austria, when most Jews had not really become aware of what was in store for them. Some were randomly stopped in the street by SS Brown Shirts, given a brush and a pail of water, and ordered to scrub any still-evident Socialist slogans from floors and walls. Jewish-owned shops were picketed by Nazis, a Star of David was scrawled on their windows, and posters were held up declaring, "Kauft nicht bei dem Saujud" (Don't buy from this pig-Jew).

Germany's annexation of Austria, or the Anschluss, took place in March 1938. It was at about this time, as I was running around in shorts during an exercise class in the gymnasium, that an official entered and made the bald announcement, with no explanation, that all Jewish boys could no longer remain at the school. Slightly dazed, but not yet able to comprehend the situation fully, we four Jewish boys in the class dressed, collected our belongings, and left the premises. This marked the termination of my formal education.

A month after the Anschluss, my father was picked up in the street on his way home from work. The Nazis had closed off the roads in our area and were stopping and questioning everyone. Those unfortunate individuals who were identified as Jews were loaded onto a truck and taken away immediately. He was interned first at the Dachau KZ and later at Buchenwald. We heard of this since the inmates were permitted to send a monthly postcard to their families. Mother made frantic efforts to secure his release—at that time any Jews who had relatives or contacts abroad who were willing to take them, or had any other form

of influence, could apply for exit permits. Luckily for my father, his sister Frieda, the eldest of eight siblings, lived in London. It was she who succeeded in obtaining a permit for him to go to London, to work, as the permit stated, as a butler.

When the entry visa arrived in January 1939, my mother headed immediately with the relevant paper in her hand to the Metropol Hotel, at that time the Gestapo headquarters. She presented the document, and within thirty-six hours my father was back home, on the condition that he must leave the country within two weeks, or else he would find himself back in the concentration camp. At that time the Nazis had not yet begun their extermination program. They were happy to get rid of Jews by any means possible, just so long as they left.

My father mentioned nothing whatsoever of his experiences in the camps on his return home, but I could see that he was a broken man. It was the first and only time in my life that I saw him cry—a traumatic experience for a young person. Thanks to the wisdom of the British Foreign Office, the permit he was given was unfortunately not extended to include either his wife or his son, so my mother and I had to remain in Vienna while my father departed to distant shores, safety, and a new life.

Without my father's income to support us, we found ourselves compelled to leave our "high-class" apartment at Tichtelgasse 28—"high class" in that it was the only one in the building that had its own indoor toilet and water faucet, although there was only one bedroom, a small living room, and no bathroom. Baths were taken once a week in a tin tub that my mother filled with hot water. From this luxury we moved down market to a one-room apartment in the city's Jewish district, the Leopoldstadt, colloquially called "Matzo Island."

Many years later, on a trip to Vienna in 1958, I felt an urge to return to our apartment in Tichtelgasse to see if it still existed. I had been sent to Austria on an assignment for *Life* magazine to photograph a story following the wave of Romanian immigration to Israel. I traveled with one particular family and covered their fate from the moment their train crossed the border from Hungary to Austria, and then all the way to the place where they eventually settled in Israel.

One evening after work, while I was still in Vienna, I called a taxi and directed him to the street where I had lived as a child. It was pitch

dark, and above the doorway there was a naked lightbulb, which gave scant illumination. I reached out instinctively for the place where the doorbell would have been, and there I found it. It was the old-fashioned kind of doorbell that you had to twist to make it ring. I decided against ringing the bell and disturbing the occupants, and instead turned around and in an instant slid my hand along the banister and, without thinking, jumped the eight steps down to street level. This Olympian feat was the same one that I had performed daily as a child, and suddenly I found myself, as a middle-aged man, leaping down the steps in exactly the same way. It is said that the skills you learn as a child are so deeply ingrained that they are never forgotten—evidently so!

On Father's departure, my role in the family immediately changed. I found myself very much left to my own devices and, aged just fifteen, became "the man" of the family. My mother, sadly, suffered severely with her nerves. I often found her weeping, and she was constantly anxious. I found escape by immersing myself in one of the flourishing Zionist organizations for young people, Hashomer Hatzair, where I rapidly became an ardent and committed activist.

Hashomer Hatzair was a Zionist Socialist pioneering-youth movement with the aim of educating young Jewish people for kibbutz life in Israel. On a spiritual level, we drew inspiration from the writings of A. D. Gordon, Joseph Trumpeldor, and others, as well as from the romantic aura surrounding the revolutionary anti-Czarist underground and its heroes. Through Hashomer we sought to create a synthesis between Jewish culture and the rebuilding and defending of Eretz Yisrael, on the one hand, and philosophical values, on the other.

Joining this group proved to be the most formative influence on the rest of my life. In January 1939, I enrolled in a Youth Aliyah school, where I was taught the basic skills of an electrician, carpenter, and cobbler, and was later sent to an agricultural camp for five weeks to learn what it was like to be a farmer.

I kept a diary from July to December 1939 that is still in my possession. It was written in perfectly grammatical German in a careful calligraphic style. The only word that I always wrote in Hebrew characters was the word *Eretz* (The Land). It was on July 18 of that year that I heard that I had been chosen to go on *aliyah* (homecoming) to Palestine. "I am among them," I proudly wrote, underlining the words for emphasis.

I was truly one of the lucky ones. Thanks to the undying efforts of Henrietta Szold, the founder of the Youth Aliyah organization in America, quotas of young people were being chosen to emigrate to Palestine. Each Jewish organization could select just a few candidates, and I was one of those picked from Hashomer Hatzair.

Our group was divided into four. One part was destined for England, another to stay in Vienna, and a third for the *hachsharah* farm (preparation for emigrating to Palestine). Mine was to be the first to leave for Eretz.

The girls were allocated the task of designing and sewing a Jewish national flag, and once it was completed, we held a symbolic ceremony and cut the flag into four equal sections—one for each group. We then solemnly swore that one day the flag would be sewn back together when our four groups were reunited in Eretz. With tears in our eyes, we fought back sobs at the emotional intensity of the moment. We never actually realized this ambition, and I never found out what happened to our flag, or to most of the members of our group.

Political idealism coursed through our veins. We sang songs such as "Techezakna," the Labor Party signature tune, meaning "Let their hands be strengthened," and, in secret, the "Internationale" and made detailed plans for the time when we would all be together again in the land of our dreams. Palestine then held half a million Jews, of whom twenty-five thousand were kibbutzniks, and it was they who, in our eyes, provided the solution for the ideal and only acceptable way of life.

My diary of this period focused exclusively on the moral and political issues that we faced as members of Hashomer Hatzair. We were obsessive about maintaining the standards of purity of thought and action befitting the organization. At one period we deliberated at length about the necessity of excluding one particular boy from our group because he wore long trousers and a tie, surely the most heinous of sins. This utterly bourgeois form of attire was wholly unacceptable to us. At that time we all wore standard-issue shorts with open-necked shirts.

Subsequently we patted ourselves on the back for having sufficient courage to oust him, justifying this action by telling ourselves that we were doing it to keep to the exacting standards that Hashomer Hatzair demanded. Another matter that mortified me was to hear that, at one of our group meetings, slices of bread were circulated, each member

being told to take for himself only the allotted one piece. Before the distribution was over, it turned out there was not enough to go around. How, I asked myself, could a member of O U R group have let down the others by taking more than his fair share? It was unthinkable.

There were several other youth groups operating at around the same time: Maccabi, which was derided as being totally bourgeois, Habonim, then called Blue and White, and the reviled right-wing Betar. We were constantly concerned about the possibility that we could lose some of our number who might be tempted to join one of the other groups because their women wore silk stockings or were better looking.

Our Socialist principles were fierce and true, if a little naive—and rereading my diary today makes me realize how, at the age of fifteen, I sounded so pompous and so utterly convinced that I knew everything about how the world should be run. All our dreams were focused on reaching Eretz and establishing a pioneering cooperative there that would transform the land and, ultimately, society as a whole. What is strange for me now is to see how little or nothing was ever mentioned in my diary about the threat of Fascism, our awareness of which appears to have been totally subsumed by our overwhelming antipathy towards international capitalism and everything that it represented. It has also been a cause for reflection for me to realize that not once, in the whole of my diary of that time, did I make any mention of either of my parents.

My father, meanwhile, had made his way to England and once there made every endeavor to get my mother and me out to join him. He had virtually succeeded in obtaining permission when, with the outbreak of World War II in September 1939, all avenues of escape were firmly closed to us.

This development also threatened to jeopardize my plans for going to Palestine, but, after weeks of anxious waiting, we saw a light at the end of the tunnel on hearing that the boat *Galilea* was again departing regularly from Trieste to Haifa. At that time, Italy still remained neutral, and all our hopes were pinned on a safe exit by this route.

3. LEAVING FOR ERETZ

Eventually, in November 1939, I bade my mother an indifferent farewell at the station—I was too busy excitedly chatting to my friends to pay much heed to her, a fact that has left me feeling guilty all my life—and left for the Promised Land. It was only in recent years that I learned that she managed to survive until 1942 but on May 27 of that year was deported to the Maly Trostenets extermination camp in Belarus, where she was killed. After the war, we learned from some Christian neighbors in Vienna just how she had suffered in those three long years by herself. They told us how they tried to perform small kindnesses by occasionally giving her bread and sometimes even a piece of chicken when they were able.

Father, meanwhile, was interned on the Isle of Man as an "alien." He was subsequently released and took up employment as a packer in a factory. He remarried after the war on hearing of my mother's fate and wrote me a very awkward letter saying that he hoped that "I did not mind."

From Trieste, I traveled with my group for five days on the boat to Palestine. My diary records how difficult I found it to express my emotions on hearing Hebrew spoken everywhere for the first time. Our boat anchored off Tel Aviv. We did not disembark but were soon surrounded by many small craft, crewed, as I observed, by *chalutzim* (pioneers). Was this really the first time, I asked myself, that I was seeing a real live "pioneer" after years of imagining what they would look like!

When we eventually arrived in Haifa, I was completely stunned by the sight before me with "its white square houses tumbling down Mount Carmel, in a style I had never before seen and bathed in a luminous white light."

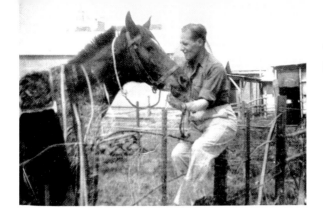

6. My dream job at Kibbutz Tel Amal— guarding the fields on horseback, 1942.

I also marveled at the thriving Arab market, where, I wrote, "Arabs came to sell their women." I am not sure from where I obtained this "reliable" piece of information. Probably I extracted it from the literature of Karl May, a German author of travel and adventure stories for children, dealing with popular topics such as desert Arabs or the American Indians in the Wild West. He wrote prolifically on both subjects, despite never having traveled to either region until very late in his life. The colorful imagery he conveyed in his books, often in a first person narrative, gave the impression that his stories were based on personal experience, when in fact they were entirely imaginary. He had a huge influence on the minds and imaginations of millions of young people, myself included.

On arrival in Palestine, we were taken at once to our host kibbutz, Beit Zera, where we were to remain for the next two years. Our welcome was very warm, with the members doing their utmost to make us feel at home and help us integrate into the supportive framework of kibbutz life.

I tended bananas, worked as an electrician, and transported cow urine across the fields to the manure plant. After I had been carrying out this particular activity, I noticed that no one chose to sit next to me in the dining hall afterward, since, in spite of all my efforts to contain the liquid in the open cans by covering them with sacks, it was impossible to stop it spilling just about everywhere. My ambition, along with that of most of my male contemporaries, was to drive a tractor, but this I never managed to achieve.

At the end of two years, we were transferred to another kibbutz, Tel Amal, where, because I contracted recurring malaria, I was offered a dream job—that of field guard. This meant that each day I rode off on a magnificent black horse to check the perimeters of the kibbutz for any sign of intruders or damage, wearing a huge Mauser pistol on my belt. It was a job made in heaven—I would leave in the early morning, pick a watermelon, tie it securely with string, lower it into the river Assi, and leave it until midafternoon. I would then return to my treasure, now deliciously cool, and open the melon, burying my face in its refreshing pinkish-red flesh.

4. A SOLDIER FOR KING GEORGE

The atmosphere in this kibbutz was not nearly as welcoming as in the previous one. So much so that one day eighteen of us, dissatisfied with conditions there, decided to take action—we got up and left and went to enroll in the British Army to fight the Nazis. At the time, this was very much the heroic and expected thing to do. So there I was, aged just eighteen and a soldier in the army of King George VI.

We were taken immediately to basic training camp to learn how to become soldiers. Our drill sergeant was a typical mustachioed British sergeant major—loud of voice and short on patience. To begin with, we did not understand his barked instructions, but we very quickly learned—the hard way. We lived in the barracks at Sarafand Camp, memorable primarily because of the armies of bed bugs that gave the appearance of a heaving dark brown blanket they were so numerous. So irritating were they, that on more than one occasion we abandoned our bunks and slept out of doors.

After training, I was sent to join the Royal Army Service Corps as a driver, mostly transporting provisions and equipment. Our corps was attached to the Eighth Army serving in North Africa as part of General Montgomery's assault on Rommel. We had to drive regularly from the supply bases in Egypt across Libya to wherever the front was—usually Tobruk or Benghazi. This journey could take several days, so at night we would sleep either in dugouts or on the back of the truck. I remember one night I fell asleep on top of hundreds of cans of gasoline and awoke in the middle of the night feeling very strange, almost suffocating from the fumes.

This occupation afforded us the occasional treat. Most days our breakfast consisted of "Tobruk pudding"—condensed milk and crackers—but if we were moving a consignment of tinned fruit, usually pears,

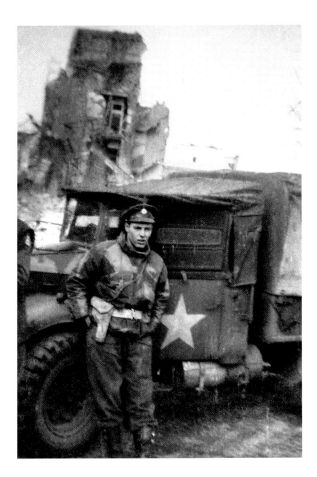

then some of these would be appropriated for our use. We would open a tin, pour out the juice, and cover the pears with condensed milk—heaven!

After Rommel's defeat at the Battle of El Alamein in November 1942, we were shipped to Malta to help prepare for the British invasion of Italy. Malta had been besieged and heavily bombarded. At one time, only one of fourteen ships that had left Britain with supplies and reinforcements managed to arrive safely in Valletta, the capital. The rest were sunk by the German or Italian air forces, which had total air supremacy in the Mediterranean.

Supplies of foodstuffs and other essentials were simply not getting through to the island. We were there for eight grueling months and were hungry all the time. During one period of privation, we were ordered to take a sleep each afternoon in order to preserve our strength. I believe this is the only time in the history of the British Army that such an order was actually carried out.

The Allied invasion of Italy eventually started, and our company sailed to Barletta, a port south of Bari in Italy. From here we slowly followed the Eighth Army as it fought its way up the Adriatic coast, stopping at Bari, Foggia, and Ravenna. We were stationed in each of these cities for a while, carrying ammunition and supplies to the advancing

forces, and, about a year later, reached the Austro-Italian border at Udine.

It was during this time that the Jewish Brigade was formed and our unit, the 178 RASC (Royal Army Service Corps) Transport Company, was attached to it. I was also elevated from the rank of private to the one-stripe glory of lance corporal. Significantly more important for me, however, was the fact that I was taken off driving duties on a three-ton truck and became a dispatch rider. This was a much sought-after job, as it was a relatively independent position to be driving a motorbike. My role was to carry papers from our unit to the brigade or to divisional headquarters.

One memorable time during this period was when we were stationed in Siena. For some reason, unbeknownst to me, it was imperative for regular communications to be delivered to the American Fifth Army, headed by General Clark. What this meant in practice was that for weeks I rode my bike back and forth to Livorno, where I was privileged to enjoy the luxury of American rations—food that for us poor "Tommys" was beyond our imagination.

To say that I suffered any hardship during World War II would be erroneous. My time in the army was a huge adventure for a young man—the British Army gave me the opportunity to see the world at their expense, and in addition, thanks to King George VI, my adult education was considerably enhanced as far as both the Italian language and Italian women were concerned. Rarely did I hear gunfire, nor was I close to any military action, except during one episode when a German fighter plane strafed our convoy as we drove through the desert.

When the war eventually ended in 1945, we found ourselves stationed in the Po Valley in northern Italy and shortly after this were transferred to the Austro-Italian border. This may have been coincidental, but to my mind it seemed a very providential choice of venue for the Jewish Brigade, offering us the opportunity to smuggle some of the displaced persons (DPs) from the camps in Europe to Palestine.

The Jewish Brigade was the only military unit to serve in the British Army in World War II as an independent, national Jewish military formation. It was made up mainly of Jews from Palestine, like me. The brigade had its own emblem, with a gold Magen David on a background of blue and white stripes and the name of the brigade in Hebrew.

The establishment of the brigade was the result of prolonged efforts by the Yishuv (Palestine's Jewish community) and the Zionist movement to achieve official participation and representation of the Jewish people in the war against the Nazis. The aim was to lift the mantle of anonymity and tell the world about the war effort made by the Yishuv, with its tens of thousands of volunteers, and to reinforce the Yishuv's political standing and promote the aims of Zionism.

The British authorities, opposed as they were to these aims, were reluctant to admit Jews into their combat units, and they therefore confined us to auxiliary corps before the brigade was established, with the infantry being largely employed on guard duties in Palestine. These obstacles were overcome only after a sustained and unrelenting campaign headed by Chaim Weizmann and David Ben-Gurion, as well as Moshe Sharett, head of the Jewish Agency political department in Jerusalem. They realized that the uncompromising hostility of the Arab world towards Zionism meant that eventually conflict with the armies of the Arab states, not just local Palestinian Arab militias, was inevitable. How right they were! Wartime events confirmed their assessment, and even though the British government disbanded the brigade in 1946, the fact that five thousand Jewish soldiers had been trained by them in modern warfare was a great asset in the War of Independence two years later.

The brigade became a reality in 1944 and in September of that year received its full equipment and was able to join the troops at the front. We were given tags on our sleeves with the new insignia of the Jewish Brigade, and this was a huge source of pride for us all.

When the fighting ended, in addition to our regular work for the army, one of the main tasks of our company, unbeknownst to the British authorities, was to fake all manner of requisition orders, primarily to enable us to smuggle Jews from Landsberg, a camp near Munich, to Genoa, where ships waited to take them to Palestine. All our false documents carried the heading "T.T.G." This was a combination of Arabic and Yiddish words, the meaning of which was something like "Kiss my backside assignment."

Not one of our British colleagues ever questioned or understood the nature of this "secret code."

On one occasion, we had loaded up twenty trucks with DPs. I remember distinctly that it was a dark, rainy night. The refugees were

secreted away safely in the trucks and covered with tarpaulins. We drove through Austria and eventually reached the border village of Pontebba, in the vicinity of Treviso, where we crossed into Italy. We had a British Jewish sergeant whose allotted task it was to ply the British military policemen at the checkpoints with whisky. This he did with enthusiasm and to good effect. When we approached the border, he told the MPs, "Don't worry about these guys—they are with me, you can let them through." Consequently we crossed with our twenty trucks full of grateful refugees.

We then stopped at the Jewish Brigade HQ, where the quartermaster emptied his stores of supplies to give the immigrants socks, underwear, and whatever other clothes they needed. From here we continued to Genoa, where they got down from the trucks and were very efficiently processed by the Mossad le Aliyah Bet—the Jewish illegal immigration organization—and put on ships to Palestine.

Whether or not someone in higher authority became aware of our covert activities I cannot be sure, but eventually we were moved away from the border and into Germany. We did not last very long there, however, as about the same time that we arrived, a group of Jews were discovered working audaciously as a terrorist cell from within the British Army. They had set themselves up with the sole purpose of indiscriminately killing as many Germans as they could, as a means of exacting revenge. We were promptly sent away from Germany and transferred to Belgium.

5. THE MARRIAGE

Since my father left for London in 1939, he and I had been in intermittent contact by mail. My relationship with him had always been very formal. He was somewhat introverted and aloof. I never remember any affection from him—this I received in abundance from my mother. His letters were very practical, telling me what he was doing and asking politely about my activities.

While I was still stationed in Belgium, an order was issued for two trucks to take some generators to Scotland. My commanding officer, knowing that my father lived in London, arranged for me to take charge of this transport so that I could have the opportunity to go to London and visit him.

On meeting my father, whom I had not seen for about six years, I learned that one of his sisters, Bertha (he was one of four brothers and four sisters), and her daughter Anni had survived the war and returned together to Gelsenkirchen—a well-known coal-mining town in the Ruhr where they had lived before the war. They had been in touch with my father, and he was therefore able to give me their address.

Anni's family was living in Gelsenkirchen in 1941 when her father was picked up and deported to a concentration camp, where he later died. His ashes, and those of forty-two other detainees, were returned to their respective families, accompanied by a note stating briefly that they had all died of pneumonia. In 1942, Anni, her mother, and her brother Theo were deported to the Riga Ghetto in Latvia. On arrival, they were ordered to find themselves accommodation in one of the many empty apartments there. What they did not immediately realize was that most of the Riga Jews, some fifty thousand of them, had just been taken out to the infamous Rumbula Forest where they were all killed and buried in a mass grave. Their homes were thus available for

the Jews brought in from Germany. Anni related how they found themselves a flat and, on entering, saw that there was food still warm on the stove. The unsuspecting previous tenants had been removed so rapidly that they did not even have time to eat their meal.

They continued to live in the ghetto for two years. Every day, Anni and her mother were part of a group of Jews picked up by an SS man and taken to work. They hid Theo in the flat, as he was too young to work. Bertha had to shovel snow, and Anni worked outside the ghetto in a hospital for wounded German soldiers. Life was not all bad for her at this time; in fact, she maintained that for her, as a young girl, it was often quite enjoyable as she attended parties and Sabbath evening singalongs after work had finished. The worst thing to happen to the family was when they returned to the flat one evening to find that Theo had been taken away while they had been out at work. The Nazis had found him and taken him together with many other children in a "Kinder Aktion." He was only nine years old at the time. Eventually, in 1944, the Riga Ghetto was liquidated by the Germans as the Russian front advanced. Anni and Bertha were transported to Stutthof concentration camp, from where they were sent out to work each day in the fields.

When the Russians had almost reached Stutthof, the Germans abandoned the camp and marched everyone away in the direction of Germany, but after a while they simply left the camp inmates to fend for themselves. It was then that Anni and her mother decided to take their chance and walk away together. This decision was not so simple for them to put into practice, as not only did Bertha have typhoid, but she also had a painfully ulcerated leg. On the night of their departure, they were unable to walk far, but found a stable where they fell asleep. The next morning, they were woken by a Russian soldier, who came in, bent over them, and said to them in Yiddish, "Kinderlach geit aheim" (Children, go home). Anni was astonished but deeply moved to realize that here was a Russian Jew, not in a camp, as she assumed all Jews now were, but in army uniform. He and his colleagues helped them as much as they could, providing bread and a place to sleep, and Anni and Bertha started the long, slow, and difficult trek back to Gelsenkirchen.

They decided to return to their hometown in the hope that, if Theo had by any chance survived, he might have managed to find his way back home. But this was a vain hope. They lived for a while praying that

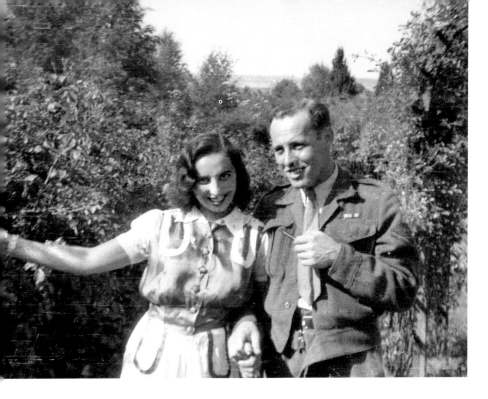

8. With my cousin Anni Reisler, when our marriage was still a fictitious one. Herford, Germany, 1946.

he might have been saved, but sadly they were never to see him or hear from him again. He, together with so many other innocent children, had been brutally murdered by the Nazis.

On hearing of them from my father, I immediately went to Germany, where I found my aunt Bertha and my cousin Anni. Anni had the typical appearance of those who had survived years of hunger and eventually were given food—her face was bloated and puffy, and she was far from the slim girlish figure that she attained a while later in Palestine. Bertha, whose hair had gone completely white, looked many years older than her age, but she too regained something of her former appearance after a couple of years in Palestine. The suggestion was made that Anni and I should be joined in a "marriage of convenience" in order to get her out of Germany and into Palestine. Under British rule, there were rigorous restrictions on Jewish immigration to the country at the time, so it was not uncommon for Jewish soldiers to offer to do this to facilitate a safe and speedy passage for some of the DP girls who had survived the camps.

So frequently did this occur that the British Army established a special unit called the Palestinian Wives Repatriation Section. Major Maurice Yaffe, who was a chaplain of the Jewish Brigade, headed this unit, which had its headquarters in Brussels. All the "wives" were sent there

first, without their soldier husbands, and from there were officially sent to Palestine as the wives of serving soldiers in the British Army.

Anni and I were married by Rabbi Israel Brodie in Herford, Germany, in September 1946. He was the senior Jewish chaplain to the British forces on the Rhine and later became the Chief Rabbi of the British Commonwealth. It was the first time that there had been a Jewish marriage between a British soldier and a German fraulein. The army enforced a strict rule of nonfraternization between its soldiers and the "natives," so our meetings were not always easy. This rule had, unfortunately, made no provision to distinguish between local girls and Jewish survivors. In any event, soldiers were not permitted to stay out of barracks later than 23:59 at night. This system persisted, in our case ironically, as Anni was employed by the British Army, helping them in the Field Security Service.

My C.O. at that time was a dour Scot. On the day of the wedding, he handed me my pass, on which it was written that I had to return by the required time. In his broad Scots accent he told me, "Here is your pass. You have to be back by 23:59 hours, but if I see you here before eight days are up, you are in big trouble!"

After the wedding ceremony was over, in walked a tall English officer from the Jewish Relief Unit with his girlfriend. His name was Ted Brandon; his girlfriend's, Edith. When Anni caught sight of the girl, she almost collapsed. Edith had been her closest friend in both the ghetto at Riga and Stutthof concentration camp. They had, together with their respective mothers, managed to survive and stay together throughout the war.

At this stage, Edith and her mother fell out of the march, while Anni and her mother continued, in the hope of reaching their home and maybe finding Theo. Neither girl had the remotest idea that the other had survived, so you can imagine the heightened emotions and excitement when they saw each other again.

Edith tearfully told Anni that her mother was now the housemother of the Jewish Relief Unit, and it was she who, at that moment, was preparing a dinner for a young couple that were marrying the same day. "But that's me!" shouted Anni. We drove back to the HQ in Ted's car for the reception. Edith rushed into the building before us and shouted

to her mother in German, "Mutti, Mutti, look at this lovely bride!" On seeing Anni, Edith's mother fainted.

We stayed with Ted and Edith all that week, by the end of which our "fictitious" marriage had become a real one. Ted and Edith have remained dear and close friends to this very day, and I never fail to visit them whenever I am in England. Anni came to Israel in December 1946, a month after I was demobbed, and we rented a room in Jerusalem for £8 per month (the equivalent in value to one hundred packets of cigarettes!).

On leaving the army, I, Lance Corporal David Rubinger, PAL/32074, was provided with £100, a new suit, and a job. How, you might ask, am I able to remember my army number even now? Curiously and coincidentally, the army number I was given happens to be exactly the same as my very first telephone number in Jerusalem, which remains the same to this day. I am told that the statistical chances of this occurring are remote beyond calculation!

The employment I was given was as assistant veterinary storekeeper in the Department of Agriculture, a post where I stayed for a year. All I remember from this period is the esoteric piece of information that you give Epsom salts to horses suffering from colic—a piece of information that will no doubt one day prove to be invaluable, although as yet I have not managed to put it into practice. My real ambition at that time, however, was to earn a living through photography.

6. MY FIRST LOVE AFFAIR—WITH THE CAMERA

The beginnings of my love affair with the camera arose from another type of love affair. We have to go back now in time, about a year, to August 1945, the date of the first anniversary of the liberation of Paris. At the time I was stationed in Belgium. I was granted leave to go to Paris together with a fellow soldier, Eliezer Goldman. We boarded the train in Brussels and then traveled for about four hours to arrive in the city of romance.

I shall never forget the smell of freshly baked baguettes on that early morning when we got off the train and started to walk through the cobbled streets of Paris. It was unforgettable, as were the days that followed. The army had given us two tickets for the Paris Opera House, where that same evening a ballet was being performed. Unfortunately, we arrived a little late. We were informed that we could not go into the auditorium until the intermission, so in order to pass the time we went around the corner, where we found a bar in the rue Scribe.

Sitting there were two girls, Claudette and Jeanette. We did not return to the opera house, and we never saw the ballet. Claudette was slender, with long blonde hair veiling half her face like the American film star Veronica Lake, whose style was very much in vogue at the time. We dined at a restaurant on the first level of the Eiffel Tower, and I was immediately captivated—so much so that twice I went AWOL in order to see her again. Once I got away with it; the second time I was confined to barracks for ten days, but it was worth it. I remember another time emptying the fuel from my army motorbike and selling it to a Belgian to fund another trip to Paris.

The impact that Claudette had on my life was hugely significant, but not for the reasons that one might immediately assume. After seeing her for a couple of months, I was granted leave to return home to Pales-

LEFT
9. Claudette Vadrot, who gave me my first camera. Paris, 1945.

BELOW
10. My first Leica, bought for two hundred cigarettes and a kilogram of coffee, 1946.

tine. When Claudette came to the station to bid me a fond farewell, in her hand she had a parting gift. A camera. It was an Argus—one of the few 35 mm cameras ever produced in the United States. It was my first camera ever, and—as with meeting Claudette—there was an instant attraction. My love affair with the camera began then and has lasted from that day to this.

My first attempts at taking photographs with this camera were at the kibbutz when I went home on that leave to see my friends in Palestine. On returning to Germany, I bought a classic Leica camera. I paid for it with two hundred cigarettes and a kilo of coffee. With it, I took pictures of the devastation caused by the bombing. These were probably my very first "editorial" images. Being a real *yekke* (slang for a German Jew who is obsessively meticulous) and thus neurotically well organized, I have catalogued and carefully stored every single photograph, including those very early ones. I believe I have a record of every picture I have ever taken in my archives.

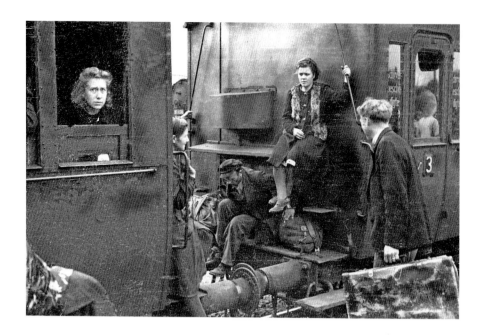

11. Scene at a German railway station, 1946. One of the first pictures I took with my new Leica.

My destiny was set. I was on my way to becoming a photographer.

In life many things happen. I do not believe in fate, but there are instances when you make a decision—to turn left or to turn right—and this choice can affect the rest of your life. For me, I am convinced that such an event was turning up late for the ballet. Being a yekke, I am also obsessively punctual, so it is curious that my one life-changing event should have been on that rare instance when I was actually late!

7. MARRIED LIFE AND BECOMING AN ISRAELI

Anni and I started married life living in one room in Jerusalem. We had absolutely nothing except a camp bed provided by the Jewish Agency. We found bricks and a plank to make a bookcase and managed to acquire two secondhand armchairs, which, we acknowledged, gave a real air of luxury to our surroundings. Suddenly I found myself, aged twenty-two, living in Palestine with a now-pregnant wife—two and a half of us in one extremely small room.

We had little money for food and so would welcome every opportunity of eating at my aunt Peppi's place. She was a *vatika* (a veteran), having reached Jerusalem in 1934 after fleeing, together with her husband, when riots broke out in Austria between the Social Democratic regime and right-wing factions—the Steel Helmets (*Stahlhelme*). Much blood was spilled in those traumatic days, with shooting and attacks a regular occurrence, until the eventual downfall of the Social Democrats. My aunt and uncle left hurriedly and arrived in Palestine, where they ran a B'nai B'rith childrens' home.

In spite of our lack of funds, Anni and I felt that we had to "live it up" occasionally and so made visits to the cinema, from where we always, without fail, took a taxi home rather than walk the fifteen minutes' distance. There we were with no money for food but taking taxis. I suppose that in a way it was a denial of our situation. On reflection, I also think that this was a pattern of behavior that I was to repeat throughout my life. I was never one for deferred gratification; if ever I had money in my pocket, I would spend it. Anni had a part-time job cleaning houses, and for the first time I sold some of my photographs—to neighbors, for six piastres a piece. I think that it was not so much the money, which was a very small amount, but rather the satisfaction of

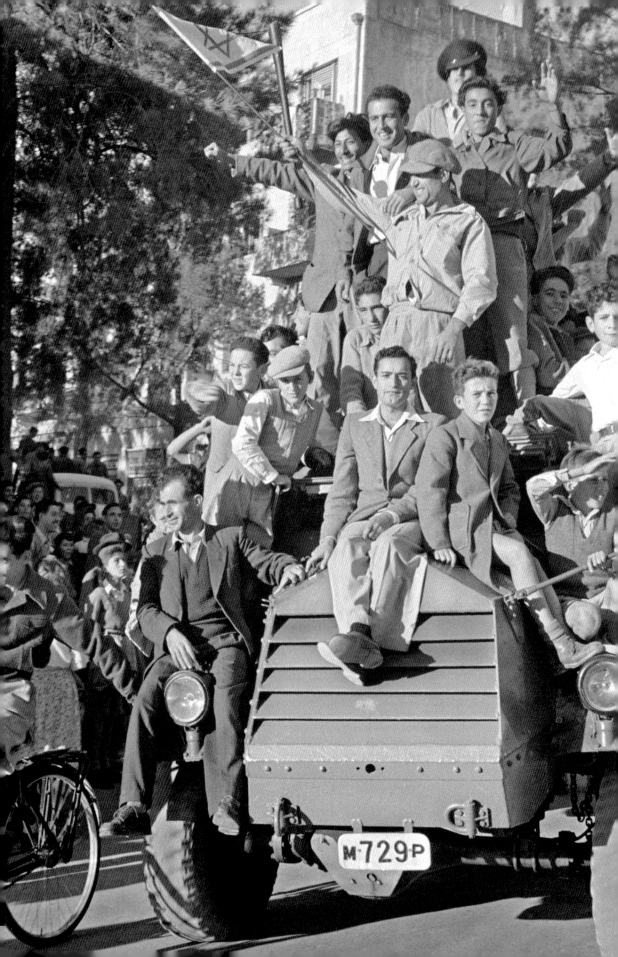

12. Young Jerusalemites celebrate the
UN's decision to establish a Jewish
state by climbing atop a British
armored car and waving a homemade
Israeli flag. November 30, 1947.

knowing that someone placed such value on my pictures that they were
prepared to part with real currency to possess them!

One of the very earliest photographs I took was an image of some of
my neighbors thrusting bread through a barbed wire fence to their rel-
atives and friends. This took place during one of the many curfews im-
posed by the British in certain areas of Jerusalem. Roads were cut off
from each other with barbed wire, largely in response to the activities
of the Jewish terrorist group, the Irgun, who were proving troublesome
and outright dangerous to the British authorities.

On November 18, 1947, our first child, a daughter we named Tami,
was born. The atmosphere in Palestine was very tense because of the
ongoing UN deliberations as to the future of the country. There were
frequent attacks by local Arabs, and it had become so dangerous that
when it came time to deliver Tami, Anni had to be escorted up to the
hospital on Mount Scopus in a British armored car.

Eleven days later, on November 29, towards midnight, the United
Nations voted for the partition of Palestine into a Jewish and an Arab
state. For anyone privileged to have been living there at the time, this
surely was one of the most momentous happenings that one could have
imagined. We, along with all our neighbors, were glued to the radio. At
midnight, a majority vote was cast for the establishment of a Jewish
state in Palestine. The city erupted with milling crowds thronging the
streets, singing, dancing, and celebrating. Anni went out to buy ciga-
rettes from a nearby kiosk. The kiosk owner gave her the cigarettes but
refused payment. "Tonight," he said, "I am not accepting any money
from anyone."

The celebrations continued all night and well into the next day. It
was on the morning of this day that I took one of my most arresting im-
ages, that of a British armored car in the center of Jerusalem onto which
ten or more young children and teenagers had scrambled, waving hand-
made Jewish flags, laughing, and cheering.

Fifty years later, this scene was reenacted for a film made by pro-
ducer Micha Shagrir and shown on Israeli television. He had managed
to trace most of the youngsters who had been clambering onto the ve-
hicle in the original photograph and who were now well into their late
middle age. He gathered them all together, brought an old armored car
into the center of the city, and encouraged the group to climb onto it so

13. An Israeli woman learns to throw a grenade, 1948. During the War of Independence, all young men and women received basic military training.

that I was able once again to take their picture. It was an extraordinarily moving experience to talk with them and listen to their reminiscences and recollections of fifty years earlier.

On that same day in 1947, David Ben-Gurion, with great prescience, warned that it was no time for dancing and singing as we had a dangerous road ahead of us. He could not have been more right, and in fact it was only one day later, on December 1, that I took pictures of Arab rioters burning Jewish shops in the commercial center then located behind the King David Hotel.

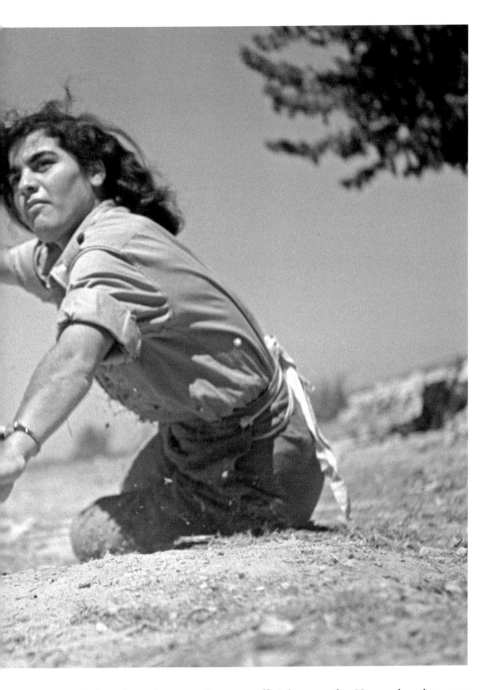

I also shot pictures of our unofficial army, the Haganah, who were attempting to reach the area in trucks but were prevented from doing so by British armored cars, which had blocked the streets.

These were some of the first real "news" pictures that I ever took, but at that stage I had no contacts in the media, so they remained un-published until several years later.

The Haganah had been formed in 1920 as a clandestine force for Jewish self-defense. Originally composed of individual units active in different towns and settlements throughout Palestine, the Haganah

gradually grew into the central defense mechanism of the Zionist movement. After the State of Israel was declared, the Haganah became the Israel Defense Forces.

In mid-December 1947, I was inducted into the Haganah and sent up to Mount Scopus for training. This activity was then considered illegal and had to be covert, as the British still controlled the country. We had a gun or two, but mostly we used make-believe guns made out of sticks.

Those of my contemporaries and I who had received military training from the British Army (about five thousand soldiers) were part of the nucleus, together with the Haganah, that eventually became Israel's legitimate army. Our experience proved invaluable; indeed, my second lieutenant in the British Army went on to become a major general in the Israeli army many years later.

The British decided to relinquish the responsibilities of the Mandate, given to them in 1919, on May 14, 1948. This thereafter became the official Independence Day of Israel, the historic occasion when David Ben-Gurion declared the establishment of the State of Israel upon the departure of the British troops.

Serious fighting began immediately the next day, with the Muslims declaring a *jihad* (holy war) on the fledgling state. Their intentions were made clear by Azzam Pasha, Secretary-General of the Arab League, when he declared, "This will be a war of extermination and a momentous massacre which will be spoken of like the Mongolian massacres and the Crusades."

Seven countries joined in the jihad, with five of them, Saudi Arabia, Transjordan, Lebanon, Egypt, and Iraq, deciding to invade our newly formed State of Israel. They were well armed and equipped, in great contrast to the makeshift weaponry that we had at our disposal.

That same day, May 15, proved to be one of the most unforgettable days of my life. My military group, dressed in civilian clothes, had taken up positions on Jaffa Road, Jerusalem, in a building that housed Barclays Bank and later became the municipal offices of the city. The building faced the Jaffa Gate of the Old City, next to which was David's Tower—a tall edifice with a commanding view of the whole area.

Among our inadequate weaponry, we had just one homemade two-inch mortar and two cases of shells. What we failed to realize, however, was that the shells we had were a fraction of a millimeter larger than

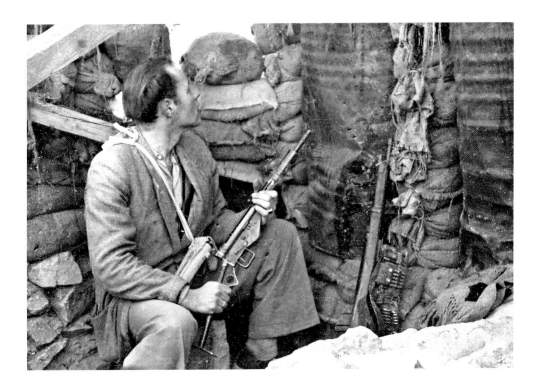

the barrel of the mortar, so it was impossible to use them without first filing down the fins of the shells to reduce their size.

I was the one "volunteered" to return to our HQ, now Bank Leumi, to try to find a file. This I managed to do, but on returning I did not know that the building immediately on the left of our previous position was now occupied by Arab snipers. It did not take long for me to realize what had happened, as the whole area, including the little garden that I had to traverse to get back, was being liberally peppered with gunshot.

I took shelter behind a low wall about twenty inches high, alongside two other Haganah fighters. They were both killed. I survived. I remember crouching, huddled down behind the wall, looking at a nearby tree as bullets tore into its trunk and branches. I went back to visit this tree many years later and could still see signs of the wounds it had suffered that day.

I lay there for some time, perhaps twenty meters from the safety of our post, when suddenly an armored car, of the same type that I had photographed some months previously, and which the Haganah had presumably "requisitioned" from the British, came into view. A man in the vehicle motioned for me to make a dash for it while its occupants poured heavy fire onto the enemy positions. I did as he suggested, armed solely with my file for protection. I got back. It seems that rusty files have played a key role in my life on more than one occasion.

Two of the places where I was involved in the street fighting were Yemin Moshe and Mount Zion. Both of these areas were extremely vulnerable as they were totally exposed to fire from the Jordanian positions on the top of the Old City walls. One of the earliest photographs

I have of myself in this war shows me crouching behind a stone wall,

wearing a sports jacket and clutching a Sten gun in Yemin Moshe. Today this place is the location of Mishkenot Sha'ananim, a very elegant residence where visiting artists from around the world are invited to stay. Quite a contrast to how it was when I was there trying to defend it!

After surviving these episodes, I was sent on an officers' training course by the then-established Israeli army, although we were still in makeshift uniforms and without insignia. I became a platoon commander, the equivalent of a second lieutenant.

We soon found ourselves once again stationed in a building opposite the Tower of David. The Tower was under the control of the Arab Legion. Their arsenal included a six-pound gun with which they continually bombarded our position. I remember that the shells went in one side and came straight out of the other side of the building. On one occasion, I needed to go downstairs to check on a machine gun. When I returned upstairs, the place where I had slept and where my desk and phone had been had simply disappeared. Someone somewhere must have been watching out for me again!

Israel won the War of Independence against overwhelming odds, but the Tower of David remained in the hands of the Jordanian army for the next nineteen years, until 1967, when Israel again took control of the Old City.

It was in this same tower where the Arabs had positioned their menacing gun that, many years later, in celebration of Israel's fortieth birthday, I opened my first exhibition, Witness to an Era, under the auspices of the managing editor of *Time* magazine and the mayor of Jerusalem, Teddy Kollek. It was an emotional time for me to compare those bitter days of fighting so many years ago with the sweet taste of success at the opening of my show, which was attended by all the illustrious political personalities of the day. One of those little bonuses in life, I suppose.

8. AFTER THE WAR OF INDEPENDENCE

After the War of Independence and the establishment of the State of Israel, Jerusalem was divided, with the heart of the Jewish section bounded by Ben Yehuda Street, King David Street, and Jaffa Road. In those days, it was impossible to walk anywhere in the center without bumping into half the people with whom one was acquainted. It was a small place, and everyone knew everyone else. Certain areas were of course closed off to us, such as the Old City, which was occupied by the Jordanians.

Young Israeli men needing to demonstrate their bravado would nip over the border and come back with trophies, such as two tickets for a movie showing "on the other side." They would then proudly show off their acquisitions at Fink's Bar, the meeting place for anyone who was anyone in Jerusalem. The ultimate rite of passage for headstrong males was to get to the ancient city of Petra, in the south of Jordan, and back, undetected. Unfortunately, they were not always successful. In one case, two youngsters were caught and horribly mutilated by Bedouin. Their body parts were returned and dumped unceremoniously in two sacks at the Mandelbaum Gate, the crossing point between the two sides of the city. I was there to photograph this gruesome sight. At the time, there was a popular song by Arik Levi called "The Red Rock" in reference to the red rocks of Petra. Critics claimed that this song encouraged young Israelis to cross the border into Jordan, and for this reason the government asked the radio stations to stop playing the song. The radio stations complied.

Fink's Bar, as mentioned earlier, was more than just a drinking place—it was an institution, owned by Kurt Rothschild, known to everyone as Dave. He used to be the headwaiter of a bar owned by a Mr. Fink, from whom he bought the place. Dave kept the name and transformed

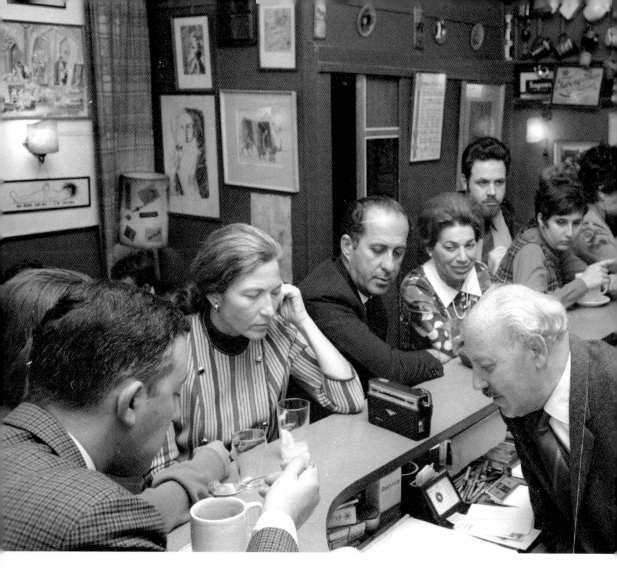

the bar into something unique. Fink's became recognized worldwide and was voted by *Reader's Digest* as one of the world's most famous bars along with Harry's Bar in Venice. The place was a success largely because of Dave's personality. He was the epitome of the restaurateur, overflowing with bonhomie and goodwill towards all his clients, each of whom he never failed to greet by name. The walls of his bar were filled with paintings by artists, many of whom became successful in their later years, but who, when they were starting out, would happily exchange a painting for a hot meal. Shelves covered the remaining wall space, and these were crammed full of the gifts that friends and patrons brought him from all over the world. Anni and I never went abroad without bringing something back for Fink's. Dave was unusual in that he treated all his clients, whether rich or poor, exactly the same. On one occasion, Henry Kissinger, when on a visit to Israel, sent his emissary to order a table for dinner, with the special request that the bar be closed to the general public because of security requirements. Dave told the envoy

15. Kurt "Dave" Rothschild and his patrons listen to the latest news at Fink's Bar during the War of Attrition, June 1970.

that Mr. Kissinger was very welcome any time to come and eat at the bar, but that there was no way he would turn away any one of his regular clients in order to accommodate even him.

Dave was also legendary for his discretion. One evening, Anni had gone there with a male friend of ours. The next night, she and I dined there together, but on our entering the restaurant Dave acted as though he had not seen her for ages. I assured him that he could relax, as I already knew that Anni had been there the previous night and with whom. She also told me that, during the 1956 Sinai Campaign, many of his male clients were away fighting so the bar was largely filled with the wives of these men. Ever the gentleman, he would tell his "regulars" to stay until after he closed at 11:30, whereupon he would pile them into his Studebaker and take them to their homes to make sure they got back safely. In June 1970, during the War of Attrition, I was asked by *Life* magazine to do a story about the prevailing mood in Israel. Those were difficult days, when there were daily casualties on the Suez Canal front.

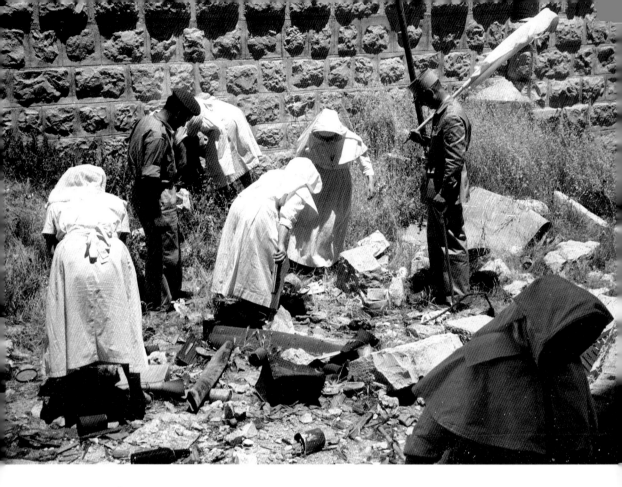

16. An Israeli officer, a French commandant, and several nuns
from Notre Dame Hospital search for a patient's dentures in
no-man's-land, Jerusalem, 1956.

We dreaded listening to the news for fear of hearing something bad, but at the same time we could not quite bring ourselves not to listen. Then, as now, the news was issued on the hour. I thought about how I could best illustrate these tense times, and decided that I would photo-graph Fink's Bar. The image shows Dave behind the counter, a radio be-side him, and a large crowd of people listening with rapt attention to the latest reports.

15

The city had been divided very much along the lines of what we had captured and that which the Jordanians had managed to retain. Conse-quently, the Green Line went winding through the city, creating many areas of so-called no-man's-land. Quite a number of new immigrants who chose to live in Jerusalem found that the only places they could af-ford to settle were those unoccupied houses adjacent to the Green Line that had been abandoned. Many of these homes had one side that faced the Jordanian positions and were therefore exposed to sniper fire. Areas that were particularly vulnerable were Yemin Moshe, which lay directly opposite the walls of the Old City, and Musrara. I remember

17. Sister Augustine finds the dentures.

taking pictures of young children playing in the rubble directly beneath a Jordanian military position located on David's Tower at the Jaffa Gate. Too frequently these children wandered across the border by mistake, and it took the concerted efforts of the Mixed Armistice Commission (MAC), established by the UN, to get them returned to their families. Other streets in the area were considered so dangerous, being in the direct sight line of the Jordanians, that one had to dash hurriedly across to avoid sniper fire.

In the nineteen years between the War of Independence and the Six Day War, many of my stories involved incidents in and around no-man's-land. They were not always tragic. I once observed with my camera an amusing little ceremony that took place every morning, when an Israeli police officer would meet with his Jordanian counterpart in order to swap newspapers—the *Jerusalem Post* in exchange for the equivalent from

Jordan. One of my very first assignments to appear in *Life* also took place here. I received a telephone call from the Israeli representative on the Mixed Armistice Commission, Major Arieh Doron, who tipped me off about a good story. In a Catholic hospital called Notre Dame, located exactly on the Green Line, a terminally ill woman had leaned out of the window of her room and opened her mouth, and her false teeth had fallen into the rubble of no-man's-land below. The MAC decided to try to retrieve these teeth and sent into the area an Israeli officer, several Catholic nuns from the hospital, and a French commandant, the latter clutching a huge white flag of truce. I went with them. The ground was strewn with garbage, barbed wire, and the detritus of years of neglect. Trees and weeds had forced their way up through the tarmac of what used to be a road. We also faced the risk of land mines, which could have been left there from the 1948 conflict. The chance of finding a set of teeth in this wilderness was fairly remote—the proverbial needle in a haystack. We wandered around for a while looking through the rubble, when suddenly Sister Augustine spied something, bent down, and raised her hand exultantly up to the heavens. In her fingers she was triumphantly clutching the lost dentures. *Life* published the illustrated story under the title "A Tale of Some Teeth." Everyone was very happy with the outcome, with the exception of the French commandant. He complained that the dignity and honor of his officer's rank had been severely tarnished by the triviality of such a story.

16, 17

One issue that brought both sides of the conflict together was the problem that each faced from the large number of rabid dogs and jackals who paid no heed to borders. This was the first time that I actually spent several hours in no-man's-land, accompanying veterinary officers from both sides as they spread poisoned meat around to attract the animals. This story ran in the *London Picture Post*. It was while covering this particular assignment that I took a memorable picture of a Jordanian soldier handing a cup of tea across the barbed wire to an Israeli paratrooper—a very rare sight, and an encouraging one, at a time when it seemed easier for us to get to the moon than to cross the border into the Old City.

18

A conciliatory event that took place every December 24th was the occasion when Christians from Israel were permitted to cross the border at the Mandelbaum Gate on their way to midnight mass in Bethle-

18. A Jordanian soldier hands a cup of tea to an Israeli paratrooper at the Green Line, 1956. A rare intermezzo during nineteen years of a divided Jerusalem.

hem. Tents were erected in the square outside the gate where documents were processed by officials from both sides in an effort to facilitate the passage of visitors. The atmosphere was festive, as befits Christmas, and once again I photographed a rare scene, of Israeli women soldiers standing side by side with Jordanian legionnaires as the pilgrims walked through—an appropriate sight for the season of peace and goodwill.

Not too many people know whence the name Mandelbaum is derived. The Mandelbaum family had a store in downtown Jerusalem on Jaffa Road and owned a house in Musrara. In 1948, their house served as one of the most forward positions of the Haganah. Later, when it was decided that this spot would become the transfer point for diplomats, journalists, and the UN, it simply became known as the Mandelbaum Gate. Its name is recognized worldwide. It has probably done a lot more for the Mandelbaum name than the store they had in Jaffa Road. It also became the title of a best seller by British author Muriel Spark.

9. MY CAREER BEGINS

At twenty-five years of age, I was absolutely determined that the career I wanted to follow was that of newspaper photographer. It was therefore fortuitous that my talent in this field became known to the Army Map and Photography Services and I was moved over to join their unit, headquartered at Jaffa. Our function was to take pictures from Israeli military positions in the hope that something we observed might help Israel's intelligence services to find out more about the enemy and its activities—my first, but not last, venture into the "spy" business.

This transfer marked the end of my fighting career in the army. I laid down my gun and took up the camera. Since then I have been through seven more wars. I have always continued to shoot, but only through a lens.

Jerusalem was not a safe place during the War of Independence in 1948. It suffered constant bombardment from the Jordanians, and although I was serving in the army, the situation for Anni was much worse. She had to queue for water, bread, and powdered milk for the baby each day, with everything being strictly rationed. Moving around town was a risky business, and civilians were killed on a regular basis by shells falling in the center of town while they endeavored to purchase basic provisions.

I, meanwhile, although technically fighting on the front line, was relatively safe in comparison, as what we had to deal with was direct-line fire. We knew where our enemy was firing from and consequently could take evasive action. Anni found this period of her life very hard to deal with, understandably. She had lost a father and a brother in Germany and was now terrified of losing me.

At the conclusion of the war some several weeks later, 1 percent of Israel's total population, i.e., six thousand out of six hundred thou-

19. On my first wheels with my daughter Tamar, 1950.

sand, had been killed, including many people whom I knew. Countless others had been injured.

Once the war was over, I was released from the army and, never having formally received a rank, ended up as I began—in civilian clothes. It was at this point that I began to take pictures and to make efforts to sell them freelance.

By then, we had moved to a three-room apartment in Zichron Moshe in Jerusalem thanks to the generosity of my mother-in-law's friends, who belonged to what was known as the "Israeli aristocracy." The elite in those days was not what it is today. The archetypal Jewish mother would never have dreamed of her son becoming a doctor or her daughter marrying a dentist. The height of ambition at that time was that one's offspring should become or should marry a member of the Dan or the Egged bus cooperative, namely a bus driver. This was by far the most prestigious career choice of the day, and in fact it remained so for many years. It was one such bus driver who guaranteed our bank loan so that we could pay the key money to get a better flat.

My next pressing need was to get myself mobile, so in 1950 I bought an old Norton 500cc army surplus motorcycle. Now, with a means of transport, I was eminently better equipped to pursue my dream. I focused on chasing after news items. You need to remember that this was a time without mobile phones or television. I sometimes wonder today how I was able to find out where newsworthy events were occurring then. I put it down to the fact that the informal Jewish "telegraph system" was highly efficient. They say in Jerusalem that if you want everyone to know something, you tell it to just one person in the morning as

a confidence, and by midafternoon everyone knows all about it. Who needed mobile phones or e-mail?

Then, as now, all the newspapers, with the exception of the *Jerusalem Post*, were based in Tel Aviv. After taking my shots, I printed them in a makeshift darkroom—our bathroom—and once a week rode over on my bike to Tel Aviv and peddled my wares.

As an ex-serviceman, I was entitled to certain benefits, and so the Israeli government gave me a small shop in King David Street, Jerusalem, which Anni and I opened as a photographic studio. We called it Photo Tamar, after our baby daughter.

I cannot say that it was an outstanding commercial success, but we did have one enigmatic client I can never forget. You know the old story about someone who goes into a hotel, knocks on a door, and says, "The rain in Spain falls mainly in the plain," whereupon the occupant replies, "Oh, you need Cohen the Spy—he lives at flat No. 16 on the next floor"? Well, this client was our "Cohen the Spy." He spent all his time gaining access to the rooms of UN personnel at the King David Hotel, from where he appropriated files and film. He brought them to us to be photographed and then returned the "borrowed" documents to their owners' rooms. He was always at great pains to tell us that his mission was highly secret and on no account must we disclose this fact to anyone.

I used to buy rolls of film on credit in Tel Aviv. Some I used, and others we stocked in our studio. Whenever we sold a roll of film, we would celebrate immediately by going across the road to a little café and having a meal. Perhaps because our lives had been so precarious, it was a matter of "let's live today, for we don't know what tomorrow will bring." This attitude has remained with me all my life. I think in some respects I am quite extravagant and impulsive. I certainly cannot resist the latest gadgets and especially anything new in cameras or related technology.

10. HAOLAM HAZEH

In 1951, an event occurred that was probably the turning point in my effort to become a professional photographer. A man named Uri Avnery bought a moribund family magazine that he proceeded to turn into a unique Israeli institution. Born in Germany in 1923, Avnery arrived in Palestine when he was ten years old. Between the ages of fifteen and nineteen he was a member of the Irgun, the illegal Jewish underground organization operating against the British, and then in 1948 he became a member of Samson's Foxes, which was an elite commando unit of the Palmach. The group took its name from the biblical tale in which Samson, during his fight against the Philistines, captured some foxes, tied flaming torches to their tails, and then sent them into the fields of his enemies, where they created havoc and burned their crops.

It was in this same year that Avnery began to advocate setting up a Palestinian state alongside Israel. He was a talented writer who had authored two books, *In The Field of the Philistines* (1949) and *The Other Side of the Coin* (1950), detailing his war experiences. This latter book was boycotted because of his description of atrocities committed in the War of Independence. The money he earned from his publications enabled him to purchase the magazine.

The name of the journal he took over was *Nine O'clock,* but he renamed it *Haolam Hazeh*—"This World." It was a combination of a mass-circulation news magazine and a medium for pursuing aggressive political opposition to the establishment. It exposed, for the first time in Israel, issues concerning political and economic corruption, previously taboo subjects, and in addition advocated a radically different national policy. To realize the impact of such a revolutionary approach to journalism, one has to appreciate that, prior to its appearance, the governing Labor Party, under Ben-Gurion, was in many ways Bolshevik—

20. Shalom Cohen, assistant managing editor of *Haolam Hazeh*, faints while watching a patient undergo insulin shock treatment at a Jerusalem mental hospital, 1951.

the party ruled, the party made all decisions, and no one dared to contradict it.

The effects of *Haolam Hazeh* were far reaching. It created a new style of journalism, subsequently adopted by all Israeli media. This original approach encouraged us to get much more involved in our subject matter. For example, on one occasion I was sent with another journalist into a mental hospital to produce an article on how it was run. Prior to Avnery, this would have involved having a chat with the director of the establishment in his office and then being shown around for about an hour, after which one would be expected to write an informed article. Instead, Uri made us stay two days and two nights in the hospital to discover what it was really like.

On that occasion, my colleague Shalom Cohen and I saw a female patient receive insulin shock treatment. She was securely strapped down on a bed, the treatment started, and the whole bed jerked up and down with her convulsions. Cohen certainly received his own "shock treatment"—he fainted. On another occasion, we spent a whole day in a leper facility, meeting the residents and living with them for twenty-four hours. Such experiences become imprinted into one's memory forever and certainly produce better journalism. *Haolam Hazeh* served as the finest training ground for most of the young men and women who later became outstanding Israeli journalists, and it also exerted a huge influence on the minds of two generations of young Israeli readers.

The public attitude towards Avnery and the magazine was mixed. There were those who greatly admired him for his iconoclasm and breaking with tradition, but there were others who regarded him with intense suspicion, fear, and even hatred. On more than one occasion, he was violently attacked—his offices and printing facility were bombed several times, and there was also a failed attempt on his life. Various government officials tried to silence him by other means, and eventually his offices and all the archives were completely destroyed by arson in 1972.

20

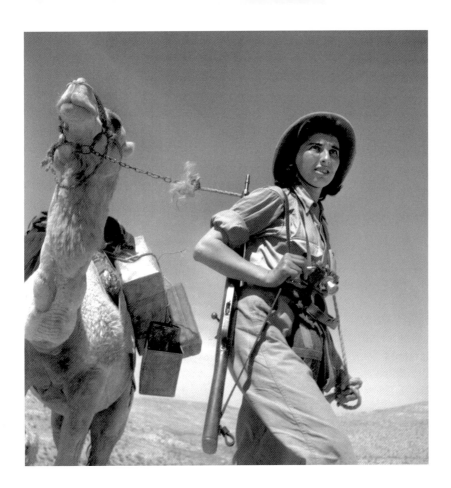

21. Anni Rubinger leads a camel
through the Negev Desert, 1952.

What Uri Avnery did for me, however, was something that no one else had done. He offered me my first permanent position with a magazine and hired me at a salary of 250 Israeli pounds per month, which at that time was, if not exorbitant, a reasonable amount to live on. I was on my way.

I too had to confront a measure of hostility, being regarded as a representative of his magazine. I once had to take a picture of Moshe Sharett, one of Israel's leading politicians—but a dove rather than a hawk like Ben-Gurion. He became prime minister for one year on the resignation of Ben-Gurion in 1954, yielding this post back to Ben-Gurion in 1955 and returning to his position as foreign minister until 1956. While I was preparing to take my shots, Sharett looked at me and with a tone of disbelief and disgust in his voice asked how could I possibly work for "such a journal." Yet I did, and continued to do so, and to this day am eternally grateful to Avnery for giving me an opportunity without which I may not have achieved my goal.

I worked at *Haolam Hazeh* for two and a half years, during which time I was dispatched on many fascinating assignments. Once Anni, Shalom

Cohen, and I were sent to accompany a group of thirty geology students on an eight-day tour through the Negev Desert. Our trip turned out to be more of a "Boy's Own" adventure story when we were attacked by a group of Bedouin bandits—the area where we were traveling was on the Egyptian border and well known for smuggling.

One of our group was injured in this incident and had to be rescued by a small Piper airplane and taken to hospital. This was quite a feat, as the pilot had to land on very uneven ground strewn with rocks. How he landed I do not know, but he managed it. We were also faced with other problems as, during the skirmish, our water containers were punctured by bullets, and consequently we lost a lot of precious water—the most essential item for desert travel. From then on we had to ration our water supplies strictly. We managed once to find a place in the rocks where rainwater had collected. It was a dirty green color, but we filtered it through our handkerchiefs and drank it. For eight days we traveled on foot, our belongings and supplies carried by camels, but we got a good story with some excellent pictures, which I still have today.

In those days there was no such thing as telecommunications. Instead, it was arranged that a small Piper airplane would fly overhead every day to check that we were safe. If the pilot had something to tell us, he would drop handwritten notes in old tin cans from the window of his plane for us to pick up. We in our turn devised a way of communicating with him. One day we realized that we were running very low on food, so we lay our rifles down on the sand to form the word *lechem* (bread). Fortunately, he saw this on his next sortie, and the following day he dropped us provisions. Not really so original, as it was not, you may recall, the first time that the children of Israel have received "manna from heaven" while wandering for many days through the wilderness.

In 1952, I bought my first car—a 1934 Ford. It was my pride and joy, and also essential, as I now had to travel each day from Jerusalem to Tel Aviv. In those days, it took more than two hours to complete the journey—not because of excessive traffic, but because the roads were circuitous and narrow. It was also necessary to take a roundabout route to avoid the danger of enemy ambushes, as at that time the Jordanians had control over certain sections of the road. These hazards of travel

were compounded by the fact that my car, while enthusiastic, was not entirely roadworthy. Once I had three flat tires during the same journey and ended up having to abandon the car in the middle of nowhere.

I was a complete workaholic. Frequently I chose to spend the night at the office, sleeping on a camp bed, if I had to complete a difficult assignment or stay to develop film in my "lab"—an enclosed space of about four feet square that I had constructed in my office.

I was responsible not only for taking news pictures but also for writing my own stories. Photography has always been second nature to me, like breathing, but writing was quite another matter. I remember once sitting in the office late at night struggling with a story. In walked Avnery. He saw that I was laboring. He sat down in front of a typewriter. "How many words do we need?" he asked. "Eight hundred," I replied. "Good," he said, "just tell me the story, David."

As I related it to him, he wrote my text. The words simply flew from his hands onto the paper, articulate and well composed. How I wished that I had that gift.

My time there with him was an invaluable training period that equipped me for so much in later years. Avnery went on to make his mark as a writer and journalist, continuing as editor in chief of *Haolam Hazeh* until 1990. He served as a Member of the Knesset on two occasions, but is primarily known as a peace activist, being the first Israeli to make contact with Yasser Arafat, in 1974, and the first Israeli to meet him, in 1982, after crossing the lines in besieged Beirut. He can still be seen today, in his eighties, at every major left-wing demonstration, fiercely propounding his views. He has won several international awards for furthering his peace objectives, including the Kreisky Prize for human rights in Vienna in 1997.

11. HOME LIFE

In 1953, my son Amnon was born at Sha'are Zedek Hospital in Jerusalem. The day before Ami was born, I was out photographing a demonstration of orthodox Jews protesting the desecration of the Sabbath. We lived at that time in a predominantly religious area called Zichron Moshe. At 5 a.m. the next day, I woke up to a commotion outside our windows. I looked out and there was my treasured 1934 Ford going up in flames. It had been torched by one of the *yeshiva* (seminary) students whom I had photographed the previous day. They had broken a window and thrown some gas-soaked rags into the car. A few hours after my car was burned, I received a phone call to say that my wife was about to give birth. It is difficult to forget that day with two such memorable incidents! Many years later, I was in the Knesset cafeteria having a coffee when an ex-yeshiva student came up to me, introduced himself, and then proudly announced, "It was I who burned your car some forty years ago." I thanked him and said that because of what he had done, I had been able to buy a new car. Anni had scrubbed the inside of the old car clean and sewn a new set of seat covers for it. I painted the outside with a paintbrush, and we actually managed to sell it to someone. I bought a 1942 Studebaker with the proceeds!

I photographed Amnon when he was just seven minutes old and sent this picture out as an invitation to his *brit milah* (circumcision). I was severely scolded for this action by religious friends of mine who told me that you are not allowed to "invite" friends to a brit milah as it is considered a *mitzvah* (voluntary good deed) to attend. By my act of inviting them, I had denied them the opportunity of carrying out this religious obligation.

In spite of now having two children, I was completely and wholly absorbed in my work—to the detriment of family life. It seemed accept-

able at the time, but today when I see the way my children relate to their own children, I realize just what a lousy father I was. I feel bad that it took me until today to see what is truly meaningful in life and to recognize where my priorities should have lain.

Fortunately for my children, we had the luxury of having Anni's mother close at hand, as she lived with us. She was convinced that I was irresponsible and reckless to have left a good job with the ministry to try to be a photographer—no job for a Jewish boy—and I resented her interference. The fact that she was living with us at that time made the tension all the more acute.

For the first two years of my marriage, my mother-in-law and I hardly spoke to each other. Any communication between us had to be through a third party. "Tell your Mother . . ." I would say to Anni. "Tell your husband . . ." Anni's mother would say in response. Anni was caught in the middle. Bertha and I fought fiercely all the time, albeit through an intermediary.

Eventually we managed to find her a small apartment nearby, and I am happy to say that, over time, we became the best of friends, and ultimately I believe she loved me even more than she loved her own daughter. In later years, she talked proudly of "my son-in-law, the famous photographer."

Tami and Ami adored staying with their grandmother. She loved to spoil them—probably the main function of a Jewish grandmother—and even today they talk about how they used to look forward to being with her on Friday nights because the following morning when they awoke there would always be chocolates and treats by their bedside.

She was a real tough old-timer. Whenever Anni and I wanted to go away from home for business or pleasure, she would be there for us. She would come and stay, and walked, loaded down with heavy shopping bags, all the way from Mahane Yehuda (the Jewish market). She refused on principle to take a bus, however much she had to carry. In retrospect, I imagine that when you have gone through what she endured during the war, a half-hour walk with a load of shopping is pleasurable, especially with the prospect of seeing your beloved grandchildren at the end of the journey.

Anni was a tigress where any members of her family were concerned and ferociously protective of anything or anyone that she regarded as

"hers." She had demonstrated this in the way that she had literally dragged and carried her ailing mother through the camps, forcing her to stay alive. Her attitude toward those around her after the war was unchanged.

It was imperative for her to share in everything that I did. As I was a photographer, she too began to work in this field, and took up photographing children. She turned out to be very talented, and even today people stop me to tell me that they have photographs in their family archive taken by Anni. She did not work from a studio but would visit the children in their own homes, ask the parents to leave, and then stay with the children, trying to penetrate the essence of their personalities. Very often she achieved a dramatic result by closely cropping the pictures, leaving the eyes as the main feature.

Sometimes she would ask my opinion of a photograph she had taken. I would foolishly say what I thought and criticize some aspect of her work. Every time anything like this came up for discussion, she would be so upset and angry that we would have a terrible fight. Finally, one day she decided to give up photography and told me that it was my fault. She accused me of trying to stop her taking pictures and claimed that this was the real reason I had found fault in her work. Nothing I said could change her mind. She was absolutely resolute.

As some sort of recompense, she started working for *Time* magazine, where I was employed. Sometimes when a story broke late in the week and it was vital to get the raw film to New York quickly, Anni would carry it there by hand. On one of her visits to New York, the chief there asked her how much the magazine was paying her for this service. She replied, "Nothing. I am doing this for David," whereupon he said, "That is ridiculous—nobody works free for *Time*. You should be paid." Shortly after this, she was put on contract as a photo researcher. We became well known for being the only married couple on their staff.

12. YEDIOTH AHRONOTH

In 1953, I started to work for *Yedioth Ahronoth*, a daily tabloid founded by Yehuda Moses as a small-time enterprise in 1939.

At the time, it was still run as a family business. I used to go up from Jerusalem to Tel Aviv to do a story and meet the correspondent with whom I would be working—usually at the home of the editor's son, Noah Moses. His wife Paula was the type of Jewish wife who categorically refused to let us leave her home without first having a hearty breakfast. She would sit over us and make sure that we finished everything.

Old Mr. Moses was the archetypal all-powerful patriarch. Anything he uttered was a command that had to be obeyed. One day, I was assigned to go with their social columnist, Mira Avrech, to cover a Purim party taking place at the Dan Hotel, Tel Aviv. I arrived at her home and, to my astonishment, found her dressed up as a French can-can dancer, complete with black tights and frilly skirt. When she commented on my casual attire, I replied, "I am a photographer; I'm not dressing up." Without comment, she picked up the telephone, called old Mr. Moses, and complained that David Rubinger refused to dress up for the party. Old Mr. Moses asked her to hand the phone to me. In his sonorous and stern voice he said, "You will do what Mira says," whereupon a gray smock and a blue beret were miraculously produced and handed to me with instructions that I should put them on. Next appeared a few paintbrushes, which were tucked into the top pocket of my smock to complete the effect. "Voila!" she said triumphantly. "Now you look good." I had been transformed into a version of Toulouse-Lautrec, albeit taller.

We left for the event, with me feeling more than somewhat self-conscious—a state that was considerably worsened when we arrived at the party, made our grand entrance, and to the amusement of those

assembled found that we were the only ones in fancy dress. Everyone else was comfortable and relaxed in lounge suits.

This particular event was notable, but not because of our attire. During the course of the evening, a phone call came through to tell us that there had been a terrible massacre at Ma'ale Akrabim. An Israeli passenger bus traveling from Eilat to Tel Aviv had been ambushed at Scorpion Pass in the Negev by an armed Arab gang. All eleven Jewish workers in the bus were killed. Mira and I left immediately and drove down the Sodom Dimona highway to reach the scene of the tragedy, where I found myself taking photographs of the most terrible heart-rending scenes, all the while being dressed up as a French impressionist painter.

The attackers were Fedayeen, Arab guerrilla fighters. They operated from bases located in and controlled by Egypt, Lebanon, and Jordan. Having lost in battle what they could have had in the peace envisioned by the 1947 Partition Plan, these Palestinian-Arab terrorist groups began systematic raids against the Israeli civilian population. One thousand three hundred Israelis were killed or wounded by Arab terrorists between 1949 and 1956.

Fifty-two years later, in 2005, I was to recount this story for a "This Is Your Life" program to honor Mira Avrech on her eightieth birthday. Fortunately, she did not expect me to get dressed up again in "French style" on this occasion.

It was not the first or the last time that I rushed to an incident that turned out to be heartrending but at the same time involved an element of absurdity. On thinking about this, it could have been that we needed to inject some humor into our lives, in order to deal with the trauma of the tragedies to which we were exposed on a daily basis because of the nature of our work.

One morning a group of us, newsreel cameramen and still photographers, were returning to Jerusalem from a truly gruesome incident we had covered. Fedayeen had infiltrated the village of Ajour in the southern part of the Judean Hills, and three farmers had been savagely slaughtered while they lay asleep in their beds. The scenes were horrendous.

As we were traveling back to Jerusalem, a jackal suddenly ran across the road. Our three-car convoy stopped immediately, and we all got out

to have a look. I had a Colt .45 with me, which Anni had bought for me as a gift and insisted that I carry, as in those days even the roads close to Jerusalem were unsafe. It was recommended that one should never travel alone but always in a convoy of at least three vehicles.

I am not sure why I did it, but I tried to play the hero and started running after the jackal with my pistol at the ready. I fired one shot and missed. The jackal turned to look at me, and I believe he actually grinned triumphantly. I sent another three bullets after him, all unsuccessfully. After my last attempt to hit the animal, Fred Czasnik, a good friend who worked for CBS, shouted, "Not with the gun, David! Catch him and strangle him." Needless to say, I did not attempt this, but the incident helped to enliven an otherwise somber day.

Life in Israel is never dull and is often lived on a knife edge. One minute you can be pursuing your daily routine, carrying out those seemingly insignificant and regular activities that make up an average day. Suddenly, a crisis occurs, and in a matter of seconds you are transported into another world, one of catastrophe, conflict, and confrontation. This is particularly true for the journalist, whose life is spent attached to his telephone, which accompanies him everywhere—the coffeehouse, the bathroom, and even his bed at night. Now, with the advent of mobile phones, its presence is completely invasive. There is nowhere one cannot be contacted. This of course suits the journalist, as he waits for that special call to rush to the latest incident.

One day, I was sitting in a café on Zion Square when a correspondent from the *Haaretz* newspaper came over and asked me if I would come with him to Ramat Rachel, a kibbutz that before 1967 was on the border of land held by Jordan, at which a group of archaeologists were holding a seminar. I suspected at the time that he only asked me because I had a car and he did not, but, having nothing better to do, I agreed to go. Shortly after we arrived, we went up to the top of an old water tower where there was a flat roof with a good view of the proceedings. We joined a large group of spectators who were standing there. Suddenly, without warning, a burst of machine gun fire came from the Jordanian side. Bullets hit the dense crowd of people gathered exactly where we stood. Four people were killed and seventeen wounded.

Everyone ran in panic towards the stairs that led down to the ground. I remember telling myself, "You have to take pictures now!"

22. Israelis who had been observing an archaeological excavation from atop a water tower flee Jordanian machine-gun fire. Kibbutz Ramat Rachel, September 23, 1956.

22, 23 The first shots I took were of everyone frantically running down the staircase to get away from the danger. Once on the ground, I photographed the awful sight of the dead and injured. One image showed a woman bending over her dead friend, who, I later found out, was the wife of my superior when I had worked at the Department of Veterinary Services back in 1947.

This incident was one of the all-too-frequent terrorist attacks that I had to cover as a photojournalist. But tragic as this particular event was, it highlighted for me the fact that a photographer can be his own worst editor. When I took these images to various picture editors, their reaction was unexpected. To me, the image of the people fleeing in terror down the stairs represented a highly dramatic moment that I had personally experienced. When the editors looked at it, first of all they could not tell that the fleeing crowds were running, and, curiously, several of the subjects appeared to be smiling, which gave a completely different impression from what had happened in reality. It brought home to me that it can sometimes be extremely difficult to convey visually a sense of what really occurs at any given moment. Because I had been there and seen with my own eyes what had taken place, I had invested that photograph with my own emotions and fears, which had evidently, in this instance, not been conveyed to the viewer.

When I phoned home to tell Anni what had happened and that I was unharmed, she told me that Yehuda Arbel (the spokesman for the Jerusalem police) had called and said to her, "Tell your husband to come immediately to Ramat Rachel—something terrible has happened there." When she replied, "But he is already there," Arbel couldn't understand and said, "But that's impossible—it only happened two minutes ago."

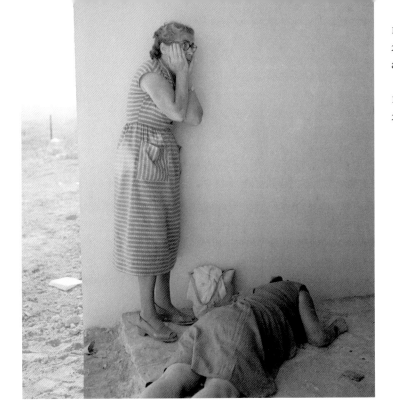

LEFT
23. The tragic aftermath of the attack at Kibbutz Ramat Rachel.

PAGE 71
24. David Ben-Gurion, 1970.

This was just one more example of how newsworthy events could take place around me even though I had not necessarily been called out to those particular assignments. In the early days, however, I was not always prepared for being in the right place at the right time. I remember so clearly that on one occasion in 1947, when I was only dreaming of becoming a photographer, I was walking home from work and came upon the Irgun blowing up the British Mandate Department of Labor in the Street of the Prophets in Jerusalem. Of course I had no camera with me, so I rushed home to get one. By the time I returned to the scene of the attack, there was only rubble left to photograph. Since then I have never left home, not even once, without taking my camera. I feel lost without it. Most days I will photograph nothing at all, but I am absolutely certain that the one time I fail to take it, I will miss something quite spectacular!

One thing that never ceases to impress me in Israel is the seemingly endless resilience of the human spirit in the face of repeated adversity. Journalists lurch from the mundane to the world-shattering as a professional matter of course, but the ability to survive this collision of worlds also holds true for our reserve soldiers—a unique feature of the military service in Israel.

They leave home on army duty for a month or more each year and then, with equanimity, are able to return and carry on as usual. A famous rabbi once said to his daughter, "My blessing for you is that you should have a lot of small problems." Being a journalist and working in Israel, one understands this very well.

13. BEN-GURION

David Ben-Gurion played a vital role in establishing the State of Israel in May 1948 and became its first prime minister. Born in Poland in 1886, he left for Palestine in 1906 at the age of twenty, inspired by a Hebrew-Zionist upbringing. Even at this age, the pattern of his future life was already established. He was a true pioneer and a secular Jewish nationalist who combined socialist ideals with Jewish messianic visions. Hugely ambitious, he had exceptional qualities of leadership and tactical political skills. He was expelled from Turkish-governed Palestine in 1915 for his socialist and nationalist activities and spent time in New York, returning after World War I. There is no question that his actions and involvement in Palestine at that time were crucial to the eventual establishment of the State of Israel. In 2000, *Time* voted him one of the top one hundred people who shaped the twentieth century. In his profile of Ben-Gurion for the magazine, Amos Oz wrote, "Part Washington, part Moses, he was the architect of a new nation state that altered the destiny of the Jewish people—and the Middle East. A tight craggy man . . . with a jawbone that projected an awesome willpower and volcanic temper."

The stories told about Ben-Gurion abound, and many of them have become legendary, as have his sayings, some apocryphal, others authentic. Three of my favorites are "In Israel, in order to be a realist you must believe in miracles"; "If an expert says it can't be done, get another expert"; and finally a statement that may be relevant to this autobiography, "Anyone who says you can't change history has never tried to write his memoirs." I count myself as one of those highly fortunate few to have had the opportunity of meeting this great individual on a number of occasions, to see and hear for myself what he was really like. Although short in stature, he was a giant of a man, with a commanding

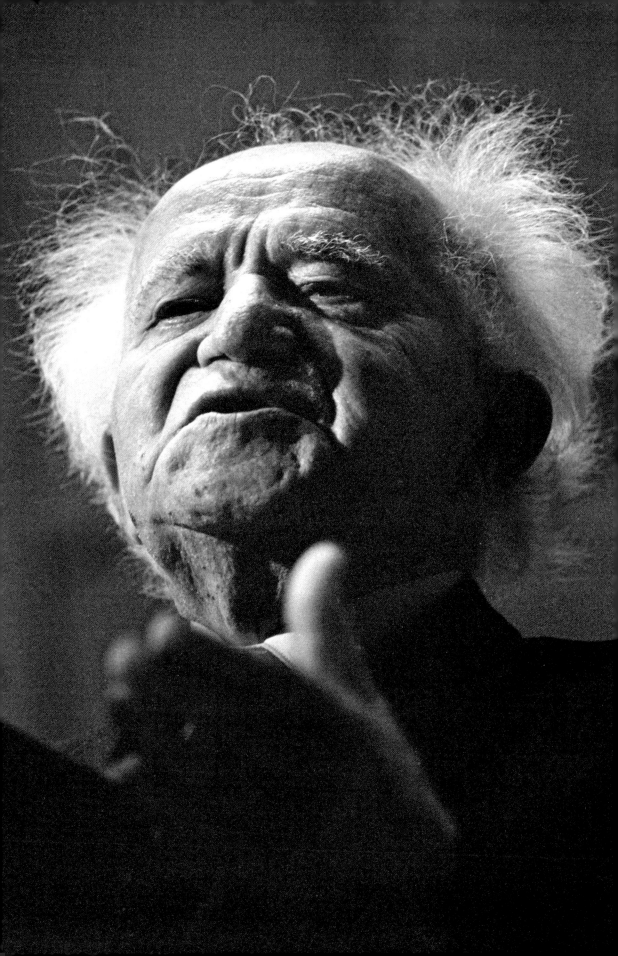

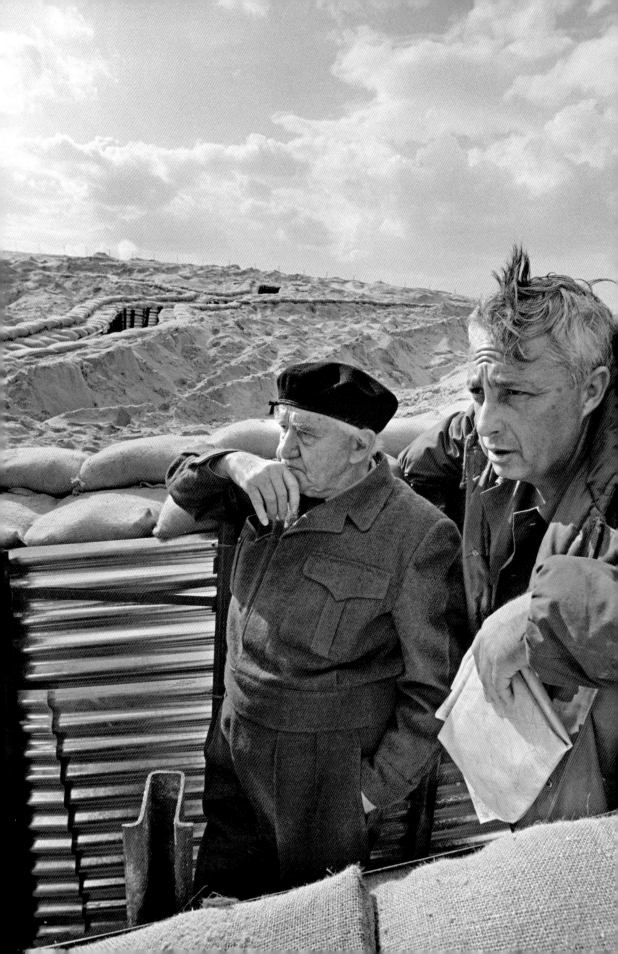

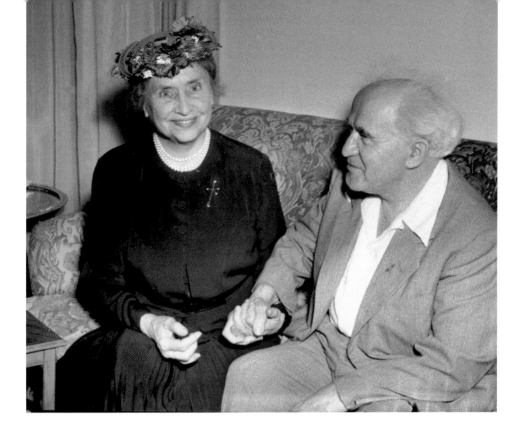

OPPOSITE
25. Ben-Gurion and Ariel Sharon on the Israeli
front lines at the Suez Canal during the War of
Attrition, 1971. At Sharon's insistence, Ben-Gurion
wears a beret, lest an Egyptian sniper recognize his
distinctive white hair.

ABOVE
26. Helen Keller visits Ben-Gurion, 1952.

presence, instantly identifiable by his halo of long white hair that flew
around uncontrollably in all directions. In 1971, during the War of Attri-
tion, when he was no longer prime minister, I flew with him to the Suez
Canal, where the commander of the section, Ariel Sharon, guided him
through the lines. So recognizable was Ben-Gurion that Sharon ab-
solutely insisted that he put on a large black beret, lest an Egyptian
sniper from across the Canal recognize his distinctive white mane and
take a pot shot at him. 25

I remember the first time I met him as if it were yesterday. It was
some time during 1949 when I, together with a couple of other journal-
ists, went to his office. In those days, one did not have the armies of
media that one sees nowadays. It was one of my very first assignments
as a photojournalist, and here was I, this inexperienced rookie, ventur-
ing in to meet the great man who was held in such awe by so many,

myself included. I felt my knees buckling under me and my throat drying up as I entered his office. It is not uncommon for young people to be inordinately impressed by those persons in positions of power, only to discover, in later years and through experience, that most leaders are flesh and blood with failings like the rest of us. In Ben-Gurion's case, it was different. He was a lion of a man in every sense.

On all the subsequent occasions when I photographed him, my knees were under control, but I never ceased to be impressed by his authoritative presence. I was privileged to see not only Ben-Gurion the consummate statesman and visionary, but also Ben-Gurion the man. I was there on the occasion when he met an American marine who had been severely injured in World War II and had lost both his arms. Ben-Gurion tenderly took hold of one of the man's artificial steel hands and spoke gently to him, trying to make him feel comfortable. On another occasion, Helen Keller, the deaf and blind American woman who became a role model for millions of people in her successful fight to overcome her disabilities, was brought to meet him in his office. I recall how moved he was and his expression as she explored his face with her hands, reading his features through her fingertips as they traveled the outlines of his face.

I also had the opportunity of photographing Ben-Gurion at a most unusual ceremony—one which I had not heard of before and have not come across since. He had gone abroad to the United States for some meetings. I believe this was his first trip out of Israel since becoming prime minister of the newly established state. On his return, his car was stopped at the entrance to Jerusalem, where Rabbi Moshe Porush, a leading religious dignitary, was waiting for him, together with a welcoming committee. Rabbi Porush was holding a large *challah* (Sabbath bread) and salt, which he presented to Ben-Gurion. This gesture, I was told, had biblical origins, going back to the time of Abraham, and was meant to welcome someone back to his home. Ben-Gurion, although not a religious man, manifestly enjoyed this ceremony.

For my part, the most complimentary incident involving Ben-Gurion was one at which I was not even present. In 1953, a foreign ambassador was to present his credentials to the president of Israel, Yitzhak Ben Zvi. This was one story I had decided not to cover, for some reason I cannot recall. It was only later that a colleague told me what had taken

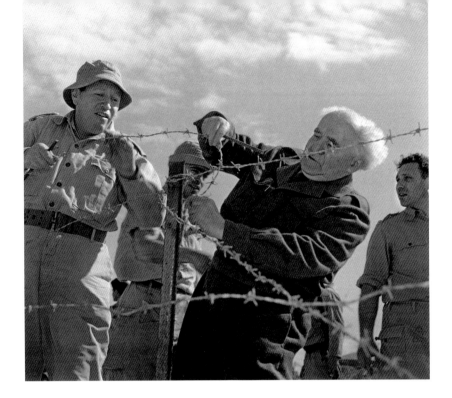

27. Ben-Gurion helps to build a security fence around the village of Mivtachim, close to the Gaza Strip, 1956.

place. All the dignitaries were standing in line waiting for the ambassador to enter. Ben-Gurion glanced at the row of photographers in front of him and asked, "Where is the one with the ginger beard?" He meant me. To this day, I am flattered to think that he was aware of me by my absence, and I am sure that this is the reason why I have never shaved my beard—a beard that, I must add, is a dignified white today rather than its former flaming ginger.

In 1955, I photographed Ben-Gurion reviewing the troops at the passing-out parade in Jerusalem of a group of newly promoted officers. He had to stand on tiptoe in order to pin a second lieutenant's bar onto the collar of an extremely tall soldier who had finished the course with honors. This soldier was Moshe Levy, who rose to become chief of staff in 1983. When Levy eventually retired years later from this top position in the Israeli army, I jokingly reminded him that I had been there when Ben-Gurion had pinned on his second lieutenant's rank. I asked him if I might now remove his lieutenant general's insignia, which I did. A picture of the two of us performing this "ceremony" remains on the wall above the desk in my study.

It is often said that what makes the Israeli army different from most other armies is that they lead from the top. This has accounted, over the years, for the disproportionately large number of officers killed in action. Ben-Gurion set this standard.

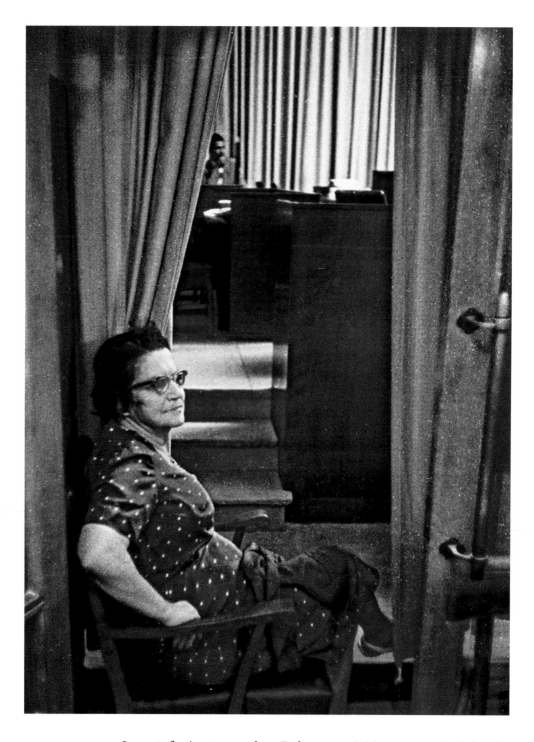

In 1956, for instance, when Fedayeen activities were at their height and border settlements were under constant threat, Ben-Gurion set a personal example and went to a settlement close to Gaza where he physically took part in building a security fence. He was never afraid to get his hands dirty and was the sort of man who would never ask anyone to do anything that he would not do himself.

27

28. Paula Ben-Gurion observes the
proceedings of the Knesset from
behind a curtain, 1960. Her occasional
comments from this position were
audible to the MKs.

Ben-Gurion was also passionate about developing the vast rocky and desert expanses of the Negev. It was his dream that pioneering Israelis would transform the area and utilize these open spaces productively. This dream never materialized quite in the way he had hoped, but it is true to say that Israel's desert regions are the only ones in the world that are shrinking, whereas every other desert is increasing in size. A great believer in putting into practice that which he talked about, Ben-Gurion eventually went to live in Sde Boker, a small kibbutz south of Beersheva.

One cannot speak about Ben-Gurion without mentioning his wife Paula. She was a character and very outspoken—a woman devoid of the niceties of polite living-room society that one might have expected in a prime minister's wife. I photographed her on a number of occasions as she sat in the old Knesset building, watching the proceedings from behind a curtain. The room was small, and her stage-whispered "asides" were audible to all present. "What do they want from him? Why are they bothering him!" she would mutter. "He hasn't even had his tea yet." She saw her role as protecting him fiercely on every possible occasion.

My friend Rolf Kneller, a cameraman who was at the time filming for a British company, Visnews, told me how, after he filmed an interview with Ben-Gurion in his home, which necessitated bringing in a lot of lights and equipment, she came up to him as he was about to leave, presented him with a broom, and said, "You made the mess, you clear it up!"—which of course he did.

On another occasion, she opened her front door to the UN Secretary-General Dag Hammarskjöld, who had arrived to see her husband at their residence. She greeted him with the words "Mr. Hammarskjöld, why don't you get married and stop giving us trouble."

In 1953, when Ben-Gurion resigned and retired to live in Sde Boker, I was there when he and his wife arrived at their simple wooden shack. I photographed Paula as, on seeing their new home, she put her head in her hands and exclaimed loudly in Yiddish, "Oy, where has he schlepped me to!" She was evidently not quite as enamored as he with the prospect of their new pioneering lifestyle. Paula was one of those unforgettable characters whose personality and actions lifted the spirits and gave color to one's daily life.

14. ALIYAH

On looking back, there is no question that a major part of my professional life was connected in one way or another with immigration. Not only did I myself emigrate from Austria at the age of fifteen, but throughout my working life I have also been witness to the successive waves of immigrants that came to Israel over the past sixty years. The fact that a small nation such as Israel managed to absorb so many newcomers is an unprecedented achievement. In 1948, there were about six hundred thousand inhabitants. This has grown in half a century to around seven million—a tenfold increase, of whom half came in as immigrants. This would be the equivalent of the United States population increasing to over two billion.

They came to Israel from seventy or more different countries, many as refugees, penniless and speaking a diversity of languages, rarely Hebrew. I was there to capture the scenes and to observe their emotional arrival and their frequently painful absorption.

It was not an uncommon sight to see newcomers fall down and kiss the ground on arrival in this land that represented their sanctuary. After an initial feeling of elation, however, things were not so easy for most of them. One particular group stands out in my memory. A party of Moroccans arrived by boat to Haifa early one morning. The young State of Israel had not yet developed an efficient infrastructure for dealing with the overwhelming task it was facing. People were taken off the boats, immediately loaded onto trucks with their meager belongings, and then driven to their allotted destinations.

In this case, it was to the far north of Israel, to a little village called Halsa, which today is Kiryat Shemona, positioned right on the Lebanese border. I went with them. The journey took a stressful twelve hours—for a distance that would normally be covered in a much

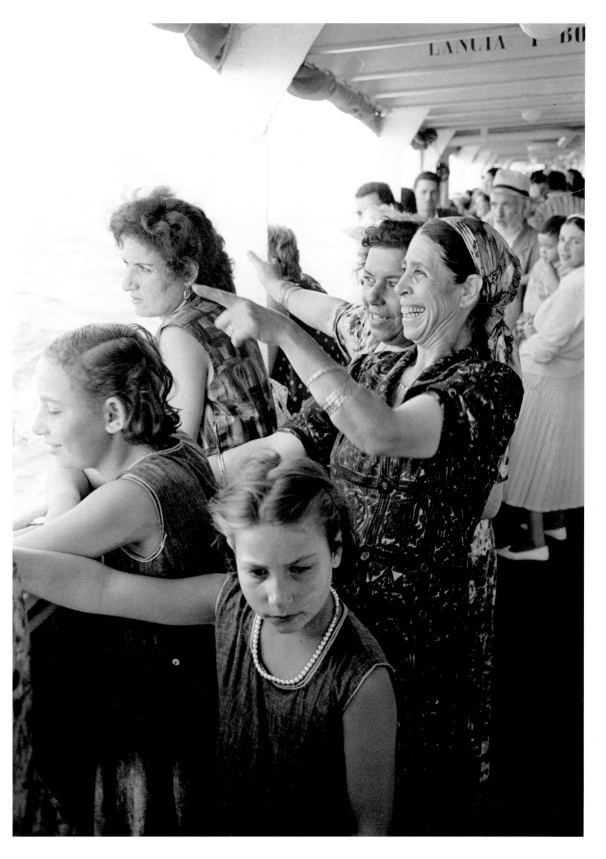

29. Immigrants from Morocco catch
sight of Mount Carmel as they approach
Haifa port on the SS *Lancia*, 1962.

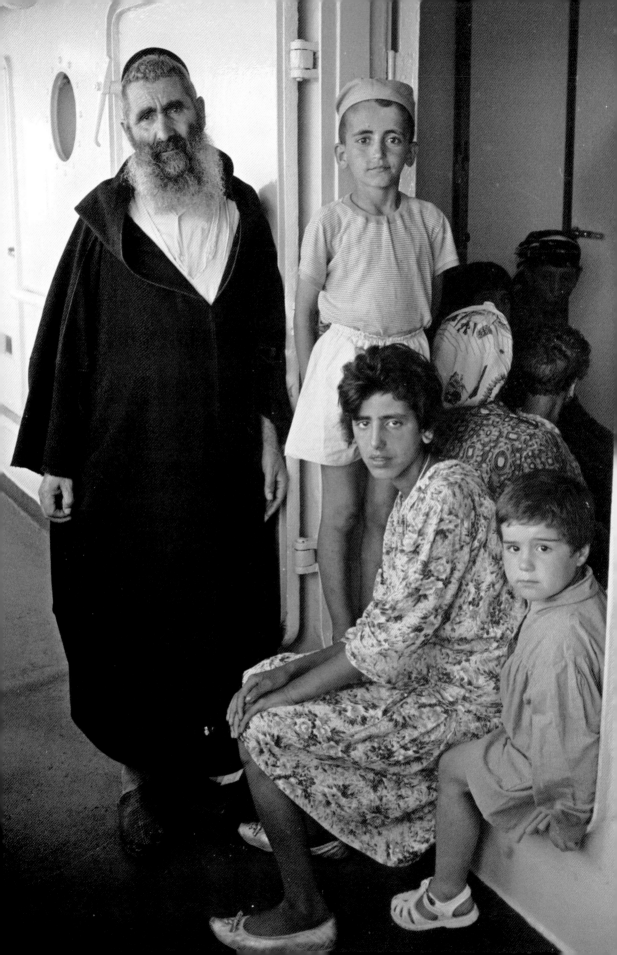

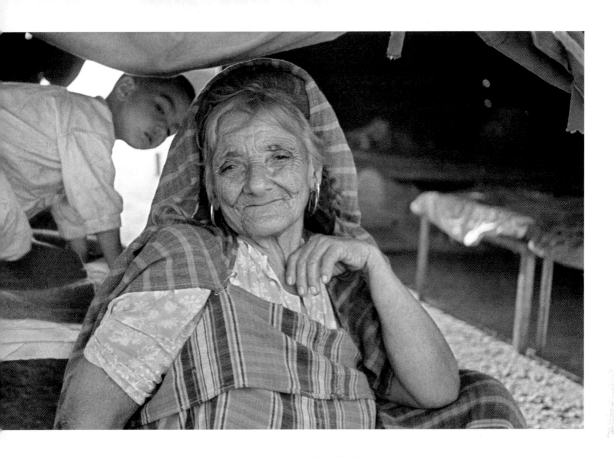

30. An immigrant family en route from Morocco, 1962.

ABOVE
31. A elderly woman from Iraq in a *ma'abara* (tented transit camp), 1950.

shorter time. We arrived at 10 p.m. in pitch darkness. The arrivals were taken off the trucks and told to queue up for processing. They did so, like sheep. Many of them were angry and shouting; others were apprehensive and fearful at the strangeness of their surroundings while trying at the same time to cope with small and fretful children. They were exhausted from their long journey and understandably anxious about their future. They were handed keys and told, "This is your new home"—a row of tin huts awaited them, and they were then left to their own devices.

They were also told, "Now you will be farmers." This was quite a culture shock for most of them, who had held quite different occupations in their countries of origin. Each hut contained narrow iron beds, straw mattresses, a table, a kerosene cooker, and a few pots and pans. The abruptness of this process seemed very hard-hearted to me at the time, but of course this was a period of deprivation for everyone in Israel, and the fledgling government had the mammoth task of providing

RIGHT

32. Flooding in the Talpiot
ma'abara, 1953.

OPPOSITE

33. A more hopeful image: an
immigrant taking home Sab-
bath dinner, 1958.

not only accommodation for the newcomers, but also employment. In addition, schooling had to be organized to suit their varying needs and, most pressing, to enable them to learn a new language. Ben-Gurion had established a policy of moving newcomers away from the main cities and towns with the objective of trying to set up new settlements in the less-populated regions. In retrospect, this was a well-thought-out scheme, and one that helped to consolidate the State of Israel. However, when I see Kiryat Shemona today with all its modern facilities and compare it with the pictures I took on that night, I get a shiver down my spine at the memory of how it was then.

31 The new arrivals were not necessarily always sent out to the border areas of the country. In some cases, they were placed in *ma'abarot* (tented transit camps) on the outskirts of cities. These tents were subsequently replaced by flimsy structures covered in tarpaulins, and at a later stage tin huts were provided. The problem with the tin huts was that in hot weather they became like ovens inside and were unbearably hot. Caravans and small homes were only built much later.

32 The conditions in the ma'abarot were awful. I remember scenes of tents being swept away by torrential rains in the Talpiot ma'abara, now

the industrial area of Jerusalem. In 1950, when we had one of the heaviest snowfalls on record in Jerusalem, I went to visit some Yemenite families struggling to survive in their tent. They had never before experienced snow and were attempting to cope with the freezing conditions, wrapping themselves up in anything available to try to keep warm. It was scarcely better when the snow melted, as then the whole place turned into a field of mud. They were cold, tired, hungry, and angry at the situation in which they found themselves.

OPPOSITE
34. Immigrants from Yemen at the Kissalon set-
tlement in the Judean Hills, 1950.

OVERLEAF
35. Immigrants from Yemen being trained to
defend their villages in the Judean Hills.

Since the newcomers perceived the then-ruling Labor Party as re-
sponsible for their plight, it is easy to see how so many Sephardim
(Jews from oriental countries) came to be attracted to opposition par-
ties such as Likud.

In that same year, I photographed a family in Kissalon in the Judean
Hills. Many Jews from Yemen were settled in this corridor that linked
Jerusalem with Tel Aviv. They came to Israel as part of Operation Magic
Carpet. Between 1948 and August 1950, the Imam of Yemen agreed to
"release" 45,000 of the 46,000 members of the Yemenite Jewish com-
munity. They had to make their way to Aden, and their journey was ar-
duous. Many of them walked with their possessions two hundred miles
across country to get there. They arrived exhausted and on the verge of
starvation, having been abused along their route and having had their
possessions stolen.

At Aden, a highly complex operation took place with the support of
British and American airlines as well as the Israeli government. In all,
some 380 flights were provided to save the Jews of Yemen, and the proj-
ect was so secret that there is very little film footage of it. It was not
until months after the completion of Operation Magic Carpet that the
news was released to the media. None of the Yemenite Jews had ever
seen an airplane before, but they were not afraid, as their belief, taken
from the book of Isaiah, was that God promised that one day his chil-
dren would return to Zion "with wings, as eagles." They saw the planes
and were fully convinced that this was the fulfillment of the prophecy.
They flew to Israel on the wings of eagles.

Thus they arrived, from very primitive conditions in rural Yemen to
the barren and rocky hillsides of Israel, where nothing awaited them
except tents. Nearly forty years later, I was involved in a project seeking
out some of these newcomers to see how they had fared during the in-
tervening years.

In one of my original photographs, a male teenager lay on a makeshift
bed, and outside the tent stood a young girl. On the floor, a baby was
sleeping on a cot. After months of research, I eventually tracked them
down and went to pay them a visit. The young man and the girl were
now married. Nathan and Sa'adia Tuvim were the middle-aged owners
of a thriving grocery store with an attractively furnished apartment
above, where they lived. Their family comprised seven children and

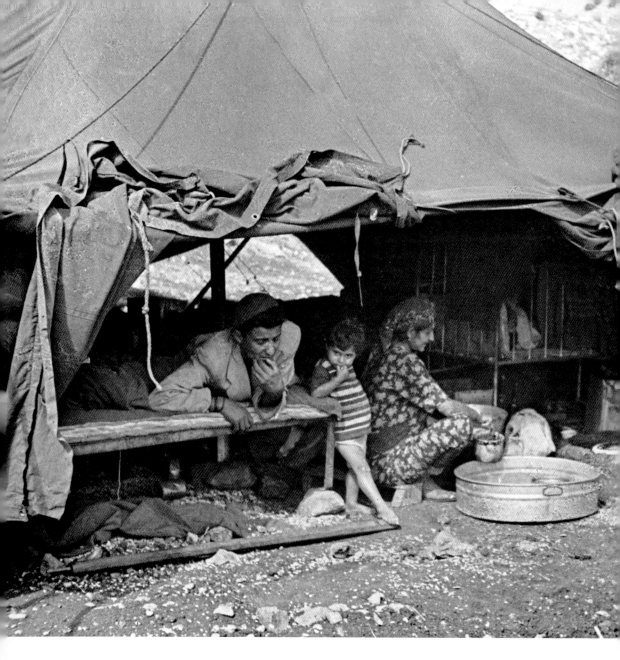

several grandchildren. Sa'adia, the young girl, was now a grandmother. The baby that was in the cot had become the chairman of a large transport company and a board member of another.

When I visited the family, Sa'adia was surrounded by her grandchildren. I showed her the original photograph, which she in turn showed to them. Said Sa'adia, "We were very poor living in our tent, but we were happy," to which her granddaughter replied, "Yes, but how awful, you didn't have a television!" How times have changed.

Some of the ma'abarot were the basis for what later were to become development towns such as Sderot, Ofakim in the Negev, and Carmiel in the Galilee.

36. The Tuvim family in their tent at the Kissalon settlement, 1950.

Over the years, the government learned from some of its earlier mistakes as to how to absorb immigrants easily and effectively. The era of the tented transit camps was over, and a new system was established called From Ship to Settlement. Through this program, hundreds of thousands of homeless Jews were welcomed to the land, with much more thought and consideration being given to the way they were introduced to their new country. No longer did they have to carry their own belongings. Trucks brought their effects directly to houses that had been prepared in advance and that contained all basic amenities. The newcomers arrived only during daylight hours so that they could see the countryside around them, and each family had someone appointed

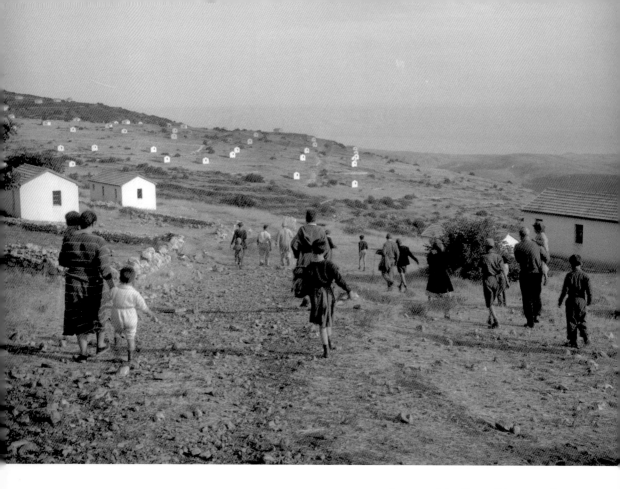

37. As part of the From Ship to Settlement program, immigrants from North Africa are taken to their new homes in the Galilee, at a place now known as Moshav Amirim, 1954.

as a liaison to accompany them to their new homes. This was in great contrast to those scenes I had witnessed years previously of newcomers arriving in Kiryat Shemona.

You may ask whether these people became accustomed to and adapted to their new lives. In almost all cases, I think the answer is yes. In 1954, I took a photograph of a group of immigrants arriving to a barren hillside in the Galilee, then a small abandoned Arab village with no facilities. Today this place is known as Moshav Amirim and has become well known as a thriving center for vegetarian restaurants and bed-and-breakfast accommodation—a place to "get away from it all" in beautiful surroundings, with a philosophy advocating an organic and natural way of life. The pattern of successful integration has thankfully repeated itself all over the country in one form or another.

37

15. MY BEGINNING WITH TIME-LIFE

My time with *Yedioth Ahronoth* was relatively brief. I returned to free-lancing in 1954, when the Jerusalem stringer for *Time-Life* contacted me. A stringer is an informal newspaper correspondent who is not on the regular staff but is retained on a part-time basis to report on events in a particular place. The term derives from the days when journalists would attach pieces of paper on a string, fastened to a nail, which itemized their expenses so that they could claim them at the end of the month. The name has persisted.

This particular stringer was Monica Dehn. She was married to a very interesting character by the name of Roy Elston. Anni and I were to become close friends with them both. He was a non-Jewish Englishman who had worked for British intelligence in Egypt and had fallen in love with Zionism. When released from the army, he settled in Jerusalem and began writing what became a famous daily feature in the *Palestine Post* called "Column One" under the pen name of David Courtney. He was best remembered for the column he wrote on the morning after British soldiers, in a revenge attack against the activities of the Irgun Zvei Leumi, blew up the offices of the newspaper. The British identified the *Palestine Post* as being the Zionist mouthpiece and wanted to silence it. In spite of the fact that most of the printing facilities were destroyed, the paper appeared as usual the next morning in a simplified version on hand-printed sheets. Roy opened his column with the words "The truth is louder than TNT and burns fiercer than arson." This was his rejoinder to his fellow countrymen's attempt to suppress the paper. Some time later, he became mentor to Yael Dayan, daughter of Moshe Dayan. Under his encouragement, she wrote her first book, entitled *Face in a Mirror*, which achieved a considerable measure of success. Her father was certainly not happy about the relationship between his

38

38. Monica Dehn, the Jerusalem stringer for *Time-Life*, interviews Moshe Dayan while he digs a trench, 1956.

young daughter and this sixty-year-old non-Jewish journalist—so much so that one day he sent over a three-ton army truck with soldiers and forcibly removed both her and all her belongings from Elston's flat.

Monica asked me if I would be interested in illustrating a story that she was writing on the Blessing of the Sun service in Mea Shearim, an ultraorthodox part of Jerusalem. The Blessing of the Sun is a prayer service in which the sun is blessed in thanksgiving for its creation. The ceremony takes place every twenty-eight years, and the date is that identified by Jewish traditional sources as corresponding to the creation of the world.

This was the first occasion that I met the legendary leader of Neturei Karta—Rabbi Amram Blau. His wife, a convert, had been a member of the French resistance and had rescued Jews during the Holocaust. Together they ran Neturei Karta, the violently anti-Zionist ultraorthodox organization that denied the existence of the State of Israel and on many occasions had even given support to Yasser Arafat and the Palestinians. Their extreme minority position is rejected by all mainstream rabbinic leaders throughout the world even though the basis for their belief is religious—i.e., that the State of Israel cannot come into existence until the coming of the Messiah, and therefore any violation of this principle is an abomination and must be fiercely opposed. In later life, I had many occasions to cover him on various assignments, mainly because he was involved in nearly every religious demonstration against the State of Israel. There were demonstrations against the desecration of the Sabbath, against autopsies, and against archaeological excavations that might involve the disturbance of Jewish graves. There was a particularly violent protest against the opening of the first mixed swimming pool in Jerusalem. Their main aim, however, was to try to obtain the annulment of Zionism and return all Palestine to the Arabs, as they believed that an orthodox minority could be viable in an Arab-controlled Palestinian state.

39. Rabbi Amram Blau and his son Uri in court on charges related to a violent demonstration, 1955.

On Israel's Independence Day, a day for national rejoicing, I photographed him wearing sackcloth and ashes. On another occasion, his followers dragged a cart through the streets with a man lying on it who they claimed had been beaten to death by the police. The onlookers, mostly Neturei Karta supporters, were wailing and crying at his demise and calling the police Nazis and Gestapo. The cart rounded a corner, and I followed it. Once they turned around the block, the "dead" man got up and walked briskly away. This story, which appeared in *Life*, was headlined "The Living Dead."

Thus began my long association with *Time-Life*, although I also continued freelancing for other international publications, such as *Stern*

and *Picture Post*. My first two pictures published in *Time* magazine were portraits of Rudolf Kastner and Malchiel Greenwald. The latter, an Israeli citizen, accused Kastner, a Hungarian Jew who had immigrated to Israel after the war, of having collaborated with the Nazis in order to save his own family and friends.

The story goes that Kastner, an influential Jew living in Budapest during the war, entered into negotiations with Adolf Eichmann through which Kastner undertook the purchase of Jewish lives in exchange for money and military equipment. In addition, Kastner agreed that he would ensure that there would be "control" and "order" in the camps, and if he was able to achieve this, a few hundred Jews would be released from Bergen-Belsen and taken to Sweden, from there to emigrate illegally to Palestine. Eichmann is reported as saying, "It was a good bargain. For keeping order in the camps, the price was not too high for me."

Greenwald published his accusations against Kastner, who was then a prominent Zionist official in Israel, alleging that the list of Jews to be released comprised only those close to Kastner. The attorney general of Israel prosecuted Greenwald for criminal libel. Kastner won his case but was awarded contemptuous damages of only one Israeli pound by Justice Benjamin Halevi, who later became one of the three judges who tried Eichmann. After the case there was public outrage and demands that Kastner himself be put on trial, but this never came about, as, not long afterward, someone took the law into his own hands and murdered Kastner on a street in Tel Aviv.

The political and security crises that occurred almost daily in Israel at the time presented me with endless opportunities to be sent on assignments, and it was in 1956 that I received my first major assignment for *Time-Life*.

16. THE SINAI WAR

Time asked me to cover the 1956 Sinai War. This war, also known as the Suez Crisis, was fought on Egyptian territory. The conflict pitted Egypt against France, the United Kingdom, and Israel. The alliance between the two European nations and Israel was largely one of convenience; the European nations had economic and trading interests in the Suez Canal, while Israel wanted the Canal kept open for its own shipping.

Beginning on October 29, the operation to take the Canal was highly successful from a military point of view, but a political disaster due to external forces. When the USSR threatened to intervene on behalf of Egypt, the United States feared a global war and put great pressure on France, Britain, and Israel to withdraw, which they did in March 1957. The crisis greatly improved Gamal Nasser's standing in the Arab world. The Egyptian government expelled almost twenty-five thousand Egyptian Jews, confiscated their property, and sent approximately one thousand more Jews to prisons and detention camps.

The war gave me my first opportunity to work with many of the great internationally known photographers, but I was very new at this game and quite inexperienced. Before setting out to cover the war, we all met at the Dan Hotel, Tel Aviv, which served as our headquarters. I was very conscious of the amount of money it must have cost to accommodate me at this plush hotel. To try to economize, I found myself approaching another *Time-Life* photographer in the lobby to ask him whether I could share a room with him. He looked at me as though I were completely mad.

As a newcomer, I was unfamiliar with the whole world of expense accounts. To me it seemed preposterous and extravagant for the magazine to pay so much for me to stay at a five-star hotel. Little did I know that, at that time, *Life* photographers were permitted to travel only first-

40. A scene from the Sinai War, 1956.

class on airplanes. This was apparently considered necessary to pre-
serve the prestige of the magazine. Once I got the hang of the system, it
did not take long for me to follow suit.

On this assignment, I found myself a few miles from the Suez Canal
together with *Life's* Rome correspondent, George de Carvalho, with
whom I shared a vehicle and a driver. For some reason, after a few days
George decided that he had to return to Tel Aviv, but he encouraged me
to stay for another day or two in order to see what else I could cover of
the campaign. As we parted, he put his hand in his pocket and pulled
out an immense wad of hundred-dollar bills. Without counting, he split
it in two and said, "Here, you'll need some expenses." There I was,
standing in the middle of the desert, with nothing but sand for hun-
dreds of miles around. To this day I am not sure what he expected me to
spend the money on, but that was the way *Time-Life* operated in those
glorious days.

I was very fortunate to meet many of the world's "greats" in photo-
journalism. In the 1967 war, I worked with an American named Paul
Schutzer. On the eve of the Six Day War, Paul and I sat drinking and
chatting together at a hotel in Tel Aviv. We decided to have a bet as to
who would get his picture on the cover of *Life* magazine first. We agreed
that the loser would have to buy a bottle of champagne for the winner.

Paul was both a great photographer and a good friend, and we fre-
quently worked on assignments together, each covering different as-
pects of the story. One day, Paul was told that the managing editor of

41. *Life* photographer Paul Schutzer in Meron, Galilee, 1960, on the Lag Ba'omer feast day. Tragically, Schutzer was killed in Gaza on the first day of the Six Day War.

Life, George Hunt, was arriving from Jordan and that we should go to the Mandelbaum Gate in Jerusalem to meet him. The Mandelbaum Gate was at that time the only official crossing point between Jordan and Israel in the divided city of Jerusalem. Tourists and diplomats could cross there under the supervision of the United Nations.

Hunt walked over to where we were waiting, greeted us both warmly, turned to Paul, and said, "Paul, I've been asked by the financial people in New York to request that you submit more detailed expense accounts." Paul replied, "George, I can't do that. My job is to take pictures. All I know in this business is that when I need money, I ask you for it and you give it to me. Once I have spent it all, I ask you for more. That's my expense account." Hunt laughed, and left it at that.

Tragically, Paul was killed on the first day of the Six Day War in an armored car that was hit by enemy fire at the entrance to Gaza. We found his burned body and his camera only four days later. My picture was first on the cover of *Life*, but I would have gladly given it up to Paul in exchange for his life and his bottle of champagne.

Some time later, Paul's young widow was given a job at *Life* in New York. One day, a young Israeli ex-serviceman named Yossi Ben Hanan,

who aspired to be a photographer, turned up at her office. He became friendly with her and asked for her help to get a job as a photographer.

She introduced him to one of the *Life* editors, who said, "Yes, of course I will help. I suggest you go back to Jerusalem and work with David Rubinger for a year." For whatever reason, Yossi Ben Hanan decided not to do so and later rejoined the army. He ended up as a major general, and on President Jimmy Carter's visit to Israel he was appointed as his aide.

Covering this visit, I found myself standing behind the barrier outside the prime minister's office, holding my camera. Carter paused for a photo shoot, with Yossi Ben Hanan behind him. On seeing me, Yossi waved, to which I shouted back, "You see, Yossi! Here but for the grace of God stand you."

Incidentally, during the Six Day War, Yossi Ben Hanan achieved his ambition to be in *Life*, but, as it turned out, not as a photographer. On one of the best-known *Life* covers, he is featured standing shoulder deep in the Suez Canal, smiling and holding aloft a Kalashnikov rifle. He at least got his front cover.

One day, about a year after the Suez Crisis, I bought a secondhand car in Tel Aviv. As I drove back to Jerusalem, I was suddenly confronted by a large number of ambulances with their lights flashing and sirens blaring. My natural instinct as a journalist was to follow them. This I did. The convoy eventually stopped near the Ziv Hadassah hospital in downtown Jerusalem.

Out of one of the cars stepped the police commander of the Jerusalem district, who happened to be both a neighbor and an acquaintance of mine. As he rushed into the hospital, I kept as closely behind him as it was possible to be, ran into the hospital after him, my Leica at the ready, and muttered to the security guard, "I am with him." As we reached a corridor, I saw a stretcher being wheeled by in front of us. On it lay the inert figure of Prime Minister Ben-Gurion.

I raised my Leica, and, without bothering to think about measuring the light or any other technicalities, took two pictures. The second frame was blocked by a hand that flashed out from behind me in an effort to cover the lens. A second later, I was grabbed by the security guards and physically thrown out of the hospital. I had no idea at the

42

42. David Ben-Gurion, injured in a grenade attack at the Knesset, is wheeled into an operating room at the Ziv Hadassah hospital in Jerusalem, October 29, 1957. Ben-Gurion's aide-de-camp, Lieutenant Colonel Nehemia Argov, thrusts his hand in front of my lens.

time what had occurred to warrant the prime minister being wheeled in on a gurney. Only later did I learn that a hand grenade had been thrown from the gallery of the Knesset into the plenum. Ben-Gurion was badly wounded.

Later, I discovered that the hand that had blocked my second shot was that of Ben-Gurion's aide-de-camp, Lieutenant Colonel Nehemia Argov. While driving back to Tel Aviv that evening, Argov accidentally hit a cyclist and almost killed him. This awful tragedy added to the emotional state that Argov must have been in that day, no doubt feeling partly responsible for Ben-Gurion's injuries and blaming himself for failing to protect his beloved leader. That night Argov put a bullet through his brain. Ben-Gurion, while still in the hospital, was not told about this tragedy, and *Ma'ariv* (the Hebrew tabloid which Ben-Gurion regularly read) went to the trouble of publishing a special single edition of the paper, just for Ben-Gurion to read, that did not contain the story about Argov's suicide.

17. TAKING TO THE SKIES

During the period between the Suez Crisis and the Six Day War, I was sent on some very interesting assignments, for once not connected with the usual topics of war, immigration, or politics. Almost always it was necessary to get to the action as quickly as possible, by whichever means of air transport was available.

In 1947, a noted Israeli archaeologist, Professor Eleazar Sukenik, bought from an Arab merchant what turned out to be one of the most major archaeological finds ever, the Dead Sea Scrolls. This Arab merchant had acquired them from a Bedouin shepherd who had found them in a cave near Qumran, close to the Dead Sea. Professor Sukenik of the Hebrew University, Jerusalem, is credited with having been the first to recognize the antiquity and value of the scrolls and the first to identify their provenance, an opinion that is still widely held as correct today.

Professor Sukenik's son Yigal Yadin, who was chief of staff during the War of Independence and was also a well-respected archaeologist, followed in his father's footsteps. In 1960, he decided to arrange a further expedition into the Judean Desert to see if he could discover any more archaeological finds in the same geographical region where the Dead Sea Scrolls had first been discovered. I was assigned to cover the story. Before the expedition could start, it was necessary to find a helicopter in order to survey and photograph from the air some of the many caves that were located in the deep canyons leading to the Dead Sea. The Israeli Air Force eventually provided this, and we went out surveying and taking aerial shots of any caves that Yadin felt might prove to be promising sites. On the basis of this survey, the expedition was organized, and a short time later we returned to the area, this time in army vehicles.

The terrain was extremely difficult to traverse. We went on foot up rock-strewn hillsides and walked along frighteningly narrow paths where there were precipitous drops down one side into the valley. When we reached the cliffs, we had to let ourselves down by climbing ropes and naturally could only proceed very slowly and with great caution. After a few hours, we arrived at the entrance to some caves. They were partially blocked with rocks and boulders, but we managed to make our way inside and then descended slowly into one of the caves by means of rope ladders. I was with Yadin, who, in order to help locate finds, had the rather unorthodox idea of bringing in military mine detectors to identify any metal objects hidden in the ground. We took the equipment and entered one cave, which from the outside looked insignificant, but soon revealed itself to be a huge cavern some thirty meters long and perhaps four or five meters high.

We made our way carefully across the rough ground, our path lit only by flashlights, when suddenly the detectors started beeping, indicating that something was there. On hearing this, our excitement became palpable, and we were all riveted to the spot in anticipation. After carefully digging in the area, one of the archaeologists called out that he had found something. It appeared to be a basket that contained several items, but as it was impossible to see clearly in the cave because of the poor light, Yadin decided to carry it to the entrance and place it on the ground. We all sat around him expectantly.

He slid his hand carefully into the opening of the basket, and, as his fingers came into contact with something, he said, "I think these may be skulls." He then proceeded to open the basket and found that the objects that he had touched were in fact copper vessels in very good condition. They each had some kind of decoration on the surface, which appeared to be human figures, but the faces on all of them had been scratched over in an evident attempt to erase them. This apparently was an indication that the items had been stolen from the Romans, presumably by Jews of the Bar Kochba revolt who were hiding in the caves and who must have made periodic forays down into the Roman encampment. The defacing of the imagery would have been in keeping with the Jewish law that one should not make or possess "graven images."

Bar Kochba was a Jewish warrior and leader who led a ferocious army of more than two hundred thousand fighters in a rebellion against

the occupying Roman forces in the year 132 CE. It has been said that he tested the resolve of his potential troops by getting them all to bite or cut off one of their own fingers to demonstrate their courage, determination, and suitability to join his ranks. He was regarded as the Messiah by the famous Rabbi Akiva and also by many of the population, but most of the rabbis regarded him as a radical threat to the Jewish people.

We camped in tents for eight nights on the plateau above the caves. One night, we woke up to find about ten yellow scorpions in our tents. This species is highly dangerous. A sting can be lethal if not treated immediately, so needless to say we hurriedly evacuated our tents and spent the rest of the night sleeping on the truck, hopefully out of harm's way.

43. Teddy Kollek, then Israel's minister
of tourism, asleep in a helicopter next to
archaeological finds from the Bar Kochba
caves, 1960.

The honor of carrying the precious archaeological hoard contained
in the basket was given to Teddy Kollek, who later became the re-
nowned mayor of Jerusalem but was then the director-general of the
Ministry of Tourism. Teddy was well known for his habit of falling
asleep at the slightest opportunity. One of my very favorite pictures is
that which I took of him fast asleep in the helicopter, next to these un- 43
believable finds.

The other objects that the basket contained were items of everyday
and ritual use, all of which are now exhibited in the Shrine of the Book
at the Israel Museum. It is fascinating to see these objects on display,
dating back almost two thousand years, but this is nothing in compari-
son with the excitement we experienced at being present when they
were actually unearthed. It was a feeling I shall never forget—a tangible
link revealing the hidden history of our people.

This expedition was by no means the only time that I went on as-
signment by helicopter. Later, in April 1967, shortly before the Six Day
War, the managing editor of *Life*, Henry Moscow, was on a visit to Israel.
We were invited to see a very unusual house constructed on a hillside
in Ramat Gan, a suburb of Tel Aviv. This particular house was of great
interest, having been designed and built by the architect Zvi Hecker in
association with his mentors (and later partners) Alfred Neumann and
Elder Sharon. The building's overall design was founded on geometric
principles. All the stories were staggered, allowing for open terraces
and panoramic views, and an inner courtyard was also a main feature.
The house was called the Dubiner House after the well-known Israeli
industrialist Sam Dubiner, who financed the venture. Zvi Hecker lived
in this house while he designed and constructed a further extraordinary
building opposite, called the Spiral House, which was based on similar
principles. He achieved world recognition for both of these highly inno-
vative constructions.

Moscow became fascinated by this unusual building and asked me
to do an extensive story for *Life* featuring the house. I took many pic-
tures of both the interior and the exterior but, being something of a
perfectionist, decided that, in order to do the assignment justice, I just
had to get an aerial view.

Nothing would deter me from this crazy idea, even though at that
time I had absolutely no idea where on earth I might find a helicopter.

44. Jerry Renoff's Colibri helicopter, 1967.

Eventually, after making extensive enquiries, I discovered Jerry Renoff, an American who had served in the Israeli War of Independence as a volunteer pilot and now ran a small aviation company. He assured me that he had just what I needed. It was called a Colibri—after the small hummingbird identifiable by the fact that it hovers. He took me to see the flying machine. On first sight, I began to question the advisability of taking off in this contraption.

44

It comprised two seats with a rotor fixed above them. There was no motor, but it worked on the principle of a ram jet; that is to say, at each end of the rotor there was a kerosene burner that, when ignited, caused the rotor to turn. The burners were supposed to be ignited by an electric charge, but, for whatever reason, this simply would not work. Not to be deterred, the pilot took out a box of matches and hopped out of his seat to light each burner in turn. He then stepped back into his seat next to me, and we took off. The Colibri was only capable of staying up for about ten minutes, which, to tell the truth, was quite enough for me. I had decided that we should fly early in the morning as the light was so good at that hour, but I had not taken into account the unbelievable noise that this machine produced. I think we must have woken up everyone for miles around, and I remember seeing angry faces at windows and residents on rooftops shaking fists at us. I got the picture I wanted, but at the cost of disturbing the sleep of rather a lot of people. In spite of promising myself never to repeat this experience, I again used the Colibri, complete with box of matches, when I flew over the newly opened Shrine of the Book in Jerusalem. Once again, my use of this appliance caused a similar disturbance, but this time to the residents of Rehavia. Nowadays I travel the world a lot by air, and I always smile when I see signs at the airport or hear announcements in the

45

45. Aerial photograph of architect Zvi Hecker's Dubiner House, taken from Jerry Renoff's Colibri helicopter, 1967.

plane saying that "smoking in or around the aircraft is strictly prohibited." Without the "smoke" for the Colibri, we simply would not have been able to leave the ground.

Another amusing incident occurred years later, when I was in a helicopter during the Lebanon War together with all the big shots from *Time* magazine, including the managing editor, Ray Cave. We were flying in total fog in the mountain regions of Lebanon. I was feeling really nervous about the appalling weather conditions, but thankfully our guests from abroad were blissfully ignorant as to what was happening,

for they did not understand a word of Hebrew. If they had, they would
have heard one pilot say to another, "My God, this is awful, I wish they
had given us more training in blind flying!"

Thankfully my flying experiences were not all so hazardous. It was
during the Lebanon War that I was traveling first-class to New York for
Time with their correspondent David Halevy. This was one of the flights
taking Prime Minister Menachem Begin to Washington to visit the
president of the United States. We were being served an elegant dinner
on board. I turned to him and said, "You know, Dudu, this is not at all
like yesterday's meal!" The stewardess overheard me and immediately
started to apologize, explaining that it was really difficult for the crew
to provide the same standards of food and service in the air as we might
expect from a five-star hotel on the ground.

She overheard but misunderstood! At the meal of the day before to
which I referred, we had found ourselves sheltering under a truck near
Beirut eating baked beans out of a tin with a spoon.

It has always been a great source of satisfaction to me to have had
the opportunity to work as a journalist, for every day has always been
different, and I literally have never known what tomorrow might
bring—a life full of contrasts, from baked beans one day to champagne
and caviar the next!

I was fortunate enough to travel with Begin on quite a number of
flights abroad when he was prime minister, and it was on one particu-
lar flight to Washington that I was privileged to witness him as the con-
cerned husband as distinct from the busy politician. On all the flights
on which I accompanied Begin, *Time* made certain that I would have a
seat as near as possible to him. I was conscious of the fact that he felt a
little uncomfortable about my presence with a camera. If he fell asleep,
as everyone does on a plane, he would wake up suddenly and shoot a
glance in my direction as if to say, "I hope you haven't taken my picture
while I was snoring!" He was evidently concerned that I would photo-
graph him looking less than ministerial. I spoke to his wife, Aliza, and
told her, "Please tell your husband not to worry. I am not a paparazzo. I
am not on this flight to shoot him in any embarrassing situation. I do
not do that kind of picture." I kept my word until one particular day
when we were about to land in New York after an eleven-hour flight. I
noticed Aliza trying to get back into her shoes, but she was having diffi-

culty as her feet had swollen during the journey. Begin bent down and
carefully helped her to put them on—a Cinderella-type shot no photog- 46
rapher worth his salt could afford to miss. I jumped up with my camera
and managed to take two shots. He looked up at me with a pained ex-
pression, as if I had stabbed him in the back, and his wife reprimanded
me with the comment, "David, you promised that you would not take
this kind of picture!"

On landing in New York, I met my editor at the airport and told him about the shot. He was very enthusiastic and said that it would be great for the People section. Torn between the desire to see the photo published and considerations of the future, I replied that we should forgo using it on this occasion, as I had to work with Begin and would hate to spoil my relationship with him for the sake of one picture. Reluctantly, he agreed. Next morning over breakfast at Blair House in Washington, the venue where the White House accommodated influential guests, Begin's daughter, who had traveled on the same flight, came up to me. "Mother told me about the picture you took of father helping her with her shoe. It sounds wonderful. My father is naive; he does not understand anything about public relations. I think you should publish it, as it will show a very tender and human aspect of his personality." By then it was too late, and it was only many years later that the picture saw the light of day. My philosophy of taking pictures has always been that I try to respect my subject's privacy. I can pride myself that I have never had to resort to the type of unkind or sensationalist photographs of celebrities that one sees far too often these days.

18. PAPAL VISITS

Probably one of the most elaborately planned assignments I have ever taken part in, and one which relied heavily on air travel, was the visit of Pope Paul VI to Israel and Jordan in January 1964. This was a joint exercise by both *Time* and *Life* and was hugely complex because of security and logistics. There was a large team of us with some fourteen photographers prepared to follow the story of his visit, and we had to try to cover all aspects of it. It was not practical or possible to follow his retinue everywhere, since we needed to be in place when he arrived at a destination. To achieve this, we hired two planes and made plans to leapfrog from place to place in two teams. While one team was working in the first location, the second went in advance of the Pope to the next place in order to be there when he arrived. It was like a military operation.

The Pope's itinerary was arduous, complicated by the fact that he was traveling between Jordan and Israel across a hostile border. He arrived in Israel at Megiddo in the north, where he was welcomed by Israeli President Zalman Shazar and Prime Minister Levi Eshkol. From here he went to Tiberias on the Sea of Galilee—a very meaningful place for Christianity. I was part of the group waiting for him at the Sea of Galilee. As he stood on a rock overlooking the sea and blessed the waters, I waded into the water to get a good shot.

When he reached Jerusalem, there was a terrible hassle at the border. The entire press corps was trying to cover his crossing from Israel to Jordanian-held Jerusalem. There were hordes of photographers and journalists from all over the world attempting to cross at the Mandelbaum Gate. It was unbelievably chaotic, with a lot of pushing and shoving for positions, and not too easy to get a good picture of him because of the crowds.

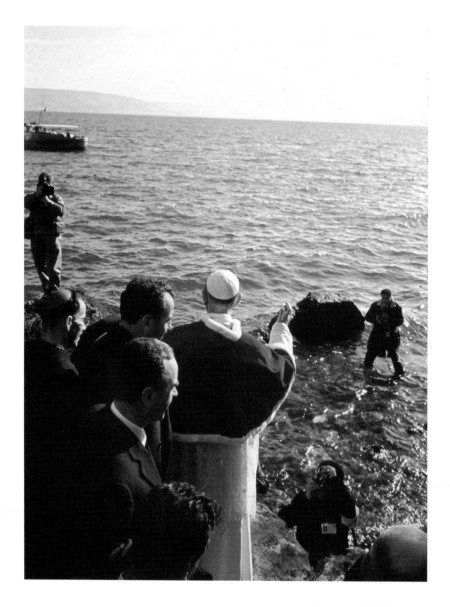

47. Pope Paul VI blesses the waters of the Sea of Galilee, January 1964.

I had occasion to cover two more events involving papal visits, both with a later Pope, John Paul II. The first was in April 1986 and took place in Rome. It was a highly significant occasion, as it was the first time in almost two thousand years that a Pope had set foot in a synagogue. It was extraordinarily moving. The Chief Rabbi of Rome, Eliahu Toaf, dressed in his *tallit* (prayer shawl), welcomed the Pope as they greeted each other in front of the Ark (the place where the holy Torah scrolls are kept in a synagogue). It was extremely affecting to see the Pope, wearing a white yarmulke, as he and the rabbi embraced in a gesture of reconciliation. Three of the elders of the Jewish community were given the honor of standing in front of the Ark, resplendent in their prayer

48

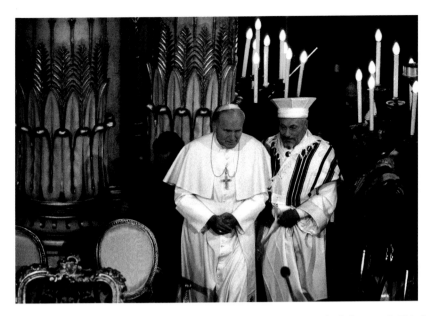

48. Pope John Paul II and Eliahu Toaf, Chief Rabbi of Rome, during the first papal visit to a Jewish synagogue. Rome, April 1986.

shawls. I was told that their role was seen as symbolically protecting Judaism's holiest scriptures from this omnipotent Christian presence. Polish-born Pope John Paul II had frequently demonstrated his willingness to address the issue of the Christian Church's almost total passivity during the Holocaust, and this event was another building block in cementing more positive relations between the two religions. This solemn ceremony was watched by a synagogue filled with local dignitaries, both Jews and Christians, all of whom, I am sure, felt the historical significance of the occasion.

In March 2000, Pope John Paul II came on his first trip to Jerusalem, an event more noteworthy for me professionally than in any other way. He visited the Western Wall in Jerusalem, where security was very tight and the whole area was cordoned off. It became evident that if I were to be able to get my pictures off quickly to New York, I would have to find some expeditious method to get over to my laboratory as rapidly as possible to process the film. I managed to resolve the problem, as fortunately I spotted Shlomo Ben-Ami, the cabinet minister in charge of the police, whom I knew personally. I explained my predicament, and his immediate response was to offer me a lift in his car and, in addition, to provide a police motorcycle escort to speed me on my way. We left with sirens blaring. The omens looked promising. I rushed into the lab, processed the film, and wired my pictures off to New York. All my efforts, however, turned out to be futile.

Sadly for me, it turned out that one of the other photographers at the event had gone digital! He had this amazing "new technology," a digital camera and a laptop, and so was able to transmit his pictures

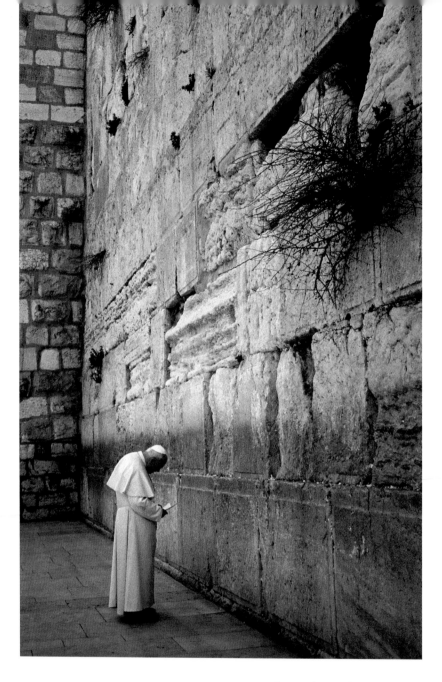

49. Pope John Paul II visits the Western Wall, March 2000.

instantaneously from the site. I was told later by New York that my pictures came in only fifteen minutes late! The magazine could not stay open any longer, as it was a Sunday and the very last moment for them to close the pages of that week's issue. This meant that every extra minute cost money. I was beaten not only by the clock but also by the advance of science.

19. TEDDY KOLLEK

Perhaps one of the most charismatic characters I have ever met and known well over the years is Teddy Kollek—primarily noted for being the dynamic mayor of Jerusalem. Teddy hailed from Vienna as I did, was active in the pioneering movement, and came to Israel five years before my arrival. He was one of the founding members of Kibbutz Ein Gev on the Sea of Galilee.

In his early years, he was involved in helping to rescue Jewish youth from Europe and worked as a representative of the Haganah in Washington, assisting in collecting essential ammunition for the fledgling army of the state-to-be. He worked closely with Ben-Gurion, heading the prime minister's office for several years, and was director of the Israel Tourist Office and founder and director of the Israel Museum.

He was elected mayor of Jerusalem in 1965 and held office for the next twenty-eight years. I had always felt a sort of personal involvement with this, as some time before his election I was sitting in my home with a group of people including Avraham Avichai, who was then working closely with Prime Minister Levi Eshkol. During the course of conversation, someone made the suggestion, "Don't you think Teddy Kollek would make a wonderful mayor?" I am not sure if this evening was in any way instrumental in sowing the seeds of his future career, but all of us there like to think that we had some part in it!

The impact that Teddy had on the city of Jerusalem is legendary. His life was dedicated to developing Jerusalem not only as a geographically and municipally united city, but as a socially unified one as well. Much of his time went towards bridging gaps between the varied ethnic and religious populations. I remember that, at one time during elections, some Arab taxis displayed posters written in Arabic in support of Kollek. Arabs voted for him in large numbers, but sadly none of them

50. Teddy Kollek, legendary mayor of
Jerusalem, campaigns for himself, 1978.

would ever stand for election to the municipal council, as Teddy would have liked, presumably because they were afraid of repercussions from the PLO on their own side. They were happy to support him anonymously but could not risk standing up and declaring their support in public.

He arose every day at 6 a.m. and was frequently to be seen walking the streets long before anyone else started work, to find out for himself what was going on in his city. I have many pictures of him shopping in Arab shops, chatting to people, and electioneering.

One day a group of yekkes were demonstrating against some policy or other of the municipality. They were members of the old self-appointed aristocracy, mostly of German Jewish descent, and living in Rehavia, a high-class area. They had gathered outside his office and stood on the lawn. Teddy came downstairs to hear their complaint, but the first thing he said was "Will you please all get off the lawn," to which one of the men present said to him, "If you treat us like this, we shall not vote for you again." Teddy's instant riposte was "You can kiss my ass, and don't vote for me, but still get off the lawn!" A news radio reporter was present and recorded this exchange, which was aired that same evening. This altercation made the residents of Jerusalem admire and support him all the more.

Teddy was seen everywhere and was loved by everyone who met him. I had occasion to follow him around for a while for a story and saw for myself how everyone warmed to him. I had a huge admiration for this very special man, with his integrity, his endless energy, his enthusiasm, and his seemingly crazy ideas. He also traveled abroad endlessly and tirelessly to enlist support for his plans for Jerusalem.

He had the ability to charm everyone he met and the knack of finding an infinite supply of wealthy overseas benefactors who fell under his spell and found themselves paying for a wide range of projects in the Holy City. He started the Jerusalem Foundation, which initiated most of the major projects in the city and was established to assist in and support the relief of poverty, sickness, and distress in Jerusalem, without regard to race, creed, or color. Over the years, it has achieved impressive results. He also had the ability to persuade internationally respected musicians, politicians, and academics to become actively involved in its institutions. Isaac Stern, the renowned violinist, chaired

51. Marc Chagall making sketches
for his mosaics at the Knesset, 1965.

the Jerusalem Music Center. One day, Teddy arranged a surprise sixti-eth birthday party for him at Mishkenot Sha'ananim. Isaac was evi-dently thrilled with his surprise "treat," and it was very touching to see how much like a small child he was in his obvious enjoyment of the fuss that was being made of him.

Teddy had countless opportunities to move into national politics and possibly even become prime minister. He chose instead to focus all his energies on his beloved Jerusalem rather than chase after power in the wider arena. What he did for the city is quite remarkable, and he has gone down in the history of the country as being one of the most outstanding personalities to emerge during the last century. Jerusalemites have a great deal to thank him for. The main football/sports stadium in the city is now called the Teddy Stadium in his honor.

It was Teddy who persuaded Marc Chagall to come to Jerusalem to work on the tapestries for the Knesset building and design the mosaics that decorate its floors. I followed Chagall around as he did his pre-liminary drawings. He lay stretched out on the floor sketching designs furiously on paper, and I also photographed him when he installed the twelve stained-glass windows he had designed for the Hadassah Hospital

51

52. Marc Chagall and Golda Meir
at the unveiling of the artist's
tapestries at the Knesset, 1969.

synagogue. Each window was dedicated to a different tribe of Israel. I felt very much in the presence of a creative genius, not just because he was famous, but because of the way he demonstrated a total dedication to the work in hand.

At the official opening of his installation in the Knesset, when the tapestries were eventually unveiled, everyone had their eyes fixed on the walls. I was kneeling in front of Chagall and Golda Meir, pointing my camera in the direction of the tapestries. Suddenly, a thought came to me that I could always come another day to take pictures of the art-work, but now was an opportunity to do something different. So instead I turned around and took a close-up picture of Chagall at the crucial moment when he leaned over and took hold of Golda's elbow just as the covers were removed from his tapestries. I overheard him say to her in Yiddish, "Nu se gefaelte dir, Goldie?" (Well, do you like it, Golda?). I saw her gasp as the work was uncovered, and I think she was overwhelmed. He smiled at her with evident satisfaction.

52

20. THE SIX DAY WAR AND AFTER

After the Sinai campaign of 1956 followed eleven years that were mainly punctuated by border skirmishes, with people being killed by sniper fire and villages near the Syrian border under constant shelling. The Egyptians under President Gamal Nasser and the Syrians had, during this period, been heavily armed by the USSR, and they began to feel that they now had enough resources to overcome Israel. Nasser threatened to block the Straits of Tiran, the effect of which would have been to bar shipping to and from Eilat. He also persuaded a reluctant King Hussein of Jordan to enter into an alliance with them. Israel was therefore surrounded on three sides by enemies intent on its destruction. Once again we could feel the situation leading inexorably toward war.

I was spending a lot of time in the valley below the Golan Heights. The Syrians controlled the plateau high above, and consequently the kibbutzim below were being harassed and endangered on a daily basis by shelling. Tractors had to be armor-plated to enable them to work in the fields. The UN put up observation posts, where on one occasion I stayed to cover a story. It felt very strange being there, as we were way out in front of the Israeli positions in what was effectively no-man's-land.

The country at that time was in a state of economic depression. There was a great deal of unemployment, and many of the stories that I covered related to poverty and its effects on people's lives. It was after Independence Day in May 1967, when Nasser started amassing his forces in the Sinai, that fear began to escalate among the Israeli population. It was also very discouraging that Prime Minister Eshkol was stammering nervously while making one of his radio broadcasts. This certainly did nothing to inspire confidence in an already anxious nation.

Most people were quite sure the country was doomed. Macabre jokes abounded. "Will the last one leaving Lod Airport please turn off the lights"; "See you all at 6 a.m. tomorrow after the war. Let's meet in a phone booth"; and so on. It was at this same time when there was such a sense of foreboding that provisional plans were made to use the Ramat Gan sports stadium as a cemetery in the event of war. It was estimated that it could accommodate up to forty thousand bodies—and this was only for the estimated dead in the Tel Aviv area. Not a happy thought.

Everything that was happening around us contributed to this feeling of impending disaster. Our spirits were lifted somewhat when, under

53. Moshe Dayan (left) and his father
Shmuel, 1957.

public pressure, Prime Minister Eshkol appointed General Moshe *53*
Dayan as minister of defense. Dayan had for years been regarded as our
national hero because of his exploits when he was chief of staff of the
Israel Defense Forces.

The eventual outcome, fortunately, defied almost everyone's expec-
tations. The war was won in six days, hence its later title, the Six Day
War. A brilliant preemptive strike by the Israeli Air Force destroyed 300
of the 385 Egyptian planes while they were still on the ground. Three
hundred and fifty of their combat pilots were killed in this assault, and
their airfields were rendered unusable. This decisive attack occurred
when most of the Egyptian fighter pilots were still having their break-
fast and were totally unprepared. Attacks on Syrian, Jordanian, and
Iraqi airfields produced similar results.

During the three weeks before the war broke out, commonly called
the "Waiting Period," Israel concentrated its forces in the Negev, and I
stayed with them throughout this time. On the day the war actually
started, I was in an armored car that was part of the advance combat
headquarters of General Israel Tal's division. This division proceeded to
battle its way south past Rafiah and El Arish on its way to the Suez
Canal, which was eventually reached on the fourth day of the war.

It was on the third day of the war, while we were camped not far from
El Arish, that I heard rumors of action taking place in Jerusalem. My
professional instinct compelled me to get back to Jerusalem as quickly
as possible in order to see what was happening. I spotted a helicopter
loading wounded soldiers who were to be flown back to a hospital in
Beersheva. Without asking anyone, I rushed over, boarded the helicop-
ter, squeezed myself in between the wounded, and took off with them.

We landed at Beersheva, where I had left my car. I jumped in and
started driving back towards Jerusalem at 3 a.m., picking up a soldier on
the way who needed a lift. I was so unbelievably exhausted that I actu-
ally asked him to take the wheel. I cannot remember another occasion
when I have ever done this! We eventually arrived in Jerusalem at about
6 a.m.

The first thing I did was to hurry back to check that everything was
all right with my family. My wife, son, and mother-in-law were all safe
and well at home, and by that time my daughter was serving in the
army somewhere in Jerusalem.

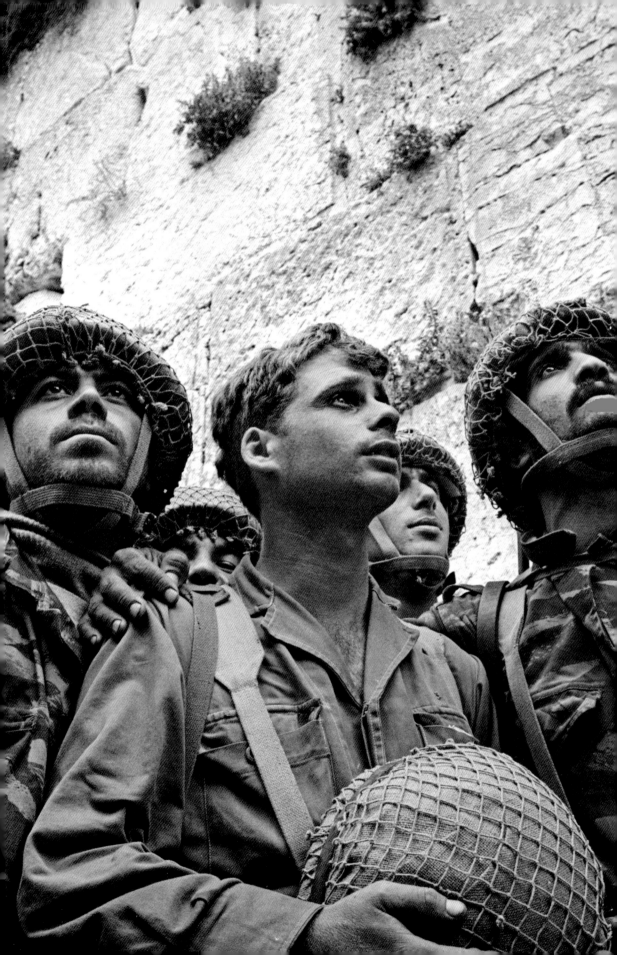

54. Three paratroopers minutes after
taking the Western Wall on June 7, 1967.
My signature image.

Jordan had now made the fatal mistake of joining in the war. They had signed a treaty with Egypt prior to its commencement, but had not until now become actively involved. Apparently King Hussein was persuaded to take part in the attack by President Nasser, who lied to the king about Egypt's outstanding military successes in the south. The Israeli government had in turn urged Hussein on repeated occasions not to become engaged in the war, advice that he foolishly ignored to his ultimate cost.

The Jordanian forces therefore began fighting both in the West Bank and Jerusalem, areas which had been controlled by them since the War of Independence in 1948. I made my way on foot as quickly as possible to the Old City. I arrived there just in time to get to the Western Wall, or, as it was previously called, the Wailing Wall, a mere fifteen minutes after an Israeli paratrooper battalion had liberated it.

The area between the Western Wall and the houses that were then standing near it could not have been more than ten or twelve feet across. To get the most effective shot in such a narrow space, it was necessary for me to lie down on the ground and shoot skywards so that I could capture in my lens both the victorious Israeli paratroopers and as much of the Wall as possible. I also took what I thought was a great picture of Chief Rabbi Goren blowing the shofar while being held aloft on the shoulders of some of the troops.

The scene around me was extremely emotional. You have to remember that this miraculous success followed three weeks of overwhelming gloom and despondency. People were crying with joy and relief, and I have to admit that, as I shot my pictures, tears were rolling down my cheeks too. My son Ami remembers this day very well because apparently when I arrived back home I was weeping like a baby. I cannot recall this, but obviously for him, as a teenager, it was something that he could not forget as he had never before seen me crying. I do not know whether the heightened emotions of that day caused the photograph of the three paratroopers to became so famous, but it was this picture that subsequently became something of an icon in Israel and was without doubt my best-known image—my signature, as I like to call it. 54

I rushed home to develop the film. I showed Anni the prints and asked her opinion as to which she considered the best, to which she replied that absolutely it was the one with the three soldiers, in her

view much more effective than the one of Rabbi Goren. I was so filled with euphoria about our victory and bursting with pride for Israel's Defense Forces that, in a moment of generosity, I cut off one of the negatives and presented it to the army spokesman, giving little thought to the implications of my actions. What happened next was that he wasted no time in handing the negative over to the Government Press Office, which in turn made prints and started distributing them to all and sundry for a dollar apiece.

This proved to be a double-edged sword as far as I was concerned. The takers for this photograph were numerous—several news agencies and even other photographers, some of whom actually had the nerve to put their own name to the image. The height of this brazen chutzpah was when a well-known Israeli tobacco company used the picture in one of their advertisements, which was shown on the front page of the *Jerusalem Post* to promote cigarettes. The accompanying text read, "Real men smoke Dubek." This was doubly outrageous as none of the three soldiers in the picture are seen smoking. Since that day, I have struggled to protect my copyright and have pursued several court cases to this end, but to no avail. I have also had countless abortive arguments with the Government Press Office, which persists in distributing my image to this day.

The ultimate indignity was when a Supreme Court judge became involved in the matter, after a certain right-wing political party published a huge campaign poster featuring my picture.

Supreme Court Judge Cheshin, who was in charge of monitoring the election process, tried to pacify me in writing, stating, "This photograph has now become a national treasure." With all due respect to the judge, I find it difficult to accept this as a correct assessment of the situation. Did he mean that because this photograph was regarded in such a way, it was available for anyone to use as they thought fit? But then who am I to argue with a Supreme Court judge?

I have often been asked whether I consider this photograph of the three paratroopers at the Wall to be a great picture. My answer must quite definitely be no. What made it significant were the circumstances under which it was taken, and it was this that caused it to emerge as the symbol with which so many people identify. As so often occurs in art, people read into images what they want. Repeatedly I heard that

the image was referred to as the "Crying Paratroopers at the Western Wall." The simple fact is, not one of the people in the photograph was weeping, but if people choose to see it like that, then it is up to them.

The irony is that, had it not been so widely distributed, my reputation might not have spread internationally so rapidly. Instead the photo would probably have appeared on half a page in the next edition of *Time* and then disappeared into oblivion. I suppose I should thank the Government Press Office for giving such a boost to my career!

After the unforgettable victory in Jerusalem, and still only on the fifth day of the war, I rushed up to the Golan, where our troops, after a fierce battle, had gained control of the plateau—the Golan Heights. Months earlier, I had been working down in the valley looking upward. It was now quite extraordinary to stand on the Heights and see what sitting ducks we had been to the Syrians for so long. I drove through the deserted streets of Kuneitra, the major town on the Golan Heights, where the only moving creature I saw was a stray cat. Israeli troops had taken an abandoned Syrian jeep and hung it high up on an electric pole. This was, of course, a photograph that I could not resist. That same day, 59 the UN representatives started pouring in, and I was there to record their settling in and their coordination with our Israeli officers.

The complete success of the overall military campaign during the Six Day War was so miraculous in the eyes of Israelis that many people were convinced that it could not possibly be the result of human endeavor, but that it must be the hand of God. A new feeling of messianic Zionism was born that day.

On the first day after the Six Day War, I found myself sitting in a helicopter with Moshe Dayan, the minister of defense, and Yitzhak Rabin, the chief of staff, heading to Gaza for a meeting with the Arab leaders. Dayan sat gazing abstractedly into the far distance; Rabin, meanwhile, had his military cap pulled down over his eyes and appeared to be dozing. To this day, I refer to my picture of this scene as "Our Tired Heroes on the Seventh Day." 55

All of a sudden, however, Rabin snapped out of his reverie, grabbed my camera, and turned it to focus on me. Never without a backup camera myself, I returned the compliment. This resulted in a charming photograph of him looking at me through the viewfinder. It was only 56 many years later, after his death, that I learned he was quite an accom-

55. "Our Tired Heroes on the Seventh Day":
Yitzhak Rabin and Moshe Dayan en route to Gaza
for a meeting with Arab leaders on the first day
after the Six Day War.

56. Shortly after I took the preceding photograph, Rabin turned the tables on me.

plished photographer. Major General Jonah Efrat, who was Rabin's confidant and a close friend of mine, told me that when he and Rabin were on a secret mission in Africa, he had real difficulty in getting Rabin to stick to his arranged schedule, as he was so preoccupied with taking pictures!

The weeks following the victory were marked with jubilation throughout the country and particularly in Jerusalem. Tens of thousands of Israelis, both religious and secular, poured into the city from all over the country. They streamed into the Old City—a revered place that had been closed to them for nineteen long years. Their route took them first to the Western Wall. All the old houses that were in close proximity to the Wall had already been razed to the ground to open up a huge plaza immediately in front of it. Every day, the area was packed with people of all backgrounds and ages, coming to gaze upon the place that they had dreamed of and that was regarded as sacred for so many—some to pray and give thanks, others merely to look and take photographs.

Crowds also thronged the narrow alleyways of the *shuk* (market) in the Old City, looking in wonderment at the unusual sights and smelling the aroma of the spices and foodstuffs piled high on the market stalls. Business was thriving for the stallholders, with tourists buying up almost everything on display. It was not only the Jews, however, who were enthralled by the new sights and smells. Arabs too came in their thousands, but they came in the opposite direction—to see West Jerusalem, the city of their conquerors. At the Jaffa Gate, by the entrance to the Old City, you could see the Arabs coming in one direction out of the Old City and the Jews going in the other direction into it.

It was noticeable that some of the Arabs appeared apprehensive, with many of the men linking fingers, maybe to give themselves confidence (although it is not an uncommon sight to see Arab men walking

57. An Arab refugee crosses the bomb-damaged Allenby Bridge over the Jordan River, 1967.

along holding hands). They were at this stage unsure of what the future held for them under the new victors. They too gazed around, absorbing the sights of Jewish Jerusalem and its way of life, which for them was largely unknown. They had lived in close proximity to it, perhaps within a few hundred yards, yet culturally it could have been a million light-years away.

Outside the Damascus Gate, a makeshift office was set up with a row of tables at which Arabs could register to leave Israel for Jordan. Buses would then take them down to Jericho, from where they made 57, 58 their way on foot over the Allenby Bridge across the narrow river. The bridge had been badly damaged by bombs and was hanging precari-

58. A man crosses the
rebuilt Allenby Bridge, 1971.

ously into the water. I saw refugees, fully loaded with belongings, clambering perilously down one side of what remained of the bridge and up the other side. Hundreds of them were fleeing in fear of what might happen to them if they stayed.

Many of these refugees had come from Kalkilya, an Arab town located at the narrowest point of Israel, where it was only seven kilometers across. The town had been a constant threat to Israel, being so strategically placed, and therefore immediately after the war many of its houses were demolished. Moshe Dayan, however, soon halted this action in order to encourage the Arabs to return. He sent emissaries to the Allenby Bridge, where many of those fleeing turned around in midstream. Dayan then gave orders to rebuild the destroyed homes. The

59. A Syrian jeep hung from an electric pole by Israeli troops in the Golan Heights during the Six Day War.

optimistic hope at the time was that this would be the "war to end all wars" between the Arabs and the Jews and that both peoples could now live peacefully together.

At about the same time, I was in a command car with Rabin and Dayan on the way to Hebron listening to them discussing what name they should give to the war. Someone, I am not sure who, suggested calling it the War of Peace. If only that had been the outcome!

The Israeli army had collected vast quantities of captured weaponry and put it on show in many parts of the country. A festive atmosphere prevailed, with families bringing their children to picnic and see the armaments on display. It was a common sight to see both adults and children clambering over the Soviet-made tanks, guns, and cannons and all the other spoils of war. Small children were using the barrels of the large guns as slides—a much happier application for them. This was one of the stories published in *Life* magazine.

In the time that followed the extraordinary victory of the Six Day War, Israel began to feel that it was entirely invincible. At the Independence Day Parade in Jerusalem in the spring of 1968, the spoils of war were exhibited with pride. Hundreds of captured Egyptian, Syrian, and Jordanian tanks rolled through the streets of Jerusalem before cheering crowds. Planes flew over the Old City in a show of indomitable strength and courage.

Things also began to improve economically. It took only two weeks after the end of the war for trucks from the West Bank to begin traveling into Jordan with produce. Two-way traffic started immediately in spite of the fact that there were no bridges over the Jordan River, since these had been destroyed during the war. It was not unusual to see heavy trucks loaded with goods fording the Jordan at places where the water was very shallow. This trade was strongly encouraged by Moshe Dayan, who wanted life to return to normal as soon as possible.

Sadly, some three to four months later, in the autumn of 1967, the first terrorist act occurred in Jerusalem. A bomb had been placed in a disused hotel near the border with Jordan. There were no casualties, but it was a sign that things were beginning to become unsettled.

At around the same time, the first strike of Jerusalem's Arab businessmen took place. They closed their shops in protest against the Israeli authorities. The police decided to act promptly and painted a

black letter X on every shop that remained closed. Their optimism in hoping that this would deter the strikers seems, in retrospect, somewhat naive.

In September of the same year, I was invited on a very interesting trip with a commander of Shin Bet (Israel's security forces). He was a close friend of mine whom I had known for a long time. Yehuda Arbel had started off as the police spokesman in Jerusalem and had been promoted over the years until he was now the commander of security services for the whole of the West Bank and Jerusalem.

I accompanied him and his team on one of the very first raids against the Arab underground movements in the West Bank. We flew in helicopters to the village of Qaddum, where, according to information received from an informer, a terrorist cell had been created and was training its members for action against Israel. In order to track down the members of this cell, Shin Bet came up with a simple but ingenious idea. They told everyone in the village that they were in possession of a highly sophisticated machine that had the ability to identify anyone who was a member of the cell.

They brought a car into the village. Seated in this car, with a sack over his head, was the Arab informer. Everyone in the village was then instructed to walk past the car in single file. As they went by, the man pointed out to the security services those who were the suspects. The whole village were devastated that Shin Bet had such an amazing machine, and it never occurred to them that it was a simple ruse.

The Israelis then took one of these suspects, a teacher, up in the helicopter with us. We flew over the village, where they threatened to throw him out of the helicopter unless he talked. He not only talked but also offered to take us to where he and his friends had a hidden cache of arms. Accordingly, we landed near the village and approached an area where there were dry stone wall terraces. He walked up to one, removed a number of heavy stones, and revealed a hoard of mines, a machine gun, and other weapons hidden in the wall. It was a successful mission.

This incident was only one example of what were, in reality, the beginnings of resistance by the Arab population, some twenty-two years before the First Intifada officially started. At that time, any opposition was speedily overcome, as Shin Bet was all-powerful and the Arabs so

broken by their defeat. (The word *intifada* is Arabic, meaning literally "shaking off," which in this context meant to be set free from Israeli oppression.)

Another effect of the '67 war was that Israel now had control over the Sinai Peninsula. This was viewed with great excitement by many. Dayan said, "I prefer Sharm El Sheikh without peace to peace without Sharm El Sheikh." The finance minister, Pinchas Sapir, was reported as saying that he would rather give back the West Bank than the Sinai. Sharm was rapidly developed as a tourist center by the Israelis, as was Taba, a resort south of Eilat. Israelis went there in their thousands to view this land that had suddenly become accessible to them.

I myself visited the Sinai a number of times. One day in particular stands out in my memory. It was a few years after the Six Day War, and I was driving there with a colleague, David Halevy, and my wife. We were on a routine trip through the area looking for anything interesting to report. It was one of those days that started ominously. We had hardly left Tel Aviv and were perhaps only twenty miles on our way when an airplane that was crop spraying misjudged where the field ended and the road began and mistakenly sprayed our car. This caused us all to start coughing like mad, so much so that we had to stop the car. We continued our journey, and as we got into the Sinai an exploding shell burst only about fifty yards from our car. Apparently there was an artillery training ground nearby, and someone had missed their target and sent the missile in our direction. The second time in one day! Homespun philosophy states that bad things usually go in threes.

We continued driving through the desert until at one point we arrived at a crossroads. There had been no traffic whatsoever for miles, and here we were at a junction with nothing but desert for at least fifteen miles in each direction. I drove over the crossroads without stopping, when, to my astonishment, an Israeli policewoman popped up from behind a low bush and handed me a traffic ticket for traversing the crossroads without halting. It was so surreal it was funny rather than annoying.

It was some time later on this same trip that we came across an area where we found the sand littered with relics from the '67 war. We stopped to investigate. Scattered around I saw Egyptian helmets, pieces

60. The wind blew away the sand
covering the hand of this Egyptian
soldier, a casualty of the Six Day War
buried in the Sinai. 1972.

of uniforms, boots, and other remains of battle. It soon became apparent that this was an area where the Egyptians had buried some of their dead. They had been placed in very shallow graves where, over time, the wind had blown away much of the sand covering the bodies. The most dramatic and poignant sight I saw was a blackened hand jutting out from the sand, in a pose like that of a medieval saint, with one finger pointing towards heaven in what resembled a cautionary gesture. The dry air of the desert had preserved the blackened skin. I decided to take a picture of this and had to lie down very low on the sand beside it to get the image I wanted. This done, we chose to have our lunch and *60* found ourselves sitting only yards away from this corpse, eating our chicken sandwiches. At the time it did not really occur to us, but in retrospect this felt somewhat disrespectful. We left the hand and went on our way. I put it down to the fact that, sadly, dealing with so many wars at close quarters, one becomes immune to such sights—or perhaps it is a question of putting up a barrier as a self-defense so that these images do not disturb you excessively.

Another postwar source of excitement for Israel was that we were now in control of the Egyptian oil wells at Abu Rudeis. The whole question of where oil was located had for years been a sensitive one for Israelis. Why, after all, should the Arabs have all the oil on their land when none was to be found in Israel? This was the case until one day, in 1953, I received a phone call at 4 a.m. from a friend saying that he had heard a rumor on the grapevine that oil had been discovered in Heletz, an area not far from Ashdod in the south of Israel.

The excitement of receiving this information presented me with a dilemma. Should I stay in Jerusalem and rush to buy shares now that we had this "insider" knowledge, or should I immediately head for Heletz to take pictures? A compromise was reached. I asked Anni to get to the bank when they opened at 8 a.m. to buy shares, and I went off to see this new oil field for myself. When I arrived there, I was faced with a most amazing scene. All the workers were being showered with oil that burst out from a pipe and covered them from head to foot in "black gold." They were beaming with happiness, laughing and joking at their *61* good fortune, oblivious to the smelly black liquid in which they were being drenched. I found an old whisky bottle and filled it with oil. It still stands on a shelf in my study.

61. Striking oil in Heletz, 1955.

Our jubilation, however, was short-lived. Anni had succeeded in buying the shares, but it turned out that the oil wells were much less extensive than anticipated. For a while, they produced a modest amount that comprised a small percentage of Israel's domestic needs, maybe 10 percent. Today I am not sure if they even produce 1 percent of our requirements. By the time I came back to Jerusalem, the shares had dropped in value, and my first venture into the stock market was to lose two thousand Israeli pounds. I was not destined to make my fortune in this instance, and from this experience I learned a lesson and kept away from the stock market for years.

21. THE WAR OF ATTRITION

Attacks had been frequent along all three fronts—Egypt, Syria, and Jordan—since the June 1967 ceasefire, with terrorists infiltrating the Jordan Valley, leading to Israeli helicopter-borne search operations. It was only in March 1969 that Egypt launched full-scale attacks along the Suez Canal with the twin objectives of inflicting as many Israeli casualties as possible and testing Israel's ability and determination to hold onto its gains from the Six Day War. Their ultimate aim was to recapture the Sinai and return it to Egyptian sovereignty. The Egyptians began pounding Israeli positions along the Canal, and Israel retaliated by using its aircraft as flying artillery. For the first time, modern American-made fighters took part in Israel's military action. This was the direct result of a French arms embargo on the Middle East following the Six Day War, an embargo that, in practice, applied only to Israel. Russia had by now also stepped in. Egypt's airpower had been virtually destroyed by the Israelis during the Six Day War, so Russia began taking a positive role in Egypt's air defenses, replacing what had been destroyed and providing not only the latest equipment, such as surface-to-air missile batteries, but also thousands of Russian "advisers" who actively took part in the war.

My involvement in this war began some six months before the start of major hostilities. In January 1968, I went to Kantara, in the northern sector of the Suez Canal. There I photographed the exchange of prisoners of war from the Six Day War under the auspices of the Red Cross. Four thousand three hundred thirty-eight Egyptian soldiers and 899 Egyptian civilians had been taken captive by the Israeli forces, as well as some 1,500 soldiers and civilians from Syria and Jordan. In total, only fifteen Israeli servicemen had been captured, eleven of whom were naval commandos who had been taken in Egypt. I watched as Egyptian

62

boats displaying large Red Cross flags ferried the few Israeli prisoners over the Canal and then returned to the other side transporting huge numbers of Egyptian prisoners together with many coffins containing the remains of those Egyptian soldiers who had lost their lives in the conflict.

I was then allowed to witness the debriefing of the Israeli returnees. A navy psychologist questioned them about their ordeal to assess if they had suffered any mental strain. Thankfully, on the whole they appeared to have been relatively well treated during their imprisonment.

While I was in Kantara, there was a very heavy blinding sandstorm, and in Jerusalem at exactly the same time there was an unusually severe snowstorm. Anni had expected me to return the same night, but when I had not shown up for twenty-four hours or more, she became worried, and no one was able to give her any information as to my whereabouts. She decided to call our friend Yehuda Arbel. He had been police spokesman when he and I first met and was now head of Shin Bet in Jerusalem and the West Bank. With the right connections, he was immediately able to track me down and reassure her that I was fine. It is sometimes useful to have "friends in high places"—or, as we call it in Israel, *protexia*. Speaking of Shin Bet, it was something of a standing joke at the time that if anyone inquired as to the whereabouts of their "secret" headquarters, which happened to be located fifty yards from my home, people would direct them by saying that it was "near the

139 The War of Attrition

Rubingers." Conversely, if anyone wanted to find our house, they were told that "it was near Shin Bet." So much for national security!

The following year, I was again sent down to Kantara, this time accompanied by a correspondent from New York, to do a story for *Life* on the hostilities. They had escalated considerably, and it was very dangerous to be there, so much so that at one time I had to fix my camera onto the end of a broomstick, which I would hold up high and attempt to take pictures this way, rather than risking my head being seen over the top of one of the fortifications. It was also during this visit that I saw a young soldier who had just been shot in the hand. He was making a huge fuss and shouting for everyone to come to his aid, in particular his mother. It became apparent to me, having seen many casualties in many wars, that those who make the most noise are invariably those with minor wounds. Sadly, those who are really badly hurt tend to remain very quiet and often do not survive.

Israel's physical defenses along the Suez Canal constituted the Bar-Lev Line, named after its architect, Haim Bar-Lev, who was the chief of staff at the time. It was supposedly the longest and strongest forward defense line in the history of Middle Eastern warfare. It consisted of earthen ramparts and a series of concrete observation posts every ten to twelve kilometers along the Canal, with extra fortifications at the more likely crossing points. The line was divided into twenty strongholds and was considered impenetrable. As part of the defenses, the railway line that ran through the Sinai to Kantara was dismantled, and the steel rails were used as supports for the roofs of the dugouts to protect them against artillery fire.

It was Moshe Dayan who advocated a "waiting game" as his war strategy. He stated, "We are ready to wait for the enemy's phone call for a hundred years"—the implication being that Israel was in no rush to take unilateral action against its enemies, but would prefer to settle for being so well entrenched that it could weather any storm. This policy was heavily criticized by Ariel Sharon, who at the time was the general in charge of the Southern Command. He strongly opposed Dayan's strategy, saying that he did not want Israel to be "sitting ducks." Further, acting like "moles" and hiding in the ground was very much against the spirit of the Israel Defense Forces, which had always advocated an aggressive approach, this being the most effective way for a

62. An Israeli position opposite the town of Kantara on the Suez Canal, 1968.

63. A Palestinian girl near the ruins of her house, bulldozed by Israeli security forces, who suspected that it harbored terrorists. Halhoul, West Bank, 1969.

small force to beat a larger one. Sharon had always believed in seizing the initiative and carrying the war into enemy territory, rather than allowing the war come over to one's own side.

In retrospect, one might feel that Sharon was right. This war was a canker in the body of Israel that seemed incurable and never-ending, and, worse, resulted in an unacceptably high loss of life and injury. In all, 367 Israeli soldiers were killed and over 3,000 wounded.

As for the invincibility of the Bar-Lev Line, this was disproved during the Yom Kippur War, when the Egyptians easily overran it, thanks to a combination of the element of surprise and overwhelming material superiority. The Egyptians used dredging pumps and high-pressure hoses. These powerful jets of water created eighty-one breaches in the Israeli line. They removed three million cubic meters of packed dirt from the ramparts on just the first day of the war and captured all the fortresses along the line, except one.

Although the main thrust of the War of Attrition came from the Egyptians in the south, there were also incursions and attacks emanating from Syria, Lebanon, and Jordan. In addition, the first signs of Palestinian resistance became evident only a few months after the Six Day War. The Fedayeen continued to infiltrate at regular intervals from Jordan and succeeded in claiming the lives of a number of soldiers, but the first major bomb attack took place in Jerusalem in November 1968, when a car loaded with explosives blew up in Mahane Yehuda, the Jewish market. Following this, a booby-trapped refrigerator exploded in the heart of the city, on Zion Square, and a bomb blasted the main supermarket on Agron Street. In this particular incident at the supermarket, I was taught a salutary lesson. I had rushed to the scene of the explosion and tried to enter to take pictures. A policeman at the gate stubbornly refused to let me in, despite my shouting, "Press! Press!" Exasperated, I finally shouted back at him and called him "Chamor" (donkey). I was overheard by a senior-ranking police officer who had known me for years. He approached me and in a very quiet voice said, "You are absolutely right; this guy really is an ass. What we need in the force are people of much higher intelligence, like you, for example. May I suggest that you enlist and join the ranks of the police?" I learned my lesson, controlled my temper, and have never since insulted a policeman. It

64. Another image of the effects of
conflict on children: the aftermath of a
Syrian mortar attack on Kibbutz
Gadot, Jordan Valley, 1967.

is all too easy to forget the difficult job that they have to do on a daily
basis, especially in times of war.

What I did find out over the years is that there are better and easier
ways of gaining access to restricted areas than losing one's temper and
being aggressive. On another occasion, I was prevented, again by a po-
liceman, from entering a particular event. One of the other officers who
was present knew me, and whispered in his ear, "Rubinger is the
Hapoel football team photographer." I was admitted immediately. So
much for fame and reputation! What I could not achieve through my
association with *Time-Life*, I achieved through the celebrity of being in-
volved in everyone's favorite pastime, football. Evidently this is where
today's really important status and prestige come from!

The three bomb attacks in the very heartland of Israeli civilian life
were a huge shock to the population, and, in addition, life in other
areas of Israel was seriously affected by the intermittent incursions of
the Arabs. Children in the kibbutzim in the Jordan Valley were forced
to sleep in underground shelters for months on end. I remember a par-
ticularly pathetic scene at Kibbutz Maoz Haim, where a group of weep-
ing children held a funeral service for their pet dog that had been killed
by shrapnel. Sometimes it is these small, human incidents that remain
in one's memory far longer than the more obvious experiences of war.
For many agricultural workers, daily life became a trial, as they were at
constant risk of being fired on, and it became necessary for them to be
accompanied by armed guards—just as they had been before the cre-
ation of the State of Israel.

Then as now, Israel's leaders were convinced that with enough
force these incidents could be dealt with and any opposition crushed.
There was still an atmosphere of intoxication arising from the swift
and overwhelming victory of June 1967, so, in an attempt to quiet the
enemy, the army launched a major attack across the River Jordan into
the Hashemite Kingdom opposite the town of Karame. This ill-advised
incursion proved costly. The Israeli forces encountered formidable op-
position from the Jordanian Legion fighting on their home ground, suf-
fered losses of both men and armored equipment, and saw the
unheard-of spectacle of our soldiers being taken prisoner. It was a trau-
matic sight to see the bodies of our boys and Israeli POWs returning
defeated over the Allenby Bridge.

Many methods were used to try to deal with the frequent infiltration across the Jordan border. Automatic-fire traps were set up to kill anyone crossing the line. These were machine guns, arranged in a circle, that would start firing as soon as anyone set off a trip wire on entering the trap. Nicknamed "sprinklers," they proved quite effective, and one day in April 1968 I had occasion to photograph the bodies of twenty-one Palestinian raiders who had the misfortune to be entrapped by one of these devices.

Punitive measures against Palestinian villagers who had harbored infiltrators were also meant to act as a disincentive. The blowing up of their homes came to be one of the most common penalties, a policy originally established by the British during the Mandate period. This punishment was intended to be a psychological deterrent. Perhaps in the early days it did have this effect, but certainly not later, when it created a breeding ground of resentment. A scene that stays engraved in my mind was a picture I took on a hill outside the village of Qaddum. The entire population, men, women, and children, were evacuated, for their own safety, to a hill overlooking the village, from where they could witness the scene. My image shows a large group of Arabs sitting dejectedly on the ground, staring at a large plume of black smoke rising from the center of their village. In the foreground stands a little girl, fear distorting her young face as she clasps her hands over her ears to lessen the roar of the explosion as it reaches the hilltop.

I sent the pictures I took to *Time* magazine. After use, the usual procedure was for them to be returned to me by their being placed in my personal tray at the Government Press Office. When I went to retrieve them, they were all there with the exception of the roll containing the picture of the little girl. I have no proof, but I strongly suspect that this roll was removed by someone from the security services, who evidently could not entertain the free circulation of this kind of material in the international media. So much for the freedom of the press!

63

22. THE YOM KIPPUR WAR

Yom Kippur 1973 was a rude awakening for the State of Israel. At about 6 a.m. on October 6, I got a phone call from a colleague in Herzlia to say that he had seen Major General Jonah Efrat driving in his car at dawn on Yom Kippur. He telephoned me as he knew that I was a close friend of the general. To understand the implications of this incident, you have to appreciate that Yom Kippur is the holiest day of the year for Jews. It is a fast day and a time for repentance and reflection. Everyone, even nonreligious secular Jews, tries to preserve the sanctity of the day out of respect for others, and scarcely anyone is seen driving on the roads. Only emergency vehicles such as ambulances and police cars are on the streets, and then infrequently.

On hearing about General Efrat, and especially with my journalistic nose for news, I immediately knew that something must be up. My gut reaction was right. Only a couple of hours later, more and more cars were being seen on the streets. Then my son received an emergency call-up order from his army unit, and my sixth sense was proven to be correct. Everyone, but everyone, was being called up for active duty on this, the most sacred day in the calendar. It was very serious. Egypt and Syria had launched a joint surprise attack in the Sinai and the Golan Heights, respectively, both of which were areas that had been captured by Israel during the Six Day War, six years earlier. The Egyptians and the Syrians advanced during the first twenty-four to forty-eight hours of the war, after which the momentum swung in Israel's favor. By the second week of the war, the Syrians had been pushed entirely out of the Golan Heights. In the Sinai, the Israelis had struck at the "hinge" between two invading Egyptian armies, crossed the Suez Canal, and cut off an entire Egyptian army just as a UN ceasefire came into effect.

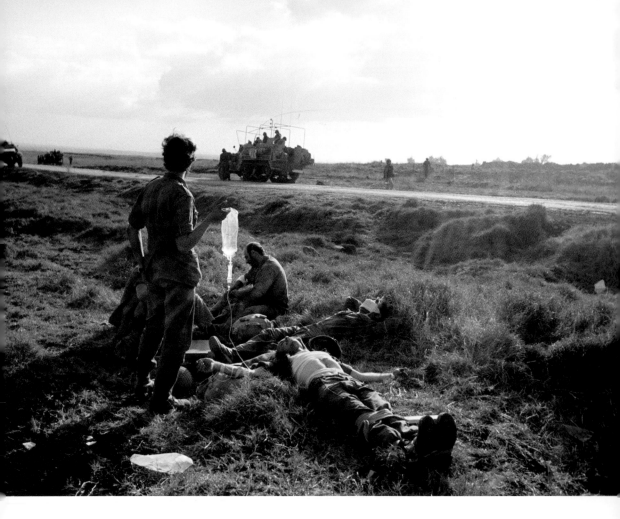

The fact that the Egyptians and the Syrians had chosen to attack on Yom Kippur was in one way a blessing in disguise. The Israeli reservists were mobilized very rapidly, as they had the roads to themselves on this holy day. Had Israel's enemies chosen to attack on any other holiday, such as Succoth (the Feast of the Tabernacles), the roads would have been jam-packed with holidaymakers out on trips, and it would have been impossible for the reservists to get to their bases quickly.

This was the first time that my son and I walked out of our home together to go to war. He went to join his unit, and I went to cover the war for *Time*, going first to Tel Aviv to make contact with the army spokesman's unit. That same afternoon, I drove up to Tzemach near Tiberias on the Sea of Galilee, where an Israeli division was forming to go and rescue our armored battalions who were fiercely battling for their lives on the Golan.

I managed to find a place in Brigade Commander Yossi Peled's armored car, and late at night we set out from Tzemach to head up to the Golan Heights. At dawn, the brigade made its way up a very steep incline to the top. We drove until about 2 p.m. in relative calm, although we did hear the rumble of distant gunfire and could see black smoke on

the horizon. Suddenly things changed dramatically. Without any warn-ing, we found ourselves caught in an artillery ambush by the Syrians, who, as they had observers on the hilltops above us, could plot all our movements easily. It turned out to be an absolute living hell, with shells exploding everywhere around us. I attempted to take pictures by lifting my camera over the parapet of the armored car, but it was very difficult and also extremely dangerous. In some of the frames that I actually did manage to take, our tanks are seen racing alongside us through a constant barrage of fire. A nineteen-year-old army reporter from Galei Tzahal, the armed forces radio station, was in the vehicle beside me. He was paralyzed with fear. I think I succeeded in giving myself a bit of courage by screaming at him over the din, "Start recording—if you don't do it now, you'll never be a reporter!" This af-fected him like a slap on the face, and he got to work.

Being in the Golan at this time taught me one essential piece of in-formation for a photographer covering a modern war: it is quite impos-sible to get any good pictures if you yourself are at the leading point of an attack, as we were, in the very first convoy. Today's warfare is not car-ried out as in days of old, when it was possible to take good pictures of soldiers in hand-to-hand combat or battling closely with the enemy. In today's fighting, you rarely get the chance to see your enemy, as they can be several kilometers away. The army nowadays uses long-range guns and highly technical electronic equipment to vanquish its opponents. I felt that nothing I had taken from my position in the command car was of any worth—the pictures seemed to me to be nothing more than the kind of images I could have taken at an army training maneuver.

At one point, we stopped to apprehend some Syrians who were hid-ing in an underpass on the road. I used this opportunity to jump off the vehicle and wait for the forces that were coming up behind us. It then became apparent that in this position, being behind the actual battle, I could get compelling pictures that told much more effectively the true story of what was going on. From here I saw burning tanks and dead bodies, some of them hanging out of the turrets of the tanks. I saw makeshift frontline first aid stations, with the wounded lying on the ground while they were being given emergency aid by medics who struggled to work under very difficult conditions. I also saw prisoners *65* being rounded up with that look of defeat and anxiety on their faces,

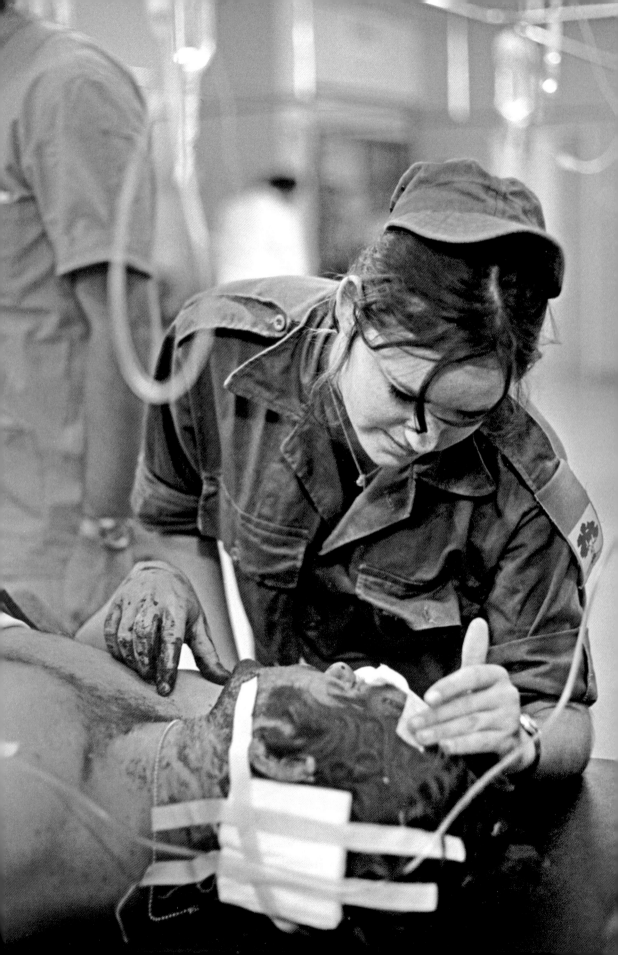

66. A nurse cares for a soldier with a
head wound in the hospital at Zefat,
in the Galilee.

their shoulders drooping and their feet dragging. What I ended up photographing, therefore, was not the fighting itself but the dramatic results of war.

This battle was without doubt one of the heaviest I have ever experienced in all my years of covering war. Thankfully we managed to eventually get through the Syrian barrage, and our battalion then went on its way to rescue the 188th Armored Battalion, who were suffering heavy casualties higher up the Golan.

It was at this point that I decided to leave them. I hitched a ride back towards the rear of the column in a tank carrying wounded soldiers on its deck and taking them to a meeting point where ambulances awaited the injured. From here I managed to get another lift back to Zefat, a town in the Galilee, and decided to go immediately to the hospital to check out what was happening. It was here that I shot one of the most tender photographs I have ever taken. This was of a young nurse caring for a soldier who had been badly wounded in the head. He was very distressed, and she was cradling him and trying to give him some comfort. Many years later, as part of the film that was made about me, we tracked down this girl, now a mature married woman. She told me that she had been particularly concerned about this soldier because of his condition, so she decided to make the effort to go and visit him at the hospital in Haifa a few days later, to see how he was getting on and if there was any way that she could help him. She continued, "I walked into the ward, and there I found him in bed surrounded by three beautiful young girls all competing for his attention. I smiled to myself, happy to see him being so well looked after, turned around, and left. I realized that he really did not need any more help from me!"

From Zefat, I immediately made my way to the Sinai, where things were not going so well for Israel and a fierce battle was raging at the Suez Canal. The severity of the situation in the south was compounded not only by the shock that Israel had received from Egypt's surprise attack, but also by the battle that was apparently going on between Israel's own generals. There were clashes of personality and breakdowns in communication at a time when everyone in Israel, particularly the military, needed to pull together.

The cause of this friction was largely that some senior officers now found themselves under the orders of soldiers who in previous years

66

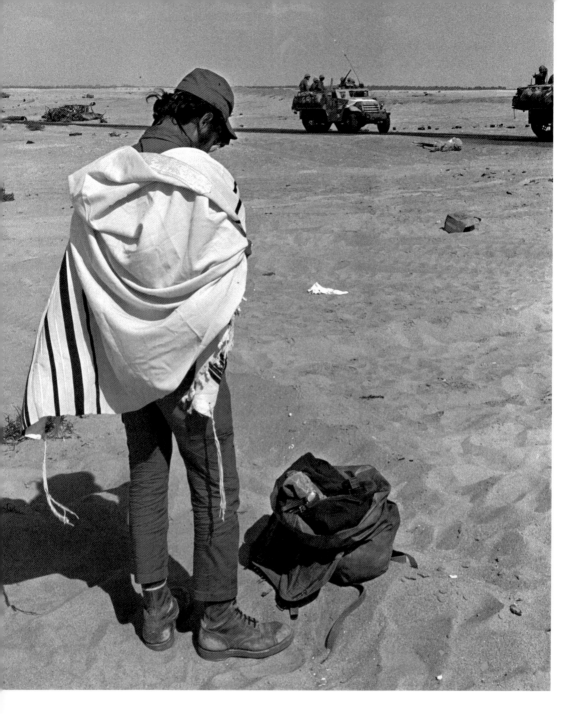

67. A soldier's morning prayers in the Sinai.

had been in lower ranks, under their own command. They found this change of status difficult to accept. For example, before the war Ariel Sharon had been the general in charge of the Southern Command, and under him was General Gorodish. Sharon in the meanwhile had retired from the army and gone into politics. At the outbreak of the Yom Kippur War, however, Sharon, along with many others, was recalled

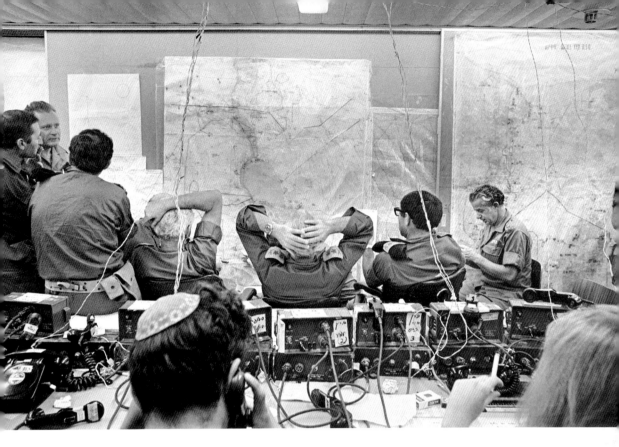

68. The Southern Command war room
at Bir Gafgafa (then called Refidim).

for duty as a reservist and now found himself given the office of divisional commander, taking orders from the new general in charge, General Gorodish.

It was rumored that certain of the "top brass" refused to answer their radios if they knew the call was from someone from whom they did not want to take orders. This situation became known as the War of the Generals. It was said that while the 1967 war was fought by the soldiers and won by the generals, the 1973 war was lost by the generals and won by the soldiers. I suppose it all boils down to the old story of chiefs and Indians. It is well known that in Israel we have always had too many chiefs and not enough Indians.

The situation was acknowledged by the government, which, in an attempt to resolve matters, decided to send Haim Bar-Lev into action. Bar-Lev, then a cabinet minister, had had an exemplary military career, having formerly been chief of staff. He went down to Bir Gafgafa, an Arab town that had been renamed Refidim after 1967, where the Southern Command had its headquarters. His arrival was not before time. When I got there, I found the place so disorganized that I was able to walk into the war room with my camera and take pictures of everyone there and also see the confidential maps on the walls. At no time *68*

did anyone bother to stop me or even inquire as to what I was doing. This was the very heart of operations, and the lack of security was unbelievable.

Bar-Lev was known for his calm demeanor and slow and deliberate way of speaking. At a GHQ meeting, Ezer Weizman once said that he, Weizman, could present his entire report in the same time it took for Bar-Lev to pause in a sentence. Bar-Lev's arrival did, however, improve things, as he was highly regarded by most of his subordinates and colleagues and was therefore quickly able to establish some sense of order.

I had had quite an amusing encounter with Bar-Lev a year before the war. Dado Elazar, deputy chief of staff, Bar-Lev, and I were flying in a helicopter over the Sinai when Bar-Lev suddenly asked the pilot to land so he could "take a leak." We did so, and Bar-Lev got out of the helicopter to relieve himself. We remained inside. Elazar suddenly whispered to me, "David, take his picture while he is peeing!" Bar-Lev, who must have had excellent hearing, turned slowly around and in his ponderous deep voice said, "You can take my picture, but if you do, we will take off without you." As we were in the middle of nowhere in the Sinai Desert, I chose to stay with the aircraft. No photograph was taken.

This was not the only aerial adventure that I shared with Haim Bar-Lev. During the War of Attrition, I was once invited to accompany him on a tour of the Israeli positions along the Suez Canal—all of which were under constant and heavy shelling by the Egyptians.

To my misfortune, Bar-Lev's hobby was flying, so to get to the front he insisted on piloting one of the army's light single-engine aircraft himself. I sat next to him in the copilot's seat. Taking off from Tel Aviv was fine, and we flew for about an hour towards the Suez Canal. Yet I think perhaps he had not gotten to the chapter on "landing" in his "teach-yourself-to-fly manual." When he came to land, the little plane hit the ground with an enormous bump, lifted up again, and bounced its way uncomfortably along the tarmac like a rubber ball. Bar-Lev was his usual sanguine self and appeared totally unconcerned that anything was amiss. I put this down to the fact that he must have been used to this exuberant and vigorous method of landing and for him it was the norm. For my part, it was a much worse experience than the one we proceeded to go through during the next few hours as we scurried on foot from one military position to another, running through tunnels

and bunkers, doing our best to avoid enemy fire. Needless to say, I chose to return to Tel Aviv in an Air Force transport plane. In the same way that my mother always warned me never to accept lifts in cars from strangers, I have added to this caution, never accept lifts in planes even from people you know quite well.

During the tough battles of the Yom Kippur War, Sharon had worked hard to establish a bridgehead on the Egyptian side, west of the Suez Canal. I was present in the war room while Bar-Lev discussed Sharon's actions with Elazar, then chief of staff. Elazar decided that he wanted to fly down to meet Sharon and see for himself what was happening. I asked if I could come along for the ride. He said to me, "You must be crazy—don't you know they are shooting at us!" to which I replied that this was the reason I wanted to go—to shoot, but only film. He agreed.

We left in a helicopter accompanied by two generals and Ezer Weizman. Weizman had left the army in 1968 and entered politics in 1969, joining Begin's Likud Party. When the Yom Kippur War began, he, like many others, found himself back in uniform. When we arrived, the headquarters was under heavy fire, but we managed somehow to land. They had their briefing with Sharon and afterwards decided to return. On the return flight, I suddenly became aware of a continuous clattering sound. At first I thought it was the helicopter rotors—which sometimes do make this sort of noise when the pilot changes their pitch. I was the only one able to hear this, as all the others were wearing earphones so that they could communicate with each other. It was then I realized that the clattering was in fact bullets. Our helicopter was being peppered with gunfire by the Egyptians below. Our pilot must have made a slight navigational error and departed from the narrow strip that was protected and crossed over the Egyptian lines. It was not a very comfortable feeling at all! In spite of my anxiety, I did manage to get one picture looking down from the helicopter. The frame shows Egyptian soldiers right underneath us in their trenches firing up at us.

The pilot had by now realized there was a problem and that his hydraulic landing system had been shot to pieces. He just made it back to Bir Gafgafa, but the landing was anything but smooth. The helicopter came to a halt with sparks flying from the skids as we touched the ground. A closer inspection of the fuselage revealed one bullet hole only about an inch away from where Elazar's backside had been! It

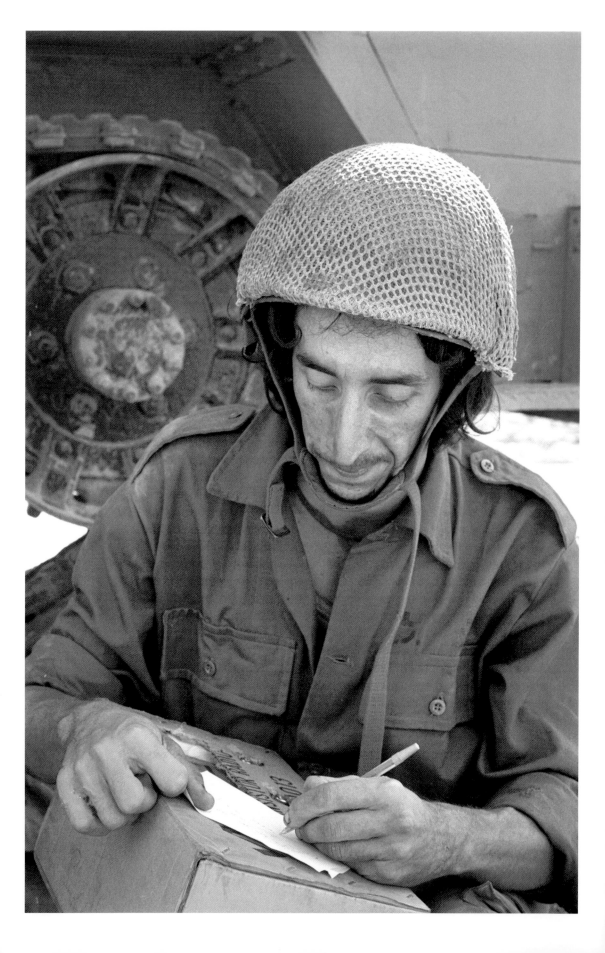

occurred to me later that, had the Egyptian gunners succeeded in downing us, no one would have remembered me, being as I was so insignificant alongside such illustrious company as Chief of Staff Dado Elazar, Ezer Weizman, and two other generals.

On October 22, 1973, a ceasefire was declared, largely negotiated by the United States and the Soviet Union, that called for an end to fighting between Egypt and Israel. When the ceasefire began, Israel's forces were just a few hundred meters short of their goal—the last road linking Cairo and Suez. They were only 101 kilometers from Cairo, deep inside Egyptian territory. During the night, the Egyptians broke the ceasefire at a number of locations, destroying nine Israeli tanks. In response, Elazar obtained the approval of Moshe Dayan, and the Israeli troops finished the drive south, captured the road, and trapped the Egyptian Third Army west of the Suez Canal.

A curious situation had developed, with Israel holding ground on the Egyptian side of the Canal, while the Egyptian Third Army remained in the Sinai, which had been Israeli-held territory. The Egyptian army was now completely encircled, without food or water, and at any time could easily have been annihilated by Israel. This, however, did not happen. The United States exerted tremendous pressure on Israel to refrain from destroying the trapped army. Henry Kissinger, in a phone call to the Israeli ambassador in Washington, Simcha Dinitz, told him that the destruction of the Egyptian Third Army "is an option that does not exist." What happened next was quite extraordinary. I watched our Israeli troops as they brought truckloads of food and water to the edge of the Canal for the Egyptians. Our soldiers unloaded the supplies onto the backs of Egyptian soldiers, who carried them down to the edge of the Canal, where they were loaded onto barges for transfer to their troops.

Many years later, an Egyptian friend of mine, who was quite close to Anwar Sadat, told me that Sadat had, at this time, called in a contractor, Osman Osman, from Egypt's leading construction company. Sadat asked him to prepare plans for the reconstruction of the city of Suez, which had been badly damaged in the war and was then still held by Israeli forces.

Osman Osman submitted his proposal and planned for a city that would be heavily fortified. On seeing this, Sadat shook his head and

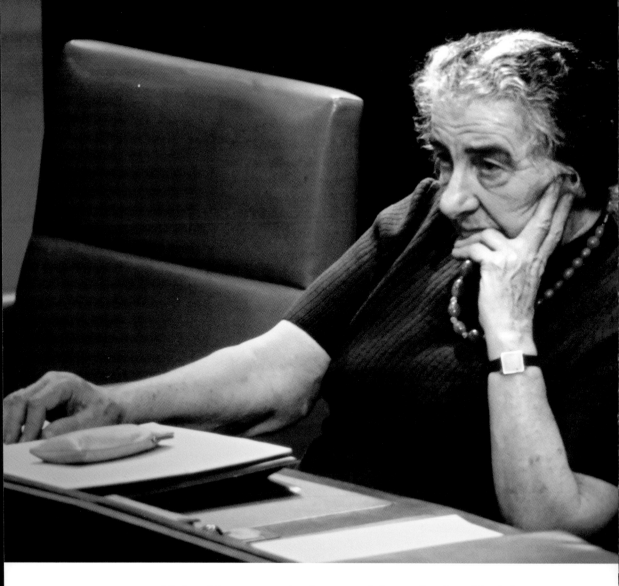

said that this was not what he wanted, but rather he wished the con-
tractor to prepare "for a city that lives in peace." I believe that perhaps
Kissinger, wisely preventing the Israelis from destroying the Egyptian
army, and Sadat, with his vision for coexistence, were both in some way
responsible for sowing the seeds of peace.

At KM 101 on the Cairo-Ismailia road, tents were erected, and talks
started between Egyptian and Israeli generals under the auspices of the
United Nations. These talks resulted in Israel withdrawing from Egypt-
ian territory and the Egyptian Third Army leaving the Sinai and return-
ing to Egypt.

There ensued several further withdrawals, with talks continuing for
some time. Shuttle diplomacy by Kissinger eventually produced a dis-
engagement agreement on May 31, 1974, based on an exchange of pris-
oners of war, Israeli withdrawal to the so-called Purple Line in the
Sinai, and the establishment of a UN buffer zone.

70. Golda Meir on the day she resigned
as prime minister, April 11, 1974.

One of the most surprising images that remained with me from this war reflected, in my mind, the uniqueness of the Israeli army. In most conflicts, warriors set out for battle accompanied by a wave of patriotic and nationalistic fervor with flags flying and drums beating. They invariably return home exhausted and drained. Our Israeli soldiers, however, went into battle without the customary fanfare. Their withdrawal from the front lines of the Yom Kippur War was also not that which one might have expected. I was there at the Suez Canal when Israeli tanks crossed back into the Sinai. The sight was astonishing. Despite withdrawing, the tanks were decorated with flowers in the gun barrels, and soldiers were sitting on top of the tanks waving and singing. It was a joyous withdrawal—seemingly a contradiction in terms.

It was good to see our boys returning home. This war had the semblance of victory, defeat having been averted after the initial shock of the Egyptian attack, but at a terrific cost in lives. The Egyptians too were convinced that they had won. Among our troops there was not-so-muted criticism of Israel's leaders both for their failure to assess the situation in the early days and for being caught unawares. I recall seeing one of the returning tanks with a large sign on which was written, "Golda, your suckers are returning to settle accounts."

Golda Meir's government paid the price for their poor judgment. Only four months after the war ended, a protest, led by Moti Ashkenazi, began against the Israeli government. He had been the commander of the northernmost Bar-Lev fort (code-named "Budapest") on the Canal, the only one not to be captured by the Egyptians during the war. Anger against the government was high, and Shimon Agranat, president of the Israeli Supreme Court, was asked to lead a commission of inquiry into the events leading up to the war and the setbacks of the first few days.

The findings of the commission were that six people were primarily responsible for Israel's failings, but they included neither Meir nor Dayan. The man who took the brunt of the blame was Chief of Staff Dado Elazar. He took this very badly and died not long afterwards of a heart attack. It was generally seen as extremely unfair that the military should take the blame that rightly should have been laid at the feet of the politicians. Public calls for the government's resignation became more strident, and finally on April 11, 1974, Golda Meir resigned. Her cabinet followed suit, including Dayan.

Time called me urgently to say they wanted a full-page picture for the next week's issue. They did not want me to take the chance of airfreighting the picture, in case it did not arrive in time, so they asked me to courier it over to them personally. The picture editor met me at the airport in New York, and on the way back to the *Time* building we looked through all the images I had brought and selected one. It showed Golda sitting thoughtfully, with her head in her hand—a perfect image of "resignation" in both senses of the word. Yitzhak Rabin was recalled from Washington, where he was ambassador, and became head of the new government in June of that year. But his government was hamstrung by a scandal. His wife had held a bank account with a balance of $20,000 in the United States while he served there. At that time, it was illegal to hold an undisclosed foreign account, and Rabin was forced to resign from the premiership in 1977. The right-wing Likud Party, under Prime Minister Menachem Begin, won the elections that followed.

70

23. SADAT AND BEGIN

Anwar Sadat, who had entered the war in order to recover the Sinai, began to get frustrated at the slow pace of the peace process. So in November 1977 he took the unprecedented step of appearing on television in Egypt, announcing that he was ready to go to Israel and address the Knesset in order to try to gain some progress. He became the first Arab leader to do so, and thus implicitly recognized Israel's right to exist.

Menachem Begin decided to invite him officially, and once again I found that luck had come my way. Quite by chance, I was at the right place at the right time and became involved in what was to be a historic happening. The director-general of the prime minister's office at that time was Eliahu Ben Elissar, a personal friend for many years. I called at his office to find out what I could about the rumors of Sadat's intended visit, and while I was there, the actual letter of invitation, dictated by Begin, was brought in by a typist for Begin to sign and was left on Ben Elissar's desk. To this day, I do not know whether Eliahu walked out of the office at this instant on purpose or by accident. The fact is, I saw an opportunity I could not resist. There was this letter in front of me, and so I photographed the document as it lay on the desk. I processed the film immediately and sent it off to *Time* for the next week's story. It was a scoop.

The photograph of the letter was printed in the magazine, and, to my amazement, I noticed that Begin's signature was on the document. It had definitely not been there when I took the picture. I then remembered that, months before, my picture editor, Arnold Drapkin, had visited Israel and asked to be introduced to Begin. I arranged this, and Begin signed a copy of *Time* for him. What had happened was that he had

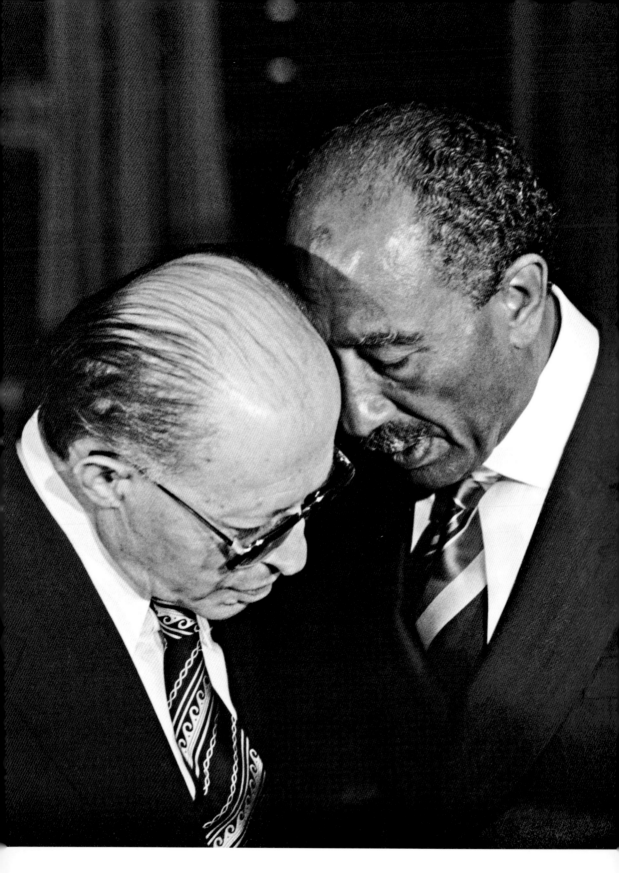

71. Menachem Begin and Anwar Sadat
in Aswan, 1980.

superimposed that signature onto the original letter to Sadat. No one had noticed.

Begin had originally conveyed a verbal invitation to Sadat via Samuel Lewis, the U.S. ambassador to Israel. Sadat accepted this but then asked for a written one, a request that was regarded as crucial by the Israelis, as it showed that he was serious about coming. In his letter, written in English, Begin said that he had planned a visit to see James Callaghan in London, but that he was ready to ask the British prime minister's indulgence to change the date in order to accommodate any date that Sadat chose. In the event, Begin did alter the date of the London trip, and Sadat's arrival in Israel was scheduled for November 19, 1977.

Once the public was informed about his trip, there were huge banner headlines in the Israeli papers announcing this historic visit. I went down to a flag-making shop in Jerusalem where the employees were working twenty-four hours a day to produce Egyptian flags. The excitement everywhere was unprecedented. Hundreds of Egyptian flags were displayed along every street of the route that Sadat would cover during his visit to Jerusalem.

On the day of Sadat's arrival, *Time* airfreighted an 800 mm lens to me so that I could take good pictures of him from a long distance away. A huge local and international press corps awaited him, and we were provided with specially erected stands where we were told to wait. As the plane landed and came to a halt, I saw through my viewfinder a scene that I regard as one of the most moving moments in my life as a photojournalist. The door of the plane opened, and an elegant and smiling Sadat emerged, paused for a moment, and waved to the crowd. It was magical. He came down the steps, walked along a guard of honor of Israeli soldiers, and at the end stopped in front of the Israeli flag, which he saluted. Here we had a truly unforgettable moment as our erstwhile most powerful enemy stood and paid tribute to the blue-and-white emblem of the State of Israel.

He then strode along the line of ministers, Chief Rabbis, and other dignitaries waiting to welcome him. When he reached Chief of Staff Lieutenant General Mordechai Gur, he stopped with a wry smile on his face. He was obviously aware of a remark that Gur had made at the cabinet session the day before, when he had asked, "What are we going to

72. Begin introduces Sadat to an Israeli soldier who lost his hand fighting against Egypt, 1979.

do if this is all a trick and he shows up with Yasser Arafat?" This picture of the encounter between Sadat and Gur is one of my favorites. The highlight of Sadat's visit was undoubtedly his appearance before the Knesset. This was something that I had never in my wildest dreams thought I would ever see. It was a profoundly unforgettable experience and one that I was so proud and privileged to have been able to photograph. In addition to his appearance before the plenum of the Knesset, he was later entertained by the various political factions in their offices. In the meeting with the Labor Party, which at that time was in opposition, he was seated next to Golda Meir. Golda had heard that Sadat had recently had a grandchild. She handed him a gift with the words written on it "From a grandmother to a grandfather."

A week later, Begin set out to London for his meeting with Prime Minister Callaghan. I flew with him. The trip was a state visit with the usual ceremonial and official duties. One small incident there, however, made Begin hugely happy. The foreign secretary, Dr. David Owen, took Begin aside and led him to a desk where he asked him to sit down. He then told Begin that this was the very desk where the then–foreign secretary Lord Balfour had signed the Balfour Declaration in 1917. (This declaration of the British government called for the establishment in Palestine of a Jewish national home.) The pictures I took show Begin beaming with delight at the thought that he, personally, was sitting in such a historic seat.

When it came time for me to return to Israel on December 3, I made a decision on the spur of the moment not to travel back with Begin. In-

stead I resolved to go to Cairo. At the time, this was quite an adventurous undertaking, as in those days I was in possession of only an Israeli passport, which could not be used to travel to any Arab country. My first port of call was the Egyptian embassy in London to make inquiries as to what I could do. They were not quite sure, as this was the first request from an Israeli wanting to visit their country they had ever had to deal with. Their suggestion was that I should go to their embassy in Paris and ask for guidance there. This I did.

On arrival at the Egyptian embassy in Paris, I was told that they could not give me a visa, as they had no authority to stamp an Israeli passport, but assured me that I would be very welcome on landing in Cairo and any legalities would be sorted out on the spot, which indeed they were. I checked into Cairo's best-known hotel, Shepherd's. I recalled that this hotel had been a sister hotel of the King David in Jerusalem, both having been built in the 1930s by an Egyptian Jewish family, very much in the same style.

For a week, I wandered the streets with Ehud Ya'ari, the chief commentator for Arab affairs on Israeli TV. We could not be there, of course, without visiting the pyramids, and it was quite an overwhelming experience to see them for the first time, especially as it was quite exceptional for an Israeli to be standing there. Nothing one can imagine could convey the grandeur and scale of these ancient structures. I felt so insignificant, so minuscule, standing beside them. Over the next few days, I visited the Cairo Museum to see the treasures of Tutankhamun and all the other well-trod tourist paths in the city. Everywhere in Cairo there were banners in the streets, in Arabic, proclaiming in one way or another sentiments such as "The victor of war shall be the victor of peace," referring to their hero Sadat.

At that time, there were no direct lines of communication between Egypt and Israel, so I kept in touch through the *Time-Life* office in New York. Through them, I learned that the Foreign Press Association in Israel was organizing a special flight for journalists to come to Cairo. They knew that Eliahu Ben Elissar, the director-general of Begin's office, was due to arrive for talks and would stay at the Mena House Hotel with his delegation. I decided that I wanted to be as close to the delegation as possible, and in order to do so it was necessary to change hotels.

When checking out at Shepherd's, as I came to pay my bill at the front desk I was approached by the assistant manager, who informed me with a big smile on his face, "You are our first guest from Israel. We have been highly honored to have you staying here with us. There is no question whatsoever that you will pay the bill, everything is complimentary." I was very moved by this gesture.

Two weeks later, Begin arrived for his first visit to Egypt, where his plan was to meet with Sadat in Ismailia. They conducted talks in a small building while the entire press corps and governmental entourages waited around outside in the courtyard. Suddenly the door to the building opened. Sadat strode out, followed by Begin. He walked up to his car, ordered the driver to get out, sat down behind the wheel, leaned over to open the passenger door, and said, "Menachem, please get in." The moment the door closed, they raced off in the direction of the Suez Canal, which was located about eight kilometers away. Pandemonium ensued. The security personnel were in total disarray, racing for their vehicles. Yehuda Avner, then adviser to Begin and later Israel's ambassador to London, was in one of the cars following Sadat. As he passed me, he opened the passenger door and said, "David, jump in!" which I managed to do, not without difficulty, as his car did not stop and I was clutching an assortment of bags and cameras. We were the first to arrive at the Canal, where we saw Sadat's car parked. He and Begin were sitting in the front seats talking with the windows open.

I got out of Avner's car and ran to the window on the driver's side of Sadat's car. If ever a photographer could dream of a situation he would like to be in, this was it for me. There were no security guards to push me away and no other photographers or journalists, just Sadat at the wheel with Begin next to him and the most perfect light you can imagine. I heard Sadat explaining to Begin how his Egyptian forces had used high-pressure water jets to cause the collapse of the earth embankments that the Israelis had built along the Bar-Lev Line to protect their positions. It was in this way that Sadat's army succeeded in crossing the Canal on Yom Kippur. I kept clicking away until Sadat finally started up the engine and reversed his car to go back. I started to rewind my film into the cassette. Horror of horrors! The rewinding knob turned much too easily, which meant that the film had not engaged the sprockets and therefore nothing at all had been recorded. I kept a faint glim-

mer of hope in my heart and prayed that I might be wrong, and that night, after my return to Israel, Anni flew to New York with all the film that I had shot during the day.

I made her promise that, as soon as she got to the laboratory and the films had been processed, she should call me immediately to let me know what was on roll number six, the film in question. Her call confirmed my worst fears. Nothing whatsoever. I could scarcely believe my misfortune and was not able to bring myself to tell this story to anyone for a long time.

Eleven years later, the managing editor, accompanied by many of the top executives of *Time* magazine, came to Israel to attend the opening of my first major exhibition. It was held at the Tower of David Museum in Jerusalem. After this it toured to London, the United States, and Canada. Teddy Kollek made the opening speech in Jerusalem, at the end of which he was supposed to introduce the managing editor of *Time*. He made his opening remarks but for some reason completely forgot to call upon the guest of honor to say a few words. I tried to save the situation by approaching the microphone. I was only five steps away, but they were the longest steps I have ever taken, as for some reason I had a total mental block and could not remember my managing editor's name. Thankfully it came back to me just in the nick of time as I reached the microphone. Henry Muller. When it was my turn to make a speech, I remarked, "If you had planned to give me my customary gold watch now, I must first go public with a story that I have never told anyone before." I then confessed as to what had happened to me that day in Ismailia. I softened it by quoting an old German proverb, "God takes good care that trees should not grow too tall, lest they take it in their mind to touch the heavens." A story that I periodically tell myself to avoid becoming conceited!

From the day that Sadat visited the Knesset in 1977 and uttered those famous words "No more war," until the final signing of the peace agreement in 1979, there were many ups and downs with the talks. They were sometimes on the verge of collapse, so much so that on one occasion President Carter made a special visit to the Middle East to address the Knesset.

Carter later summoned Begin and Sadat to a meeting at Camp David and told them, "You will sit here for two weeks, even if I have to lock

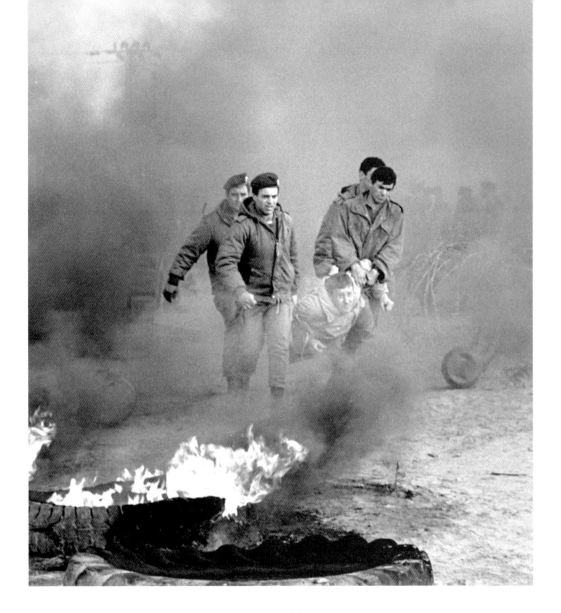

OPPOSITE
73. Settlers resisting the evacuation of Yamit, prior to the return of the northeastern Sinai to Egypt in 1982.

ABOVE
74. The evacuation of Hatzar-Adar, near Yamit, 1982.

you in, and you will not be allowed to leave until white smoke emerges" (meaning until they had reached an agreement, as in Rome when the cardinals meet to elect a new Pope). Among other matters he had to consider, Begin had a difficult domestic issue to resolve. Before he left for Camp David, a group of right-wing settlers had already expressed their anxiety about the fact that he might be pressured into giving up settlements in the Sinai. Prior to going to Camp David, he met with

eight of their leaders in his Jerusalem office, where I heard him give them the assurance that "you do not have to worry. If the demand comes up to remove the settlements, I will simply tell Aliza to pack our suitcases, and we will leave Camp David and come back home!" As it turned out, this was a promise that he may have intended to keep but ultimately was unable to do so. Before the peace treaty was signed in Washington, Israel agreed, at Sadat's insistence, to remove every one of the settlements in the Sinai, to "the last grain of sand." The reaction of much of the Arab world to Egypt's peace with Israel was outrage. Until then, Egypt had been at the helm of the Arab world, but after the signing Egypt was expelled from the Arab League.

73, 74

I was there, together with hundreds of other photographers, when President Carter, Begin, and Sadat signed the document, after which all three of them stood up for their historic triple handshake. All that day and during the whole ceremony, there had not been a breath of wind, so the three flags, one for each nation, were drooping inertly on their respective poles. I do not know if it was luck, but when I took my pictures of the handshake, all of a sudden a gust came from somewhere and the three flags opened fully and flew merrily in the breeze. My picture editor later told me that when he showed them my pictures of the ceremony at the editorial meeting, the managing editor remarked, "What's this, did David bring a wind machine with him from Israel as well?"

75

Begin and Sadat were honored for their efforts with the Nobel Peace Prize in 1978. I traveled with Begin to Oslo for the ceremony. The event was held in an old Gothic hall, very ornate and elaborate, as was the ceremony itself. Word then reached us that Golda Meir had died, and we had to make preparations for a speedy return. We rushed off to the airport. The duty-free shops were selling wonderful Norwegian smoked salmon, then unobtainable in Israel. I, along with several of the other photographers, bought a huge side of salmon, and as my suitcase was already on the plane, had to store this in my camera bag, which I took on board. There was a noticeable odor of fish permeating throughout the cabin during the flight.

On our arrival in Jerusalem, Begin set out immediately for the Knesset, where Golda's coffin was lying in state. I managed to keep up with him, following closely behind. On reaching the plaza in front of the Knesset, Begin walked slowly and solemnly up to the bier where her

168

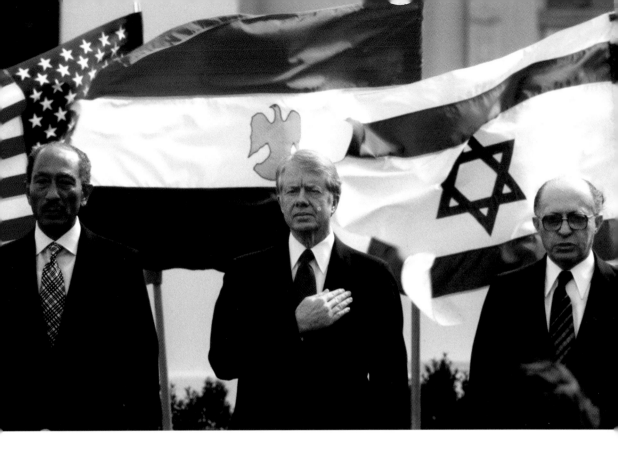

coffin was resting and bowed his head in respect. I was crouching next to him, photographing the scene, when suddenly I felt the salmon slipping out of my camera bag. There I was, in full view of hundreds of pairs of eyes and TV cameras, desperately trying to control this fish so that it should not reveal itself to the world. I am sure there is a moral in this story somewhere. All I can think of is "Don't carry fish in your camera bag when you are on an major assignment." The other important purchase I made in Oslo was a magnificent Cossack-style fur hat. Not the most recommended headgear for someone who lives in a hot Mediterranean country, but I am a compulsive buyer—I saw it, could not resist it, and quite simply had to have it. I realize now, sadly, that this hat is the only tangible reminder of the Nobel Peace Prize awarded to Sadat and Begin.

I traveled with Begin frequently during the lengthy period of the subsequent peace negotiations, mostly to the United States to meet President Carter and later President Reagan. I also returned with Begin to Egypt when he was invited to visit the Jewish synagogue in Adly Street, Cairo. Huge crowds of Egyptians were waiting there to greet him, cheering and waving and engulfing the cars in which we were traveling.

Anni was with me on this trip. I had brought a collapsible ladder, which Anni had to hold firm as I stood on it to get a better view, but as the crowds were pushing so hard around us I was in danger of falling off. I remember Begin's face very clearly as he smiled delightedly at the

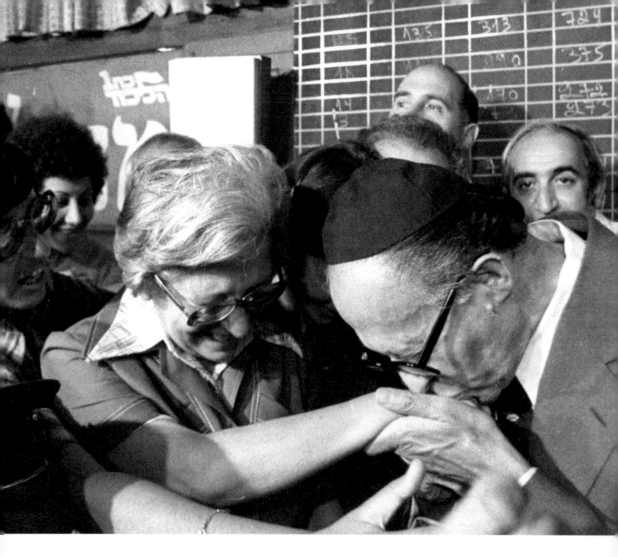

cheering crowds. This trick of always bringing a ladder was something I had learned at the White House in Washington. It means that a photographer does not have to shove and is not pushed by the crowds, but can remain literally head and shoulders above all the rest! It became so much my trademark that once, when I was descending from the plane at Alexandria, an Egyptian police officer remarked, "Oh here comes Abu Sulam," which in Arabic means "Father of the Ladder."

Being able to observe Begin at close quarters on so many occasions gave me an insight into the true nature of this remarkable man. He was a European gentleman to the core, kissing ladies' hands at any opportunity and hugging anything that moved, be it the president of the United States, a famous actor, or a maid in the King David Hotel. He was wholeheartedly devoted to his wife Aliza. On the day that he was elected prime minister after twenty-nine years in opposition, the first thing he did when he heard the results of the vote was to turn to his wife, kiss her hand, and say, "Thank you for following me through the desert all these years." He was one of the few people about whom you could say that

76. Menachem Begin, elected prime minister in 1977 after twenty-nine years in opposition, tells his wife Aliza, "Thank you for following me through the desert all these years."

he was absolutely incorruptible. He always lived modestly—before he became prime minister, during his premiership, and after his retirement. Aliza once told my wife that, far from being a gourmet, her husband was quite happy with just a cup of tea. A man of simple tastes, he was also a man of great integrity and usually extremely courteous.

On only one occasion, to my knowledge, was this ever contradicted. It happened when my bureau chief and I were interviewing him, and Begin appeared very tense and stressed. At one point, he turned to me and said sharply, "Take your pictures and vanish!" I was terribly hurt at these words, as they were so out of character. I packed up and left immediately. I later told his personal secretary Yechiel Kadishai what had happened. The following day, I received a letter from Kadishai on behalf of Begin. In the letter, he apologized and tried to explain that Begin only ever spoke harshly to those people whom he felt were so close to him that they would understand the pressures under which he worked. At least he was gentleman enough to go to the trouble to explain this to me, whereas many others might not have bothered.

My last trip with Begin to the United States was to meet President Reagan, and part of the itinerary included a visit to Texas to appear at a rally of fifty thousand Christian fundamentalists. Members of the Jewish leadership tried to dissuade him from attending, but Begin insisted. In the end, the trip did not materialize, as word reached him in Los Angeles that his wife Aliza had died unexpectedly in Israel. Begin was never able to forgive himself for the fact that he had not been with her at that time.

He was a broken man, and the question is debated to this day as to whether it was the death of his beloved Aliza that caused the great depression into which he plunged, or whether his feelings were exacerbated by the ongoing tragic events of the Lebanon War. Every day, demonstrators stood opposite his home with placards listing the increasing number of dead in Lebanon. The security services suggested removing the crowd, but Begin insisted on allowing them to stay, saying that they had the democratic right to be there to express their feelings. As for Begin, he himself felt the loss of even a single life very keenly, taking it as a personal responsibility. It was at one of the last cabinet sessions he chaired that he pronounced wearily, "I cannot go on." The final official words of a fine statesman.

Sadat, the other broker of the peace talks, who was regarded by many as another of the outstanding statesmen of his time, was assassinated by a group of militant Islamists on October 6, 1981, while watching a parade celebrating the October (Yom Kippur) War. It was a tremendous blow to the Middle East to lose one of the architects of the peace process in such a despicable manner. His funeral was scheduled for a Saturday, so Begin asked to be accommodated at a location from where he could join the procession on foot in order not to have to drive and desecrate the Sabbath. The entire Israeli entourage was therefore put up in the Railway Engineer Sports Club. I tried to capitalize on the fact that Begin was walking and followed him on foot, keeping close by him and hiding my cameras under my jacket. When we reached the mourning tent and I started to take pictures of the assembled dignitaries, including many Arab leaders, I was discovered and thrown out. I made my way to one of the towers set up for the media along the route of the funeral procession and tried to climb up. A policeman stopped me and asked where I was going. When I explained that I was covering the procession, he said, "No, you can't stay in this position. You should be over there," indicating the tower reserved for the Egyptian state TV, a much better position that I had not even dared to approach, as I was sure I would be turned away.

Most of the Arab nations shed crocodile tears at Sadat's demise; they had never supported his efforts to make peace alone with Israel. Even at home, he was not mourned as befits a great leader, for although the Camp David Accords had brought peace to Egypt, they were not accompanied by prosperity, and he had become increasingly unpopular. This was a sad ending for a great and courageous statesman.

24. AIR POWER STORIES

In the spring of 1973, to coincide with the twenty-fifth anniversary of the State of Israel, I was assigned by *Life* to do a story about Israel's military strength. In those days, the influence that *Life* magazine had was enormous. The magazine was generally regarded as being the epitome of good photojournalism, and it seemed as though they could achieve just about any objective they set themselves. This story illustrates the sway they had in persuading the Israel Defense Forces to cooperate on one of their projects.

The first thing that I did was to approach the IDF spokesman's office to tell them about the *Life* proposal. They were delighted to be featured in such a prestigious magazine and offered to give me all the help I needed to make sure that the story would turn out to be something unique, with the military being seen in the most positive light.

It was arranged that, with the help of the navy, eight missile boats would set out to sea from Haifa port. Two of these boats had an interesting history. They were known as the Cherbourg Boats, and the story of what happened to them reads like the script for a Hollywood action movie. The boats were being constructed in Cherbourg, France, shortly after the Six Day War by a team of French boat builders supported by over two hundred French-speaking Israeli experts who lived there as advisers. At that time, the War of Attrition was ongoing between Israel and the Arab states. Because of this, General de Gaulle declared a total arms embargo and refused to let the Israelis take delivery of the boats, in spite of the fact that they had been paid for.

At this point, the Mossad became involved in an ingenious plan to bring the boats to Israel. They started sending to Cherbourg young, blond, blue-eyed sailors, who told the locals that they were Norwegians who had come to take delivery of the boats. They were in fact blond,

blue-eyed Israelis. On Christmas Eve 1969, when most French people
were busy celebrating, this group crept stealthily into the boatyards
and took all the boats out from under the noses of the French in an act
of great daring, resourcefulness, and drama. They then sailed away and
delivered them to Israel.

For the *Life* feature, I had arranged with the Israeli Air Force to fly
over the boats in a helicopter to take pictures as they made their way
out of the harbor at Haifa. It was a wonderful sight to see, but nothing
compared to my experience in the next stage of this news story. I de-
cided that it would make a great photograph if I could arrange a flight of
four Phantom jet fighters over the Temple Mount in Jerusalem. My am-
bitious plan was that I would travel in a fifth Phantom that would fly
above the other four, thus enabling me to look downwards from my
vantage point and take photographs of the four planes below me with
the City of Jerusalem, and in particular the Temple Mount, in the back-
ground. Much to my delight, the Israeli Air Force agreed to this plan.

I boarded the Phantom and was placed in the navigator's seat be-
hind the pilot. He had given me instructions as to how to deal with the
tremendous thrust of the aircraft on takeoff, plus advice on how to
overcome nausea by using extra oxygen. A little more disconcerting
were the additional instructions he gave as to how to bail out in the
event of trouble. Probably no different from the airline instructions to
passengers on any commercial flight as to how to fit the life vests, but it
somehow felt more dangerous! We set off and flew in the direction of
Jerusalem. At the very moment when we were over the location I had
chosen, I realized that our plane was in the wrong position in relation
to the other Phantoms if I wanted to get the picture exactly as I had
planned. I then calculated that it was necessary for our Phantom to be
at an angle over the others, in order to get both the four planes and the
Temple Mount into the frame. I persuaded the air force to give permis-
sion for another flight to be made on another date and happily they
agreed.

We took off for a second time about a week later. I had made sure to
take with me the most modern equipment that was available at the
time. It was a camera that could take eight frames a second, which I
knew would give me the best possible chance of getting some really
good images, particularly as we would be traveling at very high speeds.

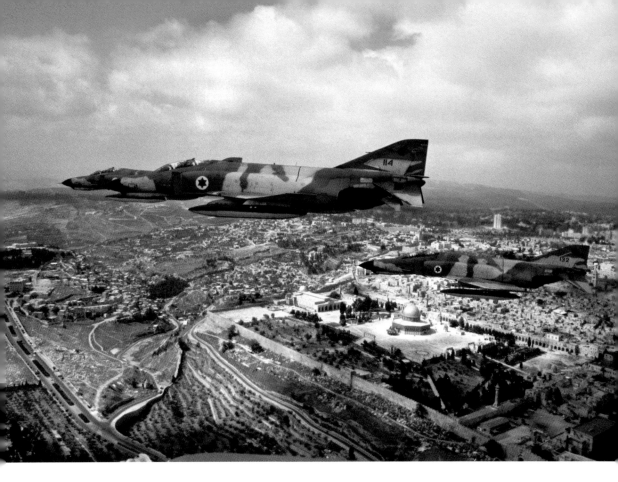

When we were above Jerusalem, I saw exactly what I wanted and squeezed the trigger, but this time absolutely nothing happened. The camera failed to react. This is the nightmare of every photographer— but in true professional mode I hit the camera with my hand from below, and it started to work. But by now we were flying miles away past Jerusalem, almost to Jericho. I quickly told the pilot that the first shots had been no good, as unfortunately there had been cloud cover above the Temple Mount, and persuaded him and the other Phantoms to make another approach over the city.

I had this awful gut feeling that if anything could go wrong again, it would. This time the pilot made sure we were flying at the right angle for me to take the shot I wanted. Everything seemed in place and luckily for me, like the proverbial Boy Scout, I was prepared. I decided to disregard the state-of-the-art high-speed camera that I had tried to use on the first run, and instead turned to my trusty Leica, which, thankfully, I had also brought with me. It had no motor drive and was fully manual. I grabbed it, and as we approached Jerusalem for the second time, I succeeded in shooting two good frames.

One of those frames made the back cover of *Life*. I also gave a print to the Israeli Air Force, who used it on a recruitment poster, with the title "The Best People Join the Air Force."

77

Sitting in the Phantom was an experience I can never forget. That feeling when the aircraft takes off and causes you to be thrust hard back into the seat is extraordinary. The plane appears to rise almost vertically and you feel the most tremendous surge of power, but, surprisingly and unexpectedly, it is very quiet inside the plane. The exhilaration was like nothing I have ever experienced. I was ecstatic. The pilot then decided to play games with me and show off a bit, so he made the aircraft perform a few acrobatic rolls. The first time he did this, I nearly threw up, but he showed me how to regulate the supply of oxygen into my mask, and after that I managed like a trouper.

When we landed, Anni was waiting at the base. She took a picture of me coming down from the plane, and according to her I looked very haggard but very happy. I had lost about two kilos in weight, apparently the result of wearing a pressure suit and of the g-force. On each of the two Phantom flights I took, I was accompanied by a different young pilot. What they had in common was that on takeoff they both sang very loudly! Perhaps this was part of the buildup to the exhilaration and euphoria they felt each time they went up in such a high-powered fighter plane. I do not believe I have ever done anything quite so exciting in my life. Quite recently, my granddaughter invited the whole family to see her jump from an aircraft, skydiving. It was her eighteenth birthday, and she received the "fall" as a gift from her sister. When she landed, she had that same expression and voiced the same comments as I had when I had been in the air so many years before. It is good to see some of our family traditions continuing!

Those flights in the Phantom were not my first encounter with these fighter planes. When Israel received the first batch in 1968, I was obviously very keen to take pictures of them. Fortunately, I had known the commander of the Israeli Air Force, Major General Mordechai Hod, for many years. We had served together in the same company of the Jewish Brigade back in the days of World War II. He was then Motti Fein, a lance corporal, and I was a private. I contacted him in the hope of arranging a meeting to ask for permission to take pictures of the new planes. He agreed to see me, and in addition the chief of security of the Israeli Air Force was in attendance at the meeting. The three of us sat there as I pleaded my case, and I was delighted when Motti said, "No problem, we'll arrange it." I thanked him profusely, and on the way out

I asked the officer who had been with us at the meeting when we could go ahead and do the shots. "Never," he replied. I was astounded. "Wait a moment," I retorted, "Did you not just hear your commander say that we could set it up?" "Oh yes," replied the officer, "He may be the commander of the air force, but I am in charge of security and I say no." It was some months later, and then only when the embargo on news of the arrival of the Phantoms was lifted, that I was allowed to take my pictures, but only along with all the many other photojournalists—so much for having protexia in Israel.

25. BECOMING AN AUSTRIAN CITIZEN—AGAIN

When I originally arrived in Palestine in 1939, I held a German passport that had a large red J stamped inside it. The J stood for Jew. Every Jewish passport holder was given a new middle name by the Nazi regime, Israel for a male and Sarah for a female. On arrival in Palestine, I, David Dietrich Israel Rubinger, became a Palestinian, and my German passport was redundant. Having been born in Austria, however, I was automatically entitled to reclaim Austrian citizenship should I wish to do so. The deadline for applying for this had been set at the year 1966. I played with the idea of obtaining it for convenience's sake, as it was very limiting to travel on just an Israeli passport, but when I mentioned this to Anni, she was quite horrified and told me bluntly that I could choose—either Austrian citizenship or staying married to her. Needless to say, I did not proceed with my application at that time.

Years later, around 1980, it became increasingly evident to me that, in order to facilitate my travel in the Middle East, it would be really helpful not to have to always travel on my Israeli passport. Then as now, it was impossible to visit many Arab countries as an Israeli. For a photojournalist this was very frustrating. I contacted the Austrian embassy, and they told me that, as it was fourteen years after the cutoff date, it was highly unlikely that I would succeed with my application.

Around this time, Bruno Kreisky was the chancellor of Austria. In 1970, he and his Social Democratic Party were able to form a minority government, and, in doing so, he became the first-ever Jewish politician to gain power in any central European country. It was quite exceptional that he should have risen to such illustrious heights, bearing in mind his religion and the fact that less than four decades ago the Austrians had enthusiastically welcomed Hitler and the Anschluss. I saw with my own eyes, as a teenager, how wildly they cheered the Führer as

he stood on the balcony of the Imperial Hotel in the Ringstrasse of Vienna.

I decided to speak to my picture editor at *Time* about the passport problem, and we came up with the idea of doing a feature on Kreisky, which we would try to place with *People* magazine. I made the necessary approach through the Austrian embassy in Tel Aviv and eventually traveled to Europe, where I presented myself at the chancellor's office in Vienna. At the back of my mind was the hope that I might be able to use his good offices to obtain my citizenship.

Kreisky agreed to be interviewed, so I found myself spending a week following him to his office, his home, his bedroom, his barbershop, and even a wine bar in Grinzing—the place where everyone went to drink. He spoke freely to me about many subjects in his strongly accented Viennese dialect. I think he put this accent on a bit for my benefit, knowing that I was from Vienna, as whenever I heard him speak in public it was in "high" German.

He turned out to be an interesting, if complex, character and somewhat ambivalent about his Jewish heritage. In his home, I saw shelves full of books on Jewish themes, and he told me with pride that he had a nephew who was a captain in the Israeli army. He also had a brother in Jerusalem to whom he regularly sent money. The brother, Paul Kreisky, was a familiar and pathetic sight in Jerusalem. He went calling at office buildings in the city selling matches and floor cloths, telling anyone who would care to listen to him about his famous but uncaring brother the *Bundeskanzler*, who, he asserted, never lifted a finger to help him. I, however, chose to believe Chancellor Kreisky when he told me that he had put himself out considerably for his brother, who in return had shown little gratitude. It was also well known that Kreisky had come to the aid of many Jews who had fled the Soviet Union. He had prepared a transit camp for them in Schönau Castle and arranged for a large police contingent to protect them.

While conscious of his Jewishness, he was quite definitely not a supporter of Zionism. He had welcomed Yasser Arafat to Vienna at a time when there was no contact whatsoever between the Arab leader and Israel. This action made Israel's prime minister Golda Meir absolutely furious. She could never forgive him for meeting the man she termed an "arch-terrorist." She visited Vienna on one occasion and, when

she returned home, was at pains to tell anyone who would listen how "Kreisky had not even offered her a glass of water." There was certainly no love lost between these two leaders.

Kreisky opened up on this topic while I was chatting with him as he pedaled hard on his exercise bike in the bedroom. He said in an aggrieved tone, "There I was, doing all these things for the Jewish people, helping them to leave the USSR for Israel, and what did she do, she spat in my face." It was obvious that this was a clash of personalities and opinions that was irreconcilable.

During my week with Kreisky, I did however succeed in meeting my personal objective. It took only one phone call from his office to the Ministry of the Interior, and I became an Austrian again. By now, after sixteen years, Anni had mellowed in her attitude and was also ready to travel on an Austrian passport as long as this did not mean giving up her Israeli passport, which it did not.

On attempting to obtain her Austrian citizenship, however, a new and unforeseen problem arose. When we applied for Anni's passport, to which she was entitled as my wife, the answer was in the affirmative only on condition that we could produce our marriage certificate.

We told the officials that Anni and I had been married under the auspices of the British forces on the Rhine. On hearing this, the embassy official said that he could not accept such a document and advised us that we must produce a civil marriage certificate. I argued with him over this and asked what he would do in the case of a German soldier on the Russian front marrying a Russian girl—would they demand a Russian civil certificate?

He seemed baffled by this, but came up with an elegant solution and suggested that we bring them a document authorized by the Jerusalem rabbinate and signed by two witnesses to prove that I was indeed married to Anni. Accordingly two of my colleagues went with us to the rabbinate and confirmed that not only were we married but we also had children and grandchildren. This document, signed by the Chief Rabbi of Jerusalem, satisfied the embassy, and they issued a passport in the name of Anni Rubinger, Austrian citizen. We were then able to travel extensively in Europe with much less hassle.

My time with Kreisky and his antipathy to Golda Meir reminded me that some years before I had spent a week with Golda Meir to produce

a story for *Life* magazine, which was eventually entitled "Grandma with a Career." She was at that time foreign minister of Israel.

When starting on an assignment like this, I always saw the process as having three stages before I could produce a story. The first step was to gain the confidence of the subjects; I chose not to shoot pictures of them initially but just hung around with them, and if I sometimes appeared to be taking pictures, there was not necessarily film in the camera. My philosophy has always been that it takes a long time to get to know the essence of another person's character and one could not achieve this in half a day.

At the beginning of this kind of relationship, the subjects usually cooperated willingly, but it soon became apparent to me that any pictures I took at this stage were mostly posed and self-conscious. During stage two, the subjects frequently tended to get nervous and upset by my presence; they would be irritated by me but could not throw me out, as they had agreed to have a story produced about themselves in the first place. The third stage is when things started to happen. This may have been because the subjects had become used to me, or that they thought, "Oh to hell with it, I'm going to ignore him," and started to treat me as if I were not there. This is the time when I was most likely to get the best pictures, informal, unself-conscious, and intimate.

It was on this principle that I worked with Golda, and it was only during the very last days of our visit that I was happy with what I had taken. On one occasion, I was sitting almost under her kitchen table photographing her as she was tenderly feeding her grandson, totally oblivious to me. It produced a very good shot.

I watched her in a true domestic role, putting out nameplates for a diplomatic dinner at her home, going shopping, buying sweets and clothes for her grandchildren, and cooking in her kitchen for the family. This kitchen became known as "Golda's Kitchen," a place where, when she was foreign minister and later prime minister, many far-reaching political and military decisions were made, rather than in the cabinet rooms.

A good friend of mine who was a high-ranking official in the Mossad related to me how she once summoned him late at night to report to her and then received him in the kitchen in her nightgown. She ordered him to sit down, made him a cup of tea, and then listened to his report.

79

182

During the week I was with her, we also went on official visits, one of which was to a paratrooper training school where Congolese soldiers, including the future president Mobutu Sese Seco, were learning how to jump out of planes. One of the uniformed men I photographed with Golda was Idi Amin, who was to become the notorious president of Uganda. Golda could never be considered a small woman, but when she stood next to Amin, she was dwarfed by his enormous size. Israel was to encounter this man later, in 1974, when it freed the hijacked Air France plane in Entebbe, of which I write later.

Golda and I also went to the Habima Theater together with her sister, where I photographed a very emotional scene as she embraced the legendary Israeli actress Hanna Rovina after a performance of *The Dybbuk*. Rovina (1892–1980) was known as the "First Lady of Israeli Theater." Born in Russia, she joined a Hebrew theater in Moscow that was to eventually form the basis of the Habima Theater, first in Moscow and

later in Israel. Her role in S. Ansky's *The Dybbuk* in 1922 earned her a reputation as a leading actress, and this recognition increased as she toured both Europe and the United States in the same production.

She came to Israel in 1928, where she was rapidly acknowledged as Israel's grande dame of theater in roles from works by Sophocles, Shakespeare, Brecht, and many others. She was awarded the Israel Prize in 1956 for her services to Israeli theater.

Golda was not the type of person who would make small talk with a mere photographer such as me. She was not very much liked by the majority of the populace, especially the oriental community. During the time that she was prime minister, a protest movement was established calling itself the "Black Panthers." They carried out a lot of petty theft, such as taking full milk bottles from wealthy areas and redistributing them to poor people. They also demonstrated regularly against the government and its social policies. They particularly objected to the elitism of the Ashkenazi community and the neglect, as they saw it, of the poorer groups, which comprised predominantly oriental Jews.

After one particularly violent demonstration in Jerusalem, Golda's reaction was to comment, *"Hem lo nechmadim"* (They are not nice children). This became one of the best-known expressions uttered by Golda, who was criticized by many for her patronizing attitude and failure to address what turned out to be a major social problem. Many years before, it was David Ben-Gurion who used to say about her that "she was the only one with 'balls' around the table." Later on, it was the same Ben-Gurion who called her derisively "THAT woman."

Having spent time both with Golda and later with Kreisky, I was on balance more inclined to give credence to his account of their relationship than to hers.

26. IMMIGRATION FROM RUSSIA AND ETHIOPIA

The camp that Kreisky set up in Schönau in the '70s for the Jews from Russia was in a beautiful old baroque castle, which had probably belonged to a member of the Austrian aristocracy. As transit camps go, you could say that this was a five-star camp. It was at this *Schloss* that the officials of the Jewish Agency carried out in-depth interviews with the new Russian immigrants to try to find out as much about them as possible. The queries were to ascertain their Jewishness, whether they had any relatives in Israel, and what occupations the immigrants had followed in their country of origin, so that the authorities could direct the newcomers to the most appropriate place to be settled. It was evident that our aliyah department had by now learned much from the earlier mistakes of the 1950s and were operating a smooth-running machine. Much was planned in advance so that the *olim* knew on arrival where they would be living.

This particular aliyah included many of the refuseniks, Russian Jews who had suffered serious persecution from the Soviet authorities because of their Zionist activities. Many were imprisoned on trivial charges or lost their jobs after applying to leave the country. Four of the refuseniks that came with this group had, in desperation, tried to hijack a plane to come to Israel. They were caught and imprisoned in Leningrad but were eventually released and came to Israel, where they were given a hero's welcome and received by President Yitzhak Navon. I was present at their arrival. Approximately twelve thousand newcomers arrived in 1986, mostly from the Soviet Union. This was nothing in comparison with the hundreds of thousands who came in later years.

Perhaps the most notable personality to come from the USSR was Anatoly Sharansky. After being denied an exit visa to Israel in 1973 on the grounds of "national security," he became an English interpreter for

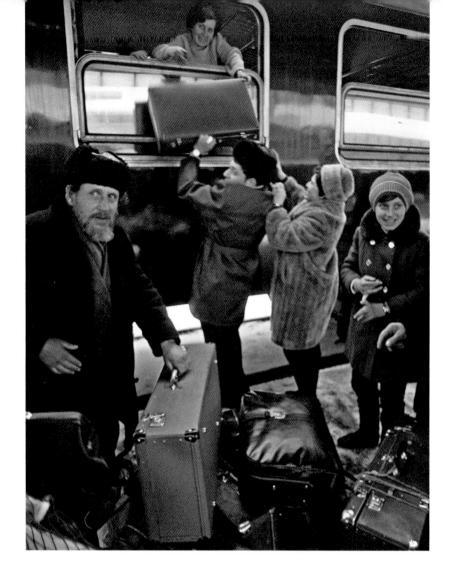

ABOVE
80. A Russian Jewish family at the Ost-
bahnhof, Vienna, en route to Israel, 1972.

OPPOSITE
81. A Russian woman and her daughters
newly arrived in Israel, 1972.

the prominent physicist and dissident Andrei Sakharov and also, like
him, a human rights activist. Arrested and convicted on trumped-up
charges of treason and spying for the United States, he was sentenced
to thirteen years forced labor, most of which he spent in Siberia. He was
eventually exchanged for a Soviet spy and came to Israel, where he
adopted the Hebrew name of Natan. I, along with many others all over
the world, looked up to this man as a champion who, against all odds,
had survived in his fight against the oppressive Soviet regime.

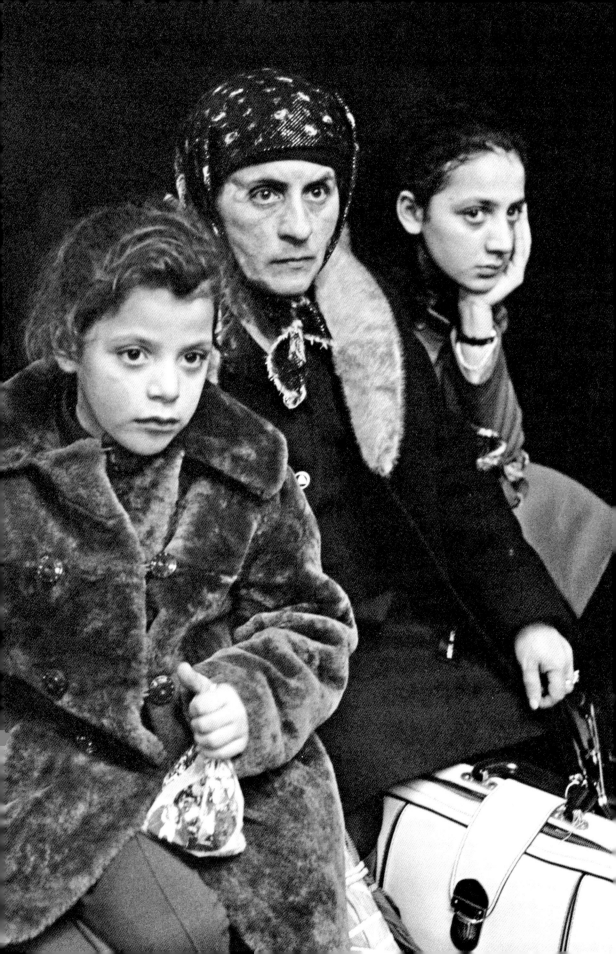

Thousands came to greet him at Ben-Gurion Airport, where he too had a hero's welcome, being met by Ministers Peres and Shamir. At the time of his arrival, he was totally secular. His wife had become religious, and he eventually followed her chosen path. He somehow slid into politics as the symbolic head of the Russian immigrants, and later developed a full-blown political party through which he represented their interests. Sharansky served as a member of the cabinet for a few years, but resigned in protest at the Likud government's plans to withdraw Israeli settlers from the Gaza Strip.

When he had first arrived, I, like many others, admired him because of his prolonged and impressive fight for human rights. Sadly, over the years, it has come to seem that my idol has feet of clay, and I have become wholly disillusioned with him. His progress on the political front coincided with a total abandonment of the principles that made him so famous, namely human rights. In my opinion, he has never supported human rights issues in Israel and, in particular, failed to address any matters concerning the Palestinians. His political platform emphasized the urgency for an "ingathering" of Jews from all over the world, but paid no heed to the displacement of Arabs in order to accommodate the newcomers.

The route that the Russians took was via Vienna, so on two occasions I went there to meet them as they arrived at the Westbahnhof from Eastern Europe. From here, I accompanied one particular elderly couple to the Schönau camp, stayed with them through their absorption procedure, and then traveled with them all the way to Arad, in the south of Israel. This particular couple did not speak a word of Hebrew, nor Yiddish, so communication between us was difficult. I remember thinking what it must be like for them, at their age, to leave home, family, friends, and familiar surroundings and travel all the way from the snow of Moscow to the desert and heat of Israel. In the photograph I took of them in their newly allocated apartment, the man sat looking forlorn and lost, while his wife stood by his side with an air of confidence—obviously keen to start "home building." This photograph reminded me very much of another one, which I had taken in 1967, of a similarly aged Arab couple fleeing Jerusalem in the direction of Jericho, with the man sitting disconsolately on the paved road, completely exhausted. Next to him stood his wife, upright with a determined air. I

came to the conclusion that women are more capable of dealing with these upheavals than their menfolk.

In the 1990s, with the collapse of Communism, the borders of the Soviet Union were finally opened, and a massive exodus of Jews (though it is questionable if many of them were truly Jewish) came to Israel. In 1990 almost 200,000 arrived, and in 1991 about 175,000. This wave of immigration comprised mostly educated people—academics, musicians, and professionals such as doctors and dentists.

As with any group of newcomers, it was difficult for many of them to find work that really suited them. There was an enormous influx of musicians who were absorbed into all the orchestras in Israel, but more often I saw them playing music, usually the violin, on street corners or in the pedestrian mall in Jerusalem. One man in particular performed with a beautiful young Russian girl who danced to his music and collected coins from passersby. It was also very common for quartets or trios of these musicians to be hired for private parties in homes. The story circulating at the time was that there were so many musicians arriving, one could assume that if a Russian came down the aircraft steps not carrying a violin, then he must be a pianist.

It was not uncommon to find doctors or other professionals sweeping streets or doing domestic cleaning work. As poignant as this seemed at the time, it must be said, however, that the resilience these people demonstrated was impressive, and it did not take long for most of them to improve their situations. This proved to be a very successful aliyah, both for them as individuals and for the country as a whole. The success of this aliyah was similar to the huge German immigration in the '30s, when one would frequently be served at a restaurant by a German professor. To this day, there is no way to summon a waiter in Israel except by calling him *Adon* (sir). One would never dream of using the term "waiter," as this is considered disrespectful—a hangover from those early days.

Many of the oriental community in the country were resentful when they observed the ease with which the Russians were absorbed. They felt that they had been discriminated against when they had arrived. They were never able to forget that their parents had been sprayed with DDT on entering the country, a process that for them had been both humiliating and an intolerable insult. What it boiled down to was the

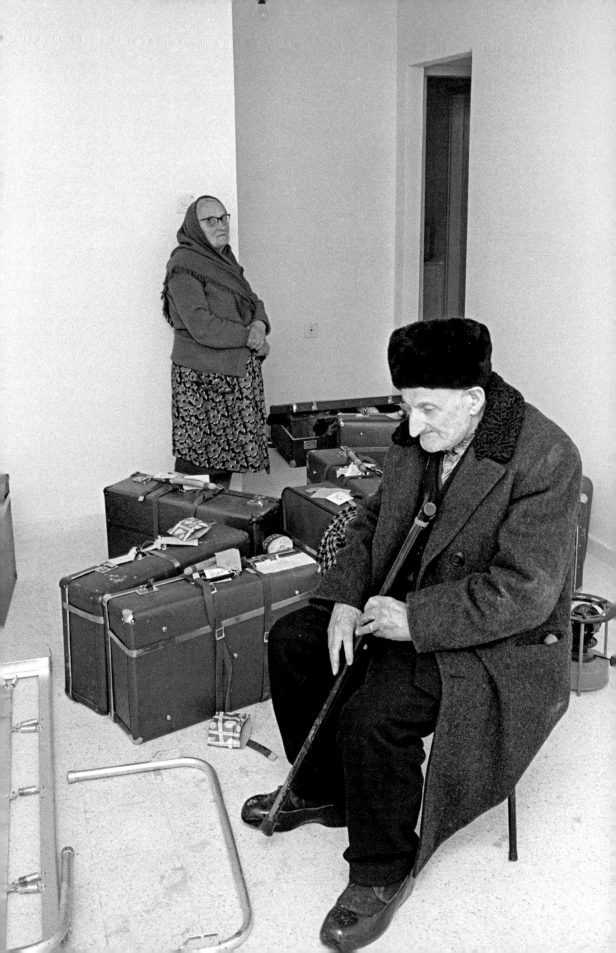

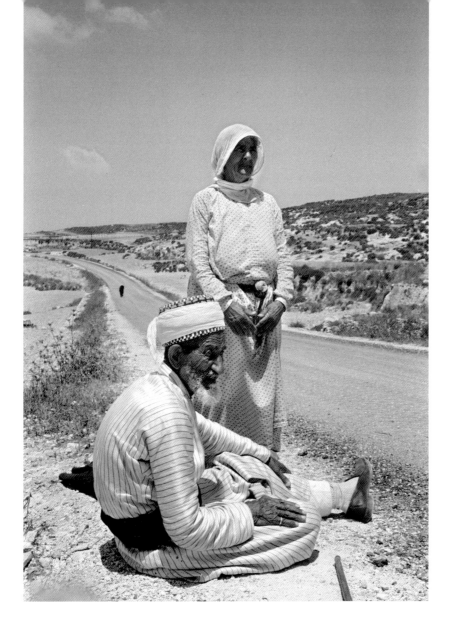

OPPOSITE

82. An elderly couple from Russia in their new apartment in Arad, 1972.

ABOVE

83. An elderly Palestinian couple fleeing Jerusalem, 1967.

fact that the majority of the Russians entered the country highly quali-
fied, with occupations that they could eventually follow, whereas the
majority of the oriental Jews did not have such professions to turn to.
Add to this the fact that most of the oriental Jews had come to Israel
much earlier, at a time when the country itself was struggling, and one
can understand why so many of them still feel aggrieved to this day.

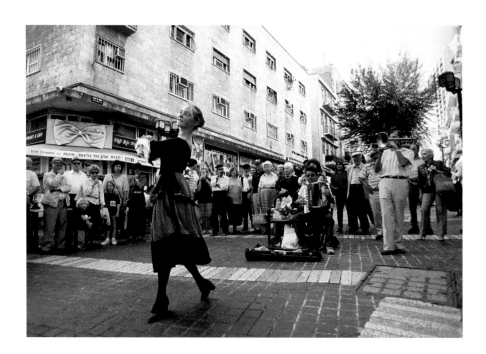

84. An immigrant from Russia dances for
alms on Jerusalem's pedestrian mall, 1992.

At around the same time, I photographed the next influx of new-comers—this time from Ethiopia. This group had a very interesting history. For centuries, world Jewry had not been aware of the existence of the Jewish community in Ethiopia, who lived in the northern province of Gondar. It was Menachem Begin who started the move to persuade the Mengistu government to consider allowing them to leave, and he succeeded in getting two hundred people released in exchange for arms.

Their position in Ethiopia became very bleak in the '80s. They were not allowed to practice Judaism, and forced conscription at the age of twelve took many Jewish boys away from their parents. Operation Moses was the first concerted effort to rescue them, and from November 1984 until January 1985 almost eight thousand were brought to Israel under a veil of secrecy. But it was really Operation Solomon, also carried out in secret, that brought the bulk of the Ethiopian Jews, or "Beta Israel" as they were called, to Israel. Around fourteen thousand remaining Jews were rescued in a modern exodus of the grandest design. It happened just in time, as in Ethiopia their situation had become critical, and their rescue was seen as yet another modern miracle for the Jews. The Likud government of Yitzhak Shamir even authorized a special permit to allow thirty-four El Al planes to fly on the Sabbath to ensure their safe arrival.

Many of the Ethiopian community in Israel who had arrived on the earlier aliyah were at the airport to welcome their relatives, so you can imagine how moving were the scenes of families being reunited. It was

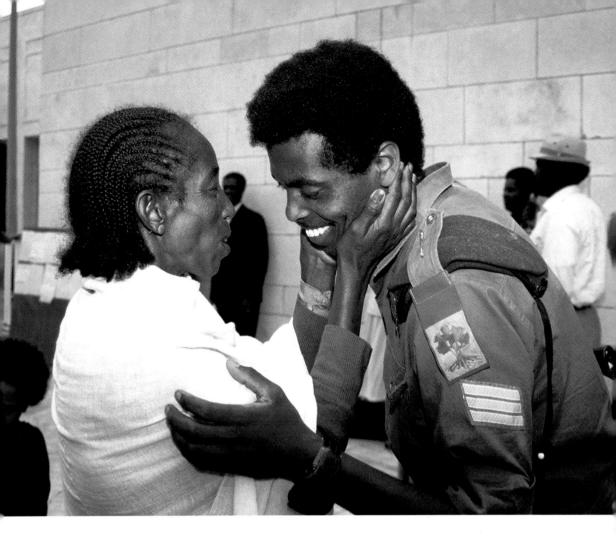

85. A sergeant in the Israeli army greets a family member newly arrived from Ethiopia during Operation Solomon, 1991.

a very emotional time. I covered one such story of a young man who had arrived in Israel as a child but was now a sergeant in the Israeli Defense Forces, happily settled and waiting for his relatives to join him. The photograph I took was of a proud young uniformed officer embracing an old wrinkled lady wrapped in a white shawl, presumably his mother or grandmother.

85

One of the most moving stories I have ever covered concerned another Ethiopian family, called Dessie, and their daughter Menhale. In the spring of 1984, Menhale was four and a half years old and living in Azazu, Ethiopia, when her parents determined to embark with her and their five older children on a dangerous journey. They began a month-long trek, together with sixty other Jews, to try to reach Sudan in the hope of finding passage to Israel. On the fifth night, they had to descend a mountain, and one of the guides who was leading the group

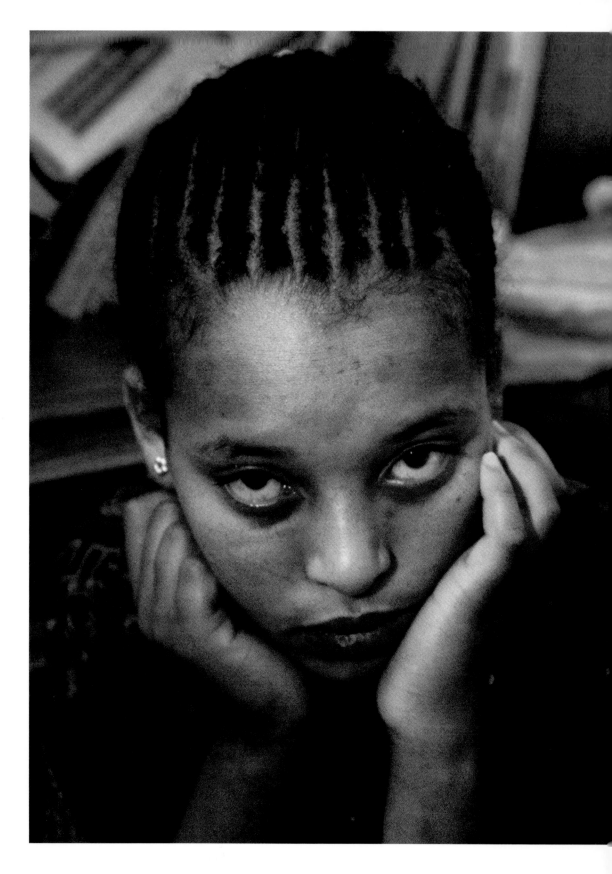

86. Menhale Dessie, the Ethiopian girl separated from her family during their trek to Sudan in 1984 and miraculously reunited with them nine years later. Photographed in 1993.

offered to carry the child. When they reached the bottom, Menhale was nowhere to be seen. The guide told her parents that she had been eaten by a crocodile, but her parents were sure that the guide had taken the $300 sewn inside the child's dress and abandoned her.

They looked for her for two days, but, finding no trace, had to abandon their search and left to continue their trek to Sudan and eventually Israel. They settled in the northern town of Migdal Ha'emek, where her father Genetu found work at a beer factory, and the couple had four more children. But nothing could erase the memory of their lost child. Her mother Dvora imagined that she had been eaten by a lion, had died of starvation, or possibly—just a faint chance—might still be alive. This last hope proved to be true.

What actually happened was that, a month after she vanished, Menhale appeared thirty kilometers away before the house of a devout Christian named Adaga Kabada. "She was almost completely naked, bewildered, and unable to utter a sound," he said. Kabada and his wife took her in and raised her as their own. After a few years, a man appeared, claimed to be her father, and took her away. He was an impostor who was a drunk and a wife-beater, and Menhale became a servant in his home. Eventually he sold her into servitude. In Israel, the Dessie family heard a rumor of a girl who had turned up lost nine years earlier. Genetu traveled to Ethiopia and met Kabada, and between them they found her. She was reunited with her family, who recognized her from photographs, and she now lives with them in Israel. I took pictures of her and can never forget the haunting beauty of her face.

86

The absorption of the Beta Israel was more problematic than that of people from other countries, as they had come from a culture in Ethiopia so indescribably different from that which they met when they arrived in Israel. They had left behind villages that to us seemed primitive, with no facilities such as running water, toilets, or electricity. They had, however, a strong sense of community and dignity and their enduring religious beliefs. It is said that miracles sometimes take a little longer, and it is good today to see so many of the second generation serving in the army and studying at the universities. This is one more example of how Israel has miraculously managed to integrate so many different peoples into one nation.

27. FOOTBALL AND THE LEBANON WAR

The great passion of my life ever since I was a small boy has been football.

Every day after school, I would be found in the street with some of the local boys, kicking a ball around. Although it was not actually a football but a bundle of rags tied together tightly with string, for us it was of Olympic quality—as were we, aping our football heroes with magnificent goals and outstanding saves. Playing football in the street, however, was not allowed at that time. One of us had to stand guard at the end of the street watching out for policemen and shout "Shmeer" (from the Hebrew word *lishmor*, "to guard") when one approached, so that we could abandon our game, hide the ball, and rapidly disappear into doorways and alleys.

I have maintained my devotion to the game throughout my life. It was quite fortuitous that the football ground for Jerusalem Hapoel was less than a hundred meters from our home in Katamon. I was appointed (or, to be more correct, self-appointed) to be an official photographer for the club, which meant that not only did I get in free to every match, but I was also allowed to sit right by the goalpost so that I could get the best shots of our team's winning goals. Every Saturday afternoon would find me, together with my young son Ami, cheering our boys on to greater efforts. What nobody knew at the time was that very frequently I did not even bother to put film in the camera, but clicked away professionally regardless.

If anyone had asked me what I would treasure more than anything else in the world if I could choose something I really wanted, the answer would always have been "tickets for the Cup Final." My dream eventually came true when Arnold Drapkin, picture editor of *Time*, knowing of my fervor for the sport, came up with the suggestion that

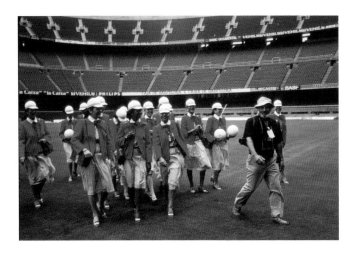

87. Myself with a group of uniformed hostesses preparing for the World Cup in Barcelona, 1982. Ariel Sharon spoiled this assignment, my best ever, by going to war in Lebanon. Photograph by David Drapkin.

perhaps Anni and I might like to take a couple of weeks off and go to Barcelona to cover the World Cup in 1982. I did not need asking twice!

I could hardly believe my luck that at long last I was about to realize my life's ambition. We flew out to Madrid a week before the games began and then on to Barcelona, where I was fortunate enough to be able to hire the last helicopter available so that I could fly over the grounds for the opening ceremony. The excitement in the city was palpable: one savored the anticipation of pleasures to come and the conversation of everyone around centered on one topic, the forthcoming matches.

During the preliminary warm-up for the event, I photographed a group of glamorous girls who were specially chosen to be hostesses for the event and, joy of joys, was present at the ceremony when Diego Maradona, the world-famous player, announced that he was to be transferred for $8 million to FC Barcelona. 87

The day before the start of the Cup Final, I received an urgent phone call to tell me that Israel had just invaded Lebanon and I had to return home immediately. I had no choice but to go, but felt exactly like a child who has had his favorite toy taken away from him. I could not believe my bad luck, and it was the most enormous anticlimax. I have never quite forgiven Ariel Sharon for his poor timing.

The 1982 Lebanon War, also known as the Invasion of Lebanon or Operation Peace for Galilee, began on June 6 when Israeli forces invaded southern Lebanon. The Israeli government justified this act as a response to the Abu Nidal Organization's assassination attempt on Israel's ambassador to the United Kingdom, Shlomo Argov, who was

seriously wounded outside a hotel in London, and to years of artillery attacks launched by the PLO against populated areas in northern Israel. The PLO, based in Lebanon, had by this time grown in number to around fifteen thousand and were backed by Syria. Another reason for the invasion was that Israel wanted to counter Syria's growing influence in Lebanon. But a former chief of Israeli military intelligence reported that both Sharon and Rabin had made misleading statements to the cabinet about the actual situation in Lebanon, exaggerating the level of terrorist attacks in order to gain support for and justify their actions. In fact, as Rabin later told the Knesset, there had been just two attacks in the north of Israel during the eleven-month ceasefire before the war.

The subtext to this war was the motive of Sharon, who was in alliance with the minority Christian Maronite community in Lebanon, headed by the Gemayel family, father Pierre and sons Bashir and Amir. Sharon hoped that, by our intervening in Lebanon, Gemayel would be appointed president, and thereafter he and Gemayel planned to broker a peace agreement between the two countries. This would amount to Israel's second peace agreement with an Arab state. Sharon made a promise to the Israeli cabinet that his invasion would terminate at forty-five kilometers over the Lebanese border, this being the point estimated to be just beyond the range of the Katyusha rockets that had attacked the northern borders of Israel over the years. Needless to say, he exceeded this limit.

My partner in Israel at this time was Dudu Halevy. Dudu had been originally hired by *Time* as a stringer. He had been in the army, from which he retired as a captain while still in his thirties. He then went into politics and subsequently on to journalism. Dudu's contemporaries who remained in the army went on to have prestigious careers as generals, or to hold similarly high offices. He was invaluable to *Time* because of the contacts that he had maintained with army personnel, and also because he was a "fixer" par excellence. I think the word *chutzpah* must have been invented for Dudu. He was wholly mercurial, and to see him in action was an experience. I recall one time when we approached an army roadblock on the Lebanese border. He drove towards it at high speed and came to a sudden halt with screeching brakes. Leaning out of the window, he yelled to the soldier on duty, "Has

Colonel Haim arrived yet? If not, tell him that Dudu has already gone through and is waiting for him!" The guard opened the gate, and we passed the control point with no questions asked. Needless to say, there was no such Colonel Haim. Another episode was when he rang me to ask urgently, "Can you be free for the next four days?" I confirmed that I could, but then heard no more. Again one evening he suddenly turned up at my home. I had not seen him for more than a year. Without any preliminaries, he demanded, "Can I use your phone?" and then left. This was Dudu. Unpredictable and unbeatable.

Dudu was the first person I made contact with on my return to Israel from Barcelona on June 6. That same evening found us in the headquarters of the Northern Command in Safed, where we asked for a meeting with Sharon. He agreed to see us, with his adviser, at 2 a.m. Sharon was very optimistic about his plans, but derided almost all the members of the Israeli cabinet, who, he said, "were coming at me with maps and a ruler and knew nothing whatsoever about planning a war."

One incident that took place early in the war exemplified this lack of knowledge about the realities of the situation on the part of the politicians. I accompanied Begin on his first flight up north to Beaufort. This fortress, located on a mountaintop in southern Lebanon overlooking the Israeli border, was built by the Crusaders and had been an impenetrable stronghold for centuries. Despite heavy bombing by Israel on several occasions, it was not captured until the Lebanon War. Begin's physical condition at that time was deteriorating, so a chair was brought along for him to sit on. He was told by the military that Beaufort had been captured without any casualties. This was patently untrue, as six young soldiers had been tragically killed in the attack. Despite the fact that Begin had seen action in his younger days, prior to the establishment of the State of Israel, it was apparent that he knew little of modern warfare when I heard him ask, "Did the enemy have machine guns?"

Over the years, many people have asked me what it is actually like to be a photojournalist covering a war. All I can say is that it is an extraordinary blend of danger and the commonplace, with a constant and sometimes disturbing interchange between the two.

When I began to recall the details of my involvement in the Lebanon War, I used my diary as an aide-mémoire, as I had kept one faithfully

every day since the early 1960s. It reads now like a crazy novel and reveals the hectic lifestyle I then had. I was scarcely in any place for longer than a couple of days, and for the duration of the war traveled back and forth to Lebanon on average three times a week. Apart from these frequent journeys, there were the trips I made at the time to Cairo and London, and two visits to the United States taking in several cities. All of this took place over a few short months. It was frenetic, exciting, and unceasing, with no pause for rest, except when I took ten days off and went to Marseilles and Monte Carlo. Today, in the serene autumn of my life, I look back and wonder how I managed to cope.

When following the progress of a battle, one has to use one's nose for news like a sniffer dog and make calculated guesses as to where the action might be. Sometimes you are right, sometimes not. You have to move around from place to place trying to get to the heart of things.

On the second day of the war, I decided to go to the western part of Lebanon to see if I could find out what was going on. The war was being fought on two fronts, the western one along the coast and the eastern one inland. We heard a rumor that Sharon's helicopter was planning to land at a small airstrip near the Lebanese border in the west, at Bezet, which had once been an R A F fighter base during World War II. Dudu and I went up there. As we had expected, Sharon did land there, his intention being to proceed to the battlefront in a small army helicopter. We asked if we could accompany him, but as there was only enough room in the helicopter for one extra passenger, Sharon chose me, and we left Dudu on the ground. I am not sure that he has yet forgiven me for this. We flew to Damur, where there was heavy fighting going on, and I watched Sharon being cheered by the troops, who were shouting, "Arik Melech Yisrael!" (Sharon, King of Israel). His enjoyment of this accolade was very apparent. On June 10, I went to Tyre, on the Mediterranean coast, and spent time photographing the streams of Arab refugees fleeing the fighting zone with their meager possessions. That same day, I returned by car to Jerusalem, where I took pictures of the first antiwar demonstration. The next day found me back up at Safed, in the Galilee, from where I proceeded to the eastern front under the command of Yanush Ben-Gal, the divisional commander, whose deputy was Ehud Barak. I spent half a day with them, shooting what I could. The following day, I went on to an army camp where the

first captured weapons were on display for the international press corps to see.

Two days later, I was in New York with Prime Minister Begin, staying at the Waldorf Astoria in Manhattan. We had come to meet President Reagan, who was addressing the UN. Begin also appeared on the television program *Face the Nation*. In another two days, we were at the White House for a meeting between Begin, Reagan, and Secretary of State Alexander Haig. We returned to Israel two days later, and the following day I was again in Jerusalem, producing a story for *Time* on the general effects of the war. To illustrate this, I photographed a completely empty King David Hotel, normally a place buzzing with activity.

Another two days on, back in Lebanon, the Israeli forces had reached Beirut. I went to the headquarters of the Lebanese Christian forces (the Phalangists) and settled in at the Alexander Hotel in East Beirut, where most of the international press corps was staying.

I had a great meal at the Ibn Sultan restaurant—all the restaurants in Beirut were amazingly good—then photographed more fighting, and went on to a meeting with the Gemayel family. While the war was raging, I decided to go up to Junieh, a sophisticated beach resort north of Beirut, where I witnessed Christian Maronite playboys driving around in their open-topped Maseratis and lounging around the hotel pools with huge gold crosses around their necks, as if nothing were happening. I engaged some of them in conversation and asked why they were not fighting, as it was, after all, their battle. They replied, "Oh, we leave this to the Israelis—they are much better at it than we are." A couple of weeks later, when the magazine gave me some time off, I decided to take Anni to Europe. We went to Marseilles and then on to Monte Carlo, and there, relaxing at the swimming pool of an exclusive hotel, I saw those same Lebanese playboys. Obviously they were deeply concerned about the situation back home.

July 5 saw concerted attacks by both the Israeli Air Force and artillery on West Beirut, the stronghold of Yasser Arafat and the PLO. The international press corps was comfortably installed on the roof of the Alexander Hotel, where we had a grandstand view of the action. We had taken sofas and easy chairs up there, and sat around drinking whisky, with our cameras resting on tripods, observing the battle in the distance as if it were a tennis match. People were bleeding and dying

out in the streets, and here were the journalists and photographers relaxing as if at a private cocktail party. It was sublimely incongruous. I went out and found my way to one of the Israeli artillery positions, where I saw 175 mm guns, which are generally fired against enemy targets thirty miles away, being used like sniper guns. Sledgehammers to crack nuts.

On July 9, I spent a pleasant morning shopping in the Armenian quarter of Beirut, where I bought myself two pairs of jeans, and then in the afternoon went to cover the fighting again. Eventually, by July 11, the PLO succeeded in hitting the Alexander Hotel. I was in my room at the time and heard a huge boom. The windows caved in, and all I saw was that the wall opposite the window was covered with holes, clearly from shrapnel. I was untouched.

On July 12, it was back to Jerusalem and then on to Cairo for meetings with Murray Gart, the chief of correspondents for *Time*. The next morning, I returned to Jerusalem, where I spent a relaxing day with my granddaughter, Meshi, at the pool of the King David Hotel. A week later, I returned to Beirut, this time taking Anni with me as if we were going on vacation. I felt a bit like showing off what Israel had achieved. We had lunch at a very good restaurant, and then I took Anni up to Byblos, a beautiful tourist spot thirty-seven miles up the coast from Beirut boasting a medieval town and Roman remains. We stayed in Lebanon for two and a half days and then went back to Israel, as another photographer, Micha Bar-Am, had been sent by *Time* to relieve me of my arduous duties for a while.

On August 4, I returned again to Lebanon. This time Dudu and I tried to make our way towards Beirut airport, where, we had heard, heavy fighting was taking place. On the way there, Yossi Ben Hanan met us. (I mentioned him earlier as the soldier who appeared on the front cover of *Life* holding a Kalashnikov above his head in the Suez Canal.) He was now a major general. When I told him where we intended to go, he said, "Are you crazy? It's mad out there." Instead, he handed me a roll of film that he had taken of the fighting at the airport himself and said, "Take this; you may find it useful." Yossi was something of a camera enthusiast, and some of his shots, showing our generals lying in a sandbox planning the war, were used in the next issue of *Time*, but without any photographer credits. In the event, I did not

bother to go to the airport. I suppose you could call this photojournalism by proxy.

On the same trip, I heard that our troops were clearing up a particularly difficult quarter of the city and so decided to join them. I sometimes wish that my brain would move into top gear more quickly than my enthusiasm and impetuousness. I found myself with a troop of nineteen-year-old combat soldiers (I was then fifty-eight) who were running forward while constantly under fire. There was no going back. I had no alternative but to try to keep up with them, and it was sheer hell. It certainly separated the men from the boys, and in this case it was definitely the boys who were in the lead. As bad as this experience was, that same day the Alexander Hotel had been the target of a PLO car bomb, and my good friend Shlomo Arad, the *Newsweek* photographer, was injured while sitting on the terrace drinking coffee. I could easily have been there with him. So much for making informed decisions as to where it was best to be, running an obvious risk with the troops in battle or relaxing drinking coffee in the hotel.

On the evening of August 9, I was back in Beirut, dining once more at the Ibn Sultan. Photographers spent money like water in those years. I remember one of them kept ordering caviar, champagne, everything. A *Time* editor visiting from New York observed, "Wow, I think Arnold Drapkin's boys are going crazy." They were. Demetra Kosters, the lady in charge of expenses in the picture department, evidently thought likewise. She later told me that the only time she ever "blew her fuse" was when she got a bill for $5,000 from Beirut for the purchase of T-shirts specially printed with the words "Please don't shoot me, I'm a *Time* photographer." I never did find out how effective this message was in protecting my colleagues.

Not every item of expenditure was extravagant, however. During the war, it cost $300 to cross from East to West Beirut in a taxi. The ride took maybe five minutes, but because it was so dangerous, the price was understandably very high.

On August 10, I went up north with an artillery unit, and the same evening we had dinner with Fadhi, one of the leaders of the Phalangists, at the Cordon Vert restaurant. His assessment of the situation was rosy. "We are going to rule Lebanon," he said, conveniently forgetting that the Christians were a minority comprising only 12 percent of

the population. A couple of days later, there was a very heavy aerial bombardment in Beirut, which I photographed from the roof of the Alexander Hotel once more—warfare coverage de-luxe. The sky was lit up like a fireworks display. In the morning, it was back to Jerusalem for talks between Begin and Philip Habib from the U.S. State Department, who was using his good offices to try to bring about a ceasefire and settlement, even while the Israeli bombardment continued. By August 16, I was back on Israel's northern border at Metulla. Dinner was at Vered Hagalil in the north of Israel; the following day I went again to Beirut and the same night back to Jerusalem. Each journey from the border to Jerusalem was about four hours. I covered a lot of miles. This possibly explains why today, when friends ask me how I can be bothered to travel from my home in Jerusalem to, say, Ramat Hasharon just for coffee, I explain that to me it is kid's play.

We went up north again, this time to Junieh for lunch with Rudi Frey, the *Time* photographer based in Rome. On this trip we brought Anni and Dudu's wife Miki to "show them the war." We returned to Beirut after lunch, packed up all our gear in the car, and were just ready to leave the hotel when a tremendous explosion rocked the whole area. The target was the headquarters of the Phalangists, situated only about 150 yards from our hotel. I was still upstairs in my room, but Dudu, who was downstairs near the car, ran immediately in the direction of the blast. I wanted to follow him but realized that my cameras were still locked in the car boot. We quickly assessed the situation and thought it prudent to leave promptly, fearing that the border would be closed. On the way, we listened to the radio stations, which reported that Bashir Gemayel was taking part in the rescue and helping the wounded. For some uncanny reason, Dudu kept insisting that he knew better and that Gemayel, the would-be president, was dead. Dudu may have guessed this from the hysteria he had witnessed among the Phalangists in the few minutes he had spent near their headquarters before running back to our car.

A few hours later, we dropped off Dudu and Miki in Herzlia, and Anni and I continued to Jerusalem. At around midnight, the phone rang. It was Dudu to say triumphantly, "Now what did I tell you? You heard the news? Bashir is dead." We immediately rang a guy we knew who owned a small Piper plane and asked him if he would fly us to

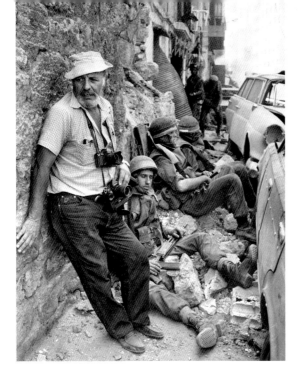

Beirut. He was very reluctant to agree on the grounds that he had no permission to land in Lebanon, but *Time*'s money talked. We took off from Herzlia at 8 a.m. without any formalities, as if we were going off on a pleasure trip, and flew back to Beirut. We landed without any problems, found a Lebanese driver, and asked him to take us to Bikfaya, the hometown of the Gemayel family. We were pretty certain that the funeral would take place there. It was also rumored that Sharon was there with the Gemayel family in their hour of grief.

The little town was seething with activity. The funeral cortege left their home and was conducted with all the pomp and ceremony that the Phalangists could muster for the first-born son of Pierre Gemayel and their president-elect. It was like a military parade, with flags, highly decorated uniforms, fanfares, and drums accompanying the elaborate casket as it was slowly carried to the local Maronite church. The route was lined with thousands of people, the women beating their breasts and wailing. Everyone was in total shock that their "son," the bright hope for the future, had been taken from them.

The whole dispute about *Time's* article on the Sabra and Shatila massacres, implicating Sharon, and Sharon's subsequent libel suit against the magazine could be said to have originated on this day. The trial hinged on the question as to whether Sharon was aware that the Maronite Christians would take the terrible revenge they did on the Palestinians. The question was also raised as to whether he was in possession of all the facts and whether or not he gave his silent consent to the events that led up to the massacres.

After the funeral, I went back to Beirut, where street fighting broke out the next day. Israeli troops were advancing under fire, and I went

88 along with them. Many of my strongest war pictures in Beirut were shot that day. Tanks were rolling through the streets, cars burning on every corner, dead bodies lying unattended, and our infantry fighting
89 from street to street through clouds of protective smoke screen. Until then, West Beirut had been occupied by the Palestinians. The area was their stronghold, and thousands of PLO fighters under the command of Yasser Arafat were concentrated there. They were now virtually trapped by the Israeli forces; however, in order to avoid further casualties, the United States insisted on a truce under which Arafat and his followers were allowed to leave en masse and go into exile in Tunisia. This offer was happily accepted, and thousands of PLO fighters assembled at the port in Beirut, cheering and waving and giving the "victory" sign as if they had won the war. The Israelis and the Americans watched them leave. They had Arafat in their gunsights the whole time. It would have been very easy for them to pick him off at any moment, had they chosen to do so.

With the conquest of West Beirut concluded, I flew back to Israel on an NBC plane with my film, shipped it to New York, and went immediately back to Beirut, as elections were scheduled to take place there in the next few days. For the first time, I was now in the western part of the city, where I met many of my colleagues from *Time* as well as other journalists who had been covering West Beirut while I had been in the eastern part of the city. We had a great get-together at the Hotel Commodore, which they had been using as their headquarters. It was quite an eye-opener to be on the western side, which for so long had been occupied by the PLO. I photographed Israelis and Phalangists as they pulled huge amounts of weapons, all types of guns and cannons, from the cellars where the PLO had stored them.

This trip was really the end of my involvement in the Lebanon War. I returned home and, in doing so, missed what was undoubtedly one of the major stories of the war, the massacre of Palestinians in the Sabra and Shatila refugee camps. This event shocked the world and appalled many in Israel, although no Israeli troops were involved in the killings. Instead, Christian Phalangists were sent into the camps to clear out all remaining Palestinian fighters. What they in fact did, however, following the earlier pattern of the Lebanese Civil War, was to wreak vengeance on the Palestinian civilian population, especially in the after-

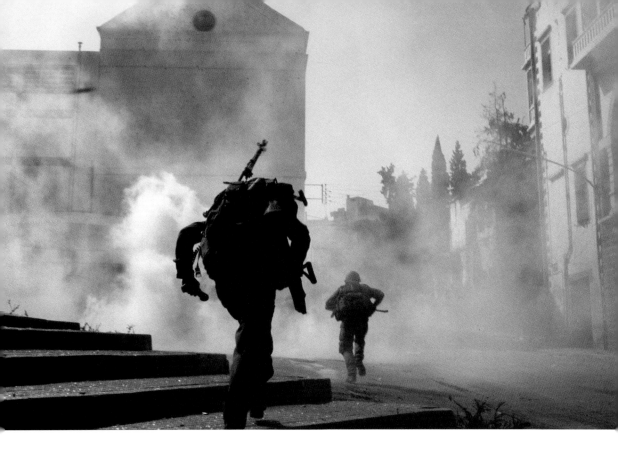

89. An Israeli infantry unit advances into West Beirut.

math of the assassination of President-elect Bashir Gemayel. Many in-
nocent civilians, including women and children, were murdered.

I became involved in this story only later, when Israel established a
commission of inquiry into the incident, following the demands of a
wide cross section of Israeli society as well as international pressure.
Ariel Sharon and the military leadership were accused of being party to
the crime, even though they had not physically lifted a finger. Supreme
Court Justice Yitzhak Kahan headed the commission. The second
member was Aharon Barak, later president of the Supreme Court. The
third member, nominated by the military, was my close friend Major
General Jonah Efrat, who had risen to officer in charge of central com-
mand and had been called back from retirement to be part of the com-
mission of inquiry.

The story of how our friendship with Efrat began goes back a long
way. While Anni was in the Riga Ghetto, amongst her closest friends
was a young boy named Monia Sherman. His girlfriend was Anni's best
friend. He was a Jew from Riga who somehow survived the first mas-
sacre by the Germans.

Over the years, Anni heard nothing from Monia and was not even
sure he had survived. You can imagine their joy when they bumped into
each other, quite by chance, in Tel Aviv some years later. He was now a

captain in the Israeli paratroops. We became very friendly and through him got to know a large circle of army officers who lived in the Ramat Hasharon area. We were the only nonmilitary couple in the crowd, which included Jonah Efrat and his wife Drora. Anni's friend Monia in later years became the mayor of Ramat Hasharon. Jonah Efrat was something of a legendary figure in the Israeli army, known for his integrity and incorruptibility. Despite our close relationship, he never passed on even the slightest tip or hint to me that would have benefited me in my work as a photojournalist. If anything, he was probably more careful not to tell me anything because of our friendship and the fact that I worked for the press. There was a popular joke in the IDF that when the road connecting Megiddo to Afula was constructed, they laid Jonah down beside it, and the road became known as the "Ruler Road," because it, like him, was so straight.

Only once do I remember having an altercation with Jonah. One day, a group of Palestinian gunmen crossed over from Jordan and attacked a building in Bet She'an, killing a man in his apartment. The army stormed the place and killed the Fedayeen. Immediately a mob of Bet She'an residents grabbed the Arab corpses and threw them down from the third-storey window to an angry crowd below who set fire to them. I photographed the scene through the window from which they had been thrown. When *Time* published these gruesome pictures the following week, showing the mob around the burning bodies, Jonah, who had come to our home for lunch with his family, berated me. "Had I seen you take these photos, I would have smashed your camera," he said. I argued with him and hoped that the point I made convinced him. I said, "No matter how ugly the truth is, owning up to it serves you best." You can be sure that the world's press would have written up the story and made much more of it. At least this way, they got the truth. I told him that I was convinced that the best course of action is always to admit that it should never have happened, that it was wrong, and that you regret it. It is, and always has been, my firm conviction that this is the best way to deal with incidents that may not be complimentary to Israel. The truth will always do less harm than the rumors you try to deny.

Once the Kahan inquiry began, no photographers were permitted to enter the hearings. On the day that Begin was called to give evidence, I caught sight of Jonah as he was about to enter the building where the

committee sat deliberating. I had brought with me a tiny 35 mm Rolleiflex, about the size of a cigarette pack. I said to him, "Please take this in, show it to the chairman, and ask if I may come in and use this little camera—it has no flash and makes no noise whatsoever." Jonah did so, and Kahan agreed that I could attend the hearing and take pictures. I therefore obtained exclusive images of Begin sitting before the three judges while giving his evidence. The Government Press Office were so furious that they had not been allowed in that they threatened to withdraw my press card unless I gave them the negatives. I gave them one negative, which was subsequently distributed to the world's media under the name of one of the photographers who worked at the press office.

The hearings went on for several weeks, and eventually, on February 7, 1983, the results were handed over to the prime minister's office.

The commission found that there was no evidence that Israeli units took direct part in the massacre, but that it was the "direct responsibility of the Phalangists." The commission did, however, record that Israeli military personnel were aware that a massacre was in progress but did not take serious steps to prevent it. Ariel Sharon was personally criticized for his inaction.

Two years later, Sharon brought a libel action against my employers at *Time*, who had published a story based on a report from Dudu Halevy. As part of the proceedings, I was ordered to come to New York with my diaries and make a deposition as to the movements of Dudu and myself during that period in Lebanon. Dudu had claimed in his report that, in Appendix B of the commission's findings, which remained confidential and has never been published, it was stated that Sharon had encouraged the Gemayel family to take revenge for Bashir's assassination.

Those who were permitted to look at the secret appendices found no proof of this allegation. Although the jury found the accusation unjustified and the article defamatory, they decided that it had been published without malicious intent. Accordingly, Sharon's $50 million claim against *Time* was rejected.

On the Saturday following the appearance of the article, the Efrats were again at our home for lunch. Jonah confirmed what the jury was later to decide. "David, I cannot tell you and will never tell you what is in the confidential Appendix B. One thing I can say is that the *Time*

account of the massacre is not contained in it." Another of our senior correspondents, Marlin Levin, a religious Jew who sat next to the secretary of the Kahan Commission, Judge David Bar Tov, in synagogue that Saturday, told me that he heard almost exactly the same words from the judge as Jonah had told me. Sharon continued to deny strenuously his involvement in the massacre, and later sued *Time* again, this time under Israeli law. He settled for $15,000.

At the end of the Lebanon War, Israel withdrew its forces, but only to eighteen kilometers from the Israeli border, in order to create what they optimistically hoped would be a security zone. Sadly, hostilities continued, the situation deteriorated, and it was now not only the Palestinians but also the Lebanese Shiites, backed by Syria, who were fighting the Israeli army. The casualties suffered by Israel were higher than in the entire war. Hezbollah became more and more efficient in their attacks on any Israeli movement in the zone. The roads were especially vulnerable, with vehicles frequently being destroyed by roadside bombs and mortar fire. Anyone driving into the zone went with great trepidation, and it was essential to wear a flak jacket and steel helmet. At one point, Israel started armor-plating civilian cars to be used by their special forces. I had to go there very often to cover the ongoing conflict, and each time I went it became progressively more terrifying. I once drove with a brigadier general who was not ashamed to admit that, despite his lofty rank, he was sitting there in the car "tight-assed." I found it more alarming to drive in an armor-plated Mercedes there than to be in that Syrian artillery ambush during the Yom Kippur War in 1973.

The situation in the security zone demonstrated what many people have since learned, that even the most heavily armed force is at a great disadvantage fighting against guerrilla units operating on their home ground. This scenario has been repeated worldwide. It is the centuries-old story of David and Goliath, where the little guy uses his strongest weapon, namely, his readiness to die for his cause, in order to overcome the heavily armed Goliath who does not have the same sense of commitment.

Israel had, in the meantime, created a force of several thousand Lebanese Christians known as the South Lebanese Army. The Israeli government paid their salaries and provided them with uniforms and

arms. The SLA suffered many casualties. When, in 2000, Prime Minister Ehud Barak finally withdrew all Israeli troops to the international border, these Lebanese soldiers were left in a highly precarious position. They were regarded as traitors by the Lebanese and given a frigid reception by the Israelis. Some decided to settle in northern Israel but felt abandoned by all and claim to have only received minimal help in rebuilding their lives. Others chose to return to Lebanon in the hope of an amnesty. These people, however, represent an unresolved problem that has persisted until today.

28. RUBBER BULLET—THE FIRST INTIFADA

Apart from a car accident on Cyprus, I have been remarkably lucky to emerge unscathed through all the many hostilities I have covered as a photographer. The only time I was actually shot was when an Israeli soldier firing rubber bullets hit me in the behind. It was painful, but in the end (excuse the pun!), worthwhile.

The incident took place during a visit I made to Gaza in 1988 with some of the senior management of *Time*, including the managing editor, Henry Muller. We were the guests of the head of Hamas, Sheikh Ahmed Yassin. At the time, Israel found it convenient to tolerate Hamas, adopting a policy of "divide and rule" in the hope that friction would develop between the secular PLO, then Israel's main adversary, and the Islamic Hamas. What they failed to realize at the time, however, was that, by giving tacit support to Hamas, they were helping to create a monster. When, after Oslo and Israel's agreement with the PLO, Israel began to see that its former policy had been misguided, Yassin was held in an Israeli jail under administrative detention. He was later released under an agreement between Israel and the PLO, the latter wanting him freed in a move to placate the Palestinian population. Hamas later developed into a major threat to Israel, and Yassin was singled out and eventually killed in a "targeted assassination"—the term used by the Israel Defense Forces for removing leading terrorists.

Our meeting was conducted upstairs, on the first floor of Yassin's home, but this did not hold much interest for me, so I went outside and photographed a group of women and young boys gathered around the house. Suddenly an Israeli jeep came swerving around the corner. In the back were two soldiers who peppered the group with rubber-coated bullets. One of these hit me in the aforementioned part of my body, my dignity being more bruised than my posterior. Why did I mention

earlier that the incident was worthwhile? The whole entourage from *Time* had a grandstand view from the first-floor window, and I emerged as a "five-minute hero" in the eyes of my employers. It probably gave them something to talk about at dinner parties over the next few weeks. It did not, however, lead to them paying me any danger money!

This particular incident took place during the early days of the First Intifada, the grassroots Palestinian uprising that started in 1987. There are varying suggestions as to how this uprising began. One suggestion is that it began after an Israeli truck had been involved in a traffic accident in Gaza in which several Arabs were killed. It was a genuine accident, but the population was so inflamed by the incident that it became the pretext for taking positive action. Their anger had in fact been seething for some time, undoubtedly because of the effects of living under Israeli occupation for the past twenty years. A whole generation of youngsters had grown up under the control of the Israelis, but they were not prepared to resign themselves to that fate, as their parents and grandparents had done after their successive crushing defeats in 1948 and 1967. Another reason for the Intifada starting at this particular time, it was claimed, was the disappointment felt by many Palestinians at the failure of their leaders to improve their quality of life, compounded by the fact that they were not getting the same level of support from other Arab countries as in former years. Some action had to be taken by the Arabs in the street, and an outbreak of violence was inevitable.

Demonstrations spread like wildfire. Youngsters literally took matters into their own hands, throwing stones and rocks at Israeli troops and policemen at every opportunity, and they soon began to use more lethal means, such as homemade bombs, grenades, and occasionally firearms. There were many acts of civil disobedience as well as mass rallies, general strikes, roadblocks, and the burning of tires.

It is too easy to forget, when hearing all the talk of violence by the Palestinians, that they are, or were, probably the most westernized and educated Arab group in the Middle East. Palestinian teachers, academics, and engineers made up a large percentage of those professions in neighboring Arab states. They have even been called the Jews of the Arab world.

It was perhaps partially because of this cultural heritage that the younger generation found it impossible to sit quietly and suffer the

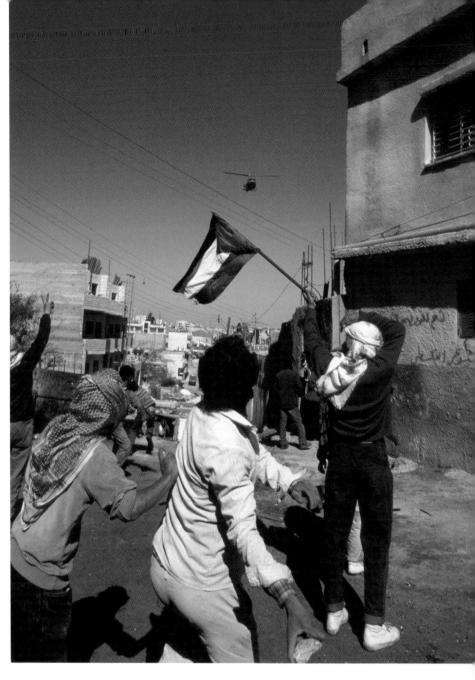

90. Palestinian youths throw stones at an Israeli
helicopter that is preparing to dump gravel on them
to break up their demonstration. Ramallah, 1988.

indignities imposed upon them by the occupation. I recall a story told
to me by a Palestinian doctor whom I had come to know quite well and
whose version of events I considered trustworthy. He had driven with
his wife and two small children from Ramallah to Jerusalem. At a road-
block, his car was stopped by the Israeli border police, who demanded
their identity cards. After scrutinizing them, the policemen threw all

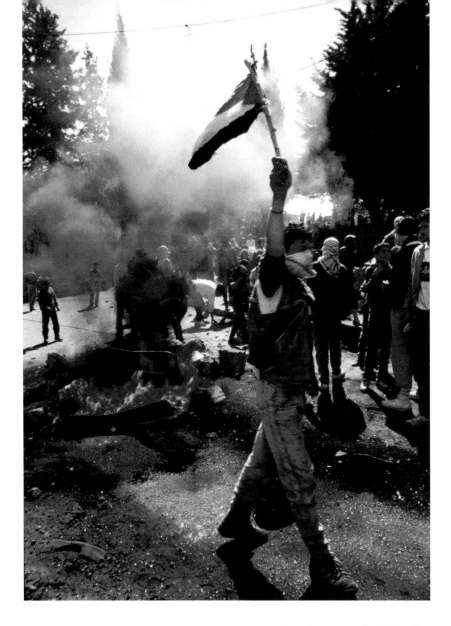

91. Burning tires at a Palestinian demonstration in Ramallah, 1988.

four IDs onto the ground with the words "Pick them up and get lost." After relating this story to me, he said, "God knows I am not a terrorist, but after this experience I think I was ready to become one." This type of behavior by our border police, who would no doubt justify it in the name of national security, has done nothing to help Israeli-Palestinian relations and indeed has made things far worse.

In 1988, a large number of middle-class Palestinian Christian merchants began a nonviolent protest and withheld taxes. Many were imprisoned, and Israel dealt with the protest by fining the merchants and in some cases impounding property from their homes or businesses.

At the time of the First Intifada, I was, at the age of sixty-three, still young enough to cover it. One day, I attended a press conference called by the mayor of Ramallah, Karim Khalef, and a leader of the P L O. With me was *Time*'s West Bank correspondent, Nafez Nazzal. There was little that Khalef had to say that was of interest to anyone, and the TV crews and journalists were close to yawning. Suddenly the door burst open and in strode the Israeli military governor of the city. Full of self-importance, he announced, "I hereby declare this gathering illegal!" Everyone sprang to life, and the cameras started to roll. At last the press conference had borne fruit. Khalef could not have been more delighted. At this point, my friend Nafez said to me, "See, it used to be that we Arabs saved you at the last moment with some dumb thing we did. Now it is the other way around." I realized then just how much the Palestinians had learned from the occupation.

90, 91 I covered many of the demonstrations that took place around this time. Once I was in Nablus, where young men were burning tires and waving Palestinian flags, which at that time were illegal to display. I was in the middle of the crowd when an I D F helicopter flew in and unloaded what must have been close to a ton of gravel onto us. Not fatal, but really unpleasant. This was one of the strategies employed by the Israelis in their battle against this "Stone Intifada." Another was to send in a jeep equipped with a cannon that spewed out volleys of gravel at demonstrators. Stones against stones.

The First Intifada continued for four years. Its effects were far reaching, for not only were Israelis the target, but around one thousand Arabs were also killed for political and other reasons by Palestinian death squads. This number exceeded that of those killed in clashes with the Israeli troops during this period. Violence had become the norm, and there was a breakdown in the social order that affected everyone. The violence began to lessen only around the time of the Oslo peace talks. These talks, initially held in secret, were to try to work out some agreement between the Palestinians, who wanted a state of their own, and the Israelis, who wanted security and an end to the aggression. The talks eventually resulted in the acceptance by the P L O of a two-state solution and the first admission by Yasser Arafat that the Jewish state had a right to exist. Previously the P L O's official doctrine had repeatedly advocated the destruction of the entire State of Israel.

216

The talks continued for about five or six years, finally culminating in the famous handshake between Yitzhak Rabin and Yasser Arafat on the White House lawn. It was optimistically and perhaps naively believed that the agreement would bring an end to the violence. While only a schematic and deliberately nonspecific plan, it stated that both sides had a right to exist independently of each other with peaceful relations between the two. The implementation of the plan was dependent on an end to the violence on the part of the Palestinians and the end of the occupation and the removal of settlements on the part of the Israelis.

This all collapsed with the assassination of Rabin, which cruelly dashed the hopes of peace lovers on both sides. Peres took over as prime minister, and this virtually coincided with the first of the suicide bomb attacks in Israel. Three buses were blown up in Jerusalem and one in Tel Aviv, causing many deaths and injuries. Matters began to escalate, in part because the left then lost the elections and the right came to power, with Benjamin Netanyahu as prime minister. Initially he paid lip service to the Oslo Accords, stating publicly that while he did not like the terms of the agreement, since the government of Israel had accepted it, he was bound by it. In practice, it appeared that he did everything possible to scupper the plans.

Things went from bad to worse. Extremists on both sides were highly vocal in their objection to the Oslo Accords. Some far-right rabbis claimed that Peres, and Rabin before him, had betrayed their country. This atmosphere had been building for some time, to the extent that, at political rallies prior to Rabin's assassination, posters were displayed of him wearing an Arab *keffiya* (headdress) with a bull's-eye in the middle of it. He was also shown wearing Nazi uniform, and right-wing protestors took delight in burning his image publicly. On the other side, the Islamic imams were constantly preaching from their mosques the vilification of Israel and death to all Israelis, which they justified by the teachings of the Koran.

29. THE SECOND INTIFADA AND THE SETTLEMENTS

In July 2000, President Bill Clinton initiated further peace talks at Camp David, attended by Yasser Arafat on behalf of the Palestinians and Prime Minister Ehud Barak of Israel. The objective was to negotiate a final settlement of the Arab-Israeli conflict, based on the Oslo Accords. After fifteen days, the negotiations ended in failure as no agreement could be reached on final status issues. This unsatisfactory outcome fueled the Palestinian discontent that led inexorably to the Second Intifada, which began less than three months later.

By this time, I was in my mid-seventies and had given up chasing after every piece of hot news. As with the First Intifada, the second one was based largely on the pretext of a particular incident. On September 28, Ariel Sharon, the Israeli opposition leader, visited the Temple Mount in the Old City of Jerusalem, the holiest site for Judaism and the third holiest site for Islam. His visit was officially announced and approved in advance, although politicians on both sides objected to what they saw as a needless provocation on his part, warning him that it could lead to riots. Sharon insisted, however, and declared that he was going to the Temple Mount with a message of peace, although it was obvious that he took this course of action to appease right-wing voters. The visit was condemned by the Palestinians, who viewed it as a provocation and an incursion, as was the one thousand–strong complement of armed bodyguards and police who arrived with him.

The next day, serious riots broke out in and around the Old City of Jerusalem, and even more disturbances occurred in the West Bank and Gaza. Matters escalated, with both sides now using guns, grenades, and rocket launchers. This resulted in considerable numbers being killed and injured. This state of affairs eventually led to a spate of Palestinian suicide bombers attacking Israeli civilians, with catastrophic

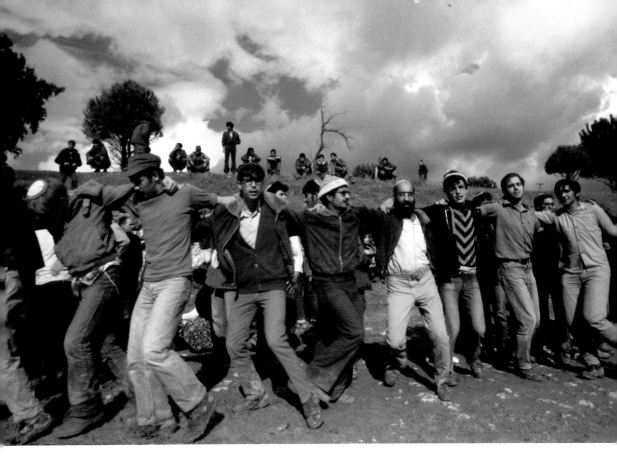

92. Gush Emunim activists celebrate the foundation of the Kedumim settlement, 1975.

results. Tragically, these atrocities have continued to this day. Because of my advancing years, I found myself watching from the sidelines, glued, like everyone in Israel was, and still is, to the hourly television and radio news. The old instincts were there, but I no longer felt the compulsion to rush out to the center of the action. I remember sitting with a friend in my office one day when suddenly we heard sirens blaring outside in the street—probably police cars and ambulances. It was a sign that something important had happened. My friend turned to me and asked, "Don't you feel that you have to run out and take pictures?" to which I replied, "No, not any longer." I think one comes to a time in life when one accepts that chasing around is best left to the youngsters in the business and that it's one's turn to lean back and relax for a change.

One of the main areas of conflict between the Palestinians and Israel was the question of the settlements. The Arabs wanted these dismantled. On the Israeli side was a demand for the end of hostilities. This thorny issue goes back quite a long way.

It was Passover 1968 when a group of right-wing activists, under the leadership of Rabbi Moshe Levinger and his wife Miriam, decided to

hold a seder at a small hotel in Hebron, which at that time was a totally Arab town. The hotel owners welcomed the Jews and permitted them to celebrate their seder. When the evening ended, however, the group refused to leave, stating that they had a right to stay. These young members of the National Religious Party were convinced that they were on a divine mission. After all, God had given them victory over their enemies against all odds in the '67 war, so they felt compelled to become pioneers and settle all the land that they considered to be part of Eretz Yisrael. The Israeli courts ordered them to vacate the premises, and eventually the Israeli army had to come in and move them. After heated negotiations, Yigal Alon, who was then foreign minister, arranged for them to be temporarily settled in a nearby derelict police station that was close to the IDF command post. This place eventually grew to become Kiryat Arba, renowned as a stronghold of the group Gush Emunim—the Bloc of the Faithful. These ultraright, mainly religious Jews maintained that the West Bank, or, as they called it, Judea and Samaria, had always been the homeland of the Jews. Consequently they claimed the right to live anywhere in these territories that they chose. I went there to photograph them a day after they had settled in. Although they were only a small and seemingly insignificant group making their own particular political statement, in retrospect I realize that this represented the beginning of what has become a major movement in Israel.

Sometime in 1975, I heard that, once again, a group of right-wing activists were trying to occupy a disused old railway station, dating back to the time of Turkish rule in Palestine, at a small place called Sebastia. This incident was one of the first occasions when Jews were attempting to settle on the hilltops in Judea and Samaria. The Labor government under Yitzhak Rabin wanted to evict them, since they were there illegally. However, Shimon Peres, as defense minister, provided the group with water tanks and electric generators—in other words, with the basic necessities for them to settle on this spot. The railway station was just one solitary disused building, and the group eventually left it when they were offered another site close to an army camp, which would later become the village of Kedumim. Throughout this period, it was illegal for Jews to stay overnight anywhere across the Green Line, but the authorities conveniently ignored this fact. Gush activists were permit-

ted to erect their tents and caravans without opposition, and although they were few in number and conditions were hard, their ideological fervor carried them along. I took many pictures of them dancing and celebrating with their leader, the same Rabbi Levinger who had started that first group in Hebron. 92

The settlements in the West Bank continued to proliferate, and in 1979 I was assigned by *Life* to do a story about them, as they were by now regarded as a controversial issue. I was interested to discover who they were and find out what type of people would choose to follow such a path. I also wanted to see what kind of life they had carved out for themselves. The location that I selected was Elon Moreh, a new settlement based on a hilltop overlooking the town of Nablus. I stayed there for two nights and was accommodated in one of the tents. This was the norm, for at that time all the residents were still living under canvas, although a paved access road had been built, and in the center of the settlement a long sink with five or six taps had been set up for communal use. A generator had also been installed to provide power.

As distinct from the early pioneering groups in Israel, who were predominantly single people working the land, all the residents of Elon Moreh were families with several children. They numbered about 93 two or three dozen inhabitants in total. Once again it was their missionary zeal that carried them through, enabling them to cope with the physical hardships they had to endure. I took many photographs, but the image that stays uppermost in my mind is that of a young father, maybe thirty years of age, with a wild, unkempt beard, holding one of his children in his arms. His *tzitzit* (ritual fringed garment) were hanging out of his shirt, and he had an M-16 rifle slung casually over his shoulder. This image of an outwardly religious man holding a machine gun has come to represent for me the ethos of what is happening in the settlements. It was to Elon Moreh that I went with Menachem Begin as he carried the first Torah scroll to their new synagogue in 1979. The ceremonial procession was very joyous, with singing and dancing along the route to the synagogue. Begin addressed the crowd with the words, "There will be many more Elon Morehs." A traditionally observant Jew, he became fired with enthusiasm for the development of these new settlements, so much so that, after he assumed the premiership, he visited Neot Sinai, a new settlement in the Sinai,

where he declared, "I promise to come and live here when I retire." He
was possibly modeling himself on Ben-Gurion, who retired to Sde
Boker in the Negev.

In the late '70s and '80s, I went on many tours to the West Bank with
Ariel Sharon when he was a cabinet minister. His attitude towards
the settlements was not guided by any religious zeal but rather by a de-
sire to see every hilltop occupied for the purpose of strategic defense
and also to prevent the creation of a Palestinian state. I took many pic-
tures of him, and one in particular shows him standing on a hilltop as
he was planning the settlements, pointing out the topography to the
people with him. "Look," he said, pointing westward, "you can see the
Mediterranean Sea easily from here. This shows you clearly just how
slim the 'waist' of Israel is. This makes us very vulnerable." The distance
from the sea to the West Bank at Israel's narrowest point—near Kfar
Saba—was only about eight miles.

By the early 1990s, the settlers had become very well organized.
During the huge wave of immigration from the former USSR, they
were the only people permitted to set up stands at Ben-Gurion Airport,
where they tried to persuade families just off the plane to settle in
Judea and Samaria. Many of the Russians were tempted to go there, not
because they had any religious or political affiliation, but because they
were offered incentives and better housing than they could have re-
ceived elsewhere.

From the outset, the two principal political parties, when in govern-
ment, pursued a policy of building in the West Bank. Israelis were en-
couraged to live there, some who were political idealists, others who
wanted to settle the land as a means of defending the country. There
were also many who fell into neither camp but chose to live there
purely because of tax incentives and more affordable housing. The set-
tlers, meanwhile, became a law unto themselves, behaving as if they
were the lords of the land. I witnessed many an occasion when senior
army officers came cap in hand to hear their demands. Some of them
obviously did so because they were afraid of the political clout that
the settlers carried, others possibly because they identified with their
aims.

Over the years, I have found it extremely difficult to accept the man-
ner in which some of these settlers, my fellow Jews, have treated the

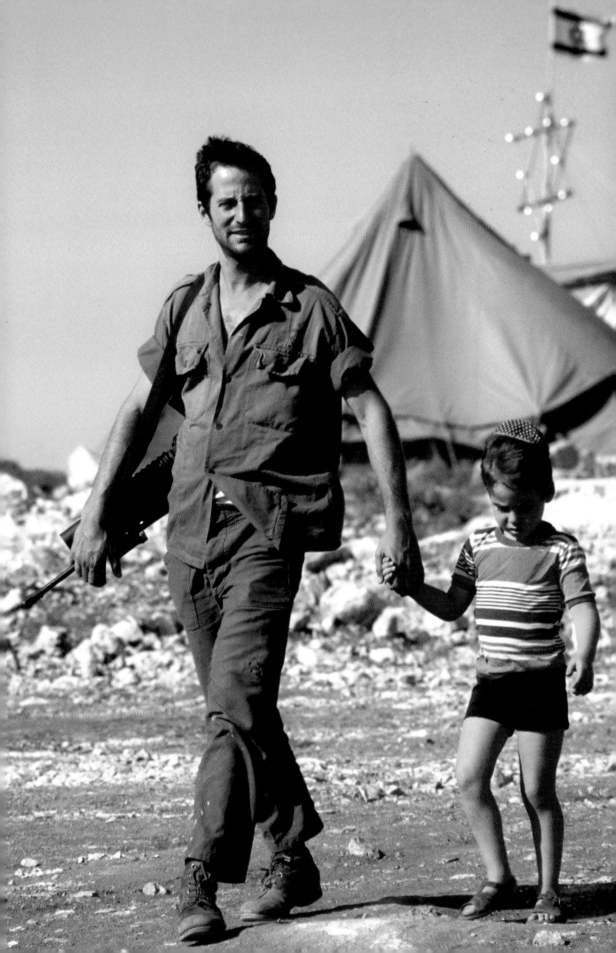

Palestinians. One day some Palestinian friends phoned me and invited me to visit them near Hebron. They wanted me to see the devastation that had been wrought upon their vineyards by settlers who had wantonly chopped down their vines, which had taken many years to bear fruit. I felt like hiding my face in shame, especially when I saw an old Arab woman sitting on the ground, crying bitterly and hugging the stump of an ancient vine. In my view, what they had done was wholly inexcusable. I found it difficult to reconcile this action with the fact that the parents of these selfsame settlers were almost certainly Diaspora Jews who had, every week, put money into their JNF Blue Box to send to Israel specifically to plant trees. Many of these settlers considered themselves religiously observant, which made me ask how they could perform this act of wicked vandalism, when it explicitly states in the Torah (Deut. 20:19–20) that Jews should not devastate the land they are setting out to conquer. This specifically applied to fruit trees, and the rabbis extended this prohibition to the wanton destruction of anything useful to man.

As Jews, we have always liked to think that we somehow rise above the worst excesses of mankind. Sadly, it has not always been true. The sense of shock felt by every Jew with a shred of moral responsibility was profound when one of our fellow countrymen, Baruch Goldstein, entered a mosque in Hebron in 1994 with his gun at the ready and mowed down twenty-nine Palestinians as they lay prostrate praying to Allah. As horrific as this act was, what seemed almost worse to me was when, in 1998, I photographed groups of supporters at his grave, praising his act, glorifying his vile deed, and turning his tombstone into a shrine.

What I observed over the years was that many of these "wild" settlers originated from the United States. I have a theory about them. It may be naive but is probably valid. America has had a long tradition of pioneers conquering the Wild West, at the same time destroying anyone or anything that happened to be in their path, in their case, the indigenous American peoples. This cowboy mentality was a part of their culture, and I have seen these new arrivals coming from the United States and continuing the same tradition, but in this case shooting at Arabs. But as anyone who has studied American history will recognize, the era of the Wild West was not a glorious period, but one about which present-day Americans feel shame. Nevertheless, our settlers are still

strutting around, toting their guns and all the other jingoistic trappings of the Wild West, but this time in the Wild West Bank.

What I find particularly disturbing is that while these settlers are relatively few, they make a great deal of noise and seem to be able to exert political influence completely out of proportion to their number. The same, of course, can be said for the extremists on the Palestinian side. It is very sad that our future could be in the hands of two such radical groups both intent on destruction. My prayer is that the middle of the road on both sides might manage to take the initiative and bring some common sense to the debating table. I hope I live long enough to see it.

My involvement in both Intifadas extended beyond just taking photographs. In 1990, at the height of the first conflict, I received an invitation to participate in the East-West Photography Conference in Helsinki, Finland. I was asked to give a slide presentation on any subject I chose. The topic I selected was the role of the photographer in the conflict raging in the Middle East.

I did my best to present a balanced view of the Israeli-Palestinian conflict, stressing that, in my view, telling the truth, no matter how unpalatable it may be, is still the best route to take—a course that is strenuously rejected by most politicians, who prefer to feed the public only those images that support their own particular platform. An article in one of Finland's leading newspapers, *Helsingin Sanomat*, quoted some of my comments. The thrust of my argument was a defense of documentary photography and a criticism of the sensationalism that has crept into press photography. I have always shied away from pictures that do not respect an individual's liberty and are published merely to increase newspaper sales. I strongly advocated that our role is to document incidents as they happen and omit speculative journalism. We should at all times try to remain objective, however impossible this may seem when one's own side is involved in the conflict. The same paper also quoted me as saying, "If my pictures survive for only a few days in the papers, I have failed. I want my pictures, at least 1 percent of them, to survive longer."

In 2002, Dirk Halstead, a leading *Time* photographer and editor of *The Digital Journalist*, approached me. He asked me to comment on a photo-essay shot by a photographer named Catherine Leuthold. She

had taken pictures that graphically showed the suffering and hardship that the Israeli occupation had caused the Palestinians. They wanted me, as an Israeli and a photographer, to respond, since they were keen to get a balanced view of the situation. I found her images to be extremely touching and impressive. I was, however, at pains to point out that what she was able to show through her work was only that which had happened at the precise moment when she took the shot. To read anything of historical or environmental significance into the image was pure speculation and could only mislead. For example, you see a photograph of a body lying on the floor. From this you can have no possible idea of how it got there, why it was lying there, or the series of events that led to it. Even historians have a job trying to convey accurately and without bias what happened at any given time. A visual image only has the capacity to comment on the "now," and in no way can it inform on the events that resulted in a particular scenario.

This issue of impartiality is one that is forever in the mind of a good photojournalist. Some years ago, it was brought to my attention that someone in the industry had started a rumor that I was not entirely impartial and, even more ridiculous, that I was a member of the Mossad. As foolish as this may sound, the implications for me as a journalist could have been far reaching, especially since someone might have actually believed this rubbish.

We journalists were always at risk, hence the need to put huge stickers on our cars saying PRESS in various languages in the hope that this would minimize the risk of our being shot. This worked well, until one day I overheard some Palestinians whispering "Muhabarat" (Secret Service) as they pointed to a group of newsmen. Their accusations turned out to be justified. It was discovered that some members of the secret service had been using press stickers to gain clandestine access to areas of conflict. Once this was revealed, the Foreign Press Association took the government to task about it. No denials were issued, but subsequently this subterfuge was stopped. We ran enough risks without the additional hazard of being mistaken for spies. However, I don't always blame the Israeli government, as the following story will show.

Sometime during the Lebanon War, two journalists were killed accidentally by an Israeli tank shell. The outcry that followed, with the American media lambasting the Israeli government and the whole

issue being taken up by the world's press, infuriated me so much that I wrote a heated letter, which appeared in full in the American Society of Media Photographers Bulletin. I think this letter conveys the passion that I felt at that time about the work that we did:

Two of my colleagues were killed last week. An Israeli tank shell hit them as they were filming a war. I may have known them. Maybe I ran into them covering another skirmish—somewhere—sometime. They were my buddies. "Comrades in Cameras" whom I may have met under any one of a number of bizarre circumstances: crouching behind a sand wall, cameras at the ready; in the lobby of the battered Ledra Palace Hotel in Nicosia; in a trench at the Suez Canal; or downing a few drinks in a bar, showing false bravado while mortar shells fell not too far away. Siblings in a brotherhood of fools, who go into the thick of fire to bring grisly images of war to the comfort of your living room, so that you can enjoy the gory details from the safety of your armchair.

Sitting in a café, the bald-headed gentleman next to you leafs through a magazine with your "marvelous" war photos in it. There it is, that great full-page photo of yours. And then he wets his finger, turns the page, and stops to look at an advertisement describing some new product. And you are dying to scream, "Hey, that page you just glossed over! I nearly lost my life getting it!" Well, I am sure this must have happened at some time to those two who were killed last week. They got killed doing what they chose to do, demonstrating a devotion to their profession, while you media moguls sit in your headquarters, impelling us to get better and better coverage. After all, competition is raging and how come the other magazine gets the better photo? Why is network X's footage so much more exciting? Get the pix! Get the pix!

Don't get me wrong. We don't blame you—presidents, chairmen, and editors-in-chief of CBS, NBC, ABC, Time, Newsweek, etc. But for heaven's sake, stop imagining you are sending us out on some picnic, or to a film set where only dummy bullets are used.

Don't complain when something goes wrong. Don't send off protest notes and don't mobilize the world press into a frenzy of accusations just because you have guilt feelings about sending us into those areas where the shit is flying. Don't try to shift the blame.

It was not Peres, Arafat, Reagan, or Gemayel who sent my two colleagues to South Lebanon. Stop pretending that you thought "war corresponding" revolves around wearing well-tailored safari suits and occasionally dining with

a general. Discard that shocked expression when someone you sent out buys it. The blame is ours—yours and mine alone.

Stop blaming that poor young soldier, scared, sitting in his tank, who in combat has to think and shoot fast and really does not have time to find out if what is coming at him is a video camera or a rocket-propelled grenade. His chances of staying alive might depend on it. Don't shift the blame to him. I may be an Israeli and a Jew, but by "him" I mean anyone anywhere who has been sent to fight in action.

You want to do something useful? See that our families, who have the misfortune to have crazy guys like combat photographers as fathers and husbands, are properly taken care of if we are killed or maimed. If you want to add a few words about the "noble profession" for which we gave our lives—that's OK by us.

30. SOME SPECIAL PEOPLE

I have fond memories of several leading figures in the world of politics with whom I came into contact through the course of my work. I was privileged to see them in a way in which they were rarely represented in the media.

YITZHAK NAVON

Yitzhak Navon was Israel's fifth president. He had the distinction of being president when the basic law that made Jerusalem the capital of Israel was enacted on July 30, 1980. He was the country's first Sephardi president and one of the most charming and cultured men I have ever had the pleasure of working with.

If anyone was responsible for initiating my first exhibition and the publication of the accompanying book, it was Navon. One day, some time after his term of office ended, I attended a Labor Party meeting at Beit Berl, Tel Aviv. Navon was there. He told me that his car had broken down and asked if I could give him a lift back to Jerusalem. Of course I was happy and flattered to do so. He spent most of the journey insisting that I had to organize an exhibition. He said, "You absolutely must have a show; you've been in this job now for over forty years, and it really is about time you did something." Before this, I had never seriously thought about the possibility of an exhibition, but Navon planted the seed and persistently encouraged me until I eventually got moving and did something about it, resulting in the show at the Tower of David, which subsequently toured to London, the United States, and Canada. The way in which he took such a personal interest in me was very touching.

He contacted me again about six months after my wife died. I received a call from him asking if I would join him for lunch. I agreed, but

had not the faintest idea why he wanted to see me. We met in a little restaurant on the Street of the Prophets. He started to tell me that he had lost his dear wife Ophira through cancer some time before, but that he had now found a woman with whom he had a very fine relationship. He continued to tell me that he felt that I should not be alone but should look for a companion with whom to share my life. Once again, I found myself quite moved by his personal concern for my well-being. Perhaps I took heed of his counsel, for some time later I met Ziona, who became my close companion.

EZER WEIZMAN

Ezer Weizman was one of the few senior Israeli politicians of my generation to have been born in Israel. A native of Haifa, he was the nephew of the first president of the State of Israel, Chaim Weizmann, a man

94. President Yitzhak Navon and his
wife Ophira on a hike in the Judean
Desert, 1980.

known for being something of a character, erudite, and outspoken.
Chaim Weizmann was recorded as once saying about Ben-Gurion, who
was prime minister during his term of office, that "the only place he
allows me to put my nose into is my handkerchief," alluding to the im-
potency of his presidency. In the case of his nephew, it seemed that the
apple had not fallen far from the tree. Ezer was known for his direct and
informal approach to everyone he met, and it was said that even his
political opponents would succumb to his charm. Even Sadat fondly
called him "Ezra." He was considered by many to be a male chauvinist;
he referred to all the women he came into contact with somewhat pa-
tronizingly as *maidelach*—"little girls" in Yiddish. He was also well
known for his sexist comment that "good boys are for the Air Force,
good girls are for the pilots." Women's lib organizations were up in
arms about this. "Honey, have you ever seen a man knitting socks?"
was his comment to Alice Miller, a female soldier who launched a suc-
cessful high court appeal against the Israeli Air Force, compelling it to
open its pilots' course to women in 1994.

This attitude might have had its origins in the fact that Weizman
was considered something of a hero in his younger days. He was a com-
bat pilot who received his training in the British Army and studied
aeronautics in England. He was a fighter pilot with the Haganah during
the War of Independence, became known as a national hero, and ulti-
mately was regarded as the father of the Israeli Air Force. In those days,
the British were not keen to elevate Jews to the elite ranks of their
armed forces, but they relented in his case, perhaps because of the in-
fluence of his uncle. During World War I, he had made a tremendous
contribution to the British war effort by developing bacterial fermenta-
tion, subsequently used to manufacture acetone, an essential ingredi-
ent in the production of the explosive TNT, which was vital to Britain
in its battle against the Germans.

Weizman played an important part in encouraging Begin to sign the
peace agreement with Egypt. I accompanied him to Cairo some time
later. He reveled in the hustle and bustle as enthusiastic crowds tried
to shake his hand. During that visit, we went to Groppi's—a very
famous café and hangout of officers and pilots during World War II,
a place of which he had fond memories, recalling the elegance of
those earlier days. I remember commiserating with him when we saw

the changed condition of the café, which had deteriorated badly over the years, now displaying fading drapes, shabby furniture, and peeling wallpaper.

Weizman was very keen on developing good relations with the Arabs. At one point, he was so unhappy with the way the Israeli government was handling things that he resigned. I had taken a photograph of him, of which he was very proud, showing him standing in front of the Pyramids and the Sphinx. It was used as the cover for his book *The Battle for Peace*. Once he told me that should he write a sequel, he would call it "How They Pissed Away the Peace." Weizman never got around to writing this book.

Many years later, I photographed him when my film *Eye Witness* was being produced. We had taken our crew to the entrance of the Knesset, and they were outside filming me as I took pictures of some dignitaries entering the building. Weizman came in, saw me, and commented, "Come on, you have been photographing me for seven hundred years already!"—as if to say, "Haven't you seen enough of me yet?" A man of the people, he dedicatedly visited all the families of soldiers killed on duty. His own latter years were tinged with sadness and tragedy. His only son was badly injured at the Suez Canal during the War of Attrition. Weizman was informed of this when he was deep in the underground bunker

95

of the IDF headquarters, the so-called Bor ("hole" in Hebrew). He is reported to have commented, "It's damn easy to sit in the cockpit of a fighter plane and look death in the eye, but what's a thousand times worse is to sit here in the safety of the bunker and know your child is at the front." Later, in 1991, this same son was killed together with his wife in a car accident. Weizman died at the age of eighty on April 24, 2005, just after ending the Passover seder in his home.

YITZHAK RABIN

As well as being totally genuine, Yitzhak Rabin was essentially shy and introspective, but a person who unexpectedly sparkled with a dry sense of humor. I enjoyed the privilege of working with him on a number of occasions, once in the framework of a project called *A Day in the Life of Israel*, published by HarperCollins. Fifty internationally known photographers were invited to select something that they felt would effectively illustrate the theme. I chose to cover a day in the life of Prime Minister Rabin.

It was arranged that early one morning, shortly after 6 a.m., I would show up at his home. His wife Leah was busy preparing breakfast in the kitchen, and Rabin had just emerged from the bathroom. I noticed that he still had soap in his ear, which he had absentmindedly forgotten to wipe off after shaving.

As they sat down at the kitchen table for their morning meal, I realized that it would be a kindness to draw his attention to the soap, as that white blob in his ear would show up clearly on any picture. "Thank you," he said, "God knows, they would probably have thought I had some secret listening device in my ear."

After breakfast, I went down to where his official cars were standing. Secret service agents and drivers stood around awaiting Rabin's appearance. I spotted the PM's Cadillac and made myself comfortable in a seat from which I thought I would get the best pictures of him reading the first dispatches of the day. At this point, the head of the security detail came up and whispered in my ear, "You can stay in this car for as long as you like, but Yitzhak is not going to be in it." I learned an instant lesson about the security methods used to protect the prime minister and hurriedly switched over to one of the other cars. This time, fortunately, I selected the one in which Rabin would actually ride.

Spending the day with him was exciting. I had asked him if he would regard me, as the saying goes, as a fly on the wall. This way, I told him, I was more likely to get natural, unposed pictures. "Of course," I added, "if you have anything really important and secret to discuss with someone, I don't mind leaving the room." He gave me one of his famous part-smiling, part-scowling looks and said wryly, "Do you really think I'd have a problem throwing you out?"

Rabin was a heavy smoker, a fact that gave me the opportunity to repay his remark with a little banter of my own. Again and again during the day, I noticed him reaching for his pack of cigarettes and then, on seeing me observing him, quickly withdrawing his hand. I gathered from this that he was reluctant to be seen smoking in the photographs I was taking of him. At one point, I took pity on him and had the chutzpah to say, "Yitzhak, please go ahead and smoke. I'll look the other way and give my camera a rest." He looked relieved and promptly lit up. The photograph that was eventually selected to appear in the HarperCollins commemorative book was the one I took of him and Leah at that breakfast table—without a cigarette in sight.

96

I had another occasion to observe Rabin from close quarters. One evening in 1977, during his first term as prime minister, *Time*'s bureau chief Don Neff and I were sitting in Rabin's home interviewing him. Rabin was relaxed, with his feet on a chair and a glass of whisky in his hand. After the last sip, he held out the glass to his wife, saying, "Leah, would you please pour me another one." In front of us, she promptly retorted, "You've had enough. If you want another one, get it yourself!" I felt as though I wanted the ground to open up beneath me. It was even more embarrassing as Leah had chosen to speak in English, so of course Don Neff understood every word. Thankfully, he did not include this little altercation in his article. This was the year Rabin resigned when it was disclosed that Leah had held an illegal foreign currency account of $20,000 in a U.S. bank. After witnessing this scene at their home, I began to understand a little more about their relationship and the underlying reasons for his resignation over what at the time seemed such a trifle.

When he was elected in 1992 for his second term as prime minister, he appeared to be a much more self-assured man. His image had become that of a quietly determined and powerful individual.

Whisky also played its part in a photograph I shot of Rabin in May 1994. I was working on a project that I called "Leaders at Leisure." My idea was to take pictures of some of our leaders in their off-duty hours, behind the scenes, so to speak, just relaxing. Included in this body of work were photographs showing Bibi Netanyahu horseback riding and Foreign Minister David Levy fishing. This latter shot needed careful thought—after all, how do you get a really interesting shot of someone fishing? To the bystander, this is probably one of the most boring forms of leisure, until eventually something happens and a fish is caught. We decided to leave nothing to chance, and therefore took him to a fish farm where there was a plentiful supply to bite on his hook. Naturally the picture I got was one of him hooking a really big fish! I caught Finance Minister Baiga Shohat on film in shorts, barefoot and topless, reading the newspaper, and snapped Shimon Peres in his shorts and sandals, standing on a small ladder dusting books in his library. The picture I chose to take of Rabin was of him watching a game of tennis on television at his home. I took the shot from behind, overlooking the bald patch on the back of his head, with the T V screen on view in the background. On the table next to the T V stood a bottle of whisky.

235 *Some Special People*

When the picture was published, some young, eager, and sensationalist journalist hurriedly drew attention to the bottle in the photo, his implication being that Rabin was "fond of his liquor." This was a cheap jibe—for in all the years I had been photographing him, I had never once seen Rabin in any way even slightly affected by alcohol. His liking for Scotch was a fact familiar to most people, and, after all, Rabin was in good company. Many great leaders had demonstrated a predilection for a drop of the hard stuff. Churchill was known to drink brandy regularly, and Ezer Weizman could enjoy a drink. In Weizman's eulogy over Rabin's grave in 1995, he spoke warmly of their relationship and said, "I have fond memories of all those drinks we downed together."

In the days when the Israel Defense Forces were still entrenched in the so-called "security zone" of southern Lebanon, I managed to obtain an exclusive invitation from Moshe Levy, chief of staff, to join him in his helicopter for a tour of Lebanon. Rabin was also on board, flying to meet the troops. It was 1985, and he was defense minister in the rotation government of Peres and Shamir. Accompanying us was Avraham Shalom, the head of Shin Bet. Much of the conversation during the trip centered on the current problems that Sharon was having as a result of his libel suit against *Time* magazine. Perhaps it was because I was an employee of *Time* that I reminded them of this issue by my very presence. They were not unduly sympathetic towards their colleague in government.

We landed in Lebanon, and while walking around, I inadvertently stepped on some barbed wire and ripped open my shoe. One of the generals quipped, "The Shiites are attacking Rubinger," to which Rabin countered, "Rubinger works for *Time*, and I think the danger for him looms closer to home!" He then went on to tell me how good he felt when the top executives at *Time* asked him to lunch with them on a visit to New York, adding with a smile, "I am told that the photographer they sent to take pictures of me at the luncheon was the same photographer who shot the pictures in Sabra and Shatila. I wonder if this has any significance?" Later on during the flight, he was heard to comment about the situation he had seen in Lebanon. "Good God, what shit we have got ourselves into!" He looked at me, raised an admonitory finger, and said, "Hey Rubinger, you are here only as a photographer. No reporting what I just said."

Shalom, who was sitting next to Rabin in the helicopter, turned to me, saying, "Do you remember? It was only last year when I flew with you and Defense Minister Moshe Arens on exactly this same route and with the same objectives, but nothing has changed in this lousy situation since then." Rabin cut in, "Maybe that's because ministers of defense change, but Rubinger stays." Someone then chipped in, "Do you realize, *Time*'s photographer is the only journalist ever invited on a trip like this. It must say something." This confirmed to me once again (not that I needed confirmation) the extraordinary power and influence that the magazine used to have in those days.

I cannot think of Rabin without berating myself for not having been in Tel Aviv on the fateful night of his assassination, November 4, 1995. A huge peace rally was taking place on that Saturday night, but as I knew I could not get my pictures to New York before that week's issue of *Time* was put to bed, I decided not to go.

The rally was one of the largest ever held. Thousands had come to show Rabin their support for his efforts to establish peace through the Oslo process. A well-known "Song for Peace" was sung by those assembled. I watched it on TV and could see how deeply moving it was for those who took part. At the end of the rally, Rabin went down the stairs from the platform towards his car. It was at this point, and on those steps, that Yigal Amir, the assassin, lay in wait for him. As Rabin passed by, Amir stepped forward and shot the prime minister three times in the back. The sheet of paper with the words of the peace song was in Rabin's pocket. It was taken out by his chief of bureau, Eitan Haber, who, the following morning, allowed me to take pictures of this gruesome, bloodstained memento.

97

Rabin was rushed to Ichilov Hospital in Tel Aviv, where he died of his wounds while undergoing surgery. The young man who killed him—Amir—was a Jewish law student and right-wing activist who regarded Rabin as a traitor for supporting the Oslo Accords. When he subsequently appeared in court and, unrepentant, confessed to the crime, he told the judge that his intention had been to halt the Middle East peace process. This he surely did. The country was in total shock. Rabin was the first Israeli-born prime minister and the only prime minister of Israel ever to be assassinated. What was worst for the country was that Rabin had been killed by one of his own countrymen, a Jew

תנו לשמש לעלות
לבוקר להעיר
הזקה שבתפילות
אותנו לא תחזיר
מי אשר כבה נרו
ובעפר נטמן
בכי מר לא יעירנו
...לא יחזירנו...
...ותנו לא ישיב
מבור תחתית אפל
כאן לא יועילו
לא שמחת הניצחון
ולא שירי חל...

...

...ש... כ...
...חשו תפילה
...בכרסדו שיר לשלום
...

... ש...
...בעד לפרה
...אל תביטו ל...
...חן להולכים
...ום לתקווה

שיר
ולא למ...
אל תגידו יו...
הביאו את...
כי לא חלום
ובכל הכיכרות
הריעו רק שלום

פז...

תנו לשמש לעלות
לבוקר להאיר
הזקה שבתפילות
אותנו לא תחזיר
אל תגידו יום יבוא
הביאו את היום
כי לא חלום הוא
ובכל הכיכרות
הריעו לה שלום

פזמון חוזר 3x פעמים

97. The lyrics of the "Song for Peace"
that were in Rabin's pocket when he
was assassinated on November 4, 1995.

and an Israeli, and not by someone from the hostile Arab nations who
for so many years had conspired towards Israel's destruction.

All that was left for me to do was to attend his funeral. Rabin, who
was regarded by many as a martyr for peace, was buried after eulogies by
many world leaders. They addressed an audience of over four thousand
VIPs from all over the world. These included Jordan's King Hussein,
who declared, "Yitzhak Rabin, you lived as a soldier and died as a sol-
dier for peace," and Hosni Mubarak of Egypt, who called Rabin "a fallen
hero for peace." There then followed further commitments from world
leaders to try to end the religious and ethnic bloodshed in the area.
Rabin's granddaughter spoke most touchingly and personally about her
Saba (grandfather), and President Clinton, his voice full of emotion,
ended his words with "Shalom, chaver" (Goodbye, friend). It is Clin-
ton's voice and those words that remain with me from that tragic day.

The nation's outpouring of grief went on for several days. Over a
million people, out of a total population of six million, visited the
square in Tel Aviv where Rabin had been murdered to pay their respects
and light a candle in his memory. In all my sixty years in Israel, through
all the wars and other crises, I have never before experienced anything
quite so moving as the sight of the nation grieving for Rabin. The grief
was compounded by the feeling of so many of us that not only had we
seen the death of a special human being, but we had also witnessed the
destruction of that faint glimmer of hope for peace in such a savage and
senseless way. It was as if, when each small candle flickered and sput-
tered, our optimism died a little with the extinction of its flame.

Over the many years that I worked alongside the personal protection
teams for VIPs, I often felt that they were sometimes overzealous in
marshaling the press, while not seeming to pay much attention to ordi-
nary bystanders. In this case, it was Amir, one such ordinary bystander,
who took it upon himself to carry out his remorseless and catastrophic
act. Perhaps if Amir had been carrying a camera, the security people
would have been more diligent, would have focused on him—and
moved him along. Maybe Yitzhak Rabin would still be alive today.

SHIMON PERES

Shimon Peres was another character with whom I shared many encounters over the years. I frequently felt that he took his "official" role very seriously, whatever ministerial position he was holding—and over the years these have been many and varied, culminating in his serving as prime minister in 1984–86 and 1995–96. He often gave me the impression of being somewhat aloof, but this may have been his perceived need to maintain the dignity of his office. However, I did sense a difference when he was not in power; then he seemed to relax, paying more attention to the lesser mortals around him, myself included, on one occasion even noticing that I had lost weight.

In 1981, I took some pictures of him that were intended as a cover for *Time*, with a backdrop of the Knesset projected on a screen. In order to do this shot, I needed to use a lot of extra lighting. I was busily working away when all of a sudden the door burst open and a group of security men came rushing in. It appeared that my lights had generated so much heat that the smoke detectors in the room were activated and I was

98. My studio session with Shimon
Peres that nearly burned down the
Tel Aviv Sheraton, 1981.

running the risk of setting fire to the Sheraton Hotel in Tel Aviv, where
we were working. The end result was a good image, but sadly it did
not make the cover. Peres did, however, sign the picture for me with a
very warm dedication, "To David Rubinger, who creates miracles with
his lens."

2, 98

An accomplished speaker with an appealingly dry sense of humor, he
exuded the confidence of a highly articulate statesman. He earned both
prestige and respect from international public opinion and in diplo-
matic circles abroad, where for many years he has been regarded as the
official "spokesman" of Israel, even when his party is in opposition. He
is currently the president of Israel, and in 1994 he won the Nobel Peace
Prize with Yitzhak Rabin and Yasser Arafat for their joint efforts culmi-
nating in the Oslo Peace Accords. In this respect, he is quoted as saying,
"When you win a war, your people are united and applaud you. When
you make peace, your people are doubtful and resentful."

HOSNI MUBARAK

In 1982, *Time* commissioned me to take a portrait photograph of Hosni
Mubarak, the president of Egypt. I approached the job with some trep-
idation, not really knowing what to expect. I had intended to put up
lights in his office prior to his arrival, but when I got there, his security
personnel would not allow me access to the room until he was there.
Consequently, I had to put up the lights, prepare all the wiring, erect
light stands and bulbs, and test them, with Mubarak all the while sit-
ting behind his desk waiting for me to finish. I was all fingers and
thumbs and sweat was pouring down my face. Seeing my evident dis-
comfort, he said, "Don't be nervous, just take your time." Eventually I
finished the preparations and started to take pictures. I found him very
serious and with a perpetually stern expression on his face, evidently
choosing to look formal and "presidential." After taking some initial
shots, I plucked up the courage to ask him, "Couldn't I have a smile,
Mr. President?" to which he responded, "Tell me a joke and I'll smile!"
I replied, "Mr. President, the kind of jokes I know one cannot tell to a
president." Then he started to laugh, and I got the pictures I wanted.

99

Another Egyptian dignitary whom I was asked to photograph was
the Egyptian minister of defense, Field Marshal Abdul Halim Abu
Ghazaleh.

99. Egyptian president Hosni Mubarak in his office, 1982.

I was instructed to phone him from my hotel in Cairo. For two or three days, I phoned constantly. If I were asked to call at 2 p.m., I would do so, only to be told to ring again at 4 p.m. When I did this, I would then be told to call the next day, and so it went on. His spokesman then advised me that he would ring me, so I was unable to leave the hotel room just in case I missed his call. After three days, I finally came to the conclusion that I was wasting my time and he would never call, so I decided that action had to be taken. I put on a tie and blazer, hired a black Mercedes, and drove to the Ministry of Defense. I sat in the back and, when we approached the security guard at the gate, pulled out my American Express card and flashed it through the window. Instantly the guard saluted me and opened the barrier. I am almost sure I heard him say, "That'll do nicely!" I was driven directly up to the office of the minister of defense and was actually permitted to take his picture—so much for the power of chutzpah and American Express! In this business, I concluded, you can never afford to be without either of them.

ARIEL SHARON

One of the most fascinating and complex characters I have had the privilege of meeting over the years was Arik Sharon, a man whose private persona was often at variance with his image in the international media.

Over the years, I have taken hundreds of pictures of him. The first dates back to 1969, when, as a general, he was part of the guard of honor at the funeral of Levi Eshkol.

We came into contact again in 1970 at the Suez Canal during the War of Attrition, again during the Yom Kippur War, and later during the Lebanon War. I was taking pictures of the action, and there was Sharon, the military commander, the arch-professional whose single-mindedness in the pursuit of Israel's security caused him to lose friends but at the same time to influence people.

He was always uncompromising in his attitude, knowing exactly where he was heading and never being afraid to follow his designated course regardless of what others might think. It is well known that during the Yom Kippur War he not only countermanded official orders from higher up, but also turned off his radio so that his superiors could not contact him. In this case, the risk paid off when he brought about the total encirclement of the Egyptian Third Army.

The watershed for Sharon came when he was elected prime minister. Until then, he would push hard for all his objectives, especially the establishment of settlements on every hilltop. He was once heard to say that the tiny settlement of Netzarim had as much strategic importance to him as Tel Aviv.

Once firmly in the prime minister's chair, however, he observed, "What you see from here, you cannot see from down there," meaning that only once you become prime minister, and only then, do you become fully aware of the manifold pressures, both national and international, that influence one's course of action. As the sign on U.S. president Truman's desk said, "The buck stops here!" I became most aware that Sharon felt these pressures some years ago. In February 2001, I photographed him as he entered the polling station on the day of the parliamentary elections. At one point, in spite of his security guards, I managed to slip him a small note, which he put in his pocket. On it I had written, "I'd love to be with you tonight when the results come through." Later in the day, I received a telephone call inviting me to come that evening to the Tel Aviv Sheraton Hotel. I was the only journalist present. I placed myself opposite him, next to the TV set on which everyone's eyes were glued. From there I took an unforgettable image of Sharon surrounded by his acolytes, just as the TV anchorman

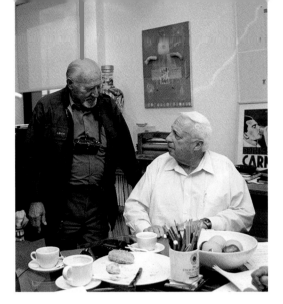

100. With Ariel Sharon during his 2001 election campaign. It was on this occasion that he said, "I trust Rubinger even though I know he doesn't vote for me."

announced the results with the words "an earthquake victory for Sharon." All the others in the room were jubilant and smiling; Sharon alone looked deadly serious, as if to say, "Well, now the buck really stops with me."

In his latter years, particularly from 2004 onward, he made a remarkable political about-turn, forcing through the closure of four settlements in the West Bank and the closure of all settlements in Gaza, plus the eventual withdrawal from Gaza. He followed this with his resignation from the Likud Party and the establishment of a new centrist party, Kadima, as he felt that a lack of cooperation from his Likud colleagues was preventing him from putting his policies into effect. Suddenly hundreds of leftist Israelis, who for years had despised him and his policies, found themselves at first grudgingly, but later wholeheartedly, supportive of this man who had had the courage of his convictions to follow a different course, one that he felt was in the best interests of Israel as a whole, but all the while in the face of huge opposition from the right-wing factions in the country.

Over the years, I had always had an open and friendly relationship with him, in spite of the fact that we came from different sides of the political spectrum. I remember one occasion during the 2001 election campaign when Sharon allowed me to remain with him the whole day at his party headquarters. He and his colleagues were discussing strategies when one of them pointed at me and said, "Hey, we can't talk freely with him around," to which Sharon replied, "Oh, I trust Rubinger even though I know he doesn't vote for me." He was one of the last remaining *chevramen* (old comrades). When my wife died in 2000, I received many letters of condolence, but he was the one who took the trouble to pick up the phone. The same happened later after the death of Ziona.

I visited him several times at his farm in the northern Negev. Sharon was passionate about the farm and all matters to do with animal husbandry and agriculture. I felt that he was truly at home there. This was

101. Ariel Sharon at his Sycamore
Ranch in the Negev in 2000, the year
before he was elected prime minister.

the one place where he was most comfortable and could relax amongst
the cows and sheep—having to deal only with problems of running his
farm, enjoying a welcome relief from the pressures of being in the pub- *101*
lic eye. He had enormous support from his wife Lily. Theirs was a true
love match, and it was touching to see the obvious signs of affection be-
tween them. I have several tender images of Lily feeding him from a
spoon in the kitchen, or with her arms wrapped around him. *102*

In January 2006, Arik suffered a massive stroke. Later I was invited
to do a program about him for Israel TV channel 2. In researching the

102. Ariel and Lily Sharon at home, 1989.

show, I had occasion to look back through the many photographs I had taken of him over thirty years. This brought back to me how significant a role this man had played in the history of our nation. There can be few politicians who had the same determination, fortitude, and courage, yet who could look forward and then take a different direction in order to follow their convictions. He was truly a colossus of a man.

EHUD OLMERT

I have known Ehud Olmert for some thirty years. The earliest photographs I have of him date from when he was a young Member of the Knesset for the Likud Party. We are also neighbors in Jerusalem, and on occasion we stood next to each other cheering our respective teams at a football match.

He was and still is an ardent fan of Jerusalem Betar, which is largely supported by those on the right, whereas I, as befits my upbringing in a Socialist youth movement, have always rooted for Hapoel, known as "The Reds."

His father had been a Member of the first Knesset, and Ehud was known as one of the "princes" of the old Revisionist movement, the forerunner of Likud. But he really came into his own when he stood for Likud in 1993 against the aging Teddy Kollek in the Jerusalem mayoral elections. Olmert won and continued as mayor for almost ten years, before returning to national politics in 2003 when he joined Ariel Sharon's Likud cabinet.

Olmert is charming and easygoing, a real chevraman who gets on easily with almost everyone. The burden of the premiership fell upon

103. Ehud and Aliza Olmert after Sabbath breakfast, 2006.

him quite unexpectedly in January 2006, when Sharon suffered his massive stroke, leaving Olmert, as deputy prime minister, to pick up the reins of government as well as to lead the election campaign for their new political party Kadima. With the other parties in disarray and with a sizable sympathy vote, Kadima obtained the largest number of seats in the Knesset, and Olmert became prime minister in his own right.

Ehud is fortunate that he can count on the support of his wife Aliza, who, while making her own political stance quite clear—she backs the left—is nevertheless wholeheartedly behind her husband, so much so that in the last election she voted, so she says, for Ehud's party for the first time in her life. Aliza is herself an accomplished artist and photographer with many exhibitions to her credit. Much of her work reflects her left-leaning sympathies. In early 2006, I was invited to give a television interview for Israel TV at my home, and Aliza was the other

principal participant. A few months later, *Time* asked for my help in arranging an interview with the new prime minister. They had tried but had been unable to get past first base, but, thanks to my contacts with the family, I was able to arrange a breakfast meeting at their home for *Time*'s assistant managing director. The interview, which lasted two and a half hours, resulted in a successful and prominent article in the next issue of the magazine.

Although I have known him for so long, when I meet him these days in front of others, I feel I can no longer call him Ehud. Instead I feel constrained to address him as Mr. Prime Minister—but inwardly I cannot help smiling.

HENRY AND NANCY KISSINGER

Sometime in the seventies, I was asked to take a cover picture of Henry and Nancy Kissinger for *People*, a sister publication within the *Time-Life* empire. They were in Israel, but I had not yet got around to approaching them when, one day, I saw Nancy sitting by the King David Hotel swimming pool not far from where Anni and I were. Nancy was being pestered by paparazzi hiding behind bushes with telescopic lenses, trying to get pictures of her in a bathing suit. After a while, I went over to her, introduced myself, and apologized on behalf of my co-professionals. I said, "You may not have noticed that I have never tried to invade your privacy here at the pool, but I would love a shot of both you and your husband against the background of the Old City." She said she would think about it. A little later, Mr. Kissinger came down to the pool, and I saw her talking to him and pointing over to where I was sitting. Mr. Kissinger called me over and said, "I understand you want a photograph. Well, I can give you five minutes. Come to our room at 3 p.m." This I did, but their room was on the sixth floor with no balcony and no view of the Old City. I had a word with his spokesman, who obviously thought I was crazy, but I did manage to persuade the hotel to clean out another room on the third floor, which had the background I wanted.

They all trooped down to the third floor, where Kissinger said, "Well, before I said I had five minutes, but now I only have three, as Golda wants to see me very soon." I asked them to lean against the balcony, positioning Nancy so that she did not tower over her husband, as she was

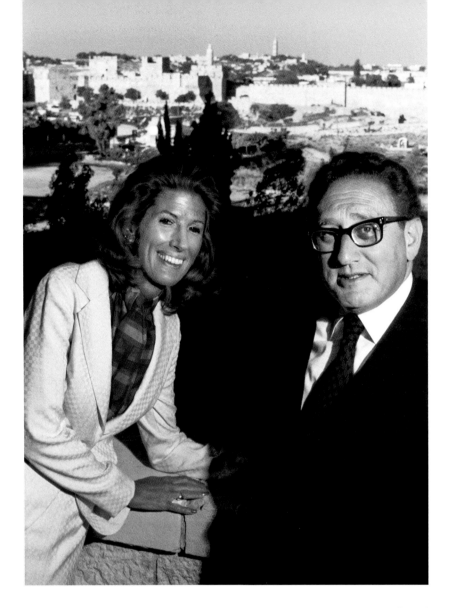

nearly a head taller than him. I got the perfect shot that I wanted, and the picture appeared on the next week's cover of the magazine.

104

After this exchange, I found I had won the Kissingers' confidence. They invited me to fly with them in a helicopter from Jerusalem to Lod Airport, where *Air Force Two*, the U.S. secretary of state's special plane, was waiting for them. During the flight, I took a delightful shot of Kissinger sitting close to his wife and tenderly stroking her cheek. It was obvious that they had a very loving relationship.

It was some time later that Nancy asked me if I would like to go shopping with her and Elizabeth Taylor. They went to Bethlehem, where they bought a lot of the usual touristy things such as crèches and other items made from carved olive wood—somehow not the sort of purchases one might associate with two such worldly and sophisticated women. But it was fun.

31. TRAVELS ABROAD WITH MY CAMERA

WARS IN CYPRUS

During my career, I covered not only wars in which Israel was involved, but also, because of my close geographical proximity to Cyprus, both the 1964 and the 1974 wars on that island, which took place between the Greek and the Turkish populations.

Photographing a conflict abroad made me realize how differently one perceives and relates to a war in which one is not directly involved emotionally. It led me to a much better understanding of the way in which non-Israeli and non-Jewish journalists covered the Arab-Israeli conflict, since previously I had found their indifference strange and painful. While I was in Cyprus, I found myself caring much less about the casualties on either side than I ever had at home. As a result, I was able to approach the whole assignment in a much more dispassionate way. This did not mean that I did not have fairly strong emotions when confronted by death and injuries in Cyprus, but not being emotionally involved made it much easier.

The relationship between the Greeks and the Turks in Cyprus has a long and turbulent history. Cyprus gained its independence from Britain in 1960, but even before this date there had been battles between the two groups. Basically, the Greek population wanted union with Greece, while the Turkish population wanted it with Turkey.

In 1964, the first time I was sent there on an assignment, severe fighting had broken out yet again between the Turkish and the Greek Cypriot communities. It was a very complicated war to follow because both populations were interwoven geographically and there were many local clashes between individual villages. No-man's-land between these hamlets ran in all directions, which is how one of my friends, Al Rosenfeld, the NBC correspondent in Israel, was shot through the

mouth while in a field between two warring villages. He had to lie there for eleven hours before he could be rescued and evacuated by the Red Cross.

This was also the only war in which I was injured. It is quite ironic to think that, having survived ten wars safely, fighting in some and photographing others, I had to go to Cyprus to be injured, and suffer the added indignity of it being caused not by any military action, but by a traffic accident. In Cyprus, they still drive on the left, as in England. My friend Eddie Hirschbain, an NBC cameraman, and I had covered a skirmish near the city of Polis on the western coast of Cyprus. On our way back, with Eddie driving, a truck suddenly appeared coming towards us on what we perceived to be the "wrong" side of the road. Wrong for us—he was in the right. Both drivers jammed hard on the brakes, but we still collided. The maximum speed of our car was maybe five or six kilometers an hour, but the collision was bad enough. I had been looking down in order to change film at that moment and was thrown against the window. Blood started flowing profusely from my head. I remember getting out of the car, sitting on the side of the road, and for some strange reason feeling great. I felt as though I were floating on a cloud, fading away and very light-headed. I almost lost consciousness and remember only vaguely that an RAF ambulance took me to a military helicopter, which flew me to a Nicosia hospital—where, after being given plasma, I woke up. It was only then that the realization of what had happened hit me. I started trembling and became freezing cold and very scared. I had a six-inch open wound on my scalp, which was sewn up by an Egyptian doctor who was very caring and comforting even though he knew I was an Israeli.

My colleagues in the world press were very considerate and did not report the story back home, so that my wife would not worry. However, when I landed two days later at Lod Airport, I had a heavily bandaged head. In order to hide my injuries, I had bought a large straw hat in Cyprus. When Anni and my little son Ami came to the airport to meet me, Ami was curious as to why I was wearing such a big hat. He soon uncovered the truth.

I had been to Cyprus on a previous occasion, but then it was on a nonmilitary assignment that I really enjoyed. The visit was on behalf of the Singer Company, who had asked me to take pictures of women,

mostly living in remote villages, working on their sewing machines. On my arrival, I shot pictures in several tiny cottages where old women, clad all in black, were pedaling away on Singers, the treadle kind that you operated by foot and which were probably even older than they were. It made a pleasant change from war and shows that photojournalists can enjoy assignments that are not necessarily concerned with killing. It was sad to see later how these tranquil, picturesque places were transformed into the battleground between the two warring ethnic groups.

After 1967, tension between the Greek and Turkish Cypriots lessened, and instead the main conflict was between factions within the Greek Cypriot community itself. Archbishop Makarios had abandoned the campaign for *enosis* (union with Greece), but there was considerable opposition to him from the extreme EOKA groups who were insisting on immediate enosis. They made repeated attempts to overthrow him, with the support of the military junta in Athens headed by Brigadier Demetrios Ioannides.

In July 1974, it was reported that Makarios had been ousted, so *Time* sent me back to the island, where I set out immediately for Nicosia, arriving just in time to photograph Makarios's residence, which had been burned to the ground by the rebels. I also attended the first press conference given by the EOKA leader Nikos ("Nikki") Samson, when he flamboyantly proclaimed himself president. He paraded a group of his cronies before us, urging them to show us the marks of torture on their bodies, which, Samson claimed, had been inflicted by the Makarios regime.

Samson's presidency lasted all of forty-eight hours. His downfall was coupled with that of the junta in Athens who had backed him in his abortive attempt to overthrow Makarios.

Most of the journalists who arrived from around the world settled into the Ledra Palace, which was one of those old-fashioned colonial-type hotels, like the King David in Jerusalem and Shepherd's in Cairo. It also happened to be located exactly on the dividing line between the areas controlled by the Greeks on the one hand and the Turks on the other.

I was enjoying a good night's rest at the hotel on the night of July 19 when I was rudely awoken at about 5 a.m. by the roar of transport

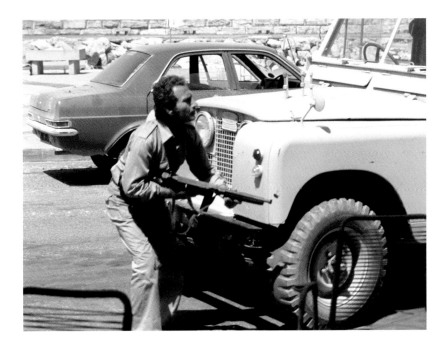

planes overhead. Jumping out of bed stark naked, I grabbed my camera
and rushed to the balcony. Turkish paratroopers were descending from
the sky over the Turkish part of the city. It was the first and only time in
my life that I found myself taking news photographs without a stitch of
clothing on.

The cause of all this military activity was Turkey's decision to act
unilaterally and invade the island. Shooting and shelling started at once
between the Turkish forces and the Greek Cypriot irregulars. We hoped 105
that the Ledra Palace, being full of tourists and foreign press, would be
spared. For the first twenty-four hours, it was; although shooting went
on all around us, the building itself was not targeted. At one point, a
Canadian officer working for the UN carefully edged himself out of the
front door of the hotel and through a megaphone shouted repeatedly,
"Cease fire! Cease fire, please!"—to no avail. Possibly the combatants
did not speak any English, or they just chose to ignore his pleas.

Most of the journalists found shelter in the ground-floor bar, which
was not only safe but also a place where the liquor flowed freely and
with no barman to collect payment. The electricity in the building was
not functioning, and when night fell, my colleague Shabtai Tal from
Stern and I went in search of our rooms. We really did not feel safe stay-
ing in the rooms, as, apart from having no lights, they faced the front of
the building, where the bullets were whizzing by too close for comfort.
We went instead to another wing of the hotel, where, lo and behold, the
electricity was working and the rooms were even air-conditioned. I
leapt into bed fully clothed, boots on, five-star hotel or not. Dawn
found the wing where we were sleeping under fire. It seems that some
Greek irregulars had lugged heavy arms onto the roof of the Ledra
Palace, and the hotel's immunity was thereafter history. We fled our

rooms at top speed for the safety of the bar downstairs. As a memento of my fortunate escape, I kept the key to my room. It still hangs in my study.

Heavy fire poured onto the hotel from the Turkish side. An Israeli journalist, Ron Ben-Ishai, who had proved his courage the year before in the Yom Kippur War, ran up the stairs to the top floor to save a badly wounded Greek fighter and then carried him down the stairs slung over his shoulder. I took a dramatic picture of this scene, but sadly it is one of the few photographs I took in my fifty years of working for *Time* that I have been unable to trace. Ron continues to ask me for a print of it to this day.

Eight or nine of us crowded into a car and made a mad dash through the gunfire in the direction of the Hilton Hotel, located some way from the dividing line between the Greek and Turkish zones and therefore safer. The hotel's management had also taken the wise step of hanging a five-storey-high banner—white with a red cross on it—from the roof and down to street level in the hope that it would be recognized as an emergency base for the injured. Not far from the Hilton, I also shot pictures at a mental hospital that had been bombed, causing many casualties among the inmates. It was hugely distressing to see those poor bewildered patients.

The British forces, who still had a strong presence in Cyprus at their base in Akrotiri, began evacuating foreigners from the war zone. At that point, neither I nor my colleague from *Time*, correspondent Bill Marmon, had given any consideration to being evacuated. After all, the whole purpose of our presence there was to cover the war, not to run away from it. Instead, we managed to slip through the lines—which were at the time very indistinct—and made our way to Kyrenia in the Turkish zone, located on the northern coast of Cyprus. Kyrenia was and, I believe, still is a favorite tourist resort, with beautiful gardens, a marvelous beach, and fine hotels. In one of them, the Dome Hotel, we encountered a large group of tourists and some Greek Cypriots huddled together awaiting their fate at the hands of the advancing Turkish military. No doubt the tourists would have some good tales to tell of their "holiday" when they got back home. After interviewing them and taking pictures for next week's issue, we set out on foot to find the war. Bill carried what was meant to look like a white flag of surrender—a

white towel tied around a broomstick—in the hope that this would prevent our being shot at. We did not find the war, but the war, in the shape of a group of Turks, found us.

Suddenly, as we were walking through a narrow lane, some six or seven Turkish soldiers, who did not seem particularly impressed by Bill's white flag, surrounded us. They all had their hair shorn, which gave them the appearance of being backwoods boys from deep inside Anatolia. This impression was reinforced a few minutes later when Bill pulled out a press card from his pocket in the hope of proving our identity. The press card, which was conveniently written in three languages, English, Greek, and Turkish, stated in big black letters B A S I N, meaning "press" in Turkish. The man in charge of the group took it and began to scrutinize it closely. We were more than somewhat perturbed to realize that he was actually holding it upside down in his attempt to read it, and we quickly realized that this document might not prove to be our salvation. Thankfully, we were extricated from what might have been an extremely uncomfortable situation by the arrival of a Turkish corporal who spoke German. It was now my turn to explain that we were only well-meaning journalists and that we were unhesitatingly in support of the Turkish invasion. He seemed happy with this explanation, and we parted on the best of terms from our captors.

On August 23, we were once again offered the chance to be evacuated by the British, and on this occasion we accepted. Our motives were somewhat devious, for we thought that the evacuation might afford us some good news coverage, which it did. A helicopter ferried foreigners from Kyrenia to the Royal Navy destroyer *Andromeda*, which we boarded together with a group of women and children. This presented us with a very different view of the war and how it affected those who got caught up in it.

We were perhaps a little ungrateful to our "rescuers"—for, as soon as possible, we disembarked and made our way back to the British base in Akrotiri, where we had the opportunity of completing a story about the arms and other tools of war that were being unloaded from incoming RAF planes, for the use of the British troops on the island. The next day we found a taxi and went to Limassol. There we rented a car, drove back to Nicosia, and checked in once more at the Hilton. We had come full circle.

Once back in Nicosia, the first thing we did was to ask for an interview with the leader of the Turkish Cypriots, Rauf Denktash. He agreed to see us, so Bill and I crossed the Green Line near the Ledra Palace Hotel and went to meet him. A ceasefire was in force, and the UN had made the hotel its headquarters. Journalists were permitted to cross the lines provided that they did not stay the night, this rule having been laid down by the Greek Cypriots.

Denktash had trained as a barrister in London and returned to Cyprus to practice law. As acting solicitor-general during the armed Greek Cypriot struggle against British rule in the 1950s, he successfully prosecuted several E O K A fighters who were subsequently hanged. He had been the key figure in the Turkish community and its leader since the 1960s. Journalists encountering him for the first time frequently complained that they had to listen to a lecture on the island's political history before business could begin, but I found him both charming and friendly. His presidential office, situated in the former residence of the British district commissioner in Nicosia, was an unusually noisy one. He sat there surrounded by dozens of caged songbirds whose chirps and trills punctuated our conversation. I have a delightful picture of him gently caressing one of his little feathered friends.

106

This setting was in sharp contradiction to his military ambitions and showed an altogether different side of his personality. A short, rotund man, he propounded his theories articulately and forcibly presented the case for the Turkish community on whose part he had consistently battled to gain independence. It transpired that Denktash was a very keen and talented amateur photographer. I am sure that this helped me to establish a good relationship with him, as we had something in common about which we were both passionate. I met him several times in the years that followed, and our friendship continues until today, with exchanges of greeting cards. On one occasion, I was delighted to receive a gift of the book of photographs that he had taken and published.

Following this initial meeting with him, our paths were smoothed in whichever way we wanted. We were invited to be guests of a Turkish paratrooper unit in Kyrenia, now the center of the Turkish-controlled part of the island. Our host, General Selim Demirbag of the Turkish army, gave us royal treatment, inviting us into the officers' mess to dine and providing us with an escort wherever we chose to go—an experi-

106. Rauf Denktash, president of the Turkish Republic of Northern Cyprus, with one of his pet birds, 1974.

ence far removed from our first encounter with the Turkish army a few days before (a fact which we did not venture to disclose to him!).

On August 25, a little more than a week after my latest Cyprus adventure began, I hitched a ride on an RAF transport plane to London. The reason for this was that I needed to get my film to New York as quickly as possible. This seemingly circuitous route was actually the fastest way to achieve my objective, as under the circumstances prevailing in Cyprus no commercial flights were either coming in or going out. We traveled for eight hours in a Hercules aircraft between Akrotiri and the Lyneham air base in England. I do not have words dreadful enough to describe the flight. They say you get what you pay for. In this case I traveled free. Suffice to say that I have never been happier to see the ground than when we eventually landed. It was a salutary lesson, however, and it taught me one thing—never ever to complain again about traveling economy class on any commercial plane, which, by comparison, offers an unparalleled standard of luxury.

Turkey had demanded a geographical separation between the two communities. Makarios, who wanted the island to remain a united state, refused, but, after a continuing deadlock, the end result was that 36 percent of the island remained under Turkish control, the partition being marked by the UN buffer zone, or Green Line.

The effect of the division was catastrophic for all concerned. Thousands on both sides had been killed or wounded, many were missing, and two hundred thousand people were displaced from their homes. Prior to the conflict, the Turkish and Greek villages had been closely integrated, but now, in the confusion, uncertainty, and fear, people were traveling in all directions but were unsure as to where they should be heading.

Exactly one month after the Turkish invasion, I went back to Cyprus to do a story on the burgeoning tragedy created by this huge number of refugees. I went first to Famagusta, where I met the public relations representative of the Turkish regime on the island, a Mr. Zikhni, a very smooth character who sold the Turkish story to the media most persuasively. He took us to see farmers who had been forced to abandon their villages and fields. We saw burnt-out villages and places where refugees from the Greek-held areas had been shoved into cramped and uncomfortable emergency housing. At the end of the tour, Mr. Zikhni brought us back to Kyrenia, where news reached us that the U.S. ambassador to Cyprus, Rodger Davies, had been killed by a sniper during an anti-American demonstration outside his embassy. I rushed back to Nicosia just in time to photograph the casket carrying his body as it was loaded, with full military honors, onto a U.S. Air Force plane. A day later, I took pictures of his replacement, Ambassador Dean Brown, who gained the reputation for being an expert troubleshooter in the Middle East during the years that followed.

To try to get a balanced picture of the situation, we next needed to shoot the story from the Greek side. We found hundreds, maybe even thousands, of ethnic Greeks living as refugees in the Akhne forest and in Dekhalia, along the Nicosia to Famagusta road. Many of these families had managed to flee their villages in cars and were now using them as homes. Food was in short supply, and they had to collect water in containers and carry them by hand, sometimes long distances. Thankfully it was summertime, so they did not have to suffer the hardship of cold and rain in addition to their other problems. These stressful circumstances were somewhat alleviated with the arrival in Cyprus of Prince Sadruddin Aga Khan, the head of the UN refugee organization, which started providing emergency help for both sides.

Meanwhile, heartrending scenes were being played out over and again near the Green Line in Nicosia. Dozens of women, from both sides of the conflict, stood there pathetically holding up snapshots of their husbands and sons in the desperate hope that someone somewhere might recognize them or have news of them. The extent of the hatred between Greek and Turk was evident to anyone able to cross from one side to the other. Huge billboards were placed on each side decrying the sins and atrocities of the "enemy" for the entire world to see. A human tragedy on a grand scale, made all the more poignant since in former times these same people had managed to live relatively peaceably side by side. Such are the effects of war—a pattern repeated all over the world and all too often.

MOROCCO

One day in November 1979, I received a call from *Time* correspondent Dudu Halevy asking me if I could be in Paris the next day. On my landing in the French capital, he informed me that we were going to Morocco. It seemed that "someone" in Washington had slipped him the information that Morocco was looking for American support in its fight against the Polisario. The Polisario were a force of about fifteen thousand guerrilla fighters, predominantly indigenous nomads of the Western Sahara, who were struggling to gain independence from Morocco in what was called the Sahara War.

For some reason, the Moroccans were under the impression that they could best win Washington's backing through the influence of Israel and via the medium of the press. This must have been why we, two Israeli journalists from *Time-Life*, were invited there. We boarded an Air France plane to Rabat, and, from what Dudu had told me, I fully expected to be met at the other side by someone who would whisk us through passport control and deal with all the formalities. At that time, no one traveling on an Israeli passport was permitted to enter Morocco. We landed. There was no one to meet us—no car, nothing. Reluctantly and with no other option, we boarded the airline bus with all the other passengers and made our way to passport control. If you have ever seen anyone "pushing backwards" in a line, it was the two of us, trying to avoid actually arriving at the passport desk and therefore having to

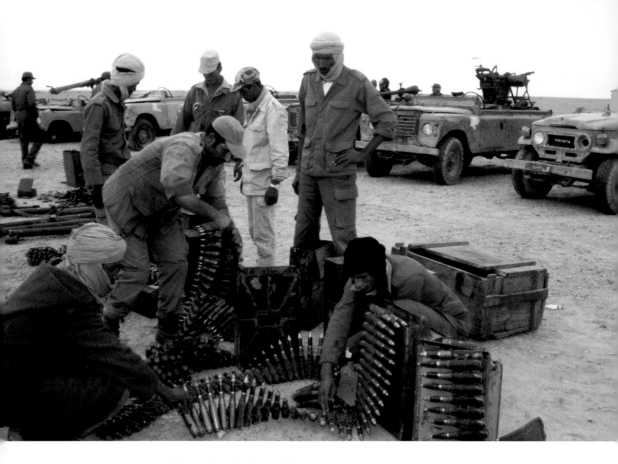

confront the clerk. Suddenly, just as we neared the counter, an announcement came over the loudspeaker asking us to come to the information desk. We sighed with relief. At the desk, we found the man who had come to our rescue and was waiting to see us through all the procedures. He took us to the Hilton Hotel—where, when the reception clerk asked to see our passports, our representative smartly intervened and said, "No need, we will take care of them." We assumed that he was a member of the Moroccan intelligence services.

107 Over the next few days, we were the guests of the Moroccan army. They were extremely hospitable. Airplanes and helicopters were placed at our disposal to take us wherever we wished. At one point, I shot images of a Moroccan armored division. To this day, I cannot believe that when I told them that the light was bad and asked that the soldiers approach us from a different direction, part of the unit turned around and came back, thus enabling me to take a much better shot. At one point during the visit, I was also allowed to photograph the interrogation of blindfolded and kneeling Polisario prisoners.

After a few days with the army, we returned to Rabat, where we had been granted an interview with King Hassan II, who spoke to us justifying his case for getting support from America to help him deal with the Polisario. A couple of evenings before we left, we had dinner with someone who, I believe, was a high-ranking Moroccan intelligence offi-

107. The Moroccan army fighting the
Polisario in the Sahara, 1979.

cer. We sat on low pillows, as is their custom, in a restaurant on the
roof of the Hilton, where we were served outstanding food and copious
amounts of alcohol. Suddenly, our host turned to Dudu and, in a voice
evidently influenced by drink, said, "I know that you are the action
man, but I can see that he"—pointing at me—"must be the brains be-
hind you." I have never forgotten the look on Dudu's face at my being
described in this way.

TURKEY

In February 1989, *Time* sent me to Turkey to do a general story about the
country, its economy, politics, and way of life. I flew to Istanbul, where
we were to concentrate on the Turkish economy, focusing first on a
leading Jewish-owned construction company called Alkent. Laila Ala-
ton, vice president and daughter of the proprietor, showed us around
some of the various projects on which they were currently engaged.
One of the most interesting was the restoration of a small street close
to the Topkapi Palace Museum. The street consisted of a row of old
wooden houses that were due to be pulled down. But Alkent made the
decision to reconstruct them instead, retaining all the charming origi-
nal features of the properties. The architect whom they chose to work
on this project was Celik Gulersoy, an internationally recognized figure
in his field, who had dedicated his life to rescuing old Istanbul from
demolition. He paid a great deal of attention to maintaining the in-
tegrity of the original design, using traditional workmanship even
down to details such as door handles and light fixtures, but at the same
time bringing the interiors up to date with all the facilities that one
might expect in a modern property. The intention was to establish a
hotel in the largest building and to rent out the adjoining properties to
visiting guests. The street itself was delightful to see, the wood-paneled
facades of the buildings being painted in pastel shades, with small bal-
conies and matching lanterns. This area has become a well-known
tourist attraction, and although I have not yet found the time to do so,
I have always promised myself that I will one day return for a holiday.
 One could not visit Istanbul without being constantly aware of the
display of carpets on every corner, in shops and even hanging outdoors
on walls and covering the pavement, all in an effort to attract passersby.
Turkish carpets are amongst the best in the world, and we saw many of

108. A Janissary **military** band performs
on the occasion of U.S. secretary of state
George Schultz's visit to Turkey, 1986.

them in all styles and materials, from the finest knotted silk carpets
to simple kilims. I was invited to take pictures at a carpet auction in the
Kapali Karsi, the Old Bazaar. This market is reputedly the largest in
the world, with an incredible display of merchandise crammed into the
hundreds of stores, warehouses, coffee shops, restaurants, and work-
shops. The architecture of the market is fascinating, with beautiful
mosaic-tiled walls, fountains, and arched ceilings. The auction itself
was an experience. Although I understood nothing of what was being
said, there was a great deal of shouting and gesticulating as the carpets
changed hands. It was an enthralling event, watching the mustachioed
dealers smoking their hookahs while making bids for the different floor
coverings.

Our evenings in the capital mostly involved social activities with for-
eign and Turkish journalists—a very enjoyable way to pass the time,
particularly as the hospitality was outstanding. In addition to seeing
the thriving commercial centers, we were also taken around by one of
the trade union leaders, who showed us the extent of the poverty in the
slums of Istanbul. It was an immense city with a huge population and
of course had its fair share of social problems.

The city of Ankara was our next port of call. Here we toured with
President Kenan Evren and Prime Minister Turgut Ozal, who spent
their time, as all politicians do, shaking hands and making speeches.
The army then flew us, as their guests, to Erzurum, a small town lo-
cated near Mount Ararat on the Soviet border.

We went there to watch and photograph their army maneuvers, but
as we arrived in the depth of winter, it was unspeakably cold, so cold
that my Canon froze and the only equipment I could use was, once
again, my trusty old Leica. We trudged through deep snow and watched
the troops flitting around on skis. Everything and everyone was camou-
flaged in white, including the helicopters, and they drifted like ghostly
specters around the mountainous terrain. This visit at least gave me the
opportunity of sporting the fur hat I had bought in Oslo at the time of
the Begin-Sadat Nobel Peace Prize ceremony. I was extremely thankful
for it, as I could pull the flaps well down over my ears to stop them from
freezing.

I had also taken the precaution of packing a pair of snow boots
bought years before in Switzerland, which did not get much wear in

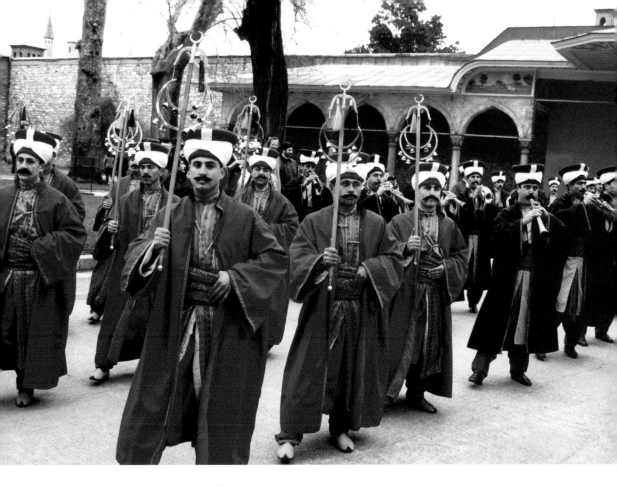

Jerusalem. It was just as well, for from then on the weather got progressively worse. We had planned to return to Ankara by air, but the pilot refused to take off, as the weather was so appalling, with fog, heavy winds, and snow, and we had to sit anxiously in the tiny airport at Erzurum waiting for conditions to improve enough to be able to leave. Eventually we did depart, but to say that I was concerned would be a vast understatement. Our hearts were in our mouths until we finally touched down in Ankara.

Some time later, on another trip to Turkey, I covered the visit of George Schultz, the American secretary of state, who was there on an official visit. After meetings with the Turkish government, he went sightseeing. The highlight of his visit was a spectacular and colorful review of a Janissary military band, dressed in traditional costume dating *108* back hundreds of years. The original Janissaries were an infantry troop that formed the Ottoman sultans' bodyguard. The first units comprised war captives and slaves, but later conscripts were non-Muslim, usually Christian, boys, aged between seven and fourteen years. They belonged to the Sultan, were encouraged to remain celibate, and were forbidden to wear beards, only mustaches. In return they had certain privileges, so over the centuries they grew in power until they were disbanded in the early nineteenth century.

109. Jimmy and Rosalynn Carter host a
Sabbath dinner for Menachem and
Aliza Begin in Washington, D.C., 1979.

The Janissaries' shrill, powerful marching music is played by an ensemble including bass drums, horns, bells, triangles, and cymbals. Their music is still played at state, military, and tourist functions, and it is said that western classical composers such as Mozart and Beethoven were influenced by it. It was certainly distinctive and apparently was designed to frighten away the enemy, just as the bagpipes of Scottish troops were supposed to do. After listening to them, I understood why.

Time later asked me to cover the rise of Islamic influence in Turkey. At the time I was there, it was predominantly a secular state. The country had been hugely influenced by Mustafa Kemal Ataturk (1881–1938), the first president of the Republic of Turkey and one of the towering figures of the twentieth century. He put an end to the antiquated Ottoman dynasty, whose rule had lasted more than six centuries, and created the secular Republic of Turkey in 1923. He introduced a broad range of rapid and sweeping reforms. In the political, social, economic, legal, and cultural spheres, his achievements were unparalleled in any other country. Some of the social reforms he instituted included banning the fez, outlawing religious sects, and proscribing the wearing of religious attire in public. The western calendar was introduced, as was the international numerical system. Use of the Latin alphabet became mandatory for all street signs. Most visitors to Turkey can be grateful for this, as indeed I was, for to my ears the language sounded quite impossible. At least I did not have the added complexity of struggling with Arabic letters, but instead could show a taxi driver an address in a recognizable script. In this way there was a reasonable chance that I might arrive at my destination.

The country maintained its secular status largely because of the control and strength of the army. But on our trip we visited some of the burgeoning Islamic schools where the children were being taught the Koran parrot-fashion, chanting out loud in unison the holy prayers in front of their teacher. This reminded me very much of the old days in the Talmud Torah schools, where we had to recite our daily prayers in Hebrew in much the same fashion. We were permitted to enter a mosque—surprisingly, as it was Friday and the service was in progress. Once inside, we were even allowed to take pictures. Then, after climbing up what seemed like hundreds of steps to the top of the minaret, we found the *muezzin* calling the faithful to prayer. I have some fascinating

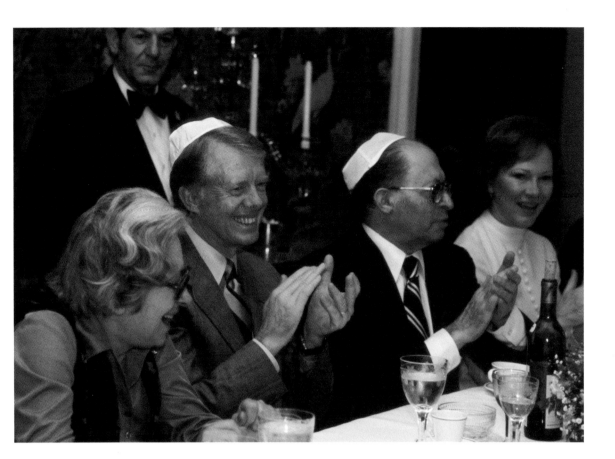

images of him performing this task. I understand that nowadays the mosques use recordings, but at the time I was lucky enough to see him carrying out his traditional role using only a microphone. Before microphones they just had to shout very loudly!

Following the global rise of fundamentalism, the influence and practice of Islam in Turkey is now much more in evidence. It is not uncommon today to see women covered from head to toe in traditional Muslim dress—a far remove from the secular and liberal ideas of Ataturk.

THE WHITE HOUSE

As the head office of *Time-Life* was in New York, the country to which I traveled most often was the United States. This was particularly true in the early days, when Anni and I had to hand-carry film there to get it to the magazine in time for the next issue. I also went to America on assignments, accompanying most of Israel's political leaders, especially during the prolonged period of peace negotiations between Begin and Sadat. I traveled frequently with Begin to Washington prior to, during, and after the Camp David talks and then again for the eventual signing of the peace treaty on the White House lawn in 1979, hosted by President Carter. It was during this visit that President Carter held a Friday evening Sabbath dinner for Menachem Begin and other guests. I have a photograph of Carter wearing a yarmulke as a mark of respect for his

109

visitors. As a consequence of the close links between the two countries and Israel's dependence on her greatest ally, it was necessary for Israeli prime ministers to travel often to the United States to hold discussions on a variety of policy issues. I invariably went along with them.

My work in Washington was made considerably easier as a result of the support I received from *Time* colleagues who were permanently based there. Over the years, they had established excellent connections with the White House staff, so while photographers from other journals were told they had to congregate on one specially erected stand from which they could take their shots, I was given the privilege of wandering around freely, thanks to a colleague who had a quiet word with the head of security on my behalf. I found out that protexia works not only in Israel, and it is quite definitely who you know that counts.

In 1983, during Ronald Reagan's presidency, I was offered the wonderful opportunity to work for a month at the White House. This project was the brainchild of Arnold Drapkin, *Time*'s picture editor. He felt that it would be an interesting idea to arrange an exchange of photographers, so while I went there, my Washington counterpart came to stay in Jerusalem. Drapkin firmly believed that photographers were in danger of becoming stale if they stayed too long in their own familiar environment. He wanted to see the impressions that would emerge from his team looking at things afresh, through new pairs of eyes. The whole month was an experience not to be missed. I had the added opportunity of going with the president to events outside Washington, in Miami, New Jersey, and Virginia. While Reagan always traveled on board *Air Force One*, the press had a special plane we called the "media aircraft." The press plane would always leave a little after the President boarded his flight so that we could cover his departure. His AF-1 would then stay in the air a short time longer than necessary, so that we could land ahead of him and be ready to photograph him on his arrival.

Before any presidential trip, it was customary for an advance party to go on ahead to check that everything was in order. Reagan's team always included a photographer and a TV man whose job it was to advise on visual coverage and ensure that the lighting, background, and locations were as perfect as possible. Nothing was left to chance. Reagan's experience in the film industry and personal knowledge of camera and film techniques were very much in evidence. Each afternoon at a

specified time, I had to call someone at the White House from whom I would receive a meticulously prepared itinerary for the next day. Nothing was omitted. I was told exactly where I would be placed and precisely how many meters away from the president this would be. In addition, I received detailed information as to which type of lens they recommended I should use. All that was left for me to do was to press a finger on the shutter. I think that if they had been able to devise a way of carrying out that simple function for me, they would have done so.

Reagan was the consummate performer. He was totally at ease with the public at all times, never failing to have a friendly smile on his face to present to the world. Having been an actor in Hollywood for many years, he knew exactly how to manipulate the media to make certain that he was always photographed from the best possible angle and with the most complimentary lighting. Tapes were stuck to the ground so that he could see exactly where he and the other dignitaries were supposed to stand. One such event I attended in 1983 was a meeting of the G7 in Williamsburg. This was a forum where the leaders of the western powers gathered together to discuss policy issues. Included in this illustrious group was Margaret Thatcher, the prime minister of Great Britain. We photographers had all been lined up down one side of a walkway while Reagan strode over to receive her, in a position that was precisely at a right angle to the cameras. President Reagan looked carefully around and then asked Mrs. Thatcher if she would move half a step forward, thus enabling us to take a picture that in professional language is called a "medallion shot." What often happens when two people are standing close to each other is that one obscures the other from view, but in the medallion position one can see both faces in clear profile, much as they would appear on a coin. It was a photographer's dream—the perfect shot that guaranteed placement in next week's magazine. And it was all the work of Ronald Reagan.

I was told of two other incidents when he used his professional expertise to ensure perfect shots. Once he went on a trip to France, which included a visit to the Palace of Versailles near Paris. As usual, the advance party went ahead to check that everything was just as they wanted it. When they saw the setting where he was to be filmed, they were not happy, as a huge Gobelin tapestry was hanging on the wall precisely behind where he would stand. They insisted that this historic

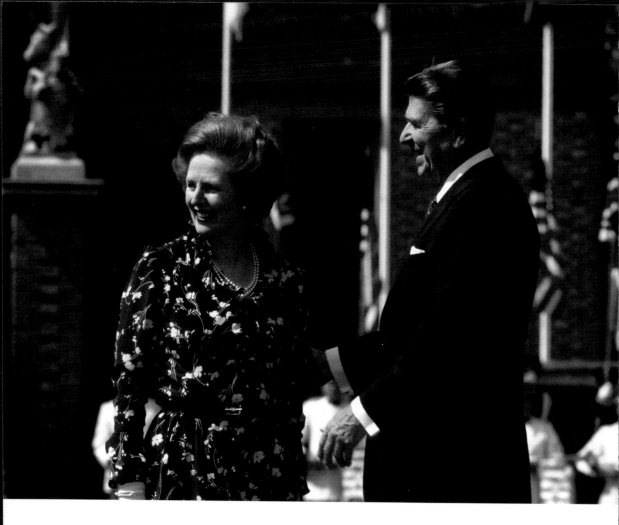

110. Ronald Reagan and Margaret Thatcher at
the G7 meeting in Williamsburg, Virginia, 1983.

and exquisite piece of art be completely covered with a piece of blue
fabric. Their argument was that Reagan photographed particularly well
against the color blue, but, more important, they did not want to run
the risk of attention being taken away from his face and drawn instead
to the priceless work of art behind him. The French naturally opposed
this measure violently, but the White House staff prevailed and Rea-
gan was photographed as he wanted, without any competing artistic
attraction.

On another official visit to Europe, he and his wife Nancy were taken
to visit the World War II cemetery where those American troops who
had not survived the Normandy landings were buried. An immense
field of white crosses, amongst them a large number of Magen Davids,
stretched in all directions, silhouetted against the bright green of the
grassy fields. The scene was set. All extraneous matter was efficiently
removed, including anyone else who might have happened to be visit-
ing the graves. Even the bodyguards were not allowed near while the

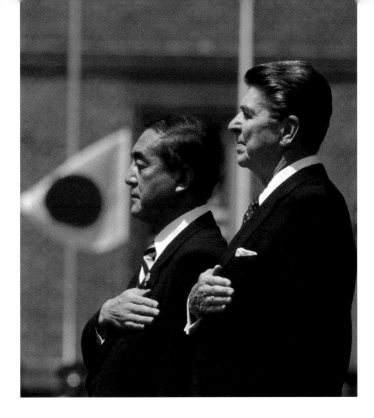

111. A characteristic Reagan medallion
shot: the president and Japanese prime
minister Yasuhiro Nakasone at the G7
meeting in Williamsburg.

president and the first lady were carefully positioned to produce an out-standing panoramic scene with the two of them holding center stage.

While I was in Washington on my month's assignment, I was fortu-nate to be invited to the annual dinner of the White House News Pho-tographers Association, an illustrious black-tie affair hosted by the president. I felt honored to be invited and duly went out to rent a tuxedo. All the photographers who had been invited—and there were many—were advised that this was the one and only evening when they were not allowed to bring a camera with them, the only exception being the official photographer on duty that night.

We all sat down at our appointed tables. Eventually President Reagan got up from his seat, moved over to the podium, and prepared to make his speech of welcome. He surveyed the room slowly, then faced his guests, smiled, and announced, "I have always dreamed that one day I might be in a room like this, full of photographers without cameras, so that I could do this." Whereupon he stuck a thumb into each of his ears and wiggled his fingers at us in a rude gesture, like a mischievous schoolboy. It seemed at the time to be a totally sponta-neous action, but the official photographer caught this performance in his lens, and the picture appeared the next day in all the papers. I

strongly suspect that this likeable and supremely professional man had carefully orchestrated the whole scenario.

In later years, I accompanied Prime Minister Yitzhak Rabin on a number of trips to the United States. The most memorable occasion was when Rabin signed the peace treaty with King Hussein of Jordan in 1994. The event was hosted by President Bill Clinton, who had a huge grin on his face at the success of his efforts. The three leading ladies, Hillary Clinton, Leah Rabin, and Queen Noor of Jordan, presented me with a wonderful shot as they walked on the White House lawn. The signing was a hugely important occasion, as it was only the second time that Israel had signed a peace treaty with an Arab nation. I felt very proud to have been able to witness both, the first with Sadat of Egypt and this one with the king of Jordan. It was enormously satisfying to

112. Vice President Al Gore applauds as King Hussein of Jordan and Yitzhak Rabin shake hands at a joint session of the U.S. Congress, 1994.

have been present at such historic events—which we all prayed would determine a peaceful future for the State of Israel.

The day after the signing of the peace treaty, there was a joint session of both houses of Congress, and I have a photo of Al Gore (who, as vice president, also presided over the Senate) standing on a podium above Hussein and Rabin, applauding as they shook hands with tears in their eyes. There is no doubt in my mind that this was a most important occasion for these leaders, who were both very earnest in their desire to bring about peace in the Middle East.

112

32. MY LIFE IN THE MOVIES

One of the more pleasurable aspects of being a photojournalist was being invited to undertake assignments that were, for a change, far removed from the headlines about war and political upheaval that one read too often in the Israeli press. One such job was being hired to do the still photography for some of the movies being produced in Israel by international film companies. Apart from being very well paid, this was welcome light relief for me. It was generally a lot of fun, and life was made easier by the fact that the film directors and crew took full responsibility to ensure that the lighting conditions were perfect for their own shots, which of course made my task much simpler.

One of the earliest films I worked on was *Ben-Hur*, directed by William Wyler. I was asked to work with the second unit director, Andrew Marton, while he was filming the crowd scenes for this historical epic. Marton was given the task of shooting those parts of the film that showed the masses of Jews coming up to Jerusalem for the census—an annual pilgrimage in biblical times. The filming took place in the mid-1950s, which was fortunate for Marton as it coincided with the time when a huge influx of immigrants arrived in the country. These newcomers were only too delighted to be hired at the rate of ten Israeli pounds a day to play their ancestors of two thousand years ago.

It is well known that directors face many problems when dealing with film extras. Apart from the sheer logistical issues of mobilizing a "cast of thousands," extras are not usually professional actors and may therefore all too often look directly into the camera or smile at an inappropriate time and thus ruin a whole scene. Marton's problems were compounded by having to work with this particular group. They were mostly new immigrants, so communication with them was virtually impossible, as the majority spoke not a word of English. I remember

113. Spaghetti all'arrabbiata: Luciano Pavarotti cooked and Zubin Mehta, music director of the Israel Philharmonic Orchestra, eats.

him having heated arguments, through an interpreter, with some of the crowd who categorically refused to remove their wristwatches during the filming. The women amongst them also adamantly refused to relinquish their handbags during the shooting of their scenes. However much he tried to explain to them that Jews in the year zero had neither watches nor handbags, his entreaties seemed to make no impression on these budding performers.

Marton, however, was not a man to give up easily. He was known for his persistence and patience, which in the end prevailed, and he eventually achieved the effects he wanted. He was well liked and admired by his colleagues in the industry. Marton was born in Hungary, as were so

many other important personalities from the world of cinema, and one story goes that, at a Hollywood party where he was present, a huge banner had been erected proclaiming, "It is not enough to be Hungarian. You must have a little talent too."

During the filming, Marton invited Anni and me as his guests to visit the Cinecitta studio in Rome, where the main part of *Ben-Hur* was being filmed. It was a fascinating visit, and I learned a lot about the tricks of the trade in the movie world. There in the middle of Rome, I suddenly found myself walking on a set that looked exactly like the Old City of Jerusalem but on closer inspection revealed itself to be entirely fabricated out of cardboard. It was extremely realistic, so much so that I would not have been surprised to turn a few corners and find myself at my own home in Katamon.

I watched a special effects man as he attached an explosive device to the axle of one of the Roman chariots. This was intended to blow up just at the right moment so that the wheel would spin off during one of

those hair-raising and perilous chariot races. Steven Boyd, the actor
who portrayed Messala, had to be clad in heavy leather underwear so
that when he was dragged along the ground under his chariot, drawn
by galloping horses, he would be protected from injury. However well
padded he may have been, it was still not something that I would have
chosen to do. Boyd was obviously made of sterner stuff—he had been
offered a stunt man to take his place, but refused and insisted on per-
forming this macho scene himself.

In the film business, you soon realize how reality is completely sus-
pended. One day on the set, I saw something that intrigued me: a group
of workmen were busily applying a coat of green paint to the leaves of
several real palm trees. I was immediately reminded of the scene in
Alice in Wonderland where the Queen of Hearts orders her knaves to
paint the roses in her garden red instead of yellow. In the case of *Ben-
Hur*, it was not just an eccentric whim on someone's part, but that the
leaves were not considered green enough for the film's Technicolor
process. I suppose that, in a world of total artifice, it is quite acceptable
to "improve" upon nature.

About twenty years later, in 1973, I was hired to do the still photog-
raphy for the C B S production of *Moses*, which was filmed partly in the
Judean Desert and also in a former Arab refugee camp near Jericho. The
filmmakers had chosen this location as many of the buildings were con-
structed from mud bricks in the same traditional style that had been
used over the centuries and were therefore very appropriate for a bibli-
cal epic.

Burt Lancaster was cast in the role of Moses. He turned out to be not *114*
the easiest of people to deal with, as I learned to my cost. It soon be-
came apparent that he had no great love for still photographers and
went out of his way to make sure that everyone knew how he felt. I
once saw him threaten to slap a female photojournalist if she did not
vanish from his sight. It made me wonder whether he had got his roles
confused and thought he was playing God rather than Moses.

My turn to become the object of his wrath eventually arrived. While
shooting a particularly difficult scene, he turned on me and shouted,
"Who needs your f—— pictures!" I could not take this, even if I was
being paid a massive $400 per day, so I packed up my camera gear and
promptly left the set. I went home and immediately set about writing

a letter to this great actor. My letter stated, "You asked who needs my
f—— pictures—I'll tell you who needs them. The same people who are
paying your f—— salary—they need them. Furthermore, let me tell
you, you may be a world-renowned actor and are no doubt proud of
your profession, but for your information I am also proud of what I do
as a photographer." I did not mail the letter but had it delivered by hand
to his suite at the Intercontinental Hotel on Mount Scopus. The next
thing that happened was that I received a phone call from the pro-
ducer's office asking me very politely if I would "please" come to the
film set the following day. I went.

Greatness in a man is not necessarily measured by his achievements
but is more often revealed by the manner in which he behaves towards
others. Burt Lancaster immediately called me over to meet him and ex-
tended an apology for his behavior, which of course I accepted. Not
only did he say he was sorry, but, more than that, he insisted on dis-
cussing at great length how I could best take my shots during the film-
ing of the next scene. This was the one where Moses descends from the
mountain, clutching the tablets that God has just given to him, only to
find the people of Israel dancing around the golden calf. In his anger, he
breaks the stone tablets inscribed with the Ten Commandments by
smashing them to the ground. Burt suggested that I use a long-distance
lens so that the noise of my motor drive would not distract him, a re-
quest with which I was happy to comply. This was not a scene that
could easily be repeated, as I was sure that stone tablets inscribed with
the Ten Commandments did not come cheap, and it would have meant
having a new set specially made for him to break again. Fortunately the
original Moses, while having plenty to worry about, did not have this
particular problem to contend with.

I got to meet many other stars of the silver screen from Hollywood
on their visits to Israel. I have always been in an enviable position with
Time, as I believe I was one of their few photojournalists privileged
enough to be able to self-assign. This meant that I could select for my-
self those activities that I thought would produce good articles, rather
than wait until the magazine sent me out to a particular project of their
choosing.

As a result, I got to meet almost anyone I chose. I photographed
115 Walter Matthau and Jack Lemmon sporting their Israeli *kova tembel*

hats on a visit to a kibbutz. I captured Maureen O'Hara putting a note into a crack in the Western Wall. (It is a custom for people to write notes to the Almighty asking for blessings.) I saw Peter O'Toole playing the Roman commander who breached the fortress of Masada and watched Anthony Quayle as he relaxed smoking a pipe, during a break in filming. This was quite an incongruous sight, since he was dressed as Aaron, the brother of Moses, in the film of the same name.

In the early days, in 1951, I watched the Italian sex symbol Silvana Pampanini crossing the hostile border at the Mandelbaum Gate and observed how both the Israeli and the Jordanian policemen set aside all thoughts of enmity in their eagerness to be photographed with her. In later years, I watched Brooke Shields acting in *Sahara*, where she was in a cave, supposedly attacked by a black panther. I marveled at the skill of the animal trainer who manipulated the panther to make it appear as if the actress were seriously under threat. In spite of his presence, however, I chose not to stand too close to take my shot!

On another occasion, I was invited by Mira Avrech, at that time working as a journalist for *People* magazine, to do a story with her. Zubin Mehta, resident conductor of the Israel Philharmonic Orchestra, had been performing with the world-famous tenor Luciano Pavarotti. Sadly, I missed the concert, but we were invited to join them for a party that evening at the Israel Philharmonic's center in Tel Aviv. We duly

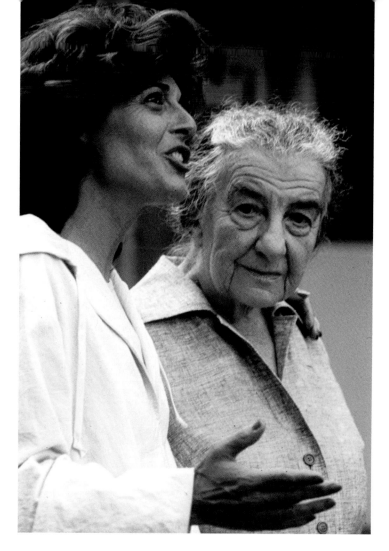

arrived to find Pavarotti in the kitchen in his shirtsleeves, standing over
the stove and cooking spaghetti, all the while to the accompaniment of
his amazing voice. As he stirred the pot, he added more and more hot
pepper. He gave some spaghetti to Zubin to try, who pronounced it
much too hot, at which the tenor laughed heartily and said, "Of course
it is hot! It's 'arrabbiato' [angry]—it has to be!" The picture I took of
them together is one of my favorites, as it showed two master show-
men in a rare moment of relaxation.

Sometimes I went with the stars to visit our VIPs. I saw Begin to-
tally convulsed with laughter at Jerry Lewis's antics. I accompanied
Lauren Bacall, Humphrey Bogart's wife, when she went to meet Shi-
mon Peres. Bacall's family name had been Persky, and so was Peres's
before he hebraized it. After they explored their family trees in detail, it
emerged that she and Peres were first cousins.

One fact that became very apparent each time I met one of these fa-
mous personalities was that they truly deserved their international ac-
claim. Without exception, the performers that I met were consummate

professionals who demonstrated a dedication to their craft that took them out of the realm of the ordinary. For example, I marveled at the commitment of David Niven when he filmed *The Best of Enemies* in Eilat. It was excessively hot, and he had to be dressed in full military uniform. It made me realize what taxing work acting can be. The actress Anne Bancroft was another such personality. A musical had been written based on the life of Golda Meir. It was scheduled to open on Broadway in 1977, and Anne was to play the leading role. She decided she must come to Israel in order to meet the real Golda, to study her mannerisms, her movements, her voice, and everything else about her. I was assigned by *Time* to accompany her. We visited the kibbutz in the Negev where Golda's children and grandchildren lived and spent time at her home in Ramat David. It was an uncanny experience because, after a week or ten days, when I closed my eyes and listened to Anne or observed the way she began to move around, I began to wonder who was who, so well had she captured the characteristics of her subject. This was undoubtedly the work of a seriously talented actress, supremely gifted in her craft.

116

The producers of the show asked me if I had any stills that could be used to enhance the production, so I showed them a slide show that I had prepared about the Yom Kippur War. The wife of one of the producers saw it and was so moved she burst into tears; so they bought the slide show to use as a backdrop on the set of their musical. The only sad ending to this story is that the show was panned by all the critics and lasted for only two weeks.

Sophie Tucker was another of the greats from the world of entertainment. She was particularly famous for her rendition of the song entitled "Life Begins at Forty." By the time I saw her in Israel in the early '50s, she was already an old woman. Backstage, she had great difficulty getting up out of her chair, so much so that she had to have two people assist her. Once on stage, however, she was transformed. Appearing as light as a feather, she gave a wonderful performance and entranced everyone. The willpower she demonstrated was a revelation.

Danny Kaye was probably one of the most charismatic personalities whom I met. His attachment to Israel was well known. I photographed him first in 1956 and for the last time in 1980, but between those dates he visited frequently. It was only two weeks after the Six Day War when

117. Danny Kaye tours Jerusalem syna-
gogues on a cold winter's night, 1959.

Danny arrived and, together with Teddy Kollek, set about visiting the
wounded soldiers in hospital. He was completely involved with the pa-
tients, and the way he lifted everyone's spirits was a joy to behold. He
was a natural entertainer and one whose personality always shone
through. It was on one of his earlier visits that I took my daughter Tami,
then nine years old, to meet him. He had a wonderful way with every-
one, but particularly with children. Danny took hold of her hand, and
the expression of delight on her face was something I can never forget.
Of course, I have a picture of them together.

Another time I accompanied him on a Jerusalem synagogue tour.
It was a freezing cold winter's night, and we sat huddled together
117 wearing huge overcoats and woolly hats. I have a charming picture of
him surrounded by small children from the Bukharian community. It

118. Myself with Harry Belafonte, visiting a Bedouin sheikh, 1960.

seemed that his fame had spread far and wide, even to those who may not have understood English so well, but, despite this, they certainly managed to communicate in their own way with Danny Kaye. The last time I photographed him was in Washington. Begin, the acknowledged serial embracer, hugged Danny Kaye as he presented him with a special award for his unfailing support for Israel over the years.

Another great personality with whom I very much enjoyed working was Harry Belafonte, the African-American singer. He came to Israel with his Jewish wife Judy and their son David. I was commissioned to take the pictures for the magazine *Ebony*, which was like a black version of *Life*. I traveled the whole of Israel with the Belafontes for fourteen days. He had a punishing schedule of performances at venues all over the country, and to watch him in action was an education. He had a most beautiful voice and a riveting personality. I saw him sing almost every evening, and after a couple of days I realized that all those gestures that on the first night I assumed were spontaneous were in fact carefully rehearsed, down to the pauses and the subtle movements, such as taking hold of a button on his shirt. Nothing was left to chance. After each show he was totally drained. You could see that he had given every ounce of his energy to the performance and there was nothing of him left afterwards. He went immediately to sleep and each morning would eat the most enormous breakfast I have ever seen, comprising a huge steak, two eggs, and a large urn of coffee. However much he ate, it did not affect his size, for he had not an ounce of surplus flesh and an enviable physique.

While in Israel, he was invited to a Bedouin encampment near Beersheva. The Bedouin put on a wonderful welcome for him, with horse and camel racing, and afterwards we all sat together on cushions in their tent while they served us coffee and refreshments. At one point, the sheikh presented Harry with a Bedouin sword, which he was delighted to accept. He then realized that it was probably good manners to reciprocate with a gift. He was sitting next to me, and turned and

119. Myself playing Edward G. Robinson's driver in a documentary film, 1959.

whispered, "I'd like to give him a watch, but I can't give him mine. Do you have one?" I gave him my watch, which he presented to the sheikh, who put it on alongside his existing timepiece, and everyone was happy. A few weeks later, a packet arrived at my home, and in it was a gold Omega watch inscribed "to David from Harry Belafonte" on the back. I still have it, but of course would much prefer that the inscription were on the watch face, where it could be seen!

Being involved with film stars brought me into contact with two personalities who reputedly had links with the underworld. The first was Frank Sinatra. I was a little apprehensive about meeting him, as I had heard he could be very brusque towards those around him, but I never noticed this at all on either of his visits to Israel. He was a perfect gentleman as he traveled with his wife Barbara, and also when he was touring for Variety, the international charity that raises money for disadvantaged children. He came with a group including Sarah Churchill, Gregory Peck, and Mrs. Johnny Carson, who went to childrens' homes, visited sick youngsters in hospital, and also saw some of the Alyn projects—an Israeli charity for handicapped children. I took a lot of photographs of them and am sure that they brought with them, and took away, a great deal of goodwill.

The second "gangster" I met was Edward G. Robinson. A Jew, he had specialized in playing gangster roles in his early movies. At the time, in 1959, I was working part-time for the Israel Bonds organization, so whenever they had an important guest, they would ask me to take stills. Robinson was taking part in a documentary for the Hebrew University. It was filmed partially in the Negev, and while we were there, they needed someone to drive the star through the desert in a command car as part of the film. I was volunteered for this role. Our car did not actually move. Instead the scenery moved behind the car to make it look as though we were traveling. This was my very first attempt at becoming a star of the silver screen, and my last. I never even saw the film when it was finished, but had already decided by then not to give up my day job to seek stardom and to stick with what I knew best and remain a photographer. I often think that it was a great pity that Robinson's role in that film was not that of a gangster, as I rather fancied myself as the driver of his getaway car. Ah well, one cannot have everything in life!

119

33. INFLUENCES ON MY CAREER

Any success that I achieved with *Time-Life* was undoubtedly furthered by my association with some of the fascinating people I was fortunate enough to meet through the magazine. One of these personalities was Ralph P. Davidson.

One day in April 1967, a young man arrived in Israel from *Time-Life* in New York to try to drum up advertising for the magazine, in particular from the Israeli Ministry of Tourism. His name was Ralph P. Davidson. He had come up with the original idea of regional advertising, which meant that local editions of the magazine would contain advertising that was relevant only to a particular geographical area. As a result, the cost to an advertiser would be substantially less than if their advertisements were to appear in the international edition. In addition, smaller countries and their local advertisers could enjoy the tremendous prestige of being featured in the pages of the world's leading news magazine. It was a very simple idea and one now widely in practice, but at the time it was wholly innovative.

A close friend at the Ministry of Tourism asked if I, as a member of *Time's* Jerusalem bureau, would meet Davidson. I did so and took him out for a meal. During the next few years, Ralph climbed steadily up through the hierarchy of the magazine's business department. About ten years later, I had a chance meeting with him in the elevator of the *Time-Life* building in London. I was delighted to see him and suggested we go out for lunch. His response was that typical of a driven business executive: "My dear David, I don't have time for lunch. I have to go out and make money, so that you people on the editorial side can spend it." We did not have lunch that day, but he kept his word about promoting the finances of the company, and his career progressed rapidly.

He rose to become publisher of *Time* and later to the ultimate position of chairman of the board of Time Inc. He had his suite of offices on the thirty-fourth floor of the building, commonly known as the "Floor of the Gods." I remember on one trip to New York coming into the Picture Department and the secretary, her voice trembling and reverential, whispering to me, "Mr. Davidson wants you to call him." The way she spoke was as if I had received a communication direct from the Almighty. Ralph and I became close friends over the years. Anni and I spent many a happy time with him and his family at his home in Southport, Connecticut, and our warm friendship has lasted until today.

Another unforgettable character was Henry Anatole Grunwald. His history was very similar to mine in that he too was forced to leave Vienna at about the same time as me, as a youngster aged fifteen. He, however, went to the United States, where, providentially, he obtained employment as an office boy with *Time* magazine. From here began his meteoric climb to the top, working as correspondent, bureau chief in London, managing editor, and eventually editor in chief of Time Inc.

I remember one incident when Anni had couriered to New York my film containing images of a barbaric terrorist attack by some Palestinians. Israeli troops had carried out an immediate retaliatory attack, and *Time* used a split cover to focus on both these incidents. While she was in New York, Anni was invited to a cocktail party in Henry's honor. There she fearlessly confronted him, berating him for using both attacks as if they were analogous. She asked him if he would equate the horrors of Auschwitz with the Allied raids on Dresden, given that in both cases thousands had been killed. Henry put his arm around her shoulder and said, "Anni, all I wish is that the Israelis had waited to retaliate until the magazine had gone to bed!"

When Henry retired from *Time*, President Reagan appointed him ambassador to Austria. We had kept in touch over the years, and when Anni and I were next in Vienna, he invited us out to lunch. We all sat in a restaurant while, outside on the street, six security officers with German shepherds guarded his Mercedes. The irony of the situation was not lost on any of us, and I sensed the gratification he must have felt at being sent back to his native country, from where he had been kicked out in 1939, as the ambassador of the world's greatest power.

Arnold Drapkin, who took over as director of photography in 1978, is another person whose friendship I value highly and who helped me enormously in my profession. Many a night I would be woken up by a phone call from him saying, "David, I cannot tell you what I want to tell you because I don't want to jinx it." This was all he said, but I understood exactly what he meant. He was trying to tell me that one of my pictures was scheduled to be on the cover of the magazine. He could not resist telling me as soon as he knew, but in this business there was always the chance that something more newsworthy might crop up and prevent my picture from appearing.

These calls often came on a Friday night. In New York, the magazine was "put to bed" either very late on Friday night or early on Saturday morning. The atmosphere in the New York office at this time was quite frenetic, and I attended several such Friday night shindigs where hard work combined with partying. People were running about bringing in film, racing to the lab, getting proof sheets, or scanning slides on a light table. This hive of industry was always accompanied by tables loaded with food and lubricated with copious amounts of alcohol. It was quite an extraordinary send-off for a magazine, and it happened every week—no doubt an essential ritual before the birth of the next week's issue. Newsmen facing deadlines are always working under great pressure to produce the best. The actual moment when they put the magazine to bed is one of great relief and a release of the week's tension—with the process starting all over again two days later.

Drapkin had a stable of some twenty-four photographers, but I believe I was something of a favorite. He once said to me, "David, I don't want you to be where all the other photographers are standing. I want you to be at the place where 'it' might happen. Even if you come back nine times out of ten without a usable image, the tenth time will make it all worthwhile." He was an outstanding picture editor with an infallible instinct for news, always encouraging his photographers to seek out the unusual and original shot.

One day the mail arrived and I was surprised to receive a cartoon from him. It was a drawing of Icarus standing on a cliff edge with his wings outstretched, getting ready to fly. Crowds of photographers and TV cameramen aimed their lenses at him, waiting to film his feat. At the bottom of the cliff stood a little photographer, with his camera

120. During Operation Litani in south-
ern Lebanon, 1978, this Palestinian
fighter was killed just before he could
throw the grenade in his hand. *Time*
thought this photo was "too perfect."

pointing towards the ground. Drapkin wrote on the cartoon in red, "David, this is where I want you to be. If he actually flies, I can get all the pictures I need from anyone else all over the world, but if he doesn't fly, I want the picture that you will take standing down there at the bottom." This cartoon has held a place of honor on the wall above my desk to this day. It truly exemplified Drapkin's approach.

He once said to me that he could get photographers who can produce a sharp image a dime a dozen, but that what he really wanted were photographers who could get close to their subjects and create an intimacy with them, thus producing outstanding shots. I think this is the reason why he sent me on every trip with Menachem Begin. When Arnold retired from *Time-Life*, photographers from all over the world were invited to send a message to be read out at his farewell party. I wrote, "Arnold is a great picture editor and loves photography, but what he loves even more are photographers."

I have been incredibly fortunate in the training that I received, both from Arnold and also in the early days from Uri Avnery. In spite of this, I often came away from an assignment feeling dissatisfied, thinking that I might have done better. I would ask myself why I had not taken the shot from a different angle, or why I had not been at the other side of the road, or higher up, or closer. I think this type of self-criticism is healthy in any art form, for without it one can become self-satisfied and complacent. It is important always to realize that in this business you have but one opportunity to take your shots. It is not like the replay of a football match that you see on TV, when you can observe the action time and time again. The players in my world cannot return to reenact the scene, and usually the event that you have gone to cover can be over in a split second. This need to be there at the right time was deeply seated in me. Consequently, I never wanted to go on vacation, in case I missed something important. On the other hand, I always had the strangest feeling that nothing of significance could possibly take place unless I was there.

Sometimes when taking pictures, however brilliant an image may seem to you, it is not always possible to have it published as prominently as you would wish, as the following story illustrates. Even before the Peace for Galilee war, there were several minor "wars" between Israel and the Palestinians in Lebanon. During Operation Litani in 1978,

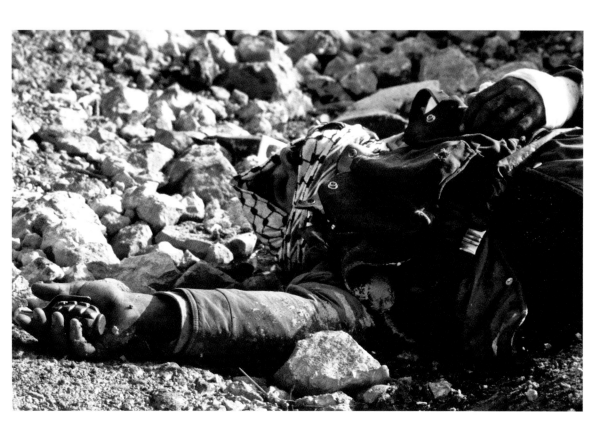

I shot what I consider to be one of the most dramatic and telling pictures I have ever taken. I was with a platoon that was advancing on foot towards the Litani River, when suddenly I came across the unbelievably dramatic sight of a dead Palestinian fighter lying on his back, clutching a hand grenade from which he had already removed the safety pin—he *120* had evidently been shot just at the precise moment he was about to throw it. I excitedly sent this picture to *Time*, where they deliberated as to whether it should be used as the cover photograph. At midnight, I received a very exasperating call from my editor in New York to tell me that, during the editorial conference at the magazine, some of the people present felt that my picture looked "too perfect," almost as if it had been issued by the Israeli Foreign Ministry propaganda department. The story it told was true enough, that the IDF had stopped this particular Palestinian terrorist just before he was able to hurl his hand grenade at them. I was really incensed and immediately sent off an irate cable, the contents of which I have never regretted. I said, "I am not in the habit of tripping up blind people, I am not in the habit of throwing my grandmother down the stairs and asking why she was running, nor am I in the habit of putting hand grenades into dead people's hands." The magazine did not reply. They used the picture on an inside page but not on the cover. One thing you soon realize in this business is that you can't win 'em all, however hard you try!

Another lesson that you learn over the years as a photographer is that sometimes the shots you take can inadvertently cause harm. This

can be very distressing. On one occasion, I had taken a photograph of Israeli fighter pilots at their base at Hatzor, sitting around and relaxing. I shot it in August 1969 as part of an article about the French-designed Mirage planes. This was a picture of no real consequence. It ran in *Time*, but it turned out to have devastating results. One of the pilots who was featured in the picture was shot down and captured by the Egyptians during the Yom Kippur War, some four years later. It turned out that the Egyptians had somehow seen him in *Time*. They were thus able to identify, interrogate, and torture him to reveal the names, identities, and whereabouts of the other pilots in the photograph. I was told about this a long time after the incident, and following the return of the Israeli prisoners of war, including this pilot. I was really upset when I heard the story, but of course there was no way I could have possibly foreseen where the picture might lead to when I took it. Since that time, however, the IDF has made it a rule never to permit pictures to be taken that show the faces of ranking members of the armed forces, or pilots, to avoid such an incident happening again.

Less serious, but in the same vein, was when the Israeli heroes returned to Israel from Entebbe. In 1976, an Air France Boeing 707 with 244 passengers on board took off from Athens en route to Paris. In the air, it was hijacked by two members of the Popular Front for the Liberation of Palestine and a couple from the German Baader-Meinhof Gang. The plane was forced to land at Benghazi in Libya for refueling and then flew on to Entebbe in Uganda. There the hijackers took the passengers hostage, demanding the release of fifty-three Palestinian prisoners held in various locations throughout the world. They released most of the hostages but kept back all those passengers who were either Jews or Israelis. The Israeli government refused to negotiate with the terrorists and launched a daring rescue mission. One hundred of the one hundred and three hostages were rescued, but one Israeli officer, Yoni Netanyahu, was killed. I was at the airport to welcome back our brave and courageous boys and photographed the pilot who led the four Hercules rescue planes as he was held aloft on the shoulders of the jubilant crowd. Many years later, at a commemorative reception at the president's residence, the pilot in question confronted me jokingly, saying, "You bastard, after I was seen publicly in your photograph in *Time*, our

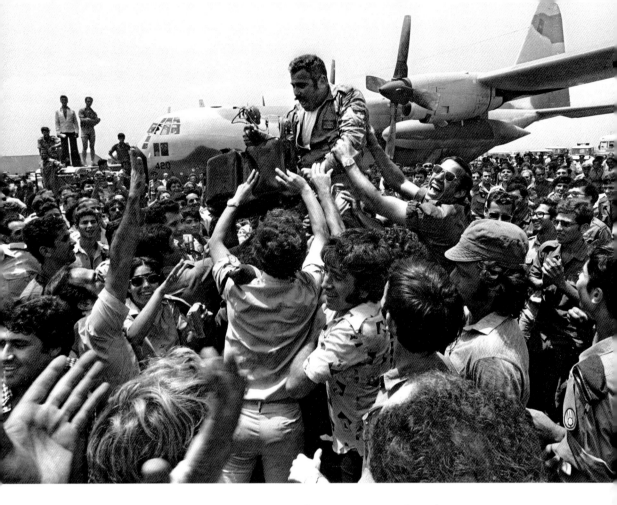

security services forced me to wear a wig for a year to avoid my being recognized and possibly attacked!"

There were other occasions when my integrity as a journalist was called into question. I was sent on an assignment to cover the funeral of a Canadian colonel named George Flint, who was serving in the UN Truce Supervision Organization (UNTSO). He had the misfortune to be shot by a sniper while trying to make his way to attend to some Israeli policemen lying wounded in no-man's-land. The investigating committee found that the bullet had come from a Jordanian position in Issawya, a village below Mount Scopus in Jerusalem. The funeral began at the Scottish Hospice in the city. I was walking backwards facing the mourners of the funeral procession, not an easy thing to do when your arms are full of equipment. Suddenly Colonel Flint's widow rushed towards me weeping and started beating me fiercely with her fists, obviously distressed at the sight of a photographer taking pictures of her in her time of sorrow. I felt terribly embarrassed that my presence should have caused such a reaction, particularly as I had always prided myself on avoiding taking photographs that might intrude on a subject's privacy, a policy that I have rigorously maintained throughout my career.

This issue of what is or is not in the public interest is of course the perennial dilemma faced by journalists and one that produces endless and often fruitless discussions.

Walking backwards, by the way, is something that all good photographers learn to do when trying to get the best shots of people approaching. Usually this works well, but once, when I was marching backwards at the funeral procession for Begin's wife Aliza, up on Mount Scopus, I tripped and fell. I was fine, but I learned a costly lesson about vanity. I had just purchased a hearing aid in the United States at a cost of $2,500, and when I fell, it was crushed to smithereens in my pocket. As I was new to wearing this contraption, I felt slightly embarrassed about it; hence it was in my pocket, a place where it could certainly not help my hearing. From then on, I tried to overcome my reluctance to be seen wearing it. My mind was eventually made up when, on a trip to New York, I saw a large billboard that said, "If you don't see well, you wear glasses. So why should you be ashamed of wearing a hearing aid if you don't hear well?" I have worn it since.

On another occasion, I attended the reburial of some bones that had been excavated at Masada by Yigal Yadin. As is the religious requirement, they were to be reinterred in a ceremony conducted by Chief Rabbi Shlomo Goren, at the foot of a mountain by the Dead Sea. Many photographers were present, so I decided to find what seemed to me to be a better vantage point up at the top of a small hill. As I stood there, a police officer suddenly approached me and demanded that I join the other photographers. I felt that as I was in no one's way, there was no reason to follow his instructions, so I refused. He then tried to physically remove me from the spot, whereupon I stumbled and, in doing so, grabbed hold of his shoulder to steady myself, accidentally pulling off his insignia. This enraged him even more. He decided to arrest me for assaulting a police officer and ordered another policeman to put me in a van and drive me to the jail in Arad. This whole incident was observed and photographed by my colleagues, who on their return to Jerusalem alerted both the Government Press Office and the Journalists' Association as to what had happened.

This incident occurred in the late afternoon, and I remained in jail for five or six hours. While in my cell, I overheard a wireless conversation in which the officer in charge appeared to have been instructed by

someone at his headquarters to release me immediately. The officer came to me, saying that he would release me on condition that I provide him with my fingerprints. As I had overheard the conversation with his superior, I felt confident and declined, saying, "No way, I didn't do anything wrong; I won't let you take my fingerprints." He went back and reported this by telephone to someone, and after several minutes I heard an angry voice on the other end of the line saying, "Never mind about the fingerprints—just release him. Also, it is dark and dangerous on the road from Arad to Beersheva. It is ten o'clock at night, so you must provide him with an escort." I was thereupon immediately released from my cell, without having to provide any fingerprints, and drove back to Beersheva in my car, accompanied by a police jeep. Many months later, the inspector general, Haim Tavori, whom I knew well, arranged a reconciliation meeting between the officer involved in the incident and me, where, over a drink, we made our peace.

Popular myth has it that "a photograph never lies" and "a picture is worth a thousand words." Both of these statements are patently untrue, and moreover a good "fake" picture can lie much better than a thousand words. I have seen for myself several instances of how the camera can distort the truth quite substantially. One case in point happened during the Lebanon War. A picture appeared in all the world's press showing a young Israeli soldier standing next to a small Palestinian boy who was crying. The accompanying text referred to the "brutality" of the armed aggressor. What in fact had happened was that the soldier had given the little boy a bar of chocolate, when along came the boy's brother, who grabbed it from him, causing him to cry. This was not exactly the impression that was conveyed to the world. It was also well observed, again during the Lebanon War, that images were published of buildings that had been "destroyed by the advancing Israeli army." A closer inspection of these photographs revealed that there were bushes and foliage growing out of the buildings. They had in fact been demolished years previously, during the lengthy civil conflict in Lebanon.

I myself once "faked" a news story. This was done as a joke and only in private, but it showed me how easily it could be achieved. I was in Eilat with Shimon Peres at the time when he and Yitzhak Shamir were running a coalition government with a rotation system for premiership.

On this occasion, Shamir was taking his turn as prime minister, so Peres was foreign minister. The latter had gone out in a convoy of two Cadillacs to visit the salt ponds that were located east of the city, in Israel but very close to the border with Jordan and in the direction of Akaba. I did not travel with the group, but stayed behind. As they were returning to Eilat, I suddenly caught sight of their convoy. I took out my 300 mm telescopic lens and framed a picture of them that for all the world looked as though they were just leaving Akaba. I printed this up and went into Shamir's office. Those were the days when you could walk in unannounced, with just your press card gaining you admission. I went to his private secretary and placed the photograph on his desk. "I am not sure," I whispered, "that you are really aware of what Peres is up to." On seeing my picture, he blanched. He immediately jumped to the conclusion that Peres must have been engaged in secret talks with King Hussein of Jordan without the knowledge of his boss, the prime minister. I put him out of his misery very quickly, but it demonstrated to me how easily one could alter the course of history with a "false" image like this—a process that is made so much easier in today's world by sophisticated computer imaging.

34. MY ARCHIVES

The most consistently rewarding work I have ever done, when not ac-
tually taking photographs, was undoubtedly that of building up my
archive of negatives, which I started in 1950. When I began, I never
dreamed that it would eventually grow into a collection of nearly half a
million images.

Almost from the beginning, I allocated a number to each roll of film
and entered a description of its contents onto index cards. Every possi-
ble piece of information was recorded: the date the images were taken,
the location, the event that was taking place, and the details of any per-
sonalities featured in the photographs. These index cards served me
well until 1980, when, with the advent of the computer era, I bought my
first PC.

I was the envy of everyone in the office because I was the only one
to have a hard disk with a capacity of ten megabytes, which in those
days seemed enormous. Nowadays, every single photograph of mine is
nearly that size or larger. The computer revolutionized my ability to
store information. Before its advent, I would have to write up several
index cards relating to the same image. For example, a photograph of
David Ben-Gurion visiting an army base in the Negev and inspecting
an armored tank would have to be recorded on at least four or five sep-
arate cards, one with his name, another relating to the specific loca-
tion, a third mentioning the Israel Defense Forces, a fourth entitled
Weaponry, and probably a fifth for the Negev. With computerization,
one line in a database sufficed and eliminated the need for all these
cards. It also became much easier to search for specific data. This new
method very much suited my temperament as a yekke, as every aspect
of my images could be recorded, captioned, and stored tidily away and
be readily accessible.

Since I first began taking pictures, I have always taken enormous care of all my negatives. In all those years I have only ever lost one roll of film. I still remember the number—577. It bothers me to this day, and I can recall exactly what it contained—photographs of Polish immigrants arriving at Lod Airport.

The responsibility that photographers have with regard to their images is something about which I feel very strongly. Pictures are like women and wine—they improve over the years. You may think at the time that some of the pictures you have taken are banal and have no significance, but when you look at them in later years, they can often be viewed in a very different light.

Arnold Drapkin, our director of photography at *Time*, used to remind us that "every image should be seen as the first draft of history." Consequently, I have always saved even those negatives that on first sight seemed to be unimportant, because one never knows when they might become relevant. This is something I am constantly emphasizing to young photographers. Too many of them nowadays view their work solely in connection with its likelihood of being published somewhere the next day, forgetting that one day these same photographs can have great historical value. This has happened with me in several instances. One day, the son of President Franklin D. Roosevelt, Congressman Franklin D. Roosevelt Jr., came to meet Ben-Gurion for a political discussion. With him was another young congressman whom I did not recognize, nor did I know his name. Many years later, when going through my archives, I was stunned to recognize that the young congressman was none other than John F. Kennedy. It would have been so easy to have destroyed that image of some apparently unknown young man. Fortunately I did not, and it remains in my archive as an interesting piece of history. Many years later, this same John F. Kennedy, now president of the United States, who because of his injured back almost always sat in a rocking chair, sent one as a gift to Prime Minister Ben-Gurion, who absolutely loved it. I have a happy picture of him smiling broadly as he sat in the chair rocking backwards and forwards.

In 1999, my archive was purchased by *Yedioth Ahronoth*, Israel's leading tabloid, who are also book publishers. It was difficult for me to sever the umbilical cord with my negatives, but I knew that they would be both well cared for and made good use of by the newspaper. I was

also financially compensated—which helped to salve the wound! I had always feared that they might end up in some dusty basement, never to be seen again, something I know has happened to a lot of work by other photographers.

I had been thinking for some time about where I would like the archive to find its final resting place, so I made contact with the chief of correspondents of the paper, who then brought it to the attention of their board of directors. They invited me to meet them to make a presentation. I duly appeared before them, bringing with me my laptop, onto which I had scanned several thousand of the half million images. I erected a screen, and the senior executives sat around the table waiting.

I knew that they would ask many questions about how the archive was organized, how they might access specific material quickly, and also the range and scope of its content. I was also fairly certain that someone would ask at some point if I had anything on the Moses family. They did, and I was well prepared. Why the Moses family? Well, old Yehuda Moses had founded the paper many years previously, and I had in fact worked for him for a period of time. Fortunately, in a matter of seconds, I was able to produce a picture of Old Man Moses, as he was called, sitting in his office at his desk.

The panel were duly impressed and next asked if I had anything further on the family. In response, I flashed onto the screen a photo of a bathroom. In the bath stood a little boy aged four, totally naked, with his little willie pointing right at the camera. The little boy, called Noni Moses, had now grown up and was actually the owner of the paper and probably the most powerful newspaper tycoon in Israel. He was also one of the people sitting around the table. I like to think it was this picture and in particular his presence there that "sold" the archive!

I still continue taking photographs, and anything that I feel is of interest to the paper, I add to the archives. To this day, I am grateful to *Yedioth Ahronoth*, for they allow me to have "visiting rights" to call in and see my half a million "children" whenever the fancy takes me. Almost every week, they or I receive a request for some picture or other. This keeps me steadily busy and also generates income for the archive, a fact that I find very gratifying.

35. HOUSE AND HOME

It is only now, in retrospect, that I realize to what an extent I was always totally obsessed with work, sadly to the detriment of my family life. I talked photography; I breathed photography; in fact, everything I did and everyone I associated with was somehow connected to this topic. All my time, thoughts, and energy were directed towards furthering my career. Some, being generous, might say that this was just an indication of my single-mindedness and focus, but it appears to me now to have been an excessive way to live. Not unexpectedly, all our friends at that time were professionals from the same field, photographers or cameramen. We played bridge with them, went out on Shabbat for picnics with them in the forests around Jerusalem, caroused and had fun with them.

The first place that the family and I could call our real home was the house in Jerusalem where I have lived for the past half a century. Around the time that our daughter Tami was nine and our son Ami three, we had had enough of living in Zichron Moshe. The area was becoming more and more religious, and as a result we felt increasingly uncomfortable there, especially after that fanatic torched my car. We therefore decided to go house-hunting together with our friends the Knellers, who also wanted to move. They had seen a house in Katamon but, after viewing it, decided to reject it largely because they thought the area was run down and a bit of a slum. The house was in the part of Jerusalem where Jews from the Old City were relocated when they were forced to leave the Jewish Quarter after its conquest by the Arabs in 1948. These refugees were rehoused in properties that had been abandoned by their Arab owners when they fled from Katamon. We went to inspect this house. Once inside, Anni and I could see only two things. In this small two-storey house there was, first, a mahogany

staircase and, second, an open fireplace. Both of us fell in love with the place instantly. We disregarded the surrounding area and set our sights on acquiring it.

Buying was not an option. A private purchase was not possible at the time, as the government was the "custodian of enemy property." Technically such properties could not be sold, as they were supposedly being held pending the possible return of the legitimate occupants. The government was therefore the de facto owner of the buildings.

To begin with, we paid what was called "key money," which was then the prevailing system in Israel. In practice, this meant that we had to pay a sum to the previous tenant, or tenants, in order to move into the place that they had occupied. The key money was not high, and the added advantage to us was that the rent, payable to the government, was extremely low.

The house comprised four small rooms, two downstairs and two upstairs. As I understand is the prevailing Jewish custom in England, we started off by knocking down a wall and turning two rooms into one. We next removed quantities of old blankets the previous tenants had stuffed into the chimney flue, presumably to keep out drafts. They were evidently not used to the luxury and modus operandi of a fireplace—not surprising, as this was an unusual feature in houses in the Middle East, both then and today.

We decided to delay moving our furniture into the house until it was ready, but instead threw a huge party, albeit one with an ulterior motive. We brought crates of beer, pretzels, cigarettes, a record player, gallons of paint in all colors, and a large quantity of brushes.

We invited all our friends to come in their oldest clothes, gave each one a paintbrush, and told them that they could choose whatever they wanted to paint, in whichever color they preferred. People drank, danced, and painted furiously. This went on for the whole night. Among the group were the famous artists Jacob Pins and Jonah Mach, but on this occasion as painter-decorators. Most of the others were photographers and journalists. They carried out their task with great enthusiasm, and in the morning we were left with not only an exhausted crowd asleep on the floor, but also a newly painted house of many hues. We liked to think that we were living a bohemian existence, which Anni complemented by always dressing in rather exotic attire—she was

affectionately nicknamed "the Gypsy." I remember several occasions when, after a particularly late night during which we had run out of cigarettes, we would collect all the old stubs, empty the remaining tobacco, roll it again in old newspapers, and smoke that.

The land surrounding the house covered quite a large area but was strewn with rocks, rubble, and stones. The only plant life was some very old fir trees that are still there today. One of my neighbors was Levi Avrahami, the head of the Jerusalem-area police. The day after we moved in, he and his wife Leah showed up holding two small tins, in each of which was a small palm-tree sapling. I planted one on each side of the entrance to the house. One died the same year, but the second survived and flourished. One of the first pictures I have of Ami, then aged three, shows him standing next to the sapling; he is the taller.

The palm tree became something of a landmark in the Katamon area. I look upon it as an old friend, a friend, I must add, that is now more than twice the height of the house. Over the years and under my care and coaxing, the garden has developed into a real oasis. It is my pride and joy. At one time, the Jerusalem Municipality even awarded me a prize for having such a beautiful garden. Mayor Teddy Kollek presented it to me. I still continue to nurture my garden, where I have planted many of the flowers in a collection of ceramic pots and other ornaments gathered over the years. They help to give the garden its distinct character. There is also a modern touch—my first computer screen, which I bought in 1980. This too has pride of place alongside the plants in the garden and gets watered together with them.

The house was perfectly located. Opposite was the kindergarten to which Ami went daily from age three to six and where he was under the tutelage of Doda (Auntie) Rivka. She was something of an institution in Jerusalem, well known and loved by everyone. She is still remembered many years later by all "her" children. In Israel, they say that the most enduring friendships are those formed during national service; in Ami's case, however, his friendships date back even further, to when he started at this kindergarten.

As we began to settle into our "real" home, our social life became much more hectic. Nearly every Friday evening, we held open house. We did not invite people; they just dropped in. Each person brought something to eat, and we partied and danced through the night. I

remember once Anne Kneller got slightly drunk as we danced to the music of the Golden Gate Quartet, a famous American gospel-singing group. The music had such a fantastic rhythmical beat for dancing that we played it over and over again, with Anne dancing a tipsy solo on the living-room couch. I meet her frequently these days for coffee at the same café where for years she met my late wife Anni, and I enjoy occasionally reminding her of those exuberant days. Anne is now over eighty.

Several years later, the government decided to sell the properties held in trust to the tenants. In those days, I frequently did assignments for Israel Bonds and the United Jewish Appeal, taking photos of visiting groups. One of these groups was from Toronto, and its leader was a Queen's Counsel, Arthur Minden. He was a multimillionaire and had never been a Zionist. But on this, his first visit to Israel, he fell in love with the country and in particular with the people looking after him during his stay. I was one of them, as the still photographer; Rolf Kneller was another, as the movie cameraman; and the third was Paul Beer, the tour guide for the group.

When Arthur visited Anni and me at home and learned that we had the opportunity to buy the property, he strongly urged us to do so. I told him that 18,000 lirot was a huge amount of money for us to find. (It was the equivalent of about ninety average monthly salaries at the time.) In any event, I did not see any reason to part with such a large sum when we were only paying eighteen lirot a month rent and could carry on doing that for the rest of our lives. Arthur persisted in his attempt to convince us. He mentioned that he had invested a lot of money in Israel in a company that produced concrete mixers. At the time, overseas residents were allowed to invest, but could not take their profits out of the country. He therefore had many thousands of lirot deposited in a blocked account at the bank. He wanted me to use some of this money to buy the house, but I was a bit worried about having to pay back such a huge sum. He finally convinced me that it did not matter how long it took to repay him. Eventually we struck a deal, but I insisted on paying the 3 percent interest he would have received from the bank. And so we bought the house. It took several years to repay the loan, but I am eternally grateful to Arthur for his generosity.

Arthur visited Israel on many occasions over the years. He was something of an eccentric, certainly one on his own. I remember some years later receiving a frantic call from his wife in Toronto. She knew he was somewhere in Israel but had not been able to get in touch with him for days and had no idea where he was. After a few inquiries, I managed to track him down to an *Ulpan* (Hebrew learning center) in Netanya—a resort up the coast from Tel Aviv. It was winter and freezing cold. I drove to Netanya and found him in a poky little room, huddled up in a greatcoat, trying to keep warm with a tiny electric stove between his legs, cold and miserable. I never quite understood why he felt he had to live like this. After all, he could have afforded to stay in a warm, comfortable hotel and to hire any number of private teachers. But perhaps he wanted to see what it was like for the man in the street. In any event, I dragged him out of the icy little room and put him into the King David Hotel in Jerusalem, where he belonged. Anni and I remained in close contact with Arthur and his family until he died some years ago.

36. MY MARRIAGE TO ANNI

My marriage to Anni was tempestuous from the very beginning. I married her to get her out of Germany. She was my first cousin, but we had never seen or spoken to each other before meeting briefly in Gelsenkirchen. We then suddenly found ourselves married without having given it any prior thought, nor did we even have time to get to know each other. On my part, it was a totally impulsive action, one that many young Jewish soldiers were taking at the time—but which, I now realize, reflected a characteristic pattern of behavior that was to repeat itself throughout my life.

We arrived in Palestine, where I found myself just twenty-two years old and married. While welcoming the stability of home life after a hectic time in the army, I was not really prepared for losing my personal freedom. These were the conflicting emotions that pervaded the entire fifty-four years of our married life.

We quarreled a great deal. From the start, Anni was emotionally very needy. This was hardly surprising when you consider her background. She had lost the father she adored and also her younger brother in the concentration camps. Suddenly all her emotions were invested in me as the only man of the family. It soon became apparent that she was in dread of losing me too, but the weight of this responsibility was something I felt incapable of bearing. This element of our lives affected both the pursuit of my professional career and my own need for personal emotional freedom.

All our rows, of which there were many, had to do with Anni's insistence on being involved in anything I did. She seemed reluctant or unable to develop any activities or interests of her own, and therefore everything she did had to be centered on me and whatever I did. I was a photographer, so she became a photographer. I worked for *Time*, so she

123. Anni at the opening of my exhibition in Boston, 1988.

got a job at *Time*. The result was that our working lives as well as our domestic life became irrevocably intertwined. Whenever I was asked to go on an assignment, Anni assumed that she could come along too. It was as if she did not want me out of her sight. It became stifling and oppressive, so much so that I often felt the need to escape, although the question of divorce never entered my mind. This situation led to emotional blackmail, to which I foolishly succumbed. The first time that this happened was in 1948, during the War of Independence, when I, as the commander of a platoon, was in a very heavily shelled building opposite the Jaffa Gate in Jerusalem. Suddenly I received an urgent message that I had to go home immediately—something had happened to Anni. I left my post and rushed home to find Anni perfectly well, but when I wanted to return to my post, she threatened to kill herself if I should leave, even placing a noose around her neck as an indication of her intent to carry out the threat. Rather than risk anything happening to her, I gave in to her demands, but have never forgiven myself for my weakness in not standing up to her. This laid the ground for many similar events in the years that followed.

I felt very trapped. Consequently, I was by no means an angel when it came to affairs of the heart. I always tried to be totally discreet in my "outside relationships" in order not to upset Anni, but there were two incidents in particular when sparks flew, although on one of these occasions I was totally blameless.

On one of my trips in Israel, I started a brief liaison with a visiting American woman. To be able to communicate with her privately, I opened a post office box in Jerusalem. This worked fine for a time, until one day the wife of a close friend asked me if I could do her a favor. Somehow she knew I had this PO box. She confided that she was having an affair with someone abroad and pleaded with me to allow her to use my address to receive communications from her lover. Not giving it much thought, I agreed, a decision I lived to regret.

On one occasion, her boyfriend sent a cable to my PO box. The post office, uncharacteristically, sprang into action and telephoned my home to say that a cable was waiting to be collected. As luck would have it, Anni answered the phone and immediately said, "What PO box? We don't have one!" And she jumped to conclusions. In my stupidity, instead of placing the blame on the woman who had asked the favor of me, I confessed to my misdeeds. The most terrible row ensued that lasted for weeks, yet somehow we managed to patch it up.

The second incident occurred when I had to go on an assignment to Beersheva to cover a performance of *Fiddler on the Roof*. After the show was over, I returned to the hotel and went to bed. The next morning, I found that Anni had called the hotel at 11 p.m. the previous night to speak to me. When she had asked for my room number, the receptionist had replied that "they" had already gone to bed and asked her if she was sure she wanted to disturb "them." It took me a very long time to placate Anni and to convince her that I was innocent. I felt particularly aggrieved that I had been "caught out" for something that I patently had not done—at least not on this occasion.

In 1995, Anni underwent a routine mammogram that revealed she had a lump in her breast. We were abroad on vacation when the call came through that the results of the biopsy were positive. We returned immediately to Jerusalem, where Anni, after having been advised that it was a malignant cancer, opted without hesitation for a mastectomy. She was impressively stoical about the whole matter, or so I thought until several years later, when I found and read some notes that she had written to herself around the time of the operation. They revealed just how terrified she had really been. At about the same time, the doctors diagnosed a serious hemoglobin deficiency. One of the doctors treating her suggested that the condition might have been caused by what had happened to her years ago when she was in the concentration camp. Anni had been sent to work in the rooms where the prisoners' clothing was fumigated. She was forced to work for weeks in an environment where she was breathing in noxious cleaning chemicals. The doctor suggested that the fumes from that process might have caused the reaction, albeit so many years later, at a time when her body was vulnerable because of the cancer. In addition, Anni had also always been a very heavy smoker, a factor that could not have helped.

During the next five years, she had to be given increasingly large blood infusions. This meant our going to the hospital at least two or three times a week for the treatment. My photographic work had by now taken a back seat, as I accompanied her on every occasion that she had to see the doctors and also did everything I could to attend to her daily needs.

Sadly, in 2000 the cancer returned, but this time it attacked her esophagus. It was only a short time after the second diagnosis that, mercifully, she died, in November of that year. During the whole five years of her illness, I was constantly at her side. I never once had the feeling that I was in any way sacrificing myself, or that I was doing anything under any obligation. It just seemed to be the right and proper thing to do at the time. I understood later from Anni's best friend that she not only appreciated my care but was actually a little surprised by the extent to which I looked after her in such a dedicated manner.

Our daughter Tami slept in Anni's room at the hospital every night for weeks in order to be with her. Previously they had not had a very good relationship, but this period proved to be very precious for both of them, and it gave them the necessary time to resolve their outstanding emotional issues. During the last few days of Anni's life, she was in the hospice for the terminally ill on Mount Scopus in Jerusalem. On the day of her death, my son Ami and I were with her. She asked if we could take her outside for some fresh air, which we did. We wheeled her outdoors, where it was a bit chilly. I took off my coat to protect her, whereupon Ami commented, "Abba, are you worried that she might catch cold?" She was sitting there plugged in to all the hospital equipment and with tubes in her nose, but there was a cigarette in her hand right until the end. I realized after her death that the only two occasions when she had ever visited Mount Scopus were first for the birth of Tami, on November 18, 1947, and, ironically, again when she died, on November 19, 2000. Almost exactly fifty-three years to the day.

We were all well prepared for her death, and when it eventually came, I felt a great sense of relief, primarily for her, but also for the family. It had been terrible to see her suffering and to be able to do so little. I also had a sudden and unexpected sense of freedom, combined with a sense of guilt, that I could now do whatever I wanted, jump on a plane and go anywhere I chose, without having to defer to anyone else. It was

only then that I realized just how socially cut off I had become. During the five years of Anni's illness, our social life had ground totally to a halt. I also wondered what there remained for me to do, as a man in my late seventies. I felt that, in many ways, the best years of my life had passed and that all that I could look forward to was the resignation and quietude of old age. I could not have been more wrong.

The person who changed much of that was Nitza Ben Elissar. Her husband Eliahu had died two months previously. For forty-six years, the four of us had been close friends, and now Nitza and I were able to console each other. Nitza's late husband had been a Member of the Knesset and Israel's first ambassador to Egypt. Later he was called to Washington, and his last posting was in Paris, where he died. Because of this, Nitza had a wide range of personal contacts, and through her I began to rebuild my social life. We were companions for about a year, during which time I also began to reestablish my working life.

The five years of Anni's illness were not all shrouded in black clouds. Two important events happened that I was happy Anni was able to share with me. The first, which took place in January 1995, was the opening of my exhibition at the Knesset. This came about after I had approached the Speaker of the Knesset, suggesting an exhibition of photographs showing life behind the scenes in the parliament building. I was thrilled when he agreed to the show, and the official opening was accompanied, as is usual in Israel, by many speeches. In one of them, I was referred to as the honorary 121st Member of the Knesset. This exhibition is now a permanent feature in the Knesset building—a bonus that I never expected when I first raised the idea with the Speaker—and is a source of great pride for me. Another benefit is that, to this day, I am the only photographer permitted to enter the Knesset cafeteria to take pictures whenever I choose. The place has become something like a second home to me.

In photojournalism, there is always a thin dividing line between what is considered in the public interest and what is an unwarranted invasion of privacy. My policy has always been never to take intrusive, sensationalist shots, such as an image of a MK looking foolish, perhaps with spaghetti hanging out of his mouth. I think that because I demonstrate a respect for my subjects, they in turn reciprocate by allowing me to have continued access.

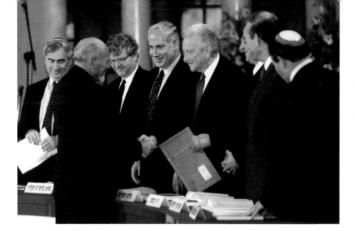

124. I receive the Israel Prize from President Ezer Weizman, who is flanked by Prime Minister Benjamin Netanyahu and Supreme Court President Aharon Barak, May 12, 1997. Photograph by Yossi Zamir.

The second, and more significant, event was when I was presented with the Israel Prize for services to the media. It was the first time in Israel's history that the prize had been awarded to a photographer. One day in 1997, I received a call on my mobile phone to hear that Zevulun Hammer, the minister of education, wanted to talk to me. I had not the slightest idea why. When he told me that he had the pleasure to inform me that I had been selected to receive the Israel Prize, I was dumbfounded. I was just getting out of my car at the time and almost fell down on the sidewalk in surprise. I phoned Anni immediately, and it took us both a long time to digest the news. The first thing I had to do was to buy myself a dark suit for the ceremony, which was always held on Independence Day at the Jerusalem Theater. It was a very special occasion, with Anni and my children and grandchildren joining me to witness the event.

President Ezer Weizman presented me with the prize. I then had to shake hands with a whole row of dignitaries, including Bibi Netanyahu, then prime minister, and Ehud Olmert, who was mayor of Jerusalem. There is no doubt that winning this most prestigious award gave an additional boost to my career, with newspapers and journals worldwide wanting examples of my work.

A couple of years later, I was invited to publish a regular weekly photograph in a small local paper called *Iton Jerusalem*. The column was entitled "David's City by David." In spite of the fact that this is just a local rag, this regular feature has given me more publicity among Jerusalemites than all my years at *Time* and *Life* had. I can scarcely go out into the street without someone stopping me to comment about the previous week's photograph. They say, "This is where I used to live!" or, with nostalgia, "My grandfather was in that picture." It obviously provides a great public service to the residents of Jerusalem and gives them great pride if they or a relative of theirs happens to appear in an issue. I get a lot of pleasure out of giving prints to such people, and I see how much it means to them. Someone once said to Ami, "Your father has very good PR—all the cabinet ministers get pictures from him," to which Ami replied, "That may be true, but I know that the street cleaner also gets a picture."

37. THE EVENING OF MY LIFE

About two years after Anni died, my life suddenly and unexpectedly changed for the better. I had received an invitation to attend the wedding of Professor Eliezer and Tova Rachmilevich in Jerusalem, and they asked me if, as a favor, I would take their photographs, something I normally never did. I had known Eliezer for a long time, though. He was one of the medical team who treated Anni during her illness, so I made an exception and agreed.

Among the pictures that I took was one of Tova Rachmilevich standing with a woman friend. I paid no heed to this particular image until, some weeks later, I bumped into the woman from the photograph standing with a group of friends on a street corner not far from my home in Jerusalem. She recognized me, and I then remembered that I had a photograph of her and promised to send it. A few days later, I was driving in my car when again I saw this same woman walking down the street. I offered her a ride, and we arranged to meet for coffee at her place.

This was the beginning of two very happy years. Ziona was a widow whose husband, an American psychologist, had died six years earlier. She was of Yemenite origin, born in the Yemenite quarter in Tel Aviv. Her family had been extremely poor, but Ziona had striven to educate herself and had developed a wide range of interests in the arts, was a voracious reader of all kinds of literature, and was also addicted to the movements of the stock exchange, stopping often in the middle of lunch to listen to news about the market—a hobby to which she introduced me.

We became constant companions, traveling to the United States, to Vietnam and Cambodia, and several times to Europe. The relationship was perfect for two people at our stage of life—free of stress and there

125. Myself with my companion Ziona Spivak.

just to be enjoyed. We both maintained our own homes and just spent the best of times together, retreating to our own spaces when we needed to be alone. As far as I was concerned, my life was happily set to continue in this fashion forever.

All of this changed dramatically and tragically on December 26, 2004, when her daughter-in-law Osnat and I found Ziona murdered in her own home.

The horror of the scene was indescribable. Ziona was lying dead on the kitchen floor. Her throat had been cut—a sight that was worse than anything I had ever encountered during all my time covering wars and other atrocities. I bent down to touch her face and stood up with my hands covered in her blood. I raced out of the house screaming in complete shock and sat down on the sidewalk. Someone must have called the police, but before they arrived an ambulance turned up and, on seeing me, one of the medics came over and tried to clean the blood from my hands. At the same moment, the police arrived and one of the officers jumped on him, saying, "What do you think you are doing!" and pushed me immediately into a squad car. I sat there for what seemed an hour, shivering and traumatized. It was only after they had questioned Osnat that they realized I was not a suspect. The detectives insisted, however, on taking me back to my home, where they made me remove all my clothes, which were taken away for analysis in the police laboratory.

While all this was happening, I was only vaguely conscious of the fact that many of my young photographer colleagues were at the scene of the crime taking news pictures. I often wonder how they must have felt seeing me, their mentor, at the receiving end of the camera. The next few days were a walking nightmare. Fortunately, I had tremendous support not only from my family but also from Ziona's, who regarded me as one of theirs.

The culprit was apprehended on the very same night of the murder in his village of Bet Omar, near Hebron. He was easily traced because,

several minutes before the killing, Ziona had been on the telephone to her brother Chaim, saying that she could not speak to him at that moment, as she had to "settle things" with her gardener. She could not have realized just how prescient those words were.

The gardener, Muhammad, had worked for her several years earlier. He was not a particularly good gardener, and she had dismissed him, but he regularly returned to ask her for help. Ziona never failed to give him one or two hundred shekels each time he came. The social worker in her (this had been her profession before retirement) came to the fore, and she found it difficult to refuse.

The gardener confessed immediately and told the police that on this occasion he had asked her for 25,000 shekels that he needed for an urgent operation for his son in Jordan—a story that later turned out to be untrue. Ziona had apparently refused his demand for money, so he took a knife from where it lay on the kitchen table and cut her throat. We had originally assumed that she had died quickly, but it was only months later, when the case came to court, that we realized the full extent of what had happened. Immediately after the murder, when Muhammad had been apprehended, Ziona's family were asked to vacate her home so that the police could videotape the murderer's confession at the scene of the crime. Her son Amos insisted on seeing the film, although the district attorney tried to talk him out of it. I also went along, because I did not want him to face this ordeal alone. It was then that we found out that her death had not been instantaneous. The first knife the murderer used had snapped, so he had to take another knife to finish the job. I felt terribly sad that her family had to see this video and therefore learn all the details of what had happened, but her son felt that it was important for him to know everything about how she had died. Muhammad was sentenced to life imprisonment.

This incident caused me to reflect on whether there can ever be a satisfactory penalty for murder. I came to the conclusion that the only proper punishment was that given by God to Cain, the brother of Abel. It is said that Cain's forehead was branded so that for the rest of his life he would be totally excluded from human companionship and completely isolated. This form of biblical retribution is not something that could be done in today's world, but philosophically it seems to me to be the only satisfactory punishment.

As I was a public figure, the story was featured in every newspaper and magazine and on all the television newscasts. I often thought how differently they might have dealt with this had I been an unknown person—it would have probably warranted a couple of short lines in the paper. Such is the effect of fame. I refused to give any interviews, but instead, within twenty-four hours of the killing, I wrote an impassioned piece expressing my immediate feelings on that awful day. This was printed in *Yedioth Ahronoth*, Israel's largest newspaper.

My Zionushka was brutally murdered on Sunday. Zionushka is not exactly a name that you would expect a girl born in Kerem Hatemanim to answer to, but that is what I called her. I felt that it mirrored my love for her more than a cold "Ziona."

They must have known something back in the thirties when they claimed that Yekkes and Yemenites made wonderful couples. Zionushka and I were living proof. Maybe it's because I was nearing my eightieth birthday when I met her a little over two years ago. Zionushka, how wonderful you were and how senseless, how incomprehensible was that brutal slaying that ended your life.

Remember when I first took you to Vienna, the city where I was born, and the waiter at the restaurant addressed you as "Gnädige Frau," how thrilled you were when I translated it for you as "Gracious Lady"?

Remember when I was on my way to you, slipped on the wet street, and called you on my cell phone to say, "Ziona, hitchalakti [I have slipped] and think I strained my ankle"? "It's hichlakti, not hitchalakti," you corrected me. How many times have we laughed about it during those last two wonderful years? When I scolded you in front of our friends, "There I was, sitting on a wet pavement, in terrible pain, and you, Ziona, had nothing better to do than to teach me Hebrew!"

Remember when you told me that, as a child, when you were sick with TB in the hospital, you listened to some Hungarian immigrant playing the famous aria from Tosca *over and over again? How this led you to learn to love opera—*Tosca *of course above anything else? And when I took you to the Vienna State Opera for that very same opera we had seats in the Royal Box? And you asked, "Do you think they changed the upholstery since the Kaiser sat here?"*

Remember when you pleaded we go to Cambodia and Vietnam instead of once more to Europe? And I told you, "OK, on one condition, that you make all

the arrangements." And how consequently at Hanoi airport and everywhere else in Vietnam we were greeted with signs reading, "Welcome Mr. & Mrs. Ziona"?

Remember that wonderful line of yours after I had succeeded in convincing you of something, "Aha, David, now that you explained it to me, I understand what I meant"?

And you surely remember what you told me only a few nights ago: "David, do you think there are many people of our age on earth who fall asleep embraced?"

If you remember all this, you'll know why I loved you so much and why I can't get over what that madman did to you. You will know, as I now know, that even late in life love can burn as fiercely as it does in youngsters.

38. THE RENAISSANCE

After this hugely traumatic event, I was once again plunged into mo-rose thoughts about what awaited me at my time of life. It did not seem that there could possibly be a bright future, but once again it just goes to show how wrong one can be and how we never know what may be waiting around the corner.

The years 2005 and 2006 turned out to be probably the most exciting and fulfilling of my life.

The seeds of this "renaissance" took root back in February 1998. I received a telephone call from Michelle Stephenson, the director of photography of *Time* in New York. She told me that the magazine was producing a special millennium edition that would feature articles on the most important people of the century. One of those selected was David Ben-Gurion.

Michelle asked if I had ever seen a photograph of Ben-Gurion stand-ing on his head on the beach and, if so, whether I knew who had taken it. I began to make some inquiries, and it soon became apparent that there was hardly anyone in Israel who had not seen that image, but no one could tell me who had taken it, largely because in the 1950s photog-raphers were not given credit for their work as they are today. Ben-Gurion, who practiced Feldenkrais to help with his back problems, is reputed to have said, "I am standing on my head so Israel can stand on its feet." After some careful research and a lot of thought, I made a cal-culated guess that it might have been taken by a photographer called Paul Goldman. He was about thirty years my senior and was, in a sense, my mentor and someone with whom I had worked on a number of occasions. *126*

I eventually managed to track down Paul Goldman's widow, aged ninety-two, and her daughter Medina, living in Kfar Saba. Arriving

there, I was struck by the evident poverty in which Medina and her ailing mother lived. I saw a single room, an old woman lying in a bed, two old refrigerators, a pair of yapping dogs, and a pile of cardboard boxes containing the belongings of the mother and daughter. I had last seen Medina when she was an eight-year-old girl. Her father had brought her along to an event that took place in Jerusalem every Christmas Day, when the no-man's-land crossing at the Mandelbaum Gate between Israeli and Jordanian-held Jerusalem was opened for Christians to make their pilgrimage to Bethlehem. Paul had given his little daughter a Rolleiflex camera, and I noticed her taking a photo of an Israeli military policeman standing next to a Jordanian legionnaire. I had snapped a picture of her, and it was probably this clue that helped me find the now fifty-three-year-old Medina. She was given the unusual name Medina, which means "state," because of Ben-Gurion. She was born on the day the UN resolved that the Jewish state be established, and Ben-Gurion told Goldman that this was the most appropriate name he could give the new baby.

Medina confirmed that it was indeed her father who had shot the famous picture of Ben-Gurion standing on his head. In the same breath, she also told me that all her father's negatives were in a loft located above their small kitchen. A ladder was produced, and I climbed into the dark and dusty space above the gas cooker. A pile of moldy old shoeboxes, fading numbers on them, confronted me. In them, I discovered yellowing and brittle old envelopes containing negatives. Some of the negatives were sticking together from the damp, some had totally

314

126. Paul Goldman's photograph of Ben-Gurion doing a headstand on the beach at Herzliya, 1957. Reproduced by kind permission of Spencer M. Partrich.

faded, and others were crumbling from the effects of the residual chemical elements. And yet I at once sensed that I had come across a lost treasure.

But how was I to find that particular negative of Ben-Gurion doing a headstand? Medina's memory came to my aid. From beneath a pile of old papers, she produced a book—one that by now was just a mass of yellowing pages, but which contained the key to solving the riddle. Paul Goldman had kept a meticulous record of everything he had ever photographed. The date, the nature of the event, the names of the subjects, and the negative numbers were all recorded in his beautiful calligraphic handwriting, unfortunately for me, all in Hungarian.

I sat on the bed in which his ninety-two-year-old widow lay ill and leafed through the pages. Every time I came across an entry where Ben-Gurion was mentioned, I showed it to her and asked her in German (as her Hebrew was far from perfect despite the sixty years she had lived in the country), *"Was ist das?"* Finally, the hoped-for answer: "Ben-Gurion and his wife Paula at the Sharon Hotel." The number next to the entry was 4410.

I could hardly wait to climb back into the loft. I found the box numbered 3500 to 4500 and frantically sought envelope number 4410. Eventually I found number 4409, but immediately after it was number 4411. The number I wanted was missing! I could have cried in frustration, but then I remembered something from my own experience of working in a darkroom. When I had no time to return negatives to their proper place immediately, maybe because I was rushing to deliver the prints to some newspaper, I put them in a small box on my desk until later I had time to file them away. Eureka! I could not believe my luck when I found a box similar to mine in the attic, containing an envelope with wonderfully preserved 2" × 2" negatives—a whole sequence of them, from the moment Ben-Gurion placed his head on the sand, through to when his legs were finally fully extended towards the sky.

I sent several prints of the scene to *Time*, feeling very satisfied that I had accomplished my mission. Somehow, though, I could not get out of my mind those forgotten treasures, moldering away in an attic in Kfar Saba. It was evident that this archive contained a great deal of material of considerable historical interest, as the photographs dated from 1943 to the early 1960s.

127. The three paratroopers return to
the Western Wall thirty years later:
from left, Zion Karasenti, Yitzhak Yifat,
and Haim Oshri.

It so happened that, around the time I discovered the archive, an American collector from Detroit by the name of Spencer Partrich, a man with a passion for photography, read an article in *Haaretz* about a photographic archive for sale in Tel Aviv. Needing to know more about what was on offer, he turned to his friend Professor Eliezer Rachmilevich for help, who in turn contacted me for professional advice. The end result was that Spencer did not purchase the archive that was for sale, but instead bought the one belonging to the Goldman family that I had found.

Thanks to Spencer, part of the collection was cleaned and restored, and the first exhibition of this hidden archive by Paul Goldman opened in 2004 at the Haaretz Museum in Israel, followed by further shows in Detroit, Palm Beach, and New York.

The first show in the United States was scheduled to take place shortly after Ziona's death. We had both been invited, but under the circumstances I had little enthusiasm for going and declined the invitation. It was Spencer who persuaded me to change my mind. Today I am convinced that had he not pushed me into traveling to Detroit, I would have slid into a morass of self-pity and my mental decline would have been rapidly followed by a physical one.

Instead I embarked on what proved to be a most unexpected journey. In February 2005, I met an old friend, Ruth Corman, who twenty years earlier had organized my first exhibition in London, at Alexandra Palace, to commemorate the fortieth anniversary of the State of Israel. As soon as I showed her the Goldman catalogue, she was hugely impressed and asked to meet Spencer. "This show should come to London," she said, to which he replied, "I give you carte blanche to go ahead and arrange it."

She took him at his word and spent the next year and a half volunteering her curatorial and organizational skills to arrange a six-week show in London, at the Proud Gallery, Camden, that was attended by over ten thousand visitors. The dynamic owner of this gallery, Alex Proud, fell in love with the Goldman catalogue as soon as he saw it and demanded to know the full story of how the archive was found. Once he heard of my involvement and saw my own book *Witness to an Era*, he said, "Wow, we have to have both of them together." "What do you call Israel?" he asked Ruth. "Eretz Yisrael," she said, to which

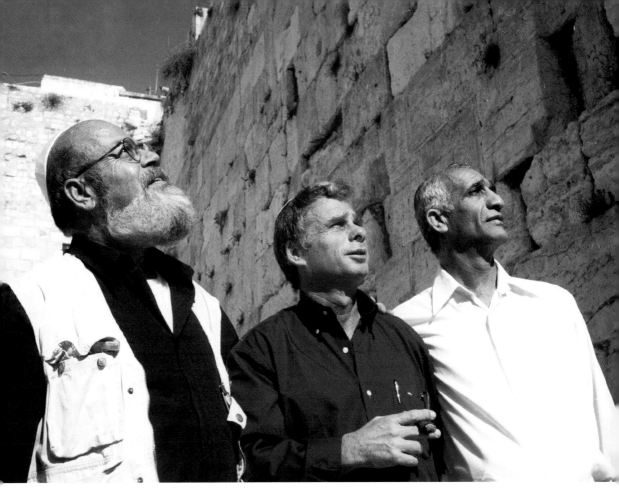

he replied, "That's a fantastic title for a show—we will call it Eretz Yisrael—Birth of a Nation."

Ruth curated my half of the exhibition, produced the catalogue, and arranged sixteen private views where invited guests saw the Israeli TV film *Eye Witness*, produced by Micha Shagrir, featuring my work. Micha did a magnificent job on this production. He took some of my old photographs and then set about finding the people who had appeared in them, in some cases up to fifty years before. One of the photographs we re-created was the iconic image of the three paratroopers at the Western Wall in 1967. Now they were all veterans—one was a gynecologist, another had worked for the Weizmann Institute, and the third had had a small kiosk in the Galilee where he sold refreshments. We met them, refilmed them, and talked to them about how their lives had changed since the original photograph had been taken. It was a deeply moving and uplifting testimony, which showed their fortitude and persistence, often through very trying circumstances. Micha has since updated the film to cover the past ten years of my life and work.

This exhibition was the first occasion ever that I have had queues of people waiting patiently to have their catalogues signed! I was overwhelmed and humbled by the extent of the public response and

the accolades that I received—but it did not end there. As a result of the London show's success, Ruth then took my show to Portland, Oregon, where we received a tremendous welcome and hospitality, and since then the exhibition has been seen in Bangkok and Vienna and has been scheduled to appear in Singapore and Budapest.

As if this were not enough, the fact that June 2007 was the fortieth anniversary of the Six Day War meant that my iconic picture of the three soldiers at the Wall was featured in most of the major newspapers in the United Kingdom and the United States, and was chosen for the front cover of the June edition of *The Economist*. I found myself very busy giving TV and radio interviews about my memories of the war to the BBC and ABC, as well as the media in the Netherlands, Austria, and, of course, Israel. I also spent a day being filmed about my work and the war for a show that is scheduled to appear on Al Jazeera.

So here I am, an elderly man, a great-grandfather eighty-three years of age, but instead of settling down just to potter in my garden and have coffee with friends, I am looking forward to a future of more travel and more public appearances. A daunting prospect, but one I would find difficult to refuse, loving challenges as I do.

Frequently these days, when looking back over the years, I find myself asking how I could have been so lucky. I went through ten wars unscathed and survived countless other high-risk situations, and I have reached the peak of the photographic profession, with worldwide recognition for my work, being the oldest person on the masthead of *Time*, one of the world's most prestigious magazines. I have had personal access to many of the world's leaders and other fascinating personalities, as well as the support of a wonderful family—my two children, five grandchildren, and two great-grandchildren.

How can anyone be so fortunate? And, after all this, what would I say to those who ask me the secret of a fulfilled life? Mine is really quite a simple philosophy—try to live every day as if it is your last, but plan your future as though there were endless tomorrows.

AFTERWORD

By Ruth Corman

I met David for the first time almost twenty years ago. My husband had seen David's first major exhibition, Witness to an Era, on display at the Tower of David Museum in Jerusalem and urged me to see it. Once I did, I realized that this was something special. I was then working as director of the British Israel Arts Foundation, established to promote all forms of cultural exchange between the two countries. This exhibition was a perfect vehicle for furthering our objectives, and it also coincided with the fortieth anniversary of the State of Israel. Because of this, there were additional funds available to mount a really big event, and this took place at Alexandra Palace in North London. David's exhibition was a key part of the event. I remember him as being a bit of a prima donna, or, perhaps I should say, a perfectionist. I have never worked so hard in my life as I did that week, so maybe I was less than responsive to his demands.

Over the years we kept in touch, albeit intermittently.

We were brought together again as a result of a tragedy that happened in his life. I phoned him to offer condolences. We got together, and he invited me to curate a new show of his work, which was of course an offer I could not refuse.

During the course of our daily discussions, I came to realize that David was a very special man with an endless source of experiences and stories that illustrated his fascinating life. I asked why he had never written his life story, to which he replied, "Oh, several people have suggested it, but I just never got round to it." I immediately insisted that we write his autobiography together, and he agreed.

I started writing in April 2005. We were fortunate in that we could take advantage of the advances of modern technology, not only the

computer but also the internet telephone program Skype. We spoke to each other several times a day, and I would ask questions and type his responses. I would then spend several hours redrafting the texts.

I began writing the book chronologically but digressed from this course slightly when interesting topics emerged that deserved special treatment, such as immigration, his movie experiences, and his archives.

David has an astounding memory for facts, dates, people, and places. I researched and checked everything on the internet, and on only one occasion was he factually incorrect, and then only by one day.

We also have the huge advantage that David not only has a massive archive of images but has also kept a diary religiously since 1967. This, together with some of his earlier diaries, the first written when he was fourteen years old and living in Vienna, provided me with the most wonderful source material.

My role has been that of drawing out the details of his life and putting them together so that they will be interesting for the reader. I frequently affected ignorance of many historical facts, in order not to assume any knowledge whatsoever on the part of the reader. I constantly asked David to elaborate, and he was frequently aghast at my apparent lack of knowledge, but in this way I was able to draw out the smallest details. Sometimes it was like extracting teeth, but mostly we got on well.

We fought a lot about the use of words and correct grammar. He also complained that I did not use enough capital letters and thought my punctuation could do with improving. Considering that David is an autodidact who finished his full-time education at the age of fourteen, he is extraordinarily knowledgeable about most things and is often right.

David's political ideals are central to his life and thought. He is remarkable in that he has remained true to the same political views he held when he first came to Palestine at the age of fifteen with Hashomer Hatzair. I have learned that there is little point in arguing with him on these matters, as he will win any such dispute on account of two factors: one, that he knows more than I do, and two, that he shouts louder. But it is heartwarming to see how he has the respect and

friendship of most of Israel's political leaders from all parties, although he is very unlikely to give them his vote. His personal friendships manage to successfully override the strength of his political convictions.

The thing that most people observe when they meet David for the first time is his consummate charm. It is surprising that he should have retained this legendary Viennese trait after having left there in his early teens. Everyone falls for him, and he knows how to turn on the charm. "How beautiful you look today," I have heard him say to the plainest of women. It is touching to see the way they re-spond to the compliment. He means it. They blush. They glow. They adore him. I have heard many women profess that he is more attrac-tive than a man half his years, and even men seem to succumb to his charm.

But the one side of David that is not revealed in this autobiography is the Jekyll and Hyde transformation that takes place when he is behind the wheel of his car. God help anyone who gets in his way when he is driving. Pity the poor guy who cuts in or enters the intersection ahead of him and blocks the road, or does not accelerate immediately once the lights change. I have seen David drive rapidly ahead down a crowded road to block an oncoming lorry, refusing to give way, despite the fact that one should not argue with a vehicle that is much bigger than one's own. This urbane, affable, and essentially courteous character turns into the man who probably invented road rage. His car stops, windows are rolled down, and a heated exchange takes place, just stopping short of fisticuffs. David's road rage is particularly addressed to one specific faction in Israel—the settlers. If he ever sees anyone wearing a *kippah* and carrying a gun, woe betide them, for they come in especially for the cutting edge of his wrath.

David is also a self-confessed loser, by which I mean that, when in the car, he is constantly getting lost. He admits to having absolutely no sense of direction and, after living in Jerusalem more than sixty years, still cannot find his way around. In order to overcome this, he was one of the first people to buy an automatic navigator. I traveled with him to the north of Israel accompanied by this female voice advising us where and when to turn left or right. It was an experience, the end result of which was that David returned the navigator to the manufacturer with a strong letter of complaint.

Despite all of this, or probably because of it, I would not have missed this experience for anything. Apart from the fact that, in a modest way, his story is an essential part of Israel's formative history and I have helped to present it to the world, the opportunity to spend time with this irascible and infuriating but enduringly lovable character is something that I shall cherish forever.

CHRONOLOGY

YEAR	BIOGRAPHICAL EVENTS	PHOTOJOURNALISTIC WORK
1945	Oct. 10—Presented with his first camera, a 35 mm Argus, by Claudette Vadrot in Paris.	
1946	Sept. 19—Marries his cousin Anni Rubinger, a Holocaust survivor, in Herford, Germany. Nov. 28—Honorably discharged from the British Army in Palestine. Dec. 28—Joined in Palestine by Anni Rubinger, under the Palestinian Wives Repatriation Section law; the couple rents a one-room apartment in Jerusalem.	
1947	Employed as an assistant veterinary storekeeper in the Department of Agriculture. July—Joined in Jerusalem by Anni's mother, Bertha Rubinger. Nov. 18—Daughter Tamar is born. Dec.—Inducted into the Haganah and sent to training on Mount Scopus.	Nov. 29–30—Jerusalemites celebrate the UN's approval of the Partition Plan.
1948	May 15—Outbreak of the War of Independence. Serves as a platoon commander in Jerusalem.	
1949	Transferred to the army's Map and Photography Services.	
1950	Having received a storefront near the King David Hotel as a bonus for service in the War of Independence, operates a photo shop.	In this and subsequent years, photographs new immigrants living in difficult conditions in *ma'abarot*, or tented transit camps.
1951	Hired as staff photographer for Uri Avnery's *Haolam Hazeh*.	

YEAR	BIOGRAPHICAL EVENTS	PHOTOJOURNALISTIC WORK
1952		Jan.—Violent demonstrations by Herut party members against Israel's reparations agreement with West Germany. May—Trek through the Negev Desert with geology students.
1953	Hired as staff photographer for *Yedioth Ahronoth*. July 15—Son Amnon is born.	
1954	After returning to freelancing, receives first assignment for *Life*.	
1955		Sept. 23—Oil discovered at Heletz.
1956	Apr.—Family moves to a house in the Katamon neighborhood of Jerusalem.	Feb. 25—First photographs in *Time*: Rudolf Kastner and Malchiel Greenwald. May—First major story in *Life*: dentures lost in no-man's-land. Sept. 23—Arab attack on Israeli archaeologists at Kibbutz Ramat Rachel. Oct. 29—Sinai War begins. First major conflict covered for *Time-Life*.
1957		Oct. 29—Ben-Gurion injured in a grenade attack at the Knesset.
1960		Incidents on the Green Line dividing Jewish and Jordanian Jerusalem provide many stories. Apr.—Yigal Yadin's archaeological expedition to the Bar Kochba caves in the Judean Desert.

YEAR	BIOGRAPHICAL EVENTS	PHOTOJOURNALISTIC WORK
1962		May—Profile of Golda Meir, then foreign minister.
1964		Jan. 5—Pope Paul VI visits Israel. Feb.—Greek-Turkish conflict on Cyprus.
1967		Apr.—Reports from the valley below the Golan Heights, where kibbutzim are harassed by Syrian shelling. June 5–10—Six Day War. Sept.—Accompanies Shin Bet squad on one of the first counterterrorist raids in the West Bank.
1968		1968–August 7, 1970—War of Attrition.
1970		May—Establishment of the Kiryat Arba settlement in Hebron.
1972	Becomes *Time-Life* contract photographer after a long freelance association with those magazines, and is added to the *Time* masthead.	Jan.—Meets immigrants from Russia in Vienna and accompanies them on their journey to Israel.
1973		April—*Life* story on Israel's military at the nation's twenty-fifth anniversary. Photographs missile boats and Phantom fighters. Oct. 6–26—Yom Kippur War.
1974		April 11—Resignation of Golda Meir's government. July 20—Turkish invasion of Cyprus.
1976		July 4—Rescuers and freed hostages arrive in Israel after the success of Operation Entebbe.

YEAR	BIOGRAPHICAL EVENTS	PHOTOJOURNALISTIC WORK
1977		May 17—Menachem Begin's Likud Party wins parliamentary elections for the first time. Nov. 19–20—Anwar Sadat makes his first visit to Israel and addresses the Knesset.
1978		Several trips to Washington with Begin for peace talks. Dec. 10—Begin and Sadat awarded the Nobel Peace Prize.
1979		Mar. 26—Israel–Egypt Peace Treaty signed on the White House lawn. May 27, 1979–April 1982—Return of the Sinai Peninsula to Egypt in stages, with some resistance by Israeli settlers. July—*Life* story on the Elon Moreh settlement, West Bank. Nov.—Moroccan army's conflict with the Polisario.
1981		Oct. 10—Funeral of Sadat in Cairo.
1982	Anni Rubinger added to the *Time* masthead as photo researcher. Oct. 11—Reunion with childhood friend Poldi Kammermeyer in Vienna.	June–Aug.—Covers Lebanon War from Beirut. Dec.—Profile of Austrian Bundeskanzler Bruno Kreisky.
1983		May– Monthlong assignment to the White House, in an "exchange" of *Time* photographers. June—Protests against the occupation of Lebanon take place in front of Begin's home.
1984		Nov. 1984–Jan. 1985—Operation Moses brings Ethiopian Jews to Israel.

YEAR	BIOGRAPHICAL EVENTS	PHOTOJOURNALISTIC WORK
1986		April 13—John Paul II visits a Jewish synagogue, Rome.
1987		Oct. 20—*Time* report on the growing influence of Islam in Turkey. Dec.—Outbreak of the First Intifada.
1988	Apr. 10—Exhibition Witness to an Era, sponsored by *Time*, opens at the Tower of David in Jerusalem. Exhibition later travels to Boston, London, Montreal, Toronto, Washington, D.C., San Francisco, and Vienna.	
1989		Feb. 10—*Time* report on contemporary Turkey: travels to Istanbul, Ankara, and Erzurum. Mar. 13—Photographs UNFICYP troops patrolling the "Green Line" in divided Nicosia, Cyprus.
1990	Aug. 28—At the East-West Photo Conference in Helsinki, speaks on the role of the photographer in the Middle East conflict.	Major wave of immigration from Russia. Mar.—First free elections in Latvia.
1991		May—Operation Solomon brings Ethiopian Jews to Israel. Oct. 30–Nov. 1—Madrid peace conference.
1993		Sept. 13—Oslo Accords signed in Washington, D.C.
1994		July 25—Yitzhak Rabin, King Hussein, and Bill Clinton sign the Washington Declaration on the White House lawn. Oct. 26—Rabin and King Hussein sign peace treaty in the Wadi Araba.

YEAR	BIOGRAPHICAL EVENTS	PHOTOJOURNALISTIC WORK
1995	Jan.—Semipermanent exhibition Behind the Scenes at the Knesset opens at the Knesset. Oct.—Anni Rubinger diagnosed with cancer.	Aug.–Sept.—Leaders at Leisure series: casual photographs of Netanyahu, Olmert, Peres, Rabin et al. Nov. 6—Funeral of Yitzhak Rabin.
1997	May 12—Awarded the Israel Prize for services to the media.	
1998	Feb. 9—Finds the negative of Paul Goldman's famous photograph of Ben-Gurion's headstand in that photographer's archive, kept by his widow and daughter.	
1999	Dec.—Sells his own photo archive to *Yedioth Ahronoth*.	
2000	Nov. 19—Anni Rubinger dies.	March 26—Pope John Paul II visits the Western Wall.
2001	Mar. 20—Brings Paul Goldman's archive to the attention of Detroit collector Spencer Partrich, who later purchases it.	Feb. 6—Exclusive photos of Ariel Sharon on the night of his election.
2002	June 30—Meets Ziona Spivak, later his companion, at a wedding.	
2004	Jan.—Visits Vietnam and Cambodia with Ziona Spivak. Dec. 26—Ziona Spivak murdered by her former gardener.	
2006	Eretz Yisrael—Birth of a Nation, a two-person show with the late Paul Goldman, opens at Proud Gallery, London.	

INDEX

Page numbers in italics refer to illustrations.